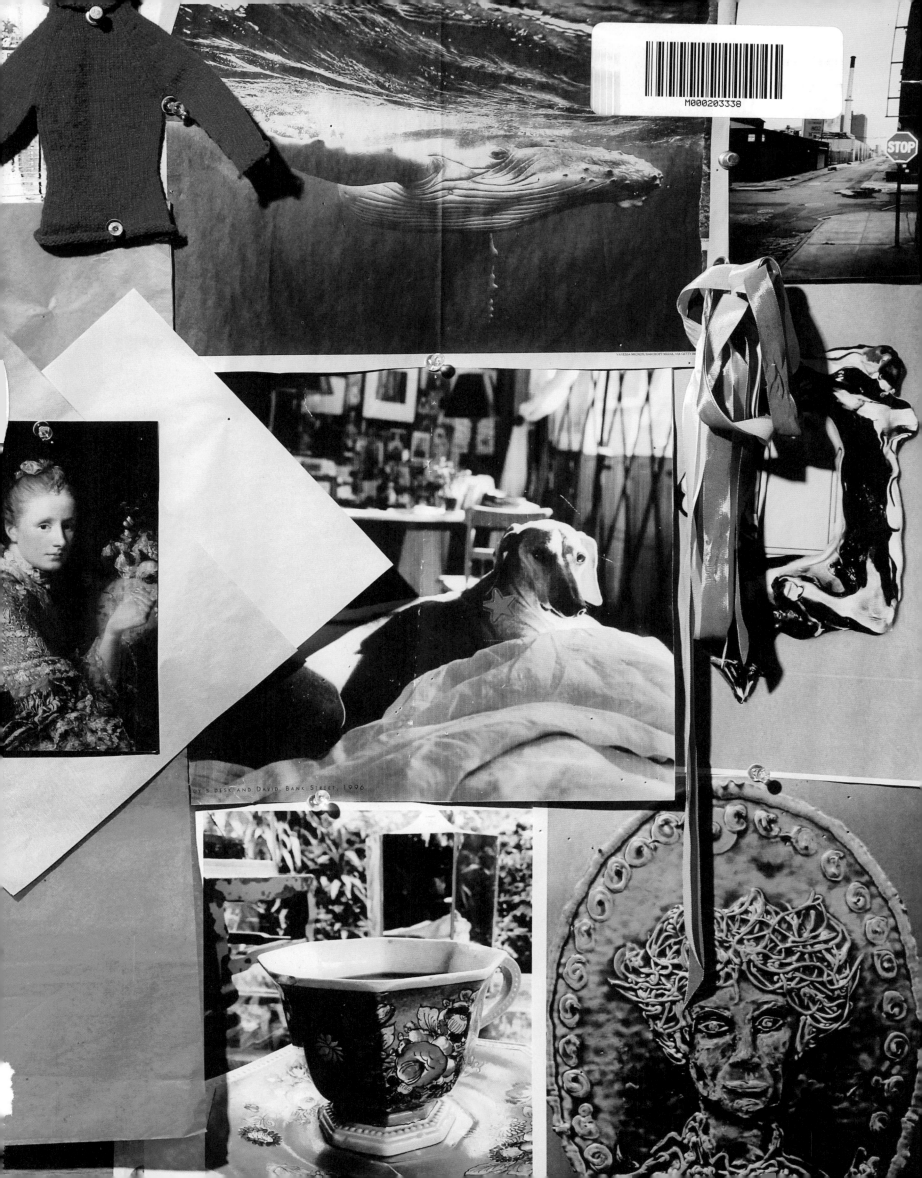

MAY I COME IN?

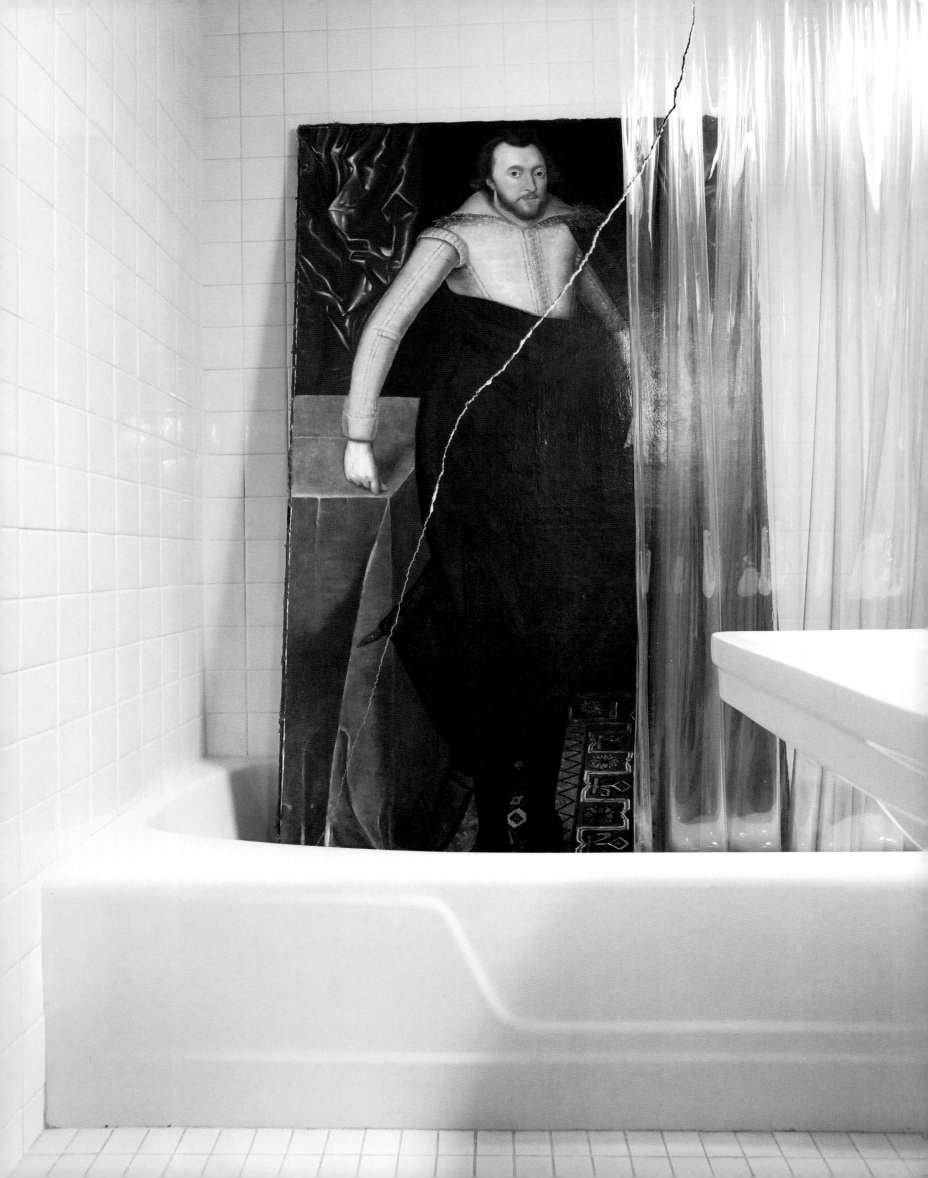

DISCOVERING THE WORLD
IN OTHER PEOPLE'S HOUSES

May I Come In?

WENDY GOODMAN

ABRAMS, NEW YORK

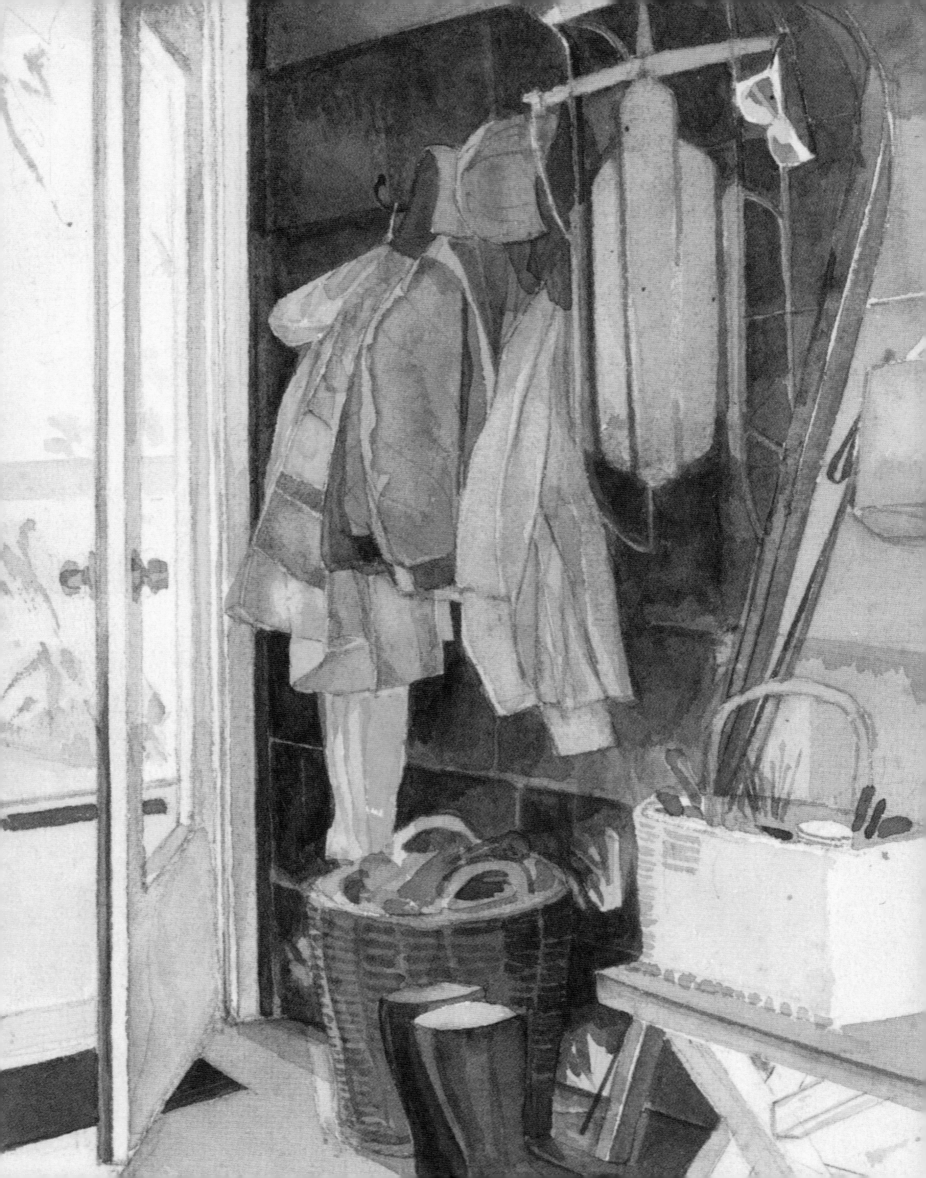

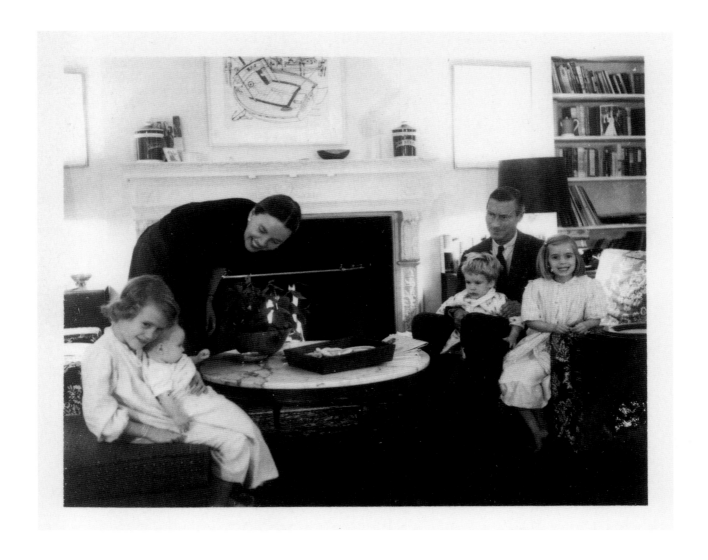

FOR MY MOTHER, MPG, WHO HUNG AN ANGEL ON THE WALL,
AND MY FATHER, ENG, WHO BUILT THE WALL.

Page 2: A knight in the guest bathroom of
Janet Ruttenberg's Beekman Place, New York, apartment,
photographed by Thomas Loof.

Opposite: My mother's watercolor of the back door of our house
in Sands Point on Long Island. *Above:* A portrait of our family
in the late 1950s: from left, me, holding my sister Stacy;
mum; dad, with my brother Ed on his lap; and my sister Tonne.

Page 6: The living room in Misha Kahn and
Nick Haramis's Brooklyn rental apartment. View from the
kitchen, photographed by Annie Schlechter.

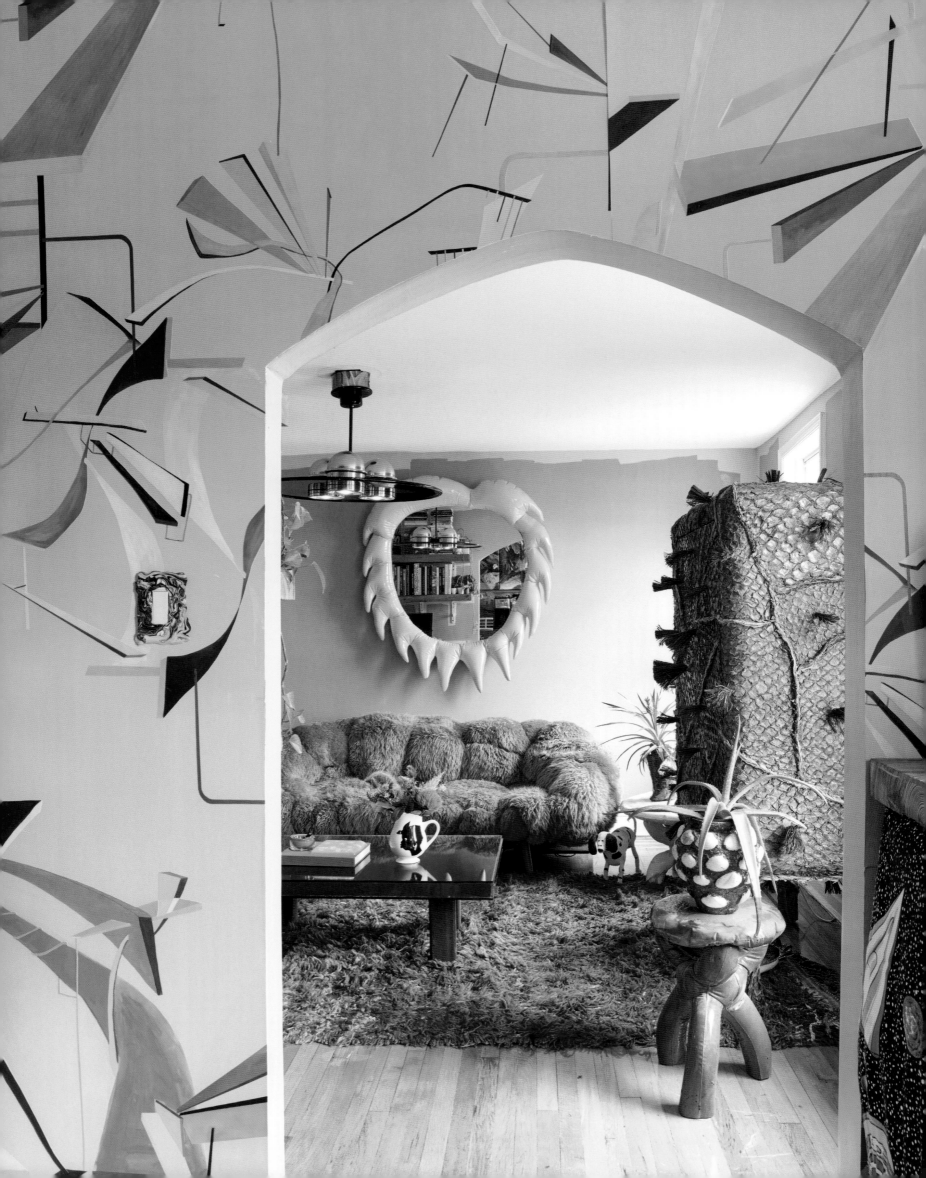

CONTENTS

Richard Avedon's New York apartment was a revelation. His walls were covered in Homasote so that Dick could pin or hang anything that caught his eye. Andrew Moore photographed the apartment after Dick's death in 2004.

BEGINNINGS

"*Nothing* is interesting
unless it is personal."

—BILLY BALDWIN

CITY KID

AY I COME IN? is a book about the last great dance with magazines, from the 1980s on up to the present. It starts at a time when simply opening a magazine was your passport to the world. There was no Internet, no social media; there were no cell phones, no computers, not even fax machines. You didn't have a clue what anyone was doing, or where they went, once you parted company. That was the world I lived in when I began my career as a fashion editor, which later morphed into a career in design. I started venturing into the private realm when privacy was something to protect, and I was always aware of what a great privilege it was to get behind closed doors. Over the years of going into other people's houses I have discovered three things to be true. The first is that curiosity and never giving up will get you everywhere. The second is what Diana Vreeland expressed so perfectly when she wrote, "Few things are more fascinating than the opportunity to see how other people live during their private hours." And the third is that houses never lie. They tell you if they are loved. They tell you if they have been created to impress, and thereby sit in loneliness, and they embrace you with palpable joy and warmth when they have been created with authenticity and heart.

I grew up in New York City privy to extraordinary people and their homes, but no place was as wonderful and inviting as our own family apartment. The door opened into our entrance hall with its floor of giant black-and-white square tiles. The air was scented with whatever was cooking for dinner, and in the winter a fire was going in the living room. Our mother, who wrangled four children and a menagerie of pets, always had an eye for the practical and would just as soon cover the walls of our father's study with Peg-Board she painted white as use it in the broom closet, where she left it brown. She hung everything on that Peg-Board: a carved wooden angel, old pocket watches, a case of our brother's Corgi Toys, and paintings she picked up at auctions. Over the years of observing our remarkable mother's efforts, I have realized that she unknowingly gave all of us the freedom to feather our own nests just the way we liked them, no rules applied. Thanks to my mother's unerring eye, I understood that the most captivating rooms exist where decoration is a by-product of a person's passions in life. That is what I am off to find when I tie on my sneakers, hop on the subway, and start my design hunting adventures every day.

If I couldn't find the right location, I created it in the studio, as I did here for a fashion shoot for *New York* magazine in 1984, photographed by Perry Ogden.

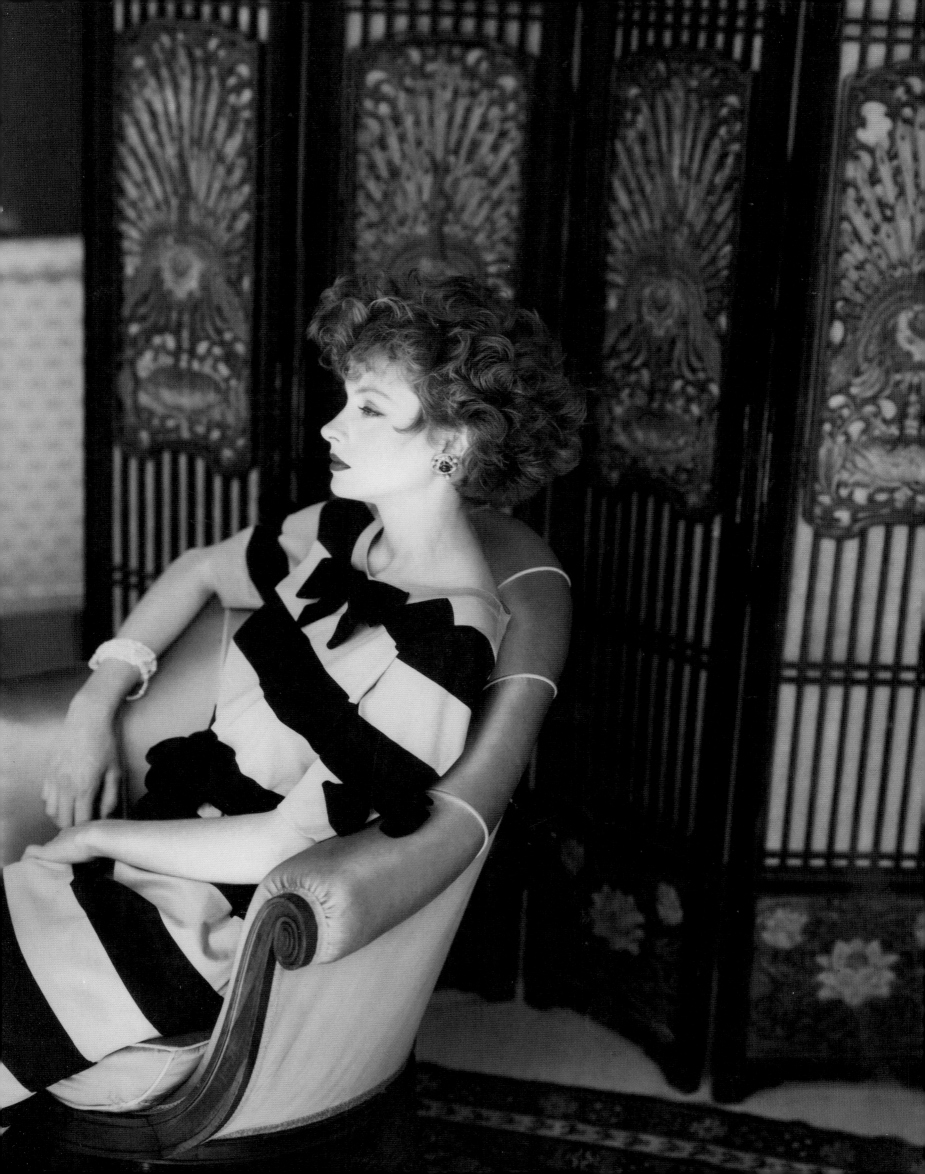

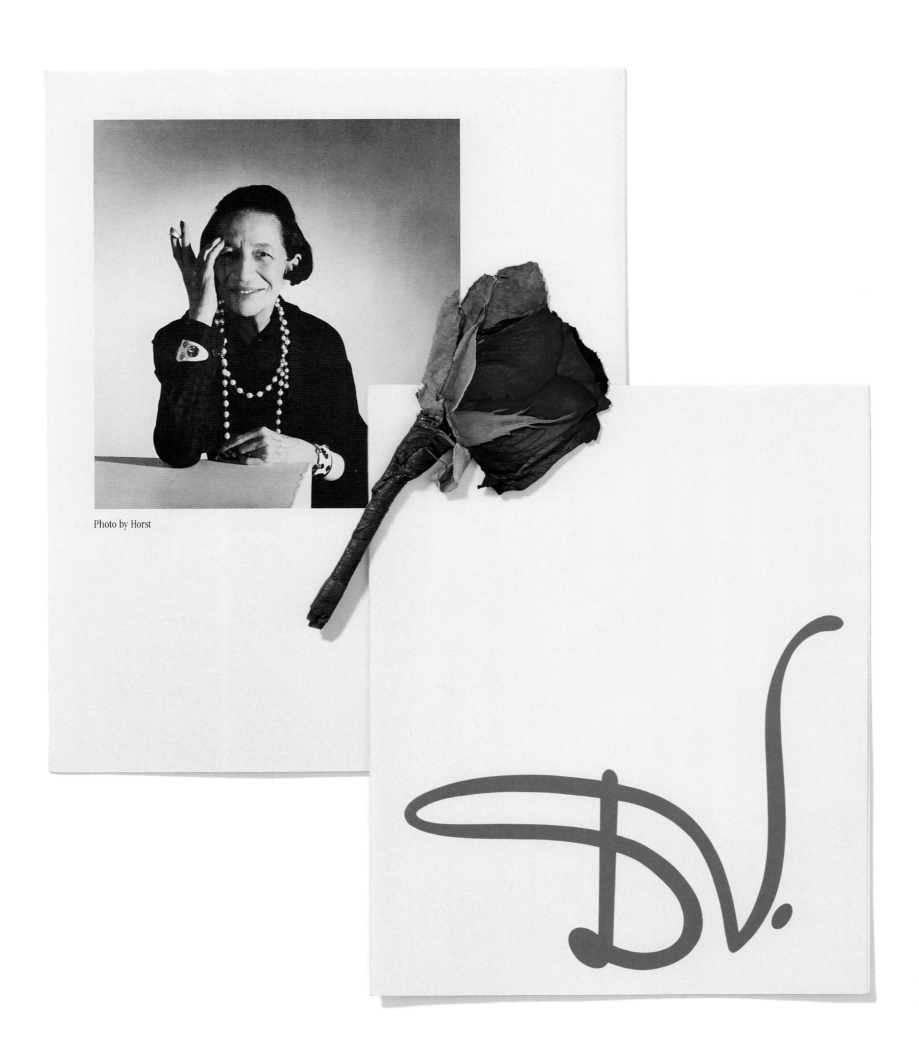

Photo by Horst

TiNY PORCELAIN FEET

DIANA VREELAND WAS A LIVING LEGEND IN MY LIFE. I was awestruck every time I saw her. Her vitality electrified the air. So it was all the more shocking that I was with her the day she died.

Her grandson Alexander and I were going to have lunch that day, but instead we flew up to Lenox Hill Hospital, where Diana Vreeland had been taken for another round of care, only this time there was nothing left to do. She was being rushed through the corridor under a blanket when we arrived at the hospital. Her tiny white feet were sticking out, each toenail perfectly painted blood red. She was being wheeled to wherever they take you when you are dying.

We were ushered into a waiting room: Alexander, Mrs. Vreeland's personal nurse, and I. We waited for the doctor to come back and tell us what we already knew. He asked if we would each like time with her alone. We said yes. So, one by one, we entered a cold room where Mrs. Vreeland lay in a state that she would never have wanted anyone to see. I didn't recognize one molecule of the face that I had been enthralled with since I was a kid, sitting in her red "garden in hell" living room, listening to her tell stories about everything from diamonds that made her cry to what she had seen at the movies. Death had given her an unrecognizable profile. This body that had lived so thoroughly and so passionately was, in death, a stranger to its former self.

We went back to Mrs. Vreeland's apartment in a state of shock. We did the things you do after a death, mechanically. I went to a coffee shop and got us sandwiches; Alexander started making phone calls to her friends and colleagues. I returned with our sandwiches, but I don't have any memory of eating them or doing anything else, except that I recall wandering around that living room, marveling that a space that had been so vibrant and alive with color, and infused with Mrs. Vreeland's favorite scents, was now cold and gray. All the passion had been drained, and what was left was the shadow of a room that had been animated by the life of this extraordinary woman. I sat on the floor by the banquette and noticed that there were drawers underneath. I pulled one out and found tons of photographs squirreled away. I took some out and knew I was looking at a precious stash of history. Alexander was working all the lines of Mrs. Vreeland's phone, and I answered the one time he couldn't get off one line to answer another. The voice that asked for Alexander was very soft; it was Mrs. Onassis on the line. I told her that Alexander would be right with her.

Program and rose from Diana Vreeland's memorial at the Metropolitan Museum of Art, New York, 1989. Portrait of Mrs. Vreeland by Horst P. Horst.

13

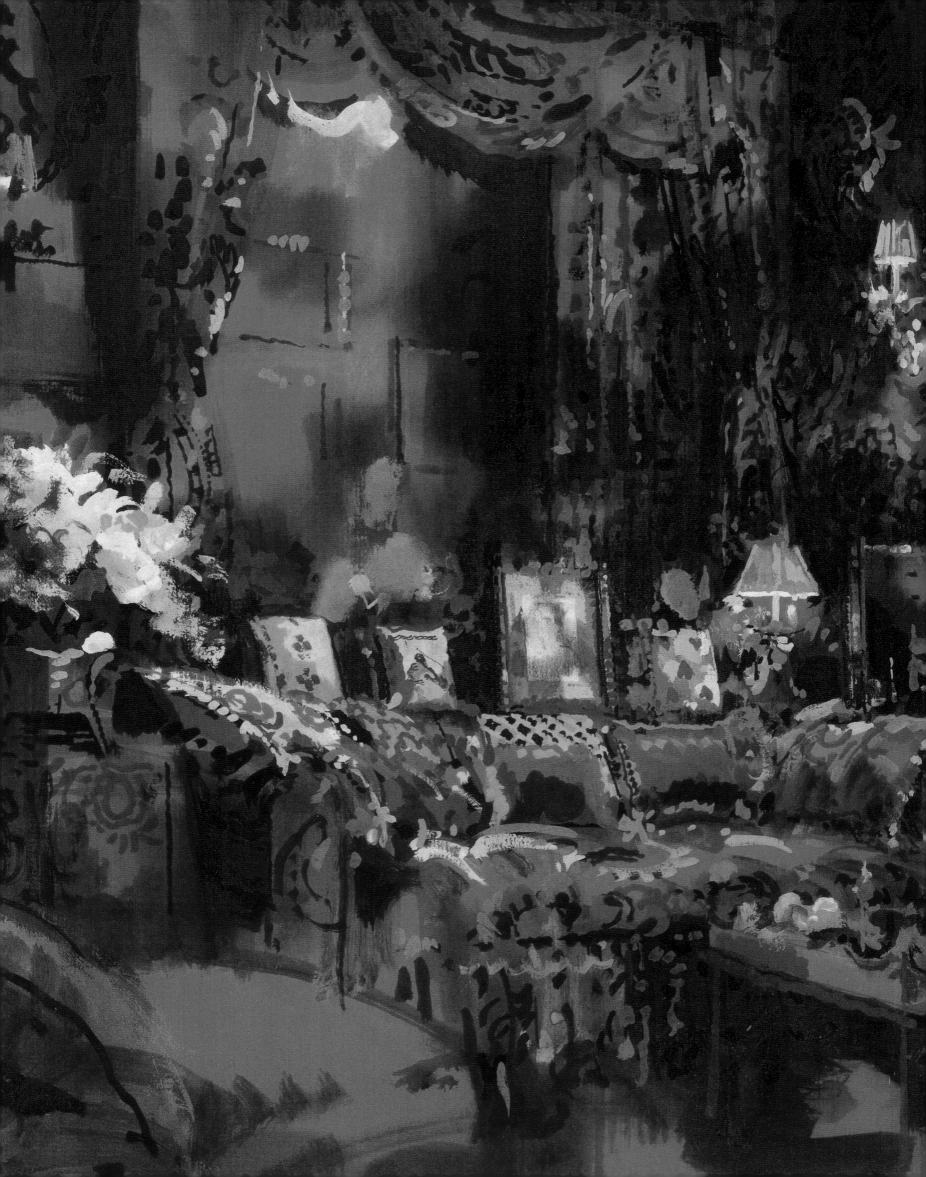

Jeremiah Goodman's painting of Billy Baldwin's "garden in hell" living room in Diana Vreeland's Park Avenue apartment. Alexander Vreeland said, "She had Rigaud candles burning, bowls of sand with incense fuming, clay coasters on the light bulbs with drops of oil smoking, potpourri in certain corners and at times a spritz or two of scent or room perfume."

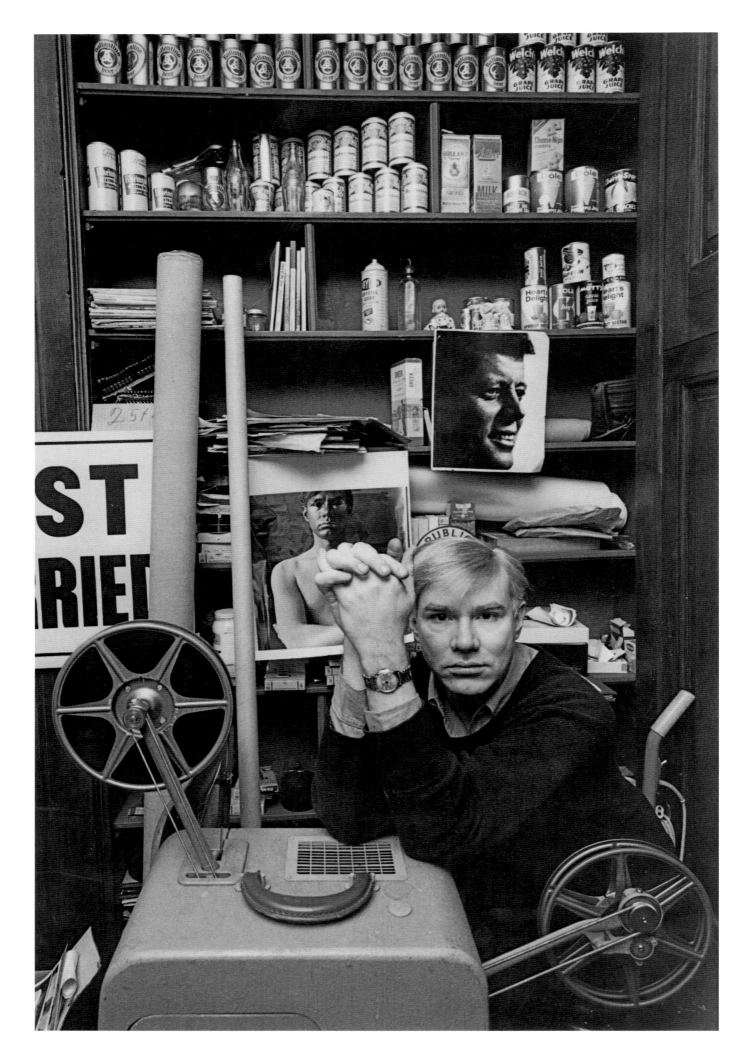

FASHION FANTASIES

Opposite: Andy Warhol at home on Lexington Avenue, 1964, by Ken Heyman. *Above:* My first fashion job was styling covers for *Interview* magazine: left, Jessica Lange, and right, Fiona McEwen, 1979. They were photographed by Barry McKinley and then the images were hand-painted by Richard Bernstein.

IT DIDN'T TAKE ME LONG AFTER GRADUATING from New York University's Tisch School of the Arts to accept that, though my love of the theater was real, my ability to lead the life of an actor was not; I wanted to work and be part of the world. I needed a real job. I had been working freelance, styling covers on and off for Andy Warhol's *Interview* magazine, when I received a call from my friend Alida Morgan at *Harper's Bazaar*, asking if I wanted to come in and interview for an assistant's position. I ended up working for two young fashion editors; one was an expat from England named Anna Wintour, and the other an expat from Japan named Jun Kanai. From there I went on to the *New York Times Magazine*, where I produced and wrote fashion stories, and I had a byline. I started working as a freelance fashion stylist for Estée Lauder, first on mailers and then on national ads. I learned from the best in the business, photographer Victor Skrebneski and CEO of AC&R Advertising, Alvin Chereskin, who masterminded the Estée Lauder campaigns as if he were a commander of the fleet. I learned how important it was to coordinate the clothing with the elaborate interiors and settings that were the trademark of those ads. I had clothes made; I scoured the market for shoes and accessories. Then, in 1984, the unthinkable happened: I became the fashion editor of *New York* magazine, after Anna Wintour left for British *Vogue.* That's when Pauline Trigère, the grande dame of fashion designers, invited me to lunch, and my life took a turn.

Model Tasha in the living room at Mar-a-Lago, 1989, photographed by Mike Russ. I wrote Donald Trump a letter asking if I could photograph the spring fashion issue of *New York* at Mar-a-Lago. He wrote back saying yes, and, no, I didn't keep that letter.

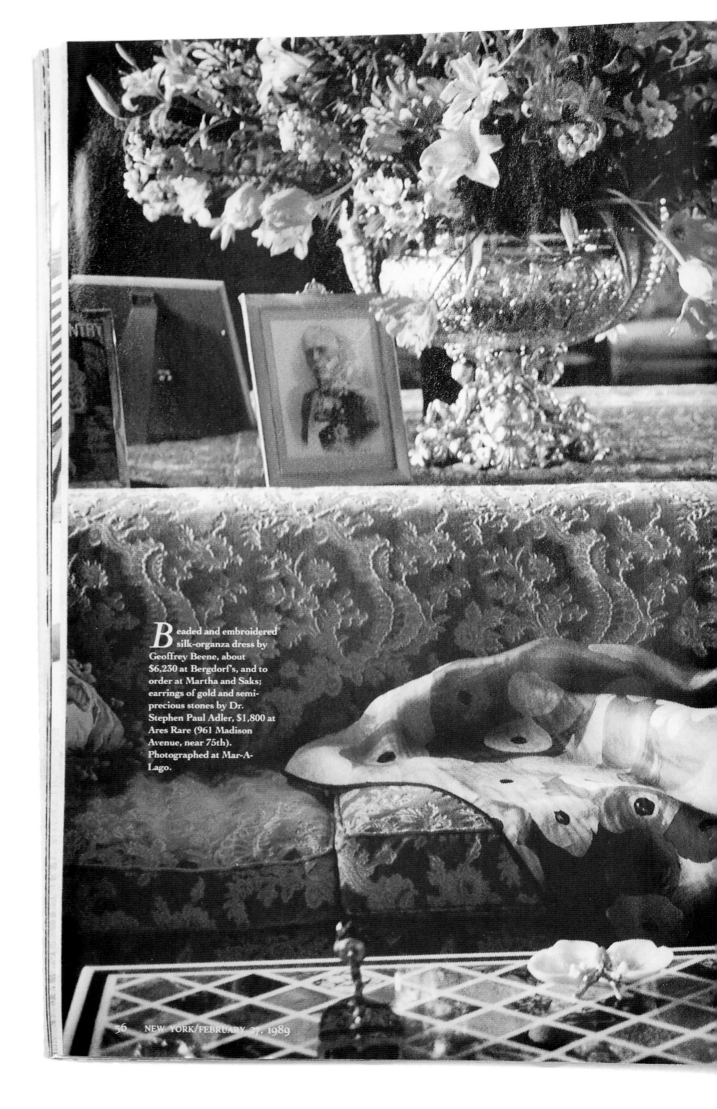

*B*eaded and embroidered silk-organza dress by Geoffrey Beene, about $6,250 at Bergdorf's, and to order at Martha and Saks; earrings of gold and semi-precious stones by Dr. Stephen Paul Adler, $1,800 at Ares Rare (961 Madison Avenue, near 75th). Photographed at Mar-A-Lago.

56 NEW YORK/FEBRUARY 27, 1989

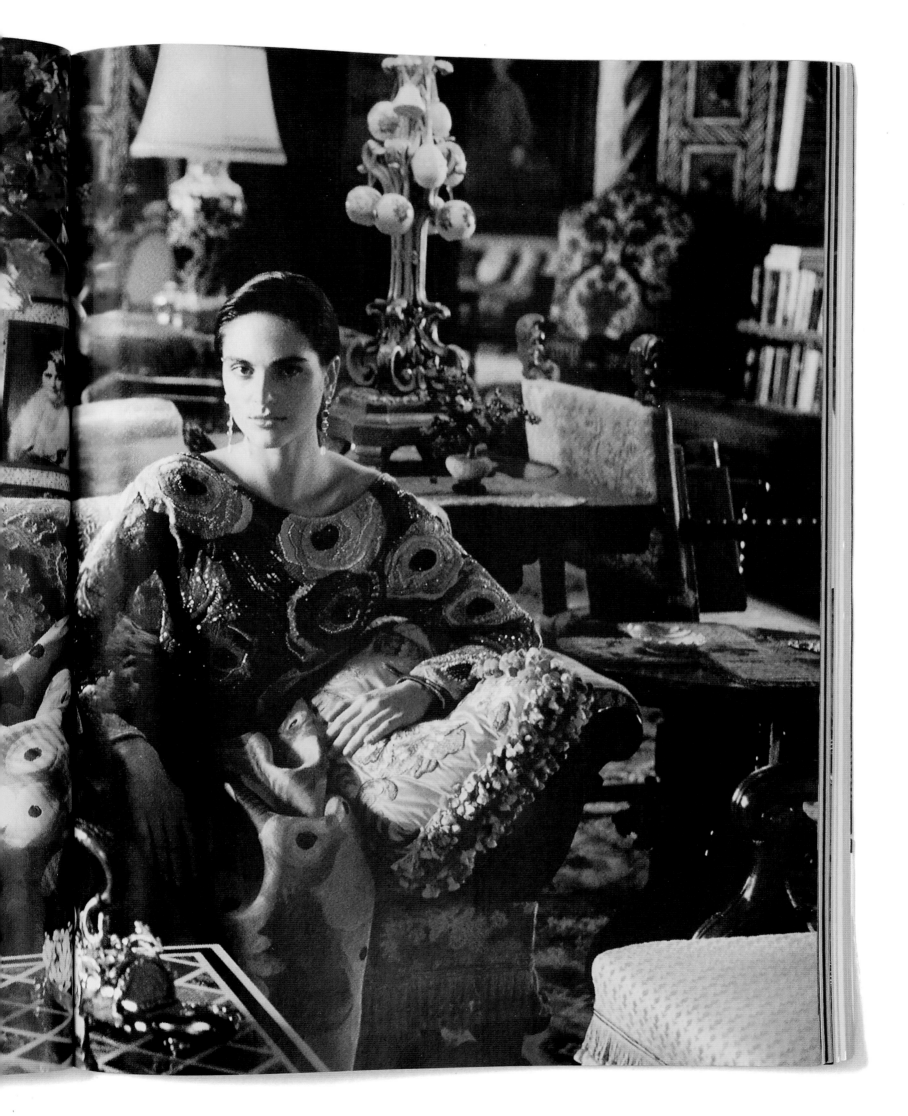

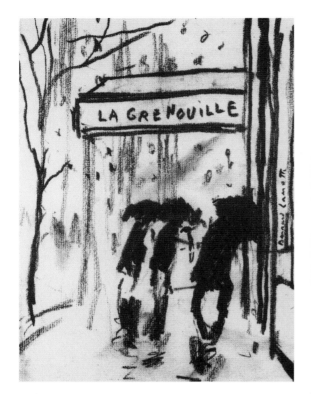

LA GRENOUILLE

I T ALL STARTED WITH A LITTLE CARRIAGE HOUSE in the heart of Midtown Manhattan. It was wedged between high-rise towers and looked so out of place. I had always been intrigued by it. Then, one day, when I had just started at *New York* magazine, Pauline Trigère was kind enough to invite me to lunch. The restaurant was La Grenouille, housed within that sweet carriage house. It had red velvet banquettes lining the front and back rooms, where the city's most glamorous doyennes and power brokers sat at tables covered in starched linen tablecloths. The walls, upholstered in pale, lettuce-colored silk, were hung with paintings of flowers. Towering bouquets in huge crystal vases were perched in every corner of the rooms, and each table sprouted its own arrangement. All the diners looked their best in the soft pink light coming from the brass table lamps sporting cream pleated-silk shades. There was a private dining room upstairs where, I was to learn, the painter Bernard Lamotte had lived in the 1940s and entertained everyone from Marlene Dietrich to Antoine de Saint-Exupéry, the author of *The Little Prince*. But there was even more. A small staircase in the back of that room led to a tiny, cramped studio where Charles Masson Jr., the proprietor, who then ran the restaurant along with his mother, Gisèle, used to go and paint with his late father, Charles Sr., and Lamotte. The studio was frozen in amber. There was a large easel surrounded by old palettes encrusted with globs of hardened paint, and coffee cans bursting with paintbrushes; there were paintings stacked everywhere. It was an Aladdin's cave.

The enchantment swallowed me whole. I wanted to write the story of the Masson family and the building. But that day, sitting with Pauline in her burgundy-red jumpsuit, with one gold frog pin on her shoulder and another on her knee, I was a fashion editor, with miles to go down that road. But I knew then that something had shifted in me, something that was to change my career, and my life, forever.

Top left: Bernard Lamotte's drawing of La Grenouille in the rain. *Top right:* I photographed Pauline Trigère outside the restaurant after one of our lunches in 1984. *Opposite:* A banquette with a magnificent bouquet, photographed by Oberto Gili.

20

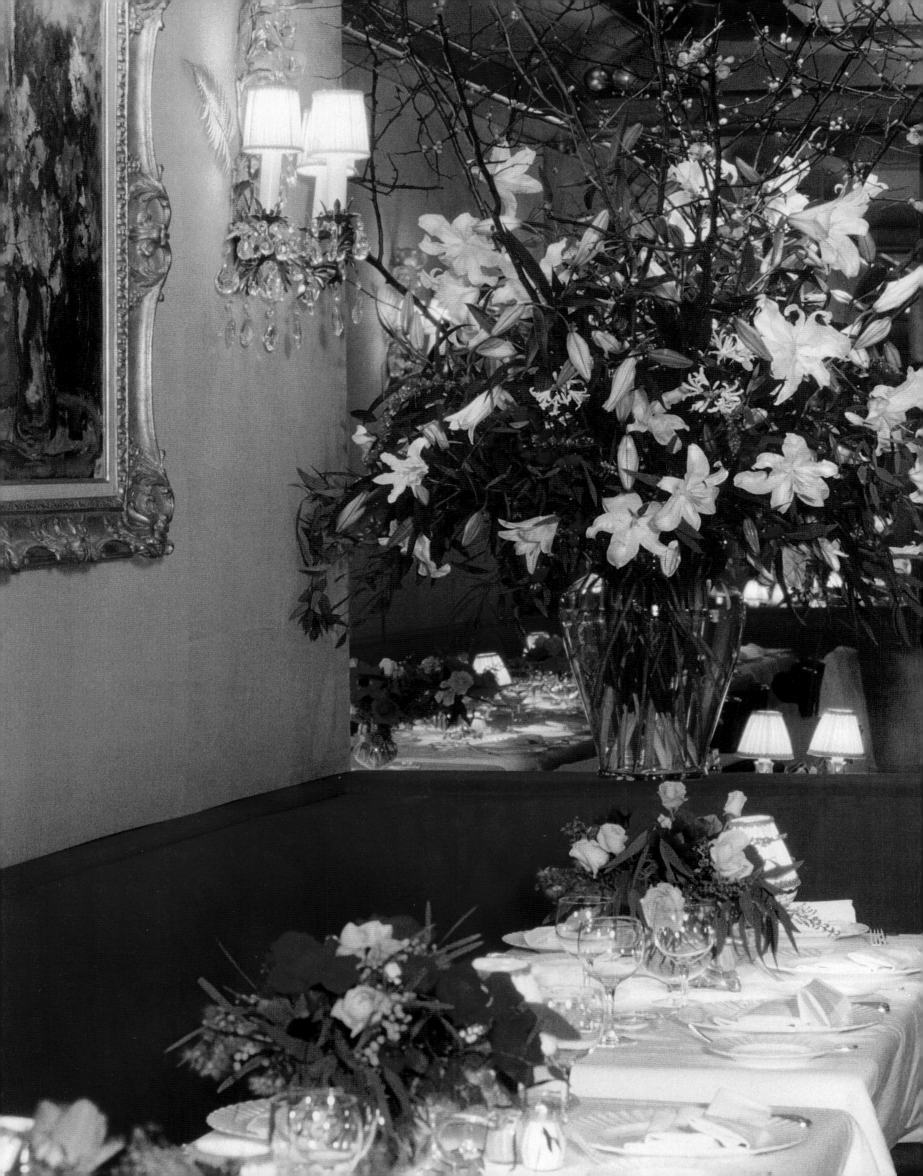

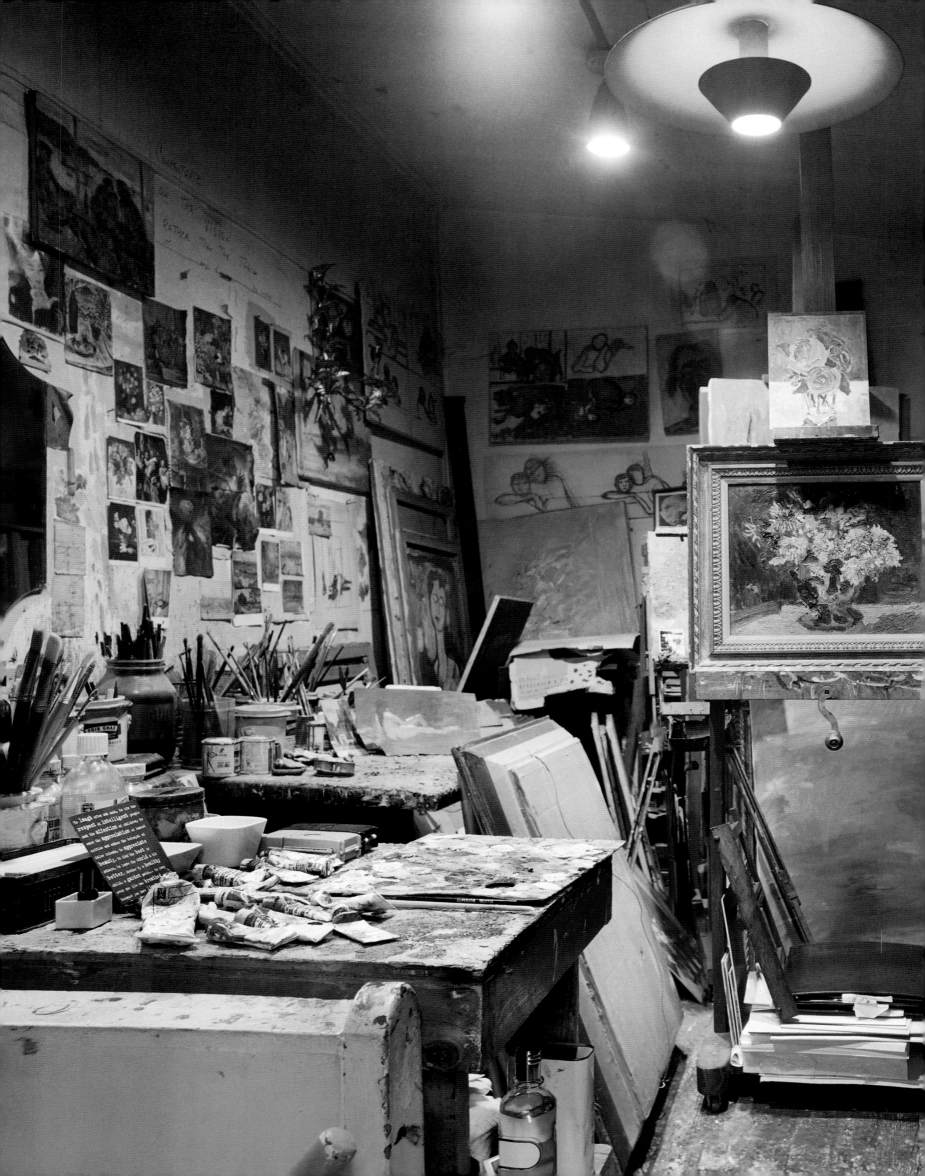

The studio above
La Grenouille where
Bernard Lamotte
gave Charles Masson
Jr. painting lessons,
photographed
by Corinne Botz.

23

1

FABULISTS

Fabulists are outlaws
of the everyday.
They create singular
kingdoms; they
don't know how to
do anything else.

RICHARD AVEDON

Opposite: The waiting area in Richard Avedon's studio, with his print of *Dovima with Elephants*, photographed by Andrew Moore. *Above:* Dick's inscription in a book about Amedeo Modigliani that he gave me for Christmas, 1997.

H E WOULD ALWAYS BE WAITING at the top of the stairs to greet me with a big hug. Just thinking about having dinner with Dick, just the two of us, at his long library table set up in front of the window in the kitchen, made me happy all day. I knew Dick through his son, John, one of my best friends, who I met during a snowball fight where we tried to kill each other when I was twelve. The first time I went to the studio, it was with John. Everyone was at attention and the atmosphere was always charged with nervous anticipation of what Dick would say, want, be thinking about, once he made his entrance into the living theater where he performed as much as created his art. A visitor was led past the reception area where studio assistants worked at desks lining the wall. Beyond, there was a waiting space, defined by simple director's chairs in a U configuration, above which a giant, gold-framed print of *Dovima with Elephants* presided. On the far side you took a step down into Dick's white, curved-wall studio, where you had to adjust your eyes to figure out where the walls, ceiling, and floor began and ended. It was like being in a perfect white

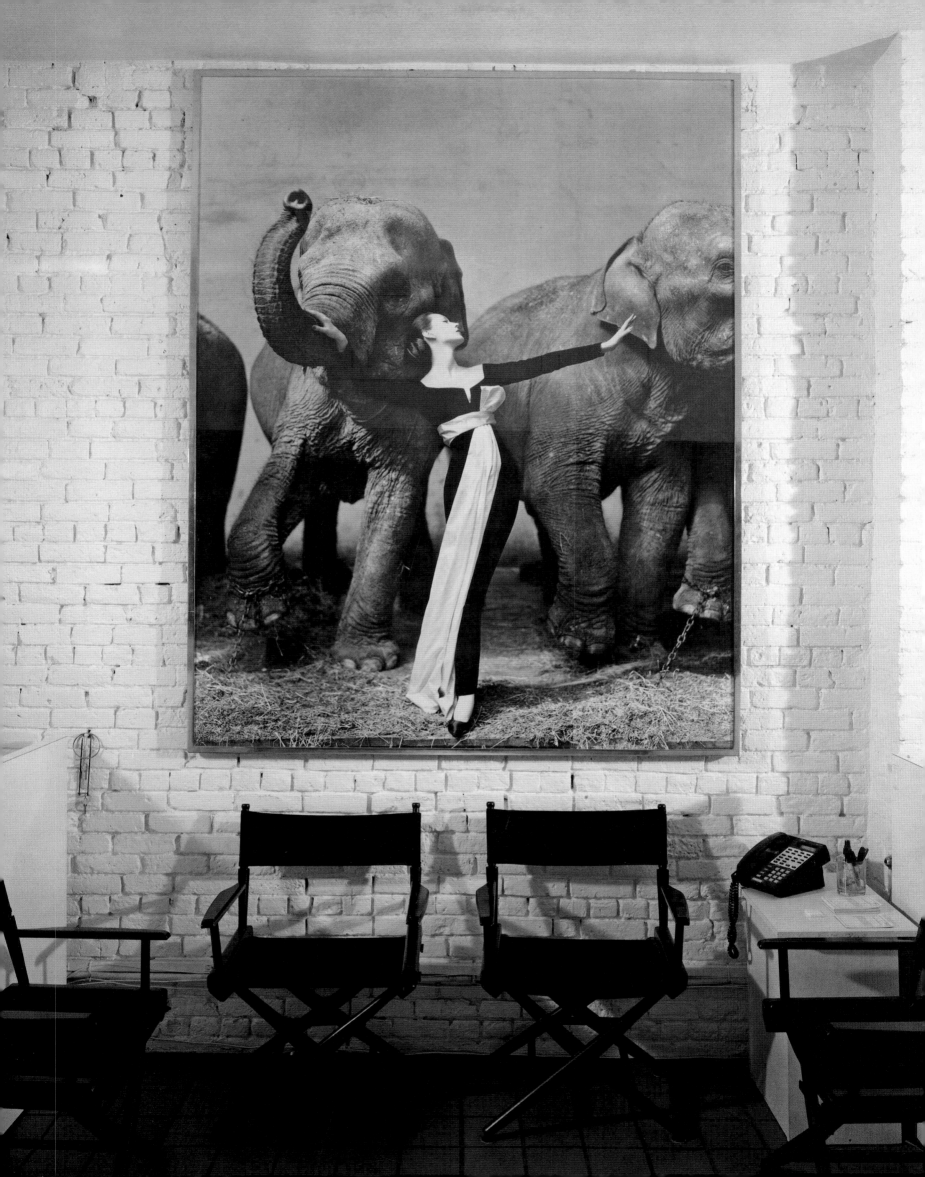

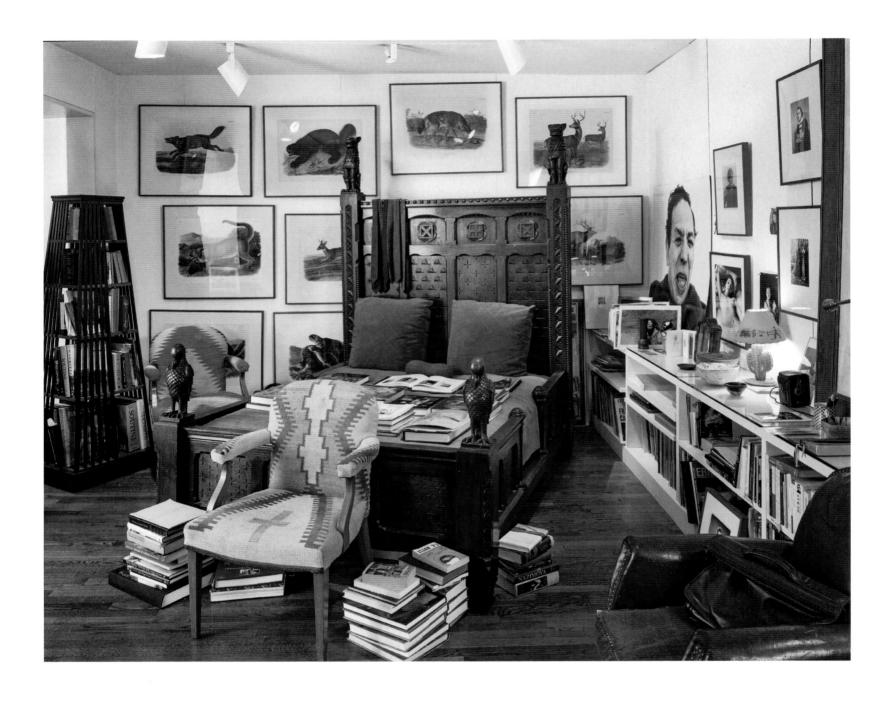

cloud. A discreet door in the wall to the right of the reception area opened to a narrow staircase, which led up to Dick's apartment. There the walls were lined in Homasote so that Dick could put up anything that caught his eye, from a postcard to a story he'd cut out of the newspaper, all with pushpins! The walls were like the lining of his brain. This was the exciting confirmation that there were really no rules to what you could do at home, especially as the first thing you saw was a magnificent mahogany four-poster bed Dick used as a tie rack, bookcase, and staging area for any number of assorted things he wanted to study or use.

I have never gotten over that apartment, which we published in *New York* magazine in 2005, not to this day. It was a private cabinet of curiosities where everything was there to please the master.

Above: The first thing you saw when you came into Dick's apartment was this four-poster Victorian oak bed hung with neckties and laden with books. Prints of North American mammals by John James Audubon hung on the back wall. *Opposite: Roberto Lopez, Oil Field Worker, Lyons, Texas*, from Dick's In the American West series in the living room.

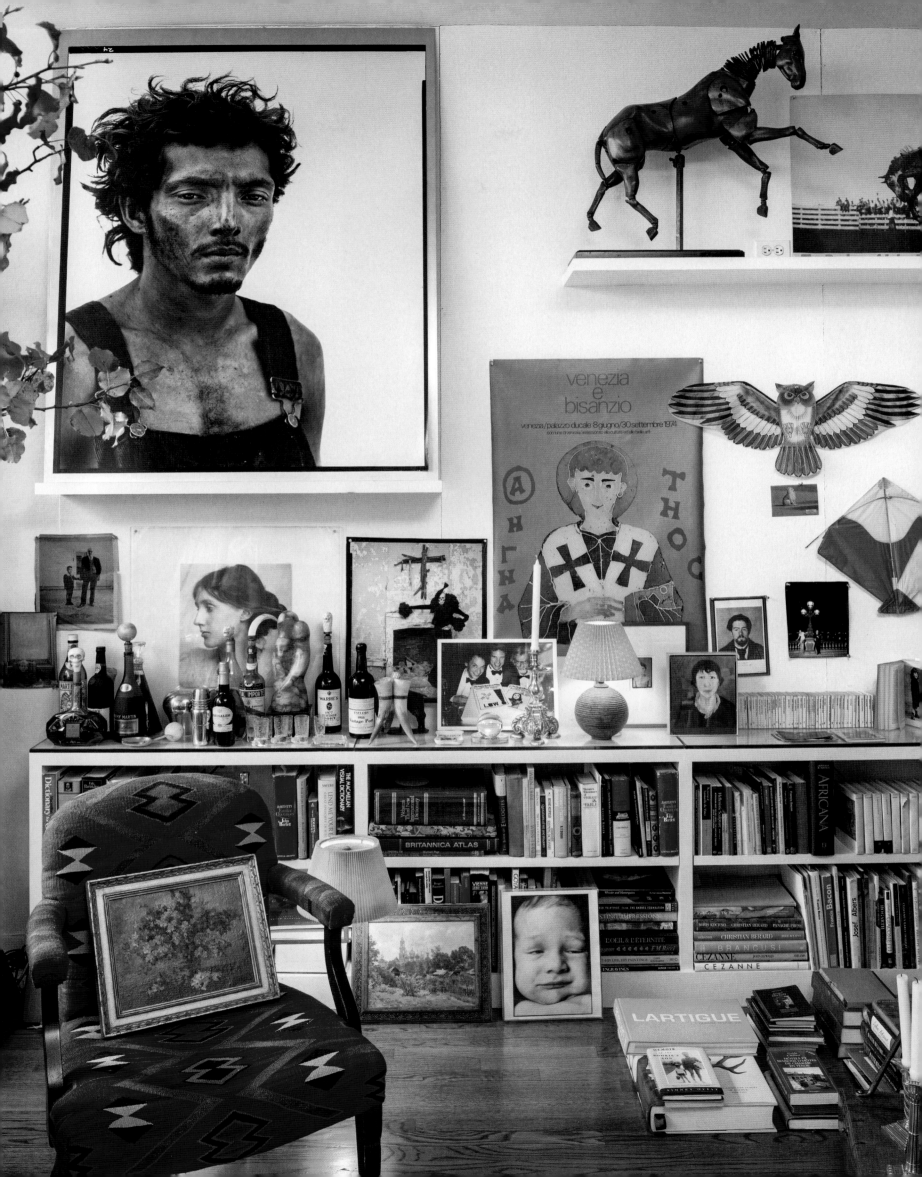

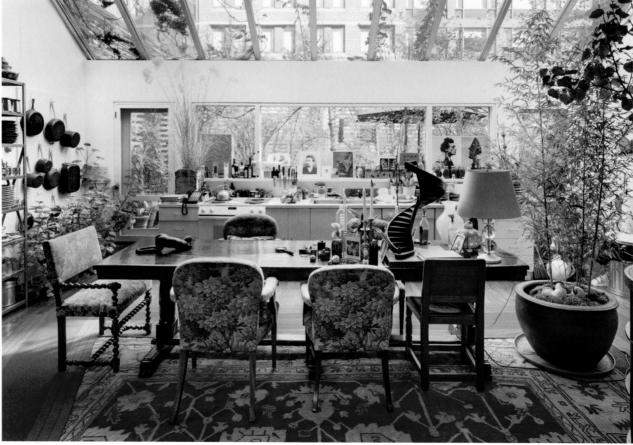

Opposite: Dick's portrait of Charlie Chaplin hung outside in his garden. *Above:* Dick asked Brian Tolle to design a bed that would let him have everything at his fingertips. Tolle came up with a series of boxes, modeled on water-cooler crates, and made one hundred cardboard boxes for Dick to configure until he found just the right design, which was then built in mahogany. *Below:* A view toward the kitchen with a large library table in an area that served as meeting place and dining room.

DONATELLA &
GIANNI VERSACE

Above: Obero Gili photographed a place setting in the dining room in Donatella Versace's former Milan apartment. *Opposite:* In her office, Donatella was all business and then she broke into a smile that lit up the room. *Overleaf:* Donatella's luxurious bathroom and bedroom.

THE PARTY WAS AS GLAMOROUS AS IT GETS during Fashion Week in Milan. The hostess, Donatella Versace, invited a handful of models, editors, and industry insiders to a buffet dinner at her apartment in a hulking prewar building covered in ivy. The decor, done by the Italian maestro of opulent interiors Renzo Mongiardino, was royally splendid. We sat bunched together on the sofas in her barrel-vaulted living room; I discovered that I was sitting next to the partner of the legendary editor Anna Piaggi! I was obsessed with getting into her house; I could only imagine that it was as original and outrageous as the way she dressed. I told her companion about my dream. Our conversation was unsatisfactory, as he didn't open the door to any possibility that a story could happen. I left the party feeling that I had somehow failed.

A few years later, in 1996, I returned to Donatella's apartment to do a story for *Harper's Bazaar*. The dining table had been set with exquisite porcelains and linen. The room was a medley of delicious color. The circular bathtub in the master bathroom had been filled with water sprinkled with floating rose petals. A satin-and-lace peignoir was hanging in the corner on a dress stand. The sense of luxury was as much in the handling of the details as in the pure extravagance of the setting. I imagined Donatella explaining to her dedicated staff just the way she liked things. I imagined how comforting this opulent sanctuary would be after a day of nonstop meetings and decision making.

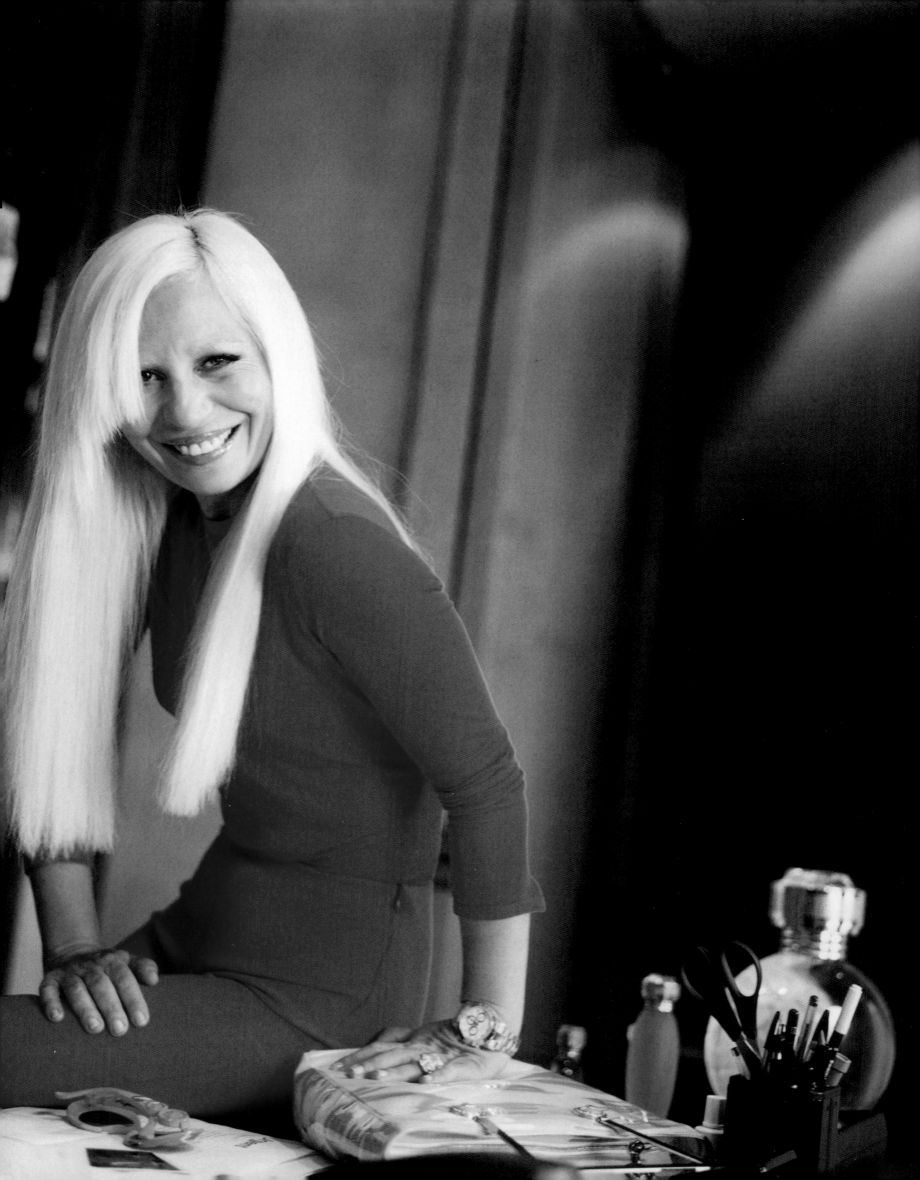

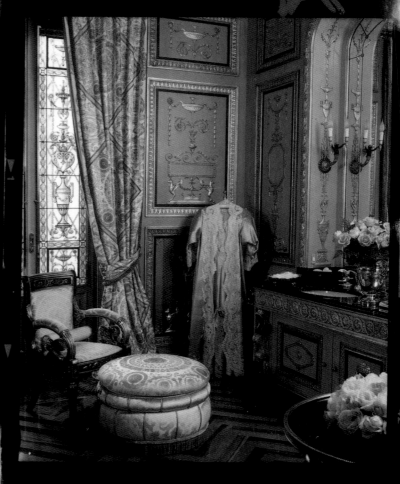

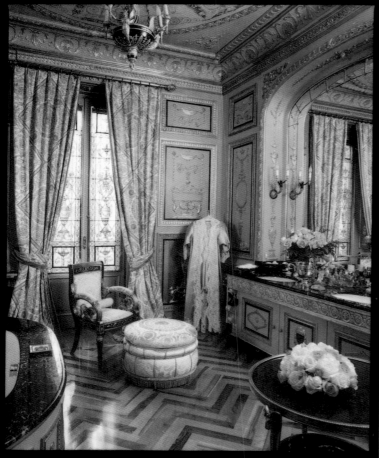

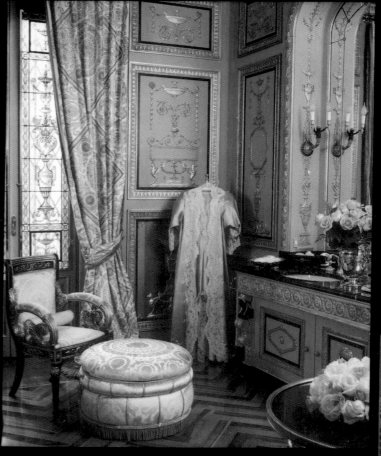

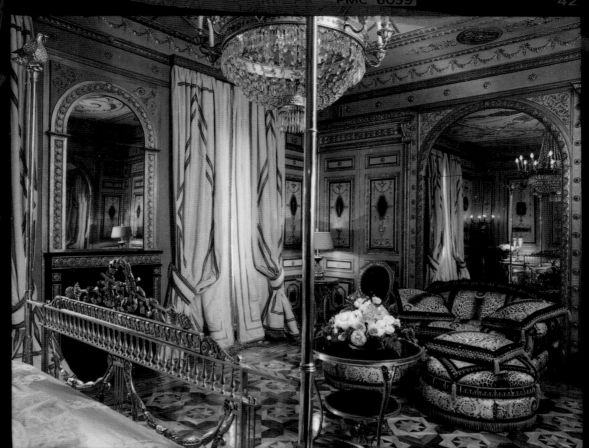

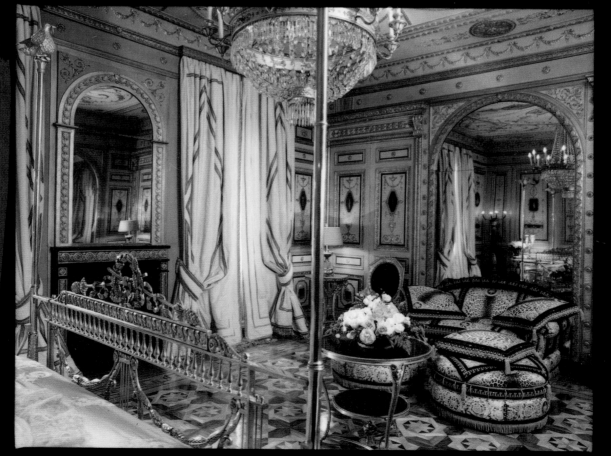

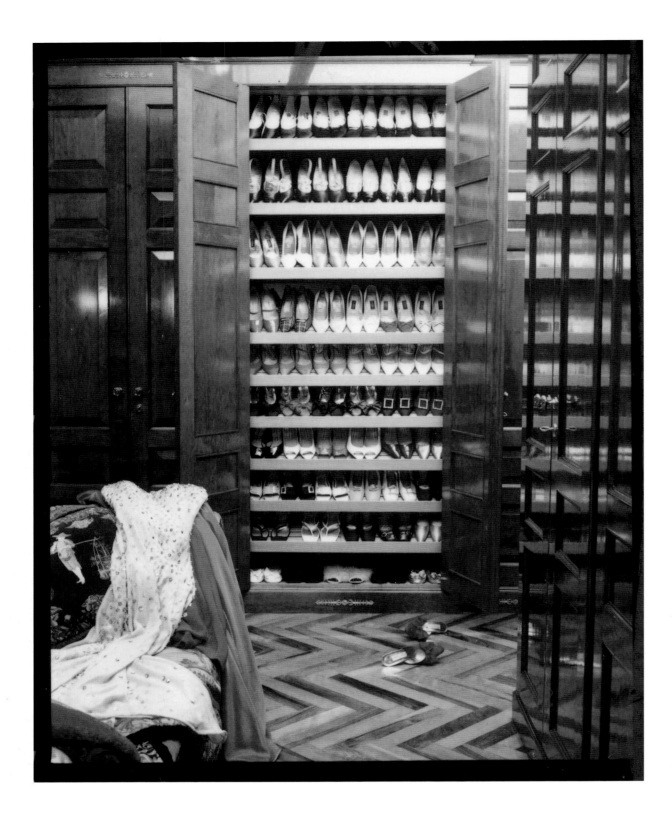

The legendary decorator
Renzo Mongiardino
worked his magic
throughout Donatella's
Milan apartment.
Opposite: The main
salon with sofas covered
in Versace fabric. *Left:*
Donatella's shoe closet.

Then there was Donatella's brother, Gianni. I had seen a show of Gianni Versace's fashion designs in New York that included some of his ballet costumes from 1987, and I thought they'd be beautiful on his terrace when we photographed his palazzo in Milan for *HG* in 1990. They would look like dreamy apparitions making a surprise appearance where you would least expect them. It was an idea that took a bit of doing, but it happened of course, with the help of Versace's tireless, devoted team of assistants. The household was run by a staff schooled in strict discipline, loyalty, and the art of perfection. Gianni's seventeenth-century palazzo on Via Gesù in the center of Milan's fashion shopping district was more formal, and the decor done on a much grander scale, than Donatella's more intimate apartment. It was filled with antiquities and classical sculpture, all reflected in the polished stone floors. At one point I stood over a table topped by a collection of Roman heads, each one with a different hairstyle carved intricately into the marble. I thought, in a museum they would be behind glass, and here I am with the privilege of seeing them up close, in a private setting. Years later, Donatella moved into her brother's palazzo.

Above: For a story I did with Oberto Gili, I dreamed of styling the outdoor terrace of Gianni Versace's seventeenth-century palazzo in Milan with the linen tutus I had seen in a show of his in New York. With a concerted effort by his studio, they were flown over for the shoot. *Opposite:* Gianni's office, with a painting by Mimmo Paladino to the left of the designer's desk.

ANDREW SOLOMON
& JOHN HABICH

Top left: Andrew Solomon and John Habich's small
dining room with mosaic work by Farley Tobin,
2014, photographed by Annie Schlechter. *Top right:* Andrew,
photographed in his library by Max Vadukul for *Casa
Vogue*, 1999. *Opposite:* Their unique guest room, which
featured an igloo-like installation by artist Stephen
Hendee and an extraordinary bed, designed by Mathias
Bengtsson to Andrew's specifications. The space
was the subject of my first Great Room feature for *New York*
magazine, in 2004, photographed by Thomas Loof.

WHEN WRITER ANDREW SOLOMON purchased a very beautiful
grand dame of a town house on West Tenth Street in 1992,
it had seen better days. Then a contributing editor at *HG,* he
had been living in a somewhat more modest loft building.
Andrew met his husband, the wonderful writer and editor
John Habich, a few years after moving into the house on West Tenth.

I went to see the house with Andrew before interior designer Robert
Couturier started the work that would turn this Cinderella into a ravishing
beauty, and later published it in *New York* magazine (2004 and 2014). Back
then the rooms were empty and forlorn, the walls were cracked, and paint
was peeling everywhere, but there was such a gloomy beauty to it all. There
was no electricity to illuminate the rooms, only the fading afternoon light.
Today, the house is a spectacular monument to grand decorating. The main
salon and library are perfect for the myriad book parties and celebrations
that have filled them with life over the years, and upstairs the cozy eat-in
kitchen is always buzzing with various family activities; Andrew and John's
son, George, might be doing homework, or a full staff of caterers might be
preparing a formal dinner.

But there is one room on the top floor that offers a window into Andrew's
more eccentric tastes. Opening the door to one of two guest rooms, you're
shocked. It isn't a room in any familiar sense; it's more of an igloo with a float-
ing barge of a bed in the center. Andrew commissioned Stephen Hendee to
create an installation based on a work he saw in one of the artist's shows.
Here Hendee used Plexiglas panels backlit by fluorescent tubes covered in
colored gels. The twin bed, created by Danish designer Mathias Bengtsson,
was made by layering fifteen hundred pieces of plywood for the frame. "It had
to be low and compressed and have movement," Bengtsson said of Andrew's
requirements. "He wanted the bed frame to resemble waves of wood."

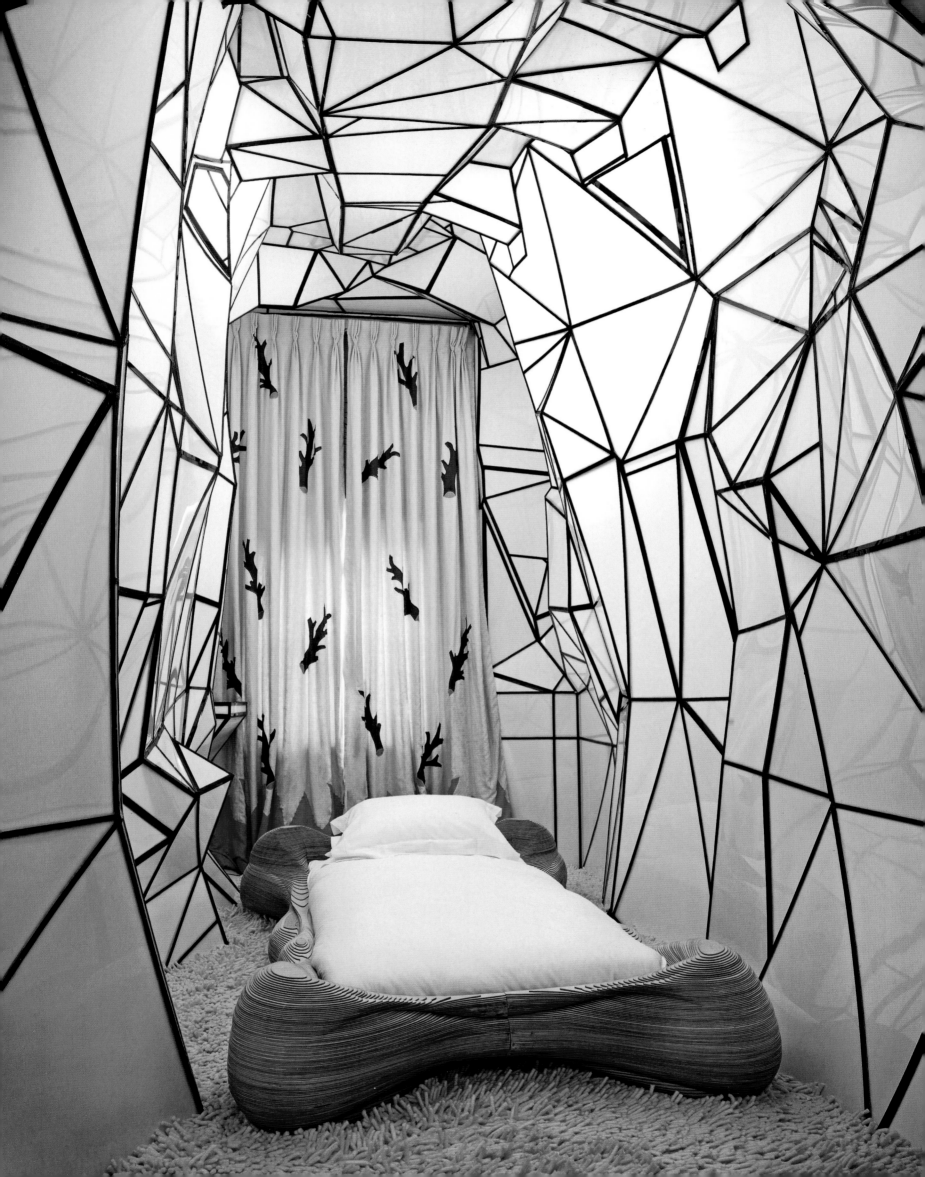

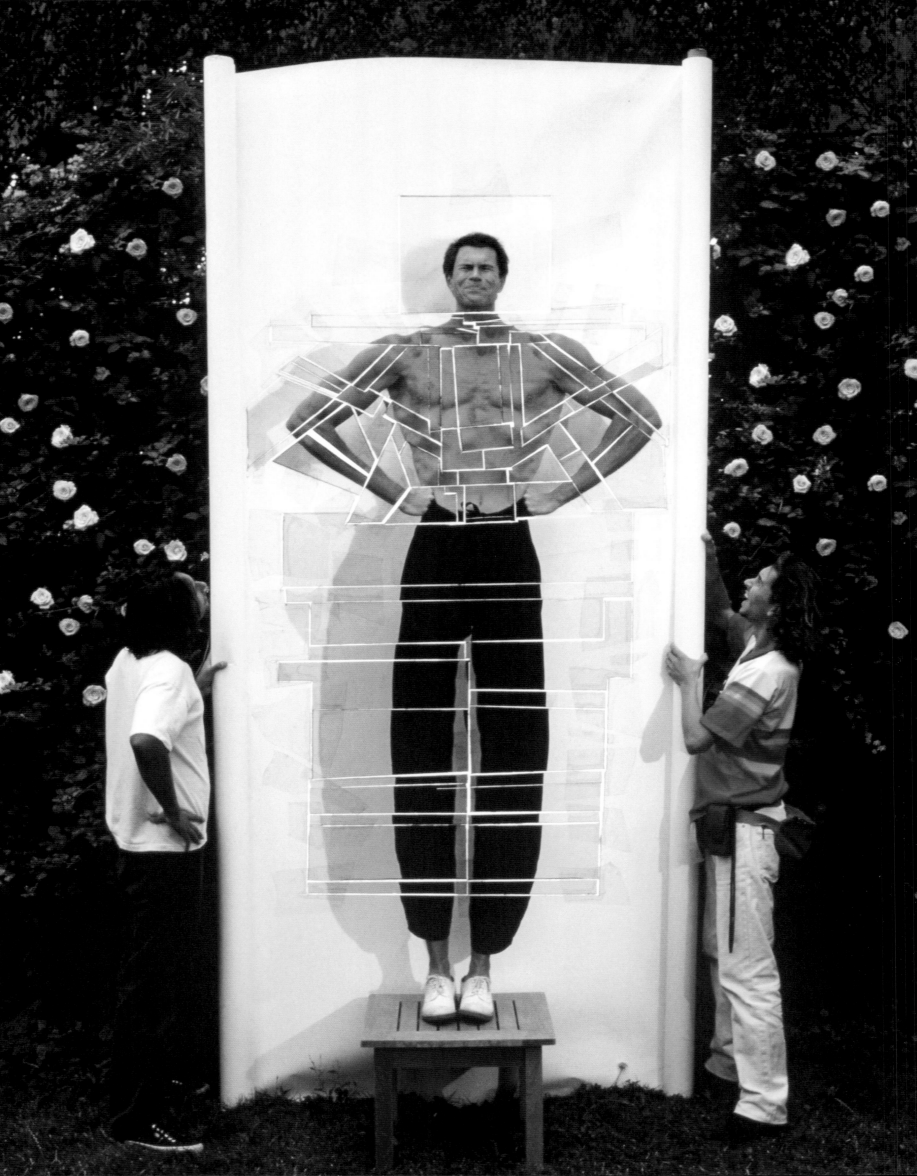

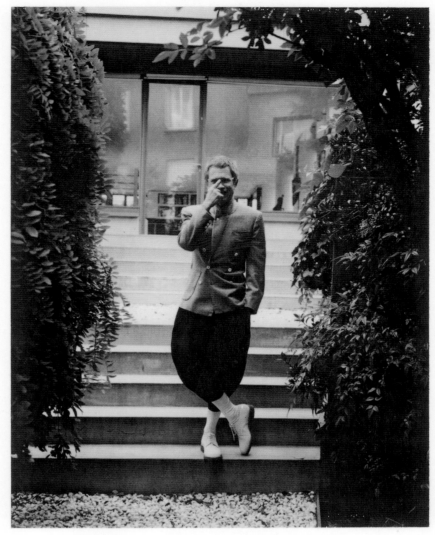

Pour mon amie Wendy

JEAN-PAUL GOUDE

I was ecstatic to do a story on Jean-Paul Goude, one of my
heroes, for *Harper's Bazaar*. I shared the adventure with
Mario Testino, and we photographed both of Goude's residences,
in Paris and New York, decorated by Andrée Putman.
Opposite: Mario photographed Goude and then gave him the
portrait to "correct." Goude created a he-man version of
himself. *Above:* I did a second story on Goude in Paris years later
for *House & Garden,* and photographer Jason Schmidt made
a Polaroid of Goude without any "corrections."

J EAN-PAUL GOUDE'S PROCLIVITY FOR ENTERTAINING was, happily, in high
gear during a photo shoot with Mario Testino for *Harper's Bazaar* in
1994. The story featured his homes in Paris and New York, both designed
with the help of Andrée Putman. In Paris Goude lived in the Nineteenth
Arrondissement, in a 1920s ivy-covered town house with a dazzling
view of the city. In New York he also had wonderful views, from his pent-
house overlooking Union Square. Goude has proclaimed himself "a jack of
all trades and master of all," a rejoinder to his mother's warning that he must
focus on one métier or pay the consequences of mastering none.

This polymath is simultaneously an artist, art director, commercial direc-
tor, and photographer. Everything he touches has been thrillingly original.
During his stint as art director of *Esquire* magazine in the 1970s, one feature
that brought him particular attention was "The French Correction," which
illustrated self-improvement using props such as platform shoes, shoulder
pads (in T-shirts), fake belly buttons, and lifts inside sneakers. Tongue in cheek
as it may have seemed, Goude has always been obsessed with self-image
and has embraced his own corrections, putting lifts in his white bucks
and high tops and visible shoulder pads in his T-shirts. Goude told me for
Harper's Bazaar: "I'm the advocate of details; the little adjustments change
everything." But the changes weren't always so little. Goude has famously
fallen in love with ravishing women, each one of whom he has reshaped
to match the ideal of his imagination. One girlfriend, Toukie Smith, hated
what he did to a life-size plaster cast to whose creation she had submitted.

Left: Mario's photograph of Goude's Paris dining room with artifacts from the parade Goude staged in Paris for the 1989 bicentennial of the French Revolution. *Opposite:* A picture of Goude with his then girlfriend, now wife, Karen Park, as the Queen of Seoul, a fantasy character created by Goude and photographed by Mario on the roof of Goude's former penthouse on Union Square in New York City.

"So my friend Matton took me to this guy who owns a pantograph," said Goude. "It's a rather primitive machine used by sculptors to enlarge statues.... We did the reverse! We reduced Toukie to a twelve-inch-high replica of the original cast, exact in every detail.... I couldn't help myself. I had to improve the masterpiece. The real Toukie was a step in the right direction, but she was not quite like my drawings." Goude made her in the image he wanted, going on to "chop up" Toukie's replica, "elongating limbs and widening shoulders." Toukie wasn't having it. Performance artist and singer Grace Jones, on the other hand, was. One of Goude's first portraits of Jones combined different photographs he took of her, which allowed him to lengthen her legs and make other adjustments, with the result that his ideal Grace Jones was not anatomically true but made a spectacular poster image. It was Goude who gave Jones her signature flattop "traditional Marine hairdo."

Goude's idea for his own portrait for the *Bazaar* story followed similar lines. He had Mario take a Polaroid of him in his garden, wearing his baggy pants and white bucks, no shirt. Then he took the Polaroid and cut it up and created his own "correction," so that in the end he looked like a cartoon, larger-than-life he-man. Years later I did a second story, on Goude's new studio space on his property in Paris. Jason Schmidt photographed that story and took a Polaroid of Goude that he left alone, no corrections added. I love that portrait the best, no corrections needed.

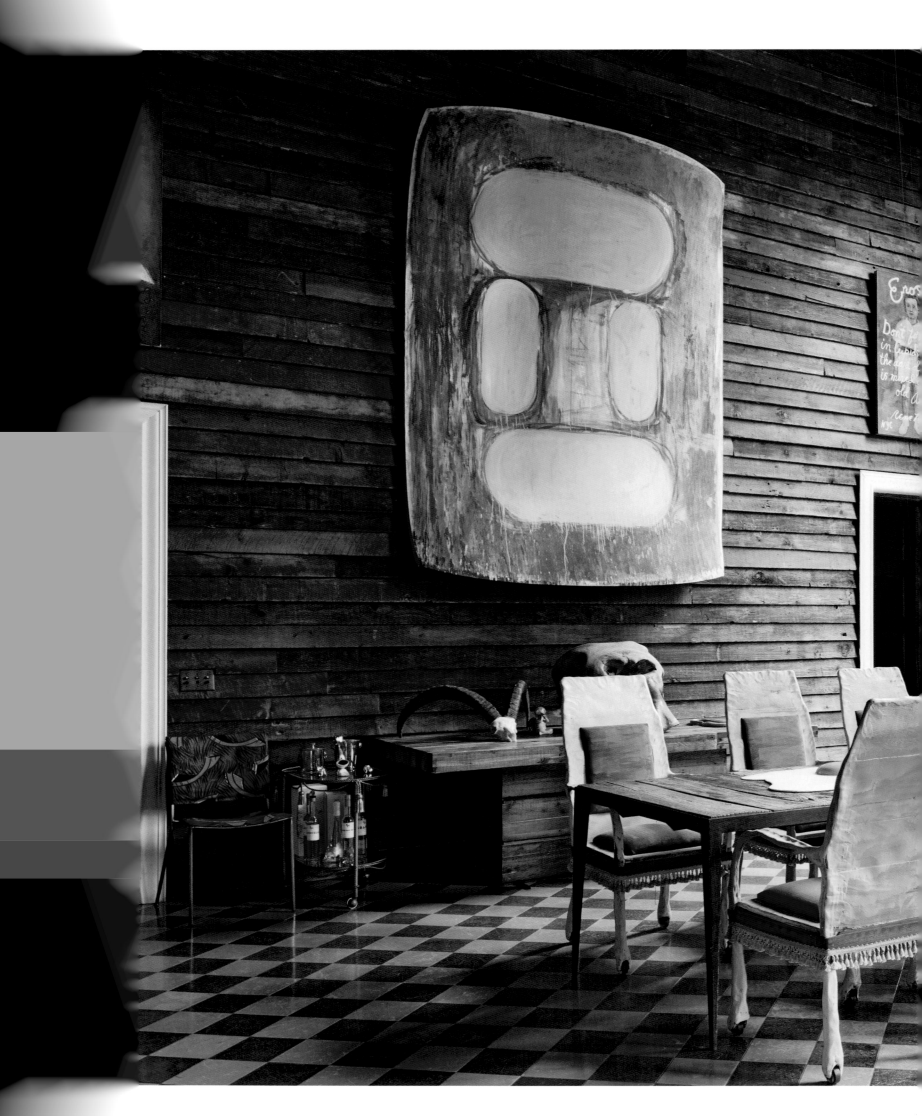

Stephen Kent Johnson photographed Vito Schnabel's great room in Palazzo Chupi, designed by his father, Julian, in the West Village. The elder Schnabel also created Vito's fantastical dining chairs.

VITO SCHNABEL

Gallerist vito schnabel is as glamorous as his famous painter-director-interior-designer father, Julian Schnabel. Wary of journalists and guarded about his private life, he wasn't sure about a story on his loft apartment in Palazzo Chupi, the pink ode to a Venetian palace designed by his father, where both of them lived. You entered Vito's apartment through a cozy, wood-paneled kitchen, and then off of that there was a great hall with a thirteen-foot ceiling, walls clad in reclaimed Douglas fir, and three enormous, north-facing windows—that was the living/dining room. The floors of both the kitchen and the great hall were covered in black-and-blue Moroccan tiles.

The day in 2016 I met with Vito to discuss a story for *New York* magazine, we sat in the hall near his sleeping bulldog, Albert. In the room were two large paintings by his father, one from a new series of flowers: *Rose Painting (Near Van Gogh's Grave) I*, from that year. What a luxury to have this space where Vito could study the work of different artists and install gigantic paintings and sculpture. But what caught my eye more than anything else were the dining chairs: oversize, throne-like armchairs made of steel and painted plaster, their seats upholstered in ruby red velvet. They looked like very beautiful cartoon furniture, something that Alice would have found somewhere down the rabbit hole. Julian Schnabel, no surprise, designed them.

47

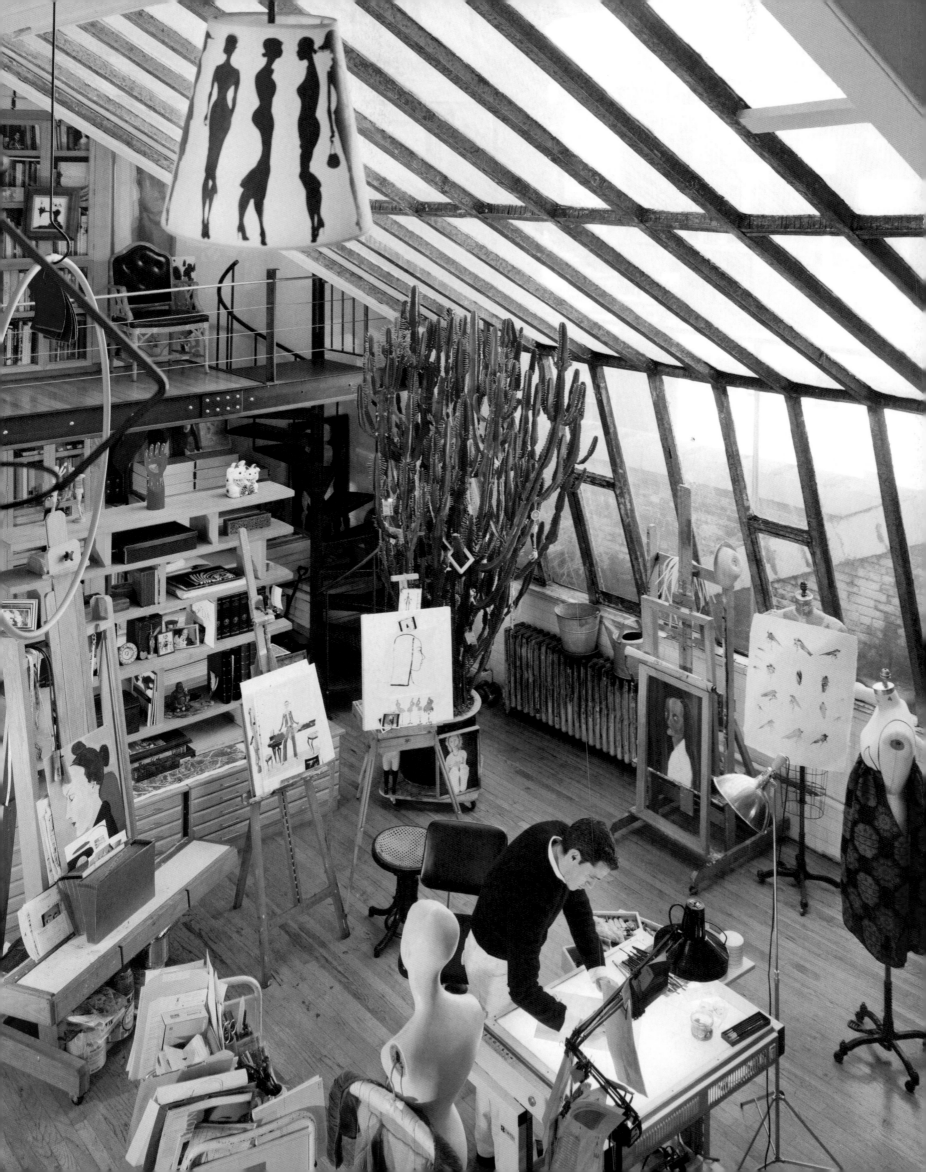

RUBEN & ISABEL TOLEDO

Above: The temple: It seemed perfectly natural that the Toledos would live in a fairy-tale-like setting. Photograph by Ruben Toledo. *Opposite:* David Allee's photograph of Ruben at work in the studio.

RUBEN AND ISABEL TOLEDO WERE MADE FOR EACH OTHER. Every aspect of their life since their meeting is fueled by their love story. They were both born in Cuba and raised there until the revolution, when their families emigrated to the United States, settling in New Jersey. Ruben and Isabel went to the same high school, and when Ruben first looked at Isabel those many years ago, she took root in his heart. It was a little longer before Ruben was to take root in hers, as she writes in her book, *Roots of Style*: "I fell in love with Ruben's art first. It took another four years for me to reciprocate and realize that this kid was the love of my life."

My first story on the Toledos, in 1992, celebrated Isabel's talent as a fashion designer and Ruben's as an artist, for a page I was producing every month for *HG* called "Living with Style." Ruven Afanador photographed model Teresa Stewart, a poetic beauty, in one of Isabel's convertible dresses, worn three ways. I found a red wagon for Teresa to stand in, and I scattered red roses on the floor. Ruben contributed an illustration of his idea for a portable garden and another of a mobile home as a covered wagon. This was to be the first of many stories.

Ruben and Isabel moved to an industrial building topped by a Greco-Roman temple. Of course they lived in the temple, a space with a big skylight where they could invent their artistic life. I did a story on it for *New York* magazine in 2015. They put in a mezzanine and installed bookshelves. Isabel hung her colorful Hula-hoops from the balcony, and, as decorative as they looked, they were also practical: She used them for her exercise workouts.

This page: I've kept every card and every drawing that I've received from Ruben and Isabel over the years. *Opposite:* Every time I visit the Toledos, I take a portrait. I have dozens.

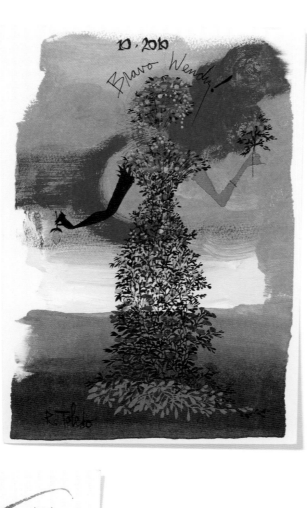

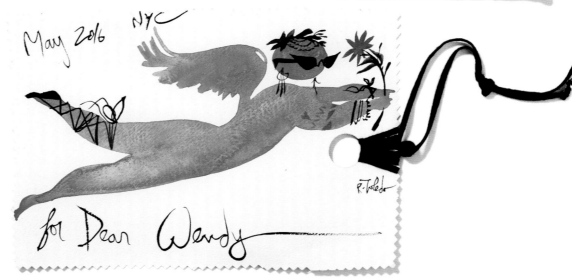

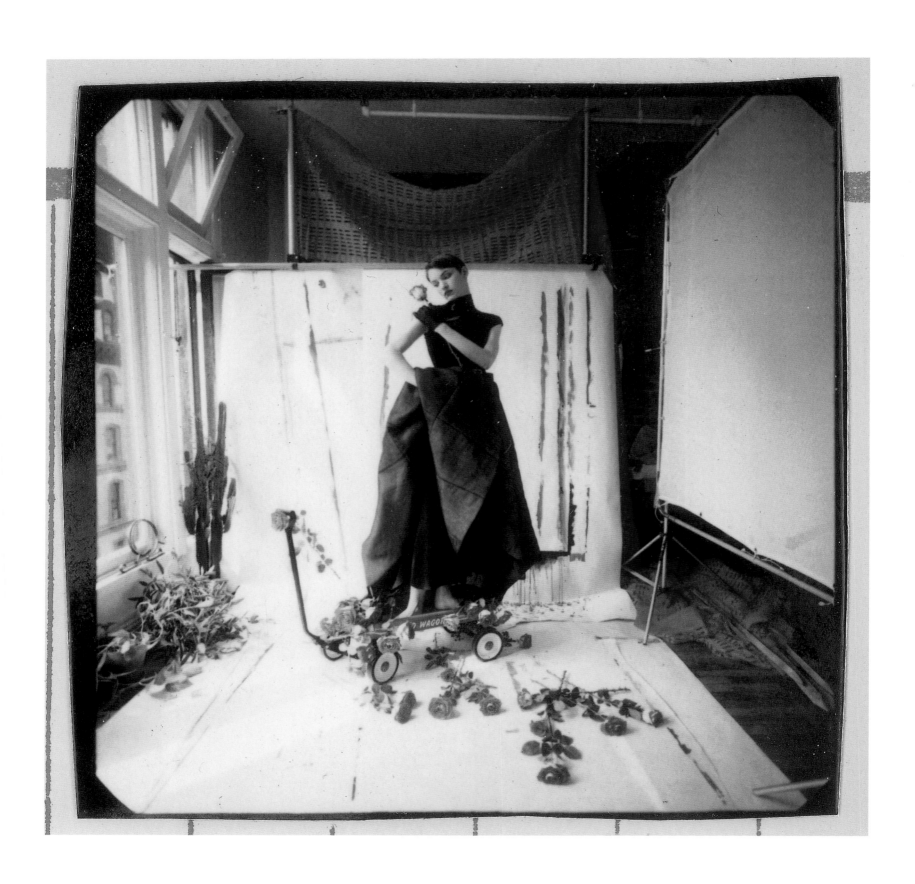

Model Teresa Stewart wearing a dress by Isabel styled three ways, photographed by Ruven Afanador. This was the first story I did on the Toledos for *HG*.

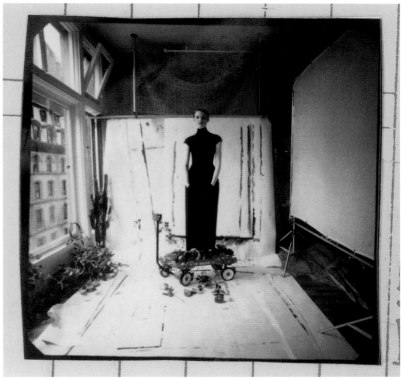

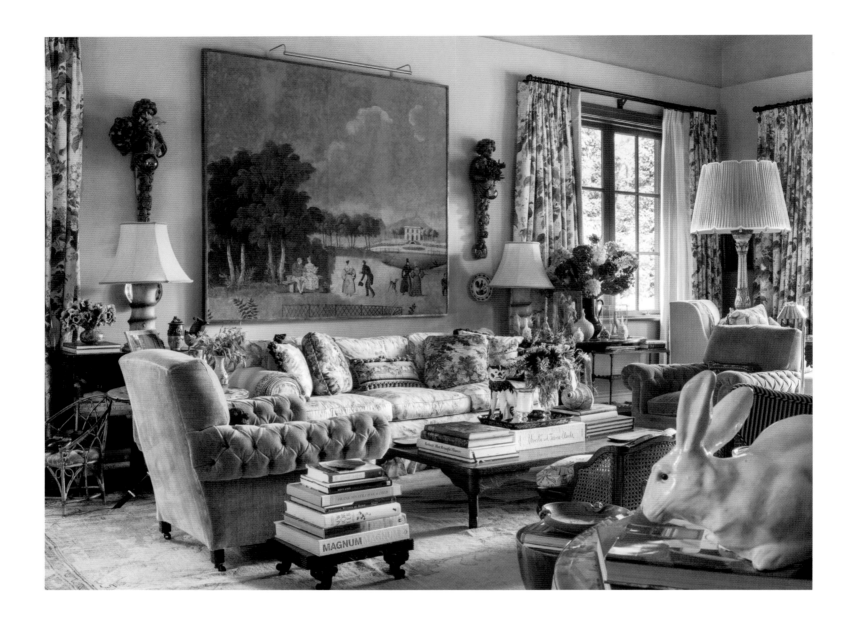

KITTY HAWKS &
LARRY LEDERMAN

Above: Kitty Hawks and Larry Lederman's living
room in Chappaqua, photographed by Larry.
Opposite: A detail of one of the hand-painted
nineteenth-century screens in the living room that
originally belonged to Kitty's mother, Slim Keith.

"I T'S NOT ABOUT THAT," Kitty Hawks said with dismissive irritation when
I asked her what she was wearing in the portrait we had done for *HG*
in 1990. The late, great editor Charles Gandee had asked me to style the
story he was writing on Kitty's first decorating project, and that involved
dressing her, in her own clothes, for a portrait with her dog, Earl. Just
because we had bonded over our dogs didn't mean that Kitty wouldn't snap
back at me, or anyone else, about what she felt was silly or unimportant.

Every place Kitty and Larry, her brilliant lawyer-photographer husband,
have lived together has been published in a major magazine, for good rea-
son. Kitty is the daughter of Slim Keith and director Howard Hawks, and
her instincts and talent for creating luxurious interiors begin with comfort.
The design masterpiece of Kitty and Larry's life is their house and garden in
Chappaqua, New York, a labor of love that they have sustained together for
more than twenty years. Kitty has decorated the interiors, and, as she studied
architecture at UCLA, she's had a large hand in the extension and renova-
tion of the house, working with her friend David Piscuskas of 1100 Architect.
Larry and Kitty bought the property in 1992, when it consisted of four acres,
and they now have twelve. Larry would stand for hours at the edge of the

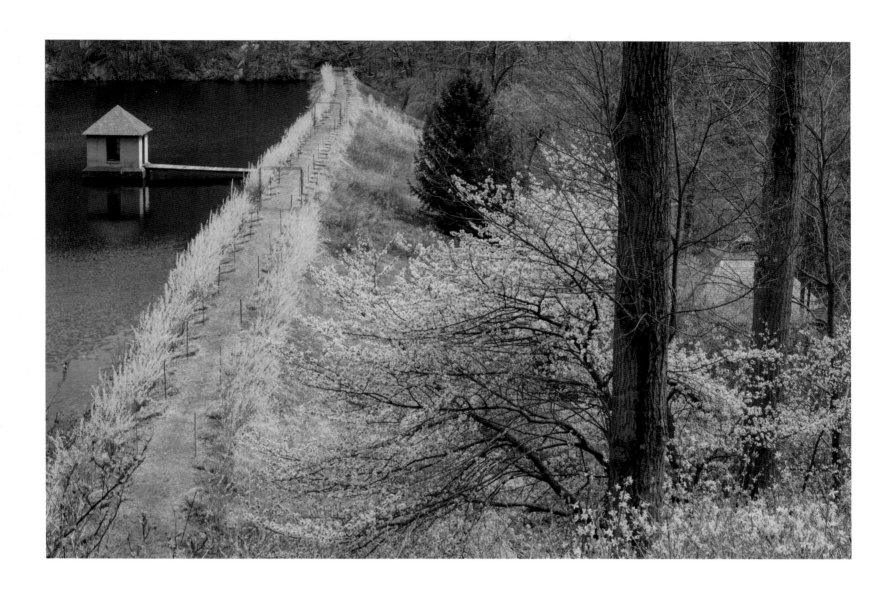

Opposite: Oberto Gili photographed Kitty with her dog, Earl, on the steps of the Metropolitan Museum of Art. *Above:* Larry Lederman's photograph of the path on the dam in front of their house in Chappaqua that he and Kitty planted with rows of forsythia.

property, looking out over the adjacent land, covered with a thick forest on hilly terrain, suspecting, he said, that there was a substantial stream running through it. He purchased that tract of forest and cleared it in such a way that it looked like it had been that way forever. He was right about the water; a major stream now supplies a pond that Kitty and Larry designed and lined with rocks that were moved from different areas of the property. Now it's their Shangri-la, only every inch is real.

The living room in Chappaqua is one of those great rooms you never want to leave. Kitty says, "It's not so much a repository of the past as an envelope of all the wonderful things from a long and happy life. The one requirement given our architect was that the room accommodate three large wallpaper panels of a French zoo. I have known these panels since I was a child. They followed my mother from house to house, country to country, and were as strong an anchor as she was . . . and so they hold pride of place, representing the thread of continuity throughout my life." Just to enter this room makes you feel that your best self will be at play.

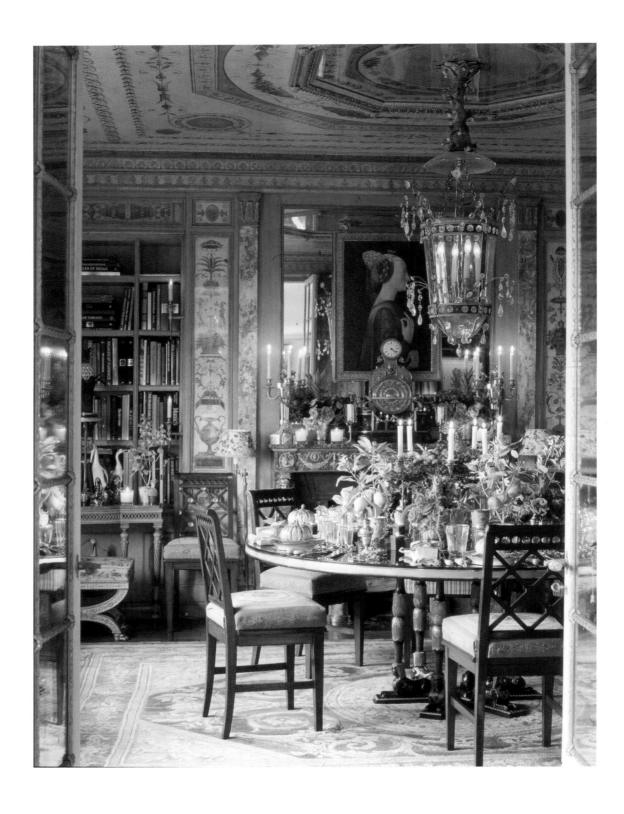

HOWARD SLATKIN

Above: A peek into the dining room of Howard Slatkin's former bespoke kingdom on Fifth Avenue, one of the photographs that Tria Giovan did for his book, *Fifth Avenue Style,* and also featured in *New York* magazine. *Opposite:* In the guest room, the French Empire bed was decked out with a canopy of hand-painted scarves by Brigitte Singh and satin sheets made to order in Rome.

WHAT DOES THE LIFE OF A PERFECTIONIST LOOK LIKE? The answer, of course, is many things, but if you are interior designer Howard Slatkin, perfectionism necessitated demolishing the not-so-perfect rooms of your upper Fifth Avenue apartment in a prewar building overlooking Central Park. He was looking for what he called a "handyman special," in other words, a pig's ear he could turn into a silk purse. Howard's custom kingdom, which I covered in *New York* magazine in 2012 and has since been sold, was astonishing in its myriad details. It could only have been imagined by a design scholar who has had exposure to the most extraordinary houses in the world. A notoriously private man whose work for clients is rarely, if ever, published, Howard made a teaching tool from the book he did on his apartment, *Fifth Avenue Style,* as it took the reader through the process of creation and calls out the artisans responsible for the spectacular results.

The elevator took the visitor directly into an entrance hall lined with nineteenth-century scenic wallpaper Howard spied in Mde. Gintzburger's rarified gallery in Paris. The inlaid floor had the patina, and the creaking-wood sound,

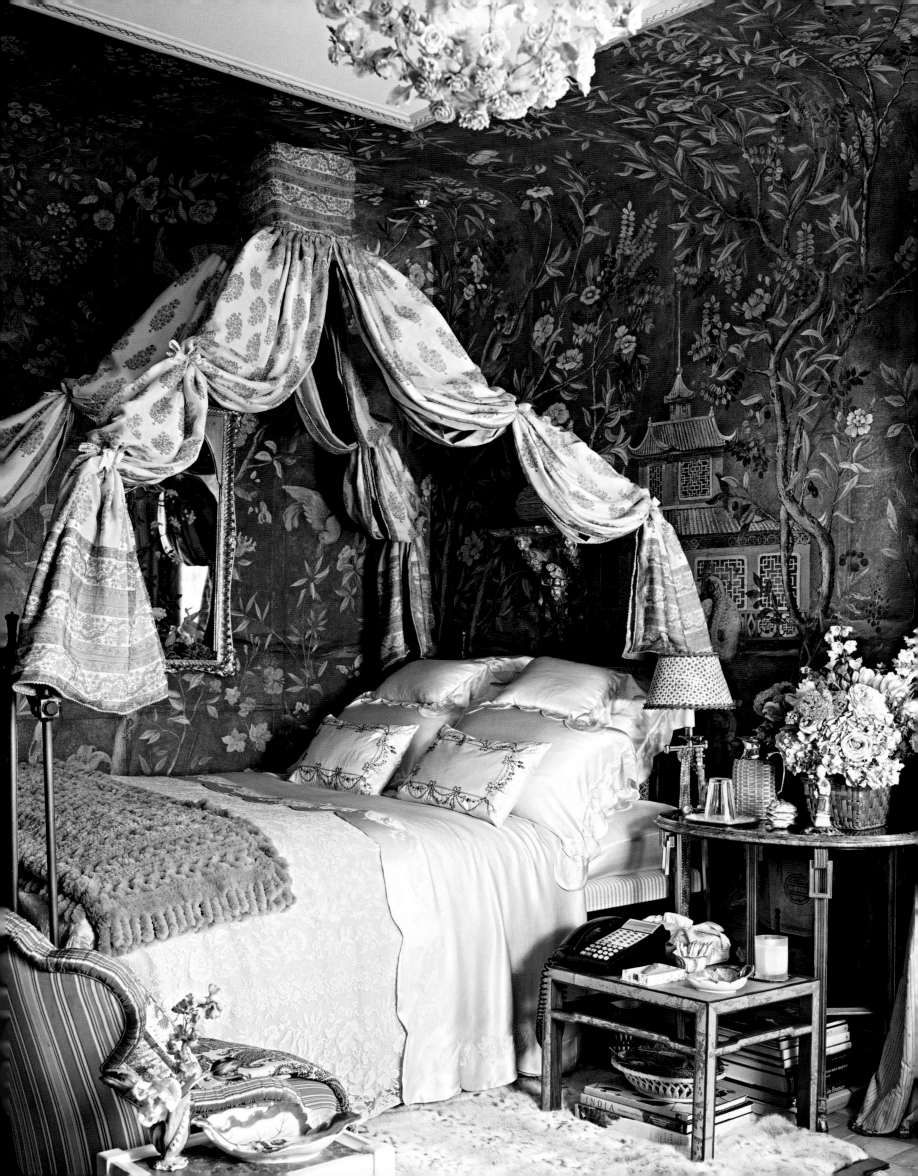

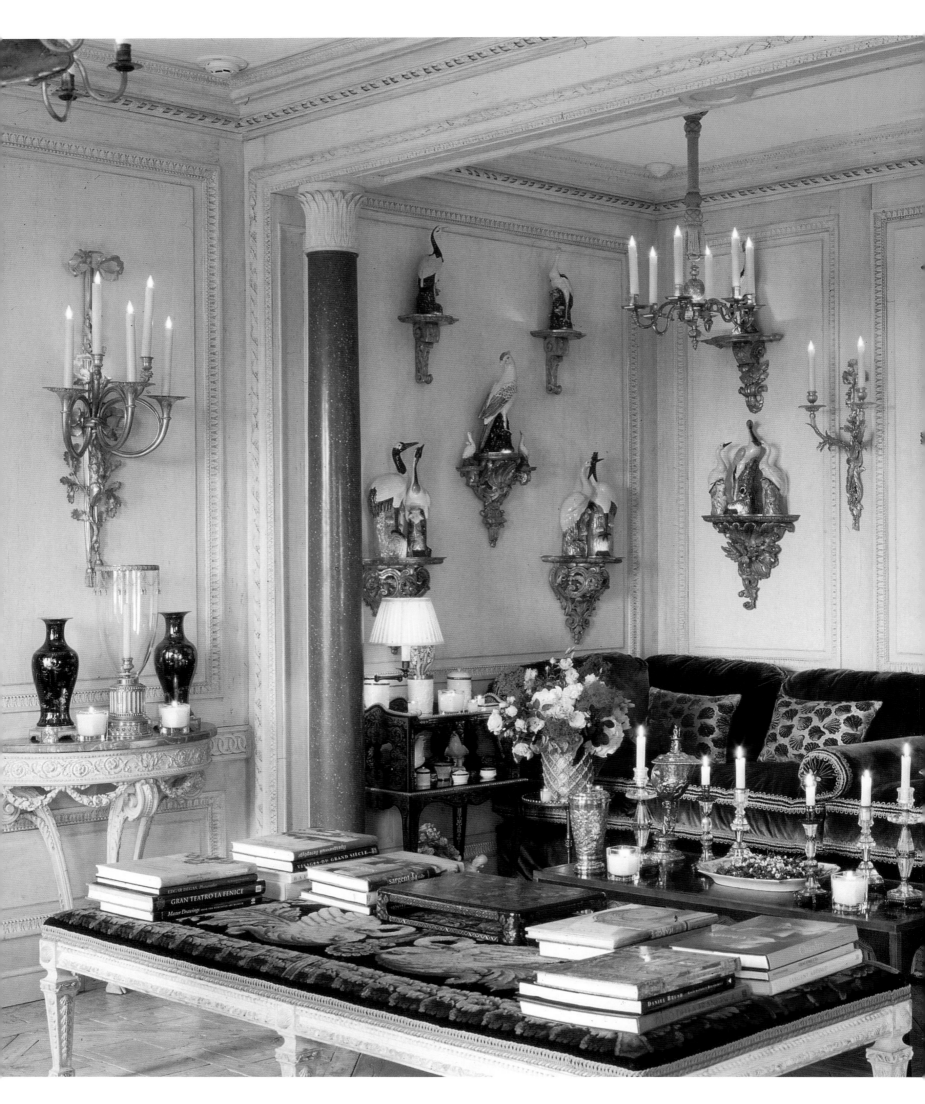

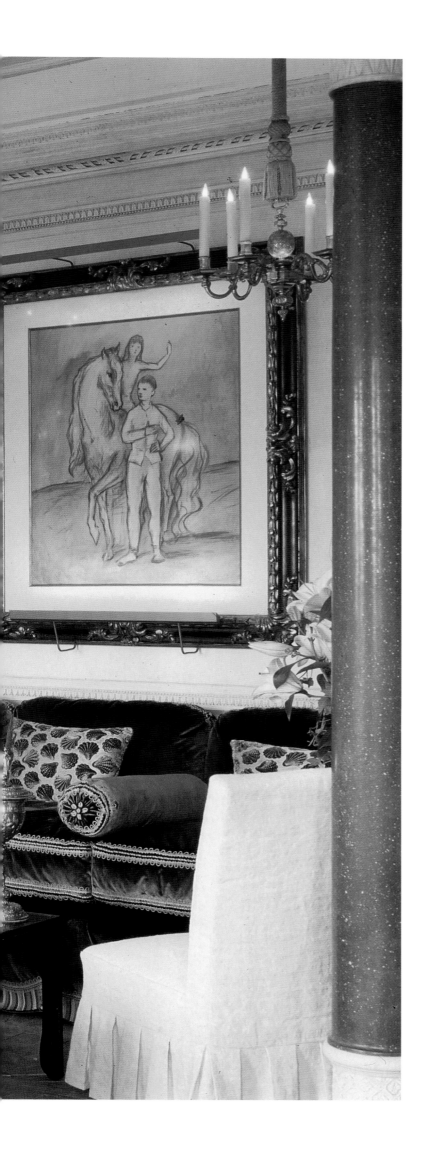

The living-room alcove
featured a custom-made
banquette for tête-à-têtes.

of ancient parquet floors in European palaces; Howard designed it, inspired by Empress Maria Feodorovna's bedroom in her palace outside Saint Petersburg, and had it made by artisan Alexander "Sasha" Solodukho and his skilled team. The room was lit as if by candlelight (the variety of different light sources throughout the apartment gives it a glow from another century). A sprinkling of Venetian mirrors and blanc de chine figures framed the room's centerpiece: a large bouquet of flowering branches, the miraculous work of tole artisan Carmen Almon, who uses cuticle scissors, a soldering gun, and oil paints to transform sheet metal into garden treasures. Venturing deeper into the apartment, you eventually arrived at a guest room too beautiful to sleep in. It was enough to gaze at the canopy bed decked with silks, cashmere, and a light-as-a-feather braided fur throw. The satin sheets, the top one of which had a scalloped edge, were the palest of pale ice blue, and the hand-painted chinoiserie wallpaper begged the question: Were we in Russia? Or Paris? And had Proust or Balzac slept here?

61

TODD OLDHAM &
TONY LONGORIA

Opposite: Oberto Gili photographed Todd Oldham's and Tony
Longoria's London Terrace apartment. I asked Todd
to style a model dressed in a skirt he designed that was inspired
by a painting in his and Tony's living room. *Above:*
A beaded jacket Todd designed for his 1991 spring collection.

T ODD OLDHAM'S FASHION SHOWS were high points of the collections in
New York in the 1990s. Todd was and is a brilliant magician. Back
then he was a sorcerer who played with ideas, upending what you
thought was fashion and what you thought was everything else.

The apartment Todd shared with Tony, his partner in life and in
art, at London Terrace during those years was filled with portraits by outsider
artists. The furniture was covered in bright-colored fabrics; their bed, cloaked
in an orange satin bedspread, dust ruffle, and pillowcases, glowed like a fiery
ember. When we did a shoot for *HG* in 1992, Todd had designed a collection
that was all about interiors and art. He made a beadwork skirt that replicated
a portrait on his living-room wall. I booked a model, dressed her in the skirt,
and positioned her in front of the painting. Todd and Tony's story hit the
jackpot; I thought it was everything a great interiors story for *HG* should be.

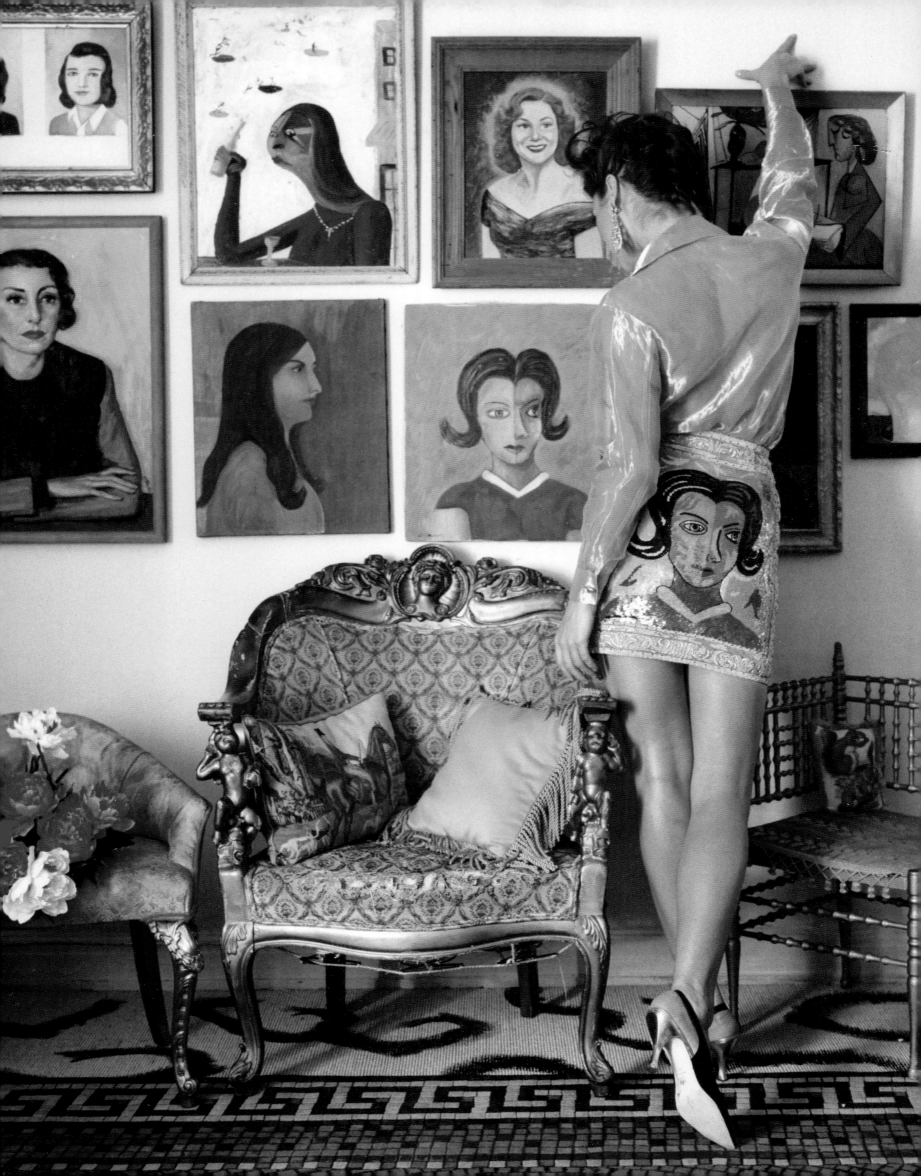

Todd and Tony's living room, with their collection of portraits by outsider artists. They were champions of designer, Liora Manné's Lamontage felt rugs, and had one in their living room. Todd collaborated with Manné on a fashion collection in fall 1991.

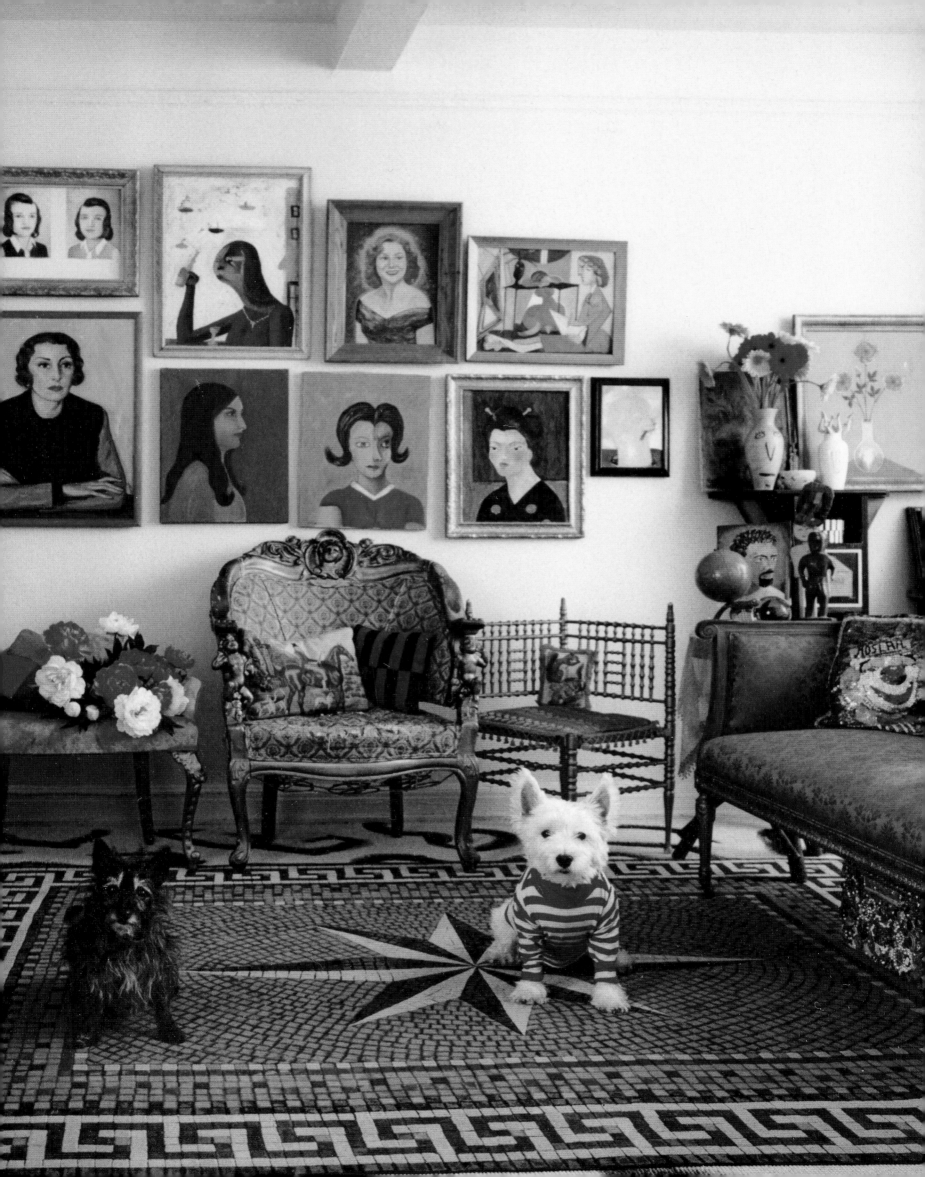

GLORIA VANDERBILT

I'VE OBSERVED GLORIA VANDERBILT from the time I was a little girl and could never have imagined that the day would come when I would propose doing a book about her life, inspired by one black-and-white photograph taken by Richard Avedon in the 1950s, featuring Gloria lost in thought in the living room of her New York apartment at 10 Gracie Square. Gloria was always mysterious, coming from a wealth of exotic glamour and then an abundance of beauty of her own making, especially in the homes she created. I remember going to her Christmas parties with my parents, first at 10 Gracie Square and later in her town house at 45 East Sixty-Seventh Street. Her world at home was a rich combination of colors and exotic textures. Nothing better illustrates her originality, or instinct for design, than the bedroom she created on East Sixty-Seventh Street, where she covered every inch of the room—walls, floor, and ceiling—with a collage of cut-up quilts. Gloria's homes were sensual retreats. The scent of Rigaud candles and flowers wafted through the rooms, and the layers of art and décor blended together to create a unique ambiance wherever she landed. In the midst of all this was Gloria, as luminous as a polished angel. Gloria's homes have evolved into ever-changing canvases for her art. One day she will invite you over to see her latest painting project on the surround of the living-room fireplace; another day it's the redecoration of her bedroom. Nothing is static in Gloria's life. Her homes are the reflections of the revolving rooms of her imagination.

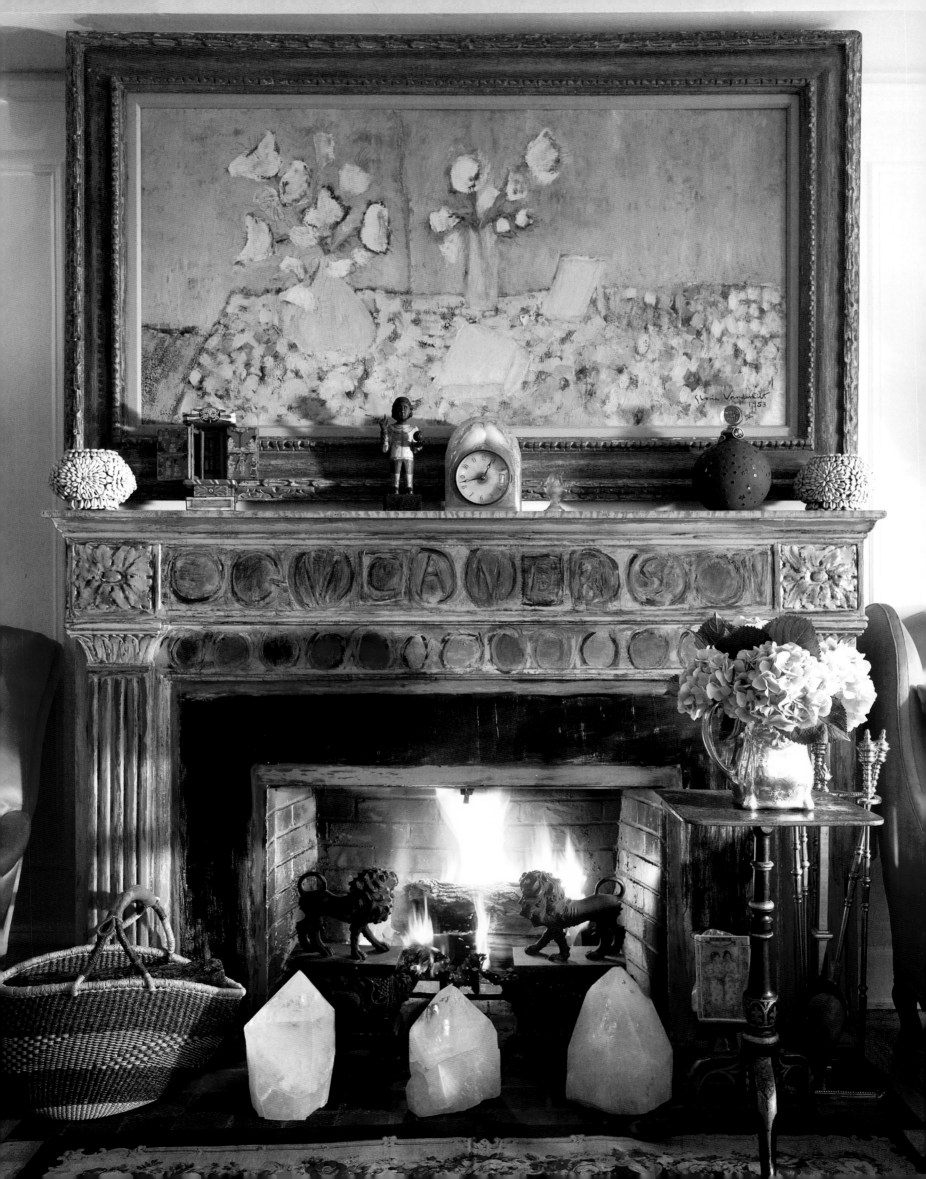

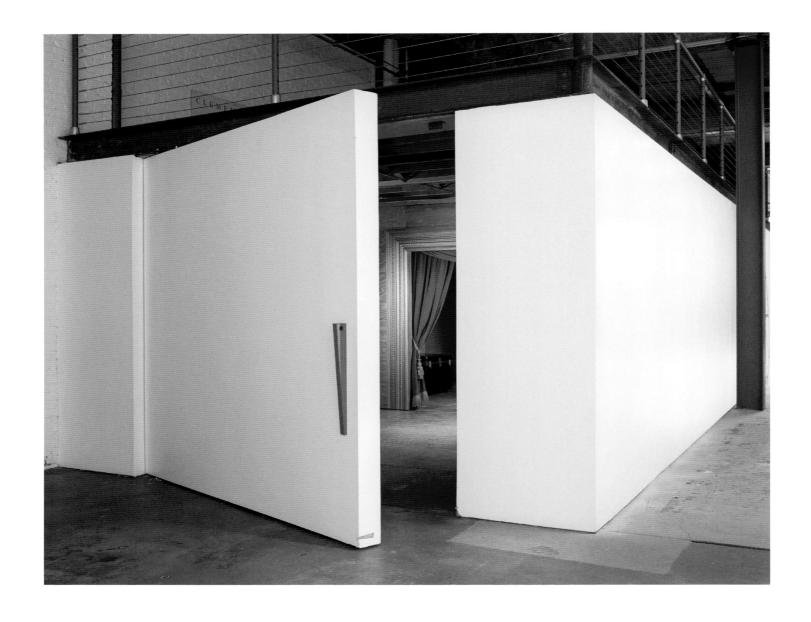

ALBA CLEMENTE

Above and overleaf: Alba Clemente's imaginative wardrobe storage in her husband Francesco's Brooklyn studio, photographed by Jason Schmidt. *Opposite:* Alba at her dressing table inside.

LBA CLEMENTE WAS SITTING in the massive Greenpoint studio of her husband, artist Francesco Clemente. This was his second studio, opened in 2006; he's had his first studio, on Broadway, since moving his family to New York in 1982. The former paper factory in Brooklyn had a mezzanine and a second-floor addition designed by Richard Gluckman, who tucked a small kitchen and a bathroom under the mezzanine, leaving an empty space; it was the perfect space, Alba thought, to store her designer treasures from the halcyon days of one party after another, when people dressed up for the evening's outings and Alba was photographed everywhere she went as a style icon for the ages. "It is so different from the eighties and nineties. I was always overdressed anywhere I went," Alba said with a huge laugh when we met in 2016 for a *New York* magazine story. "It was so much fun."

It's fair to say that this storage space, in the form of a theater, containing designs by Azzedine Alaïa, Comme des Garçons, Jean-Paul Gaultier, and Moschino, among many others, doesn't resemble any other such space in the city. After asking Gluckman to draw up the plans, and then installing red velvet curtains and canvas panels, Alba enlisted artist and family friend Jim Long to help her fully realize her vision by finding a photograph of a theater interior looking out over the audience, not toward the stage. Long combed through hundreds of photographs of theater interiors, all of them too big, until he spotted the small theater built in 1798 in Asolo, Italy, to honor Caterina Cornaro, which in the early 1950s had been purchased by the

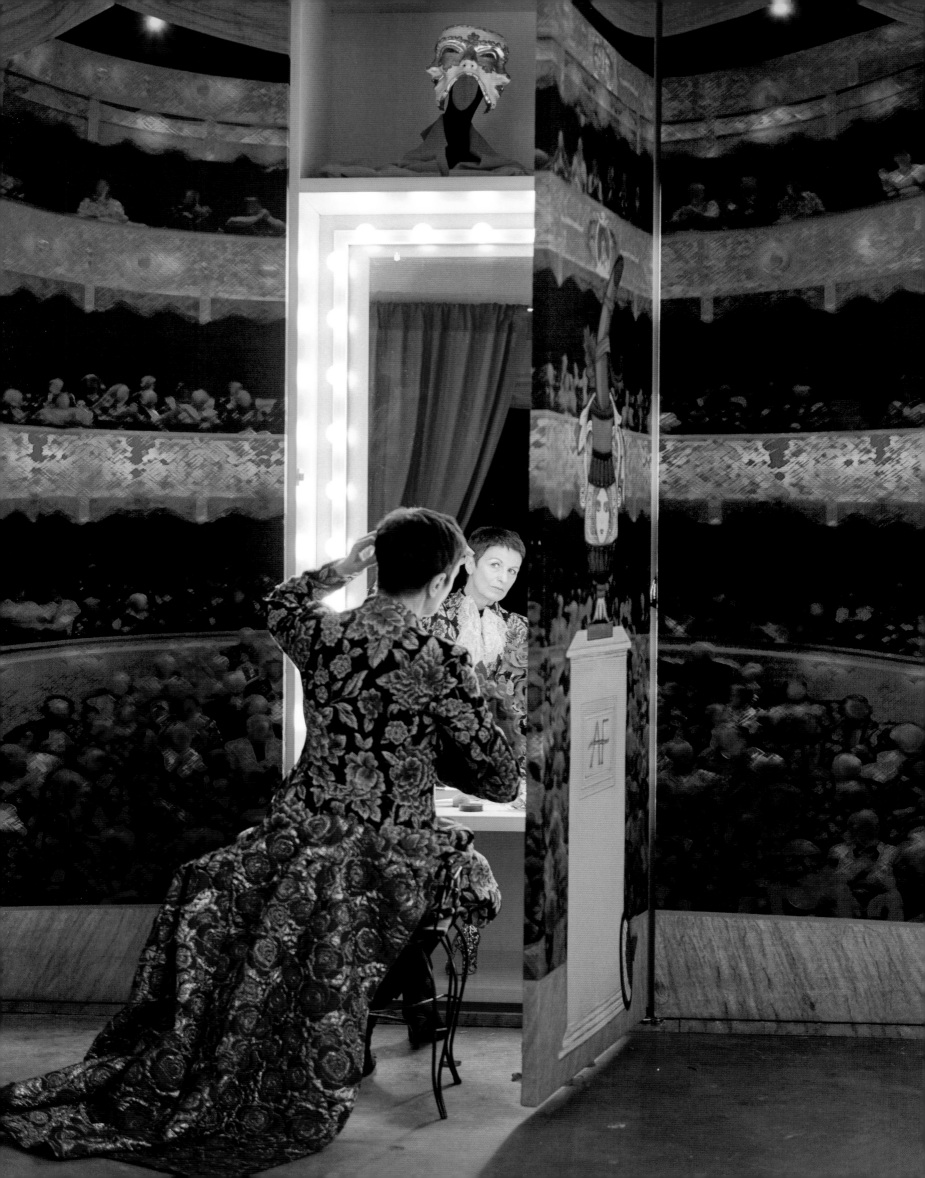

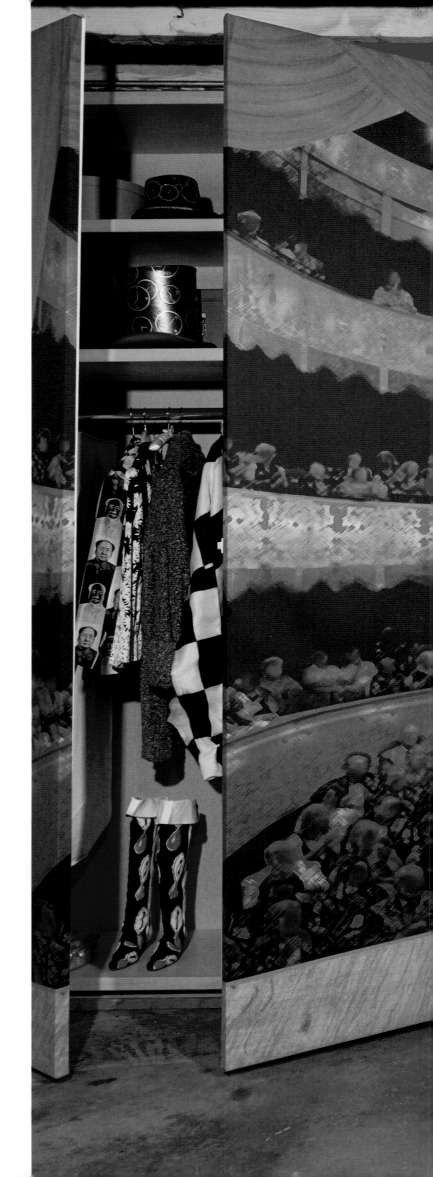

Ringling Museum in Sarasota, Florida, where it remains today. A blow-up of that photograph now camouflages Alba's closet doors. Long believed that it shows the audience on opening night following the reassembly of the theater in Sarasota, provoking Alba to do a little brushwork to obscure the identity of the faces.

Alba, who was born and raised on the Amalfi coast, has been drawn to the theater since she started putting on puppet shows at the age of seven. Today she is busy designing costumes for productions at the Kitchen, a New York City performance-art space. She has held two performances in her little storage theater. The first was during a party to celebrate the opening, when Alba hired a performer who did a burlesque inside a balloon. The second took place during Alba's birthday party a few years ago. "I had three performers, butoh dancers dressed like Marie-Antoinette, big wigs, and then I made a huge cake, fake, with candles for all the years, and all the time those girls were decorating this fake cake (behind a blue gauze on the theater set), and in the end they took it out and I blew out the candles! So it was kind of mysterious. It was very nice," Alba said with her enormous laugh.

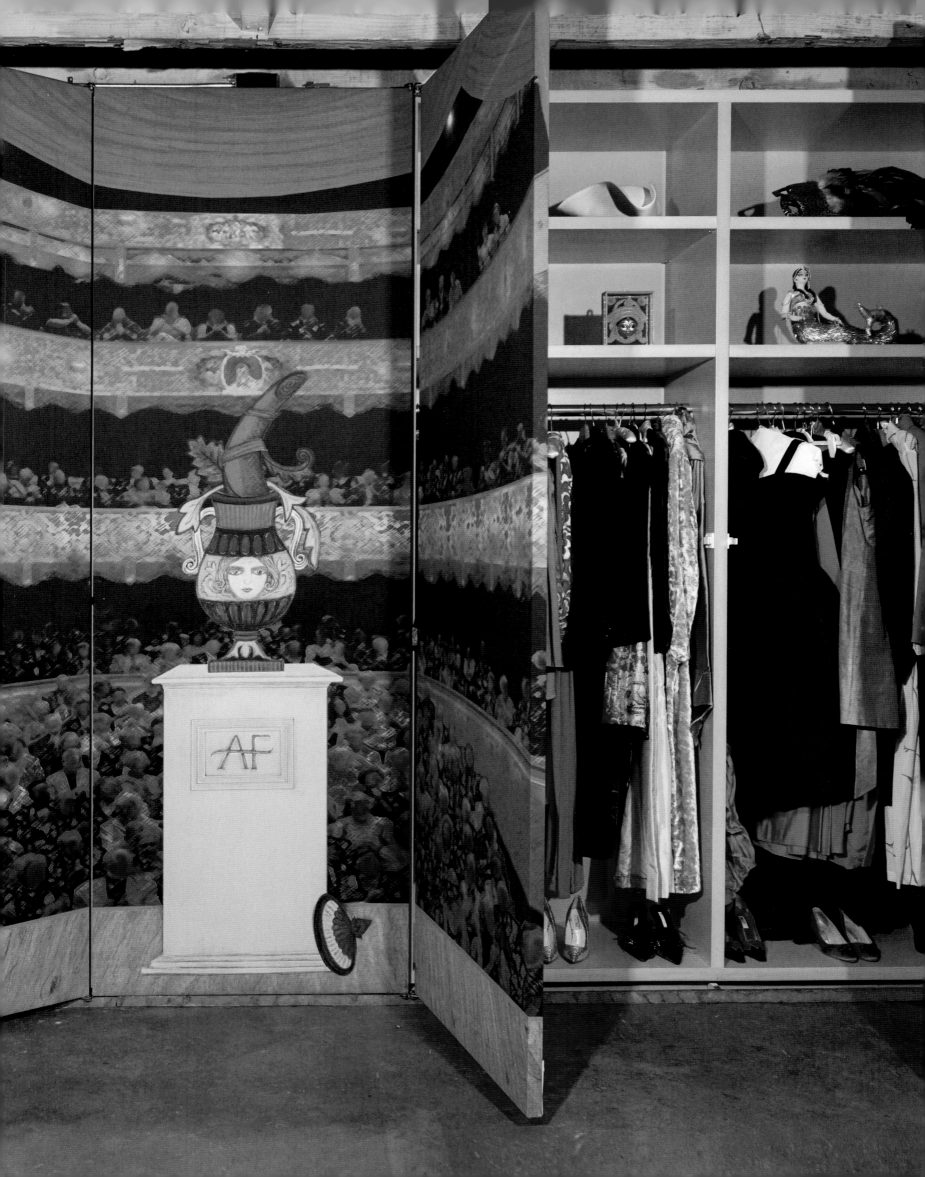

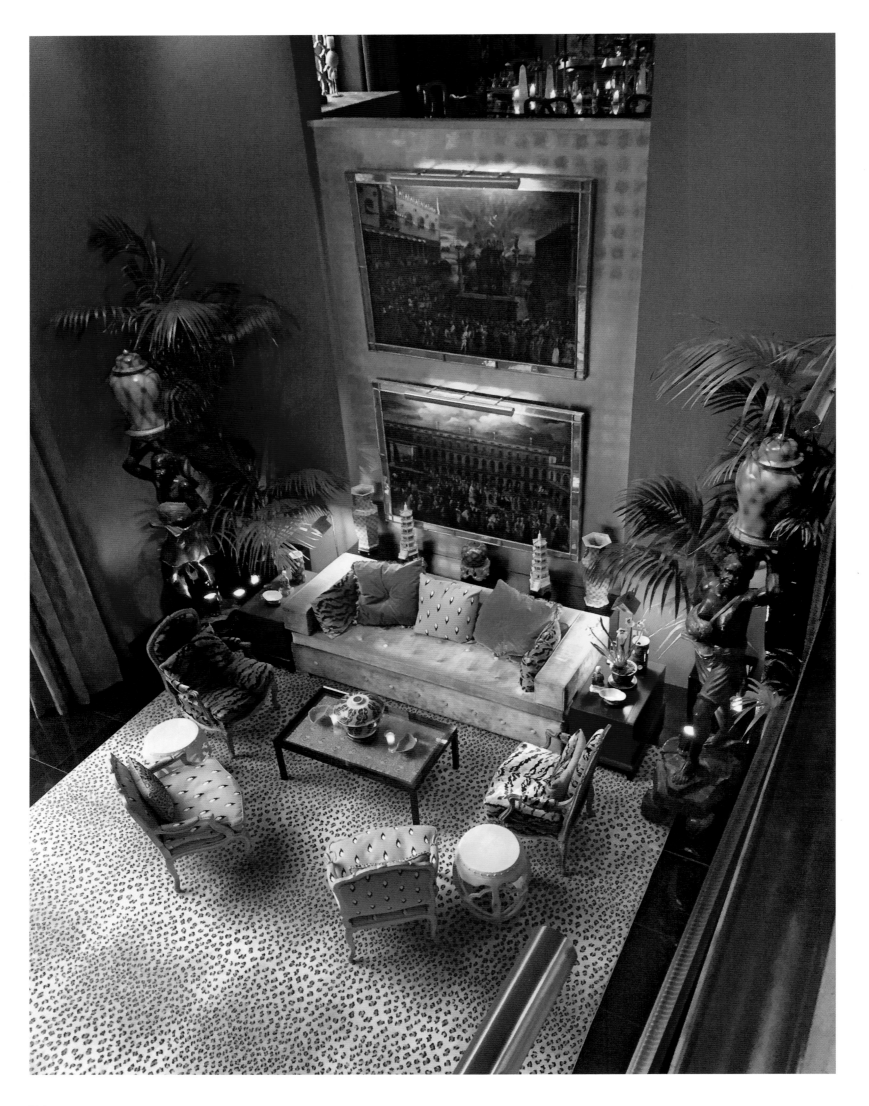

HUTTON & RUTH
WILKINSON

Opposite: Hutton and Ruth Wikinson's drawing
room in the Casa La Condesa. *Top left:*
Ruth's dressing-room walls are covered in digital
enlargements of Beegle's paintings. *Top right:*
One of Tony's plaster art pieces hangs in the house.
All photos by the author. I can't resist taking tons
of pictures every time I visit.

"WHO DID THAT?" I asked, standing in the middle of Hutton and Ruth's guest room in the house they owned years ago on Outpost Drive in Hollywood, during a shoot for *HG* in 1991. I was facing a fantastical painted bureau covered with bits of jewel-toned glass; it looked like it might have started out as a normal piece of furniture, before a crazy-brilliant child had attacked it, transforming it into something out of a Grimms' fairy tale. "Don't you know Tony Duquette?" Hutton asked me incredulously. I didn't have a clue who Tony Duquette was, but I insisted that Hutton lead me to him, and, once he did, my life was never the same.

Hutton and Ruth are out of another time, especially Ruth, who is a genius in her own right, quietly designing and sewing all of her own clothes, and creating anything else that she can, when she is not masterminding the schedule of their lives. Hutton, meanwhile, stirs up a three-ring circus wherever he goes. They are a perfectly synchronized team, and, like Tony and Beegle, they met in young adulthood and became childhood sweethearts; their complementary differences are the secret to their multilayered life.

As Tony's protégé, Hutton has been steeped in Duquette's inventive, more-is-more scheme of interior design, whipping up his own concoction of decorative icing to gild every lily. He has built for Ruth and himself the Casa La Condesa, a palace of grand proportions on the grounds of Dawnridge, the Beverly Hills estate he acquired from Tony Duquette, in order to take advantage of a site overlooking the garden and also to create the proper setting for the giant eighteenth-century Venetian paintings that Tony purchased from the Baroness Catherine d'Erlanger when she moved to Hollywood on the eve of World War II. Those paintings are some of the treasures that Tony and Beegle gave to Hutton and Ruth. As of this writing, Hutton has been the keeper of the flame of all things Tony Duquette. He has made a successful business going forward with Tony's designs, and with his own; he has redone the original house at Dawnridge and the gardens but has still kept Tony and Beegle's stamp intact. That is quite a remarkable feat.

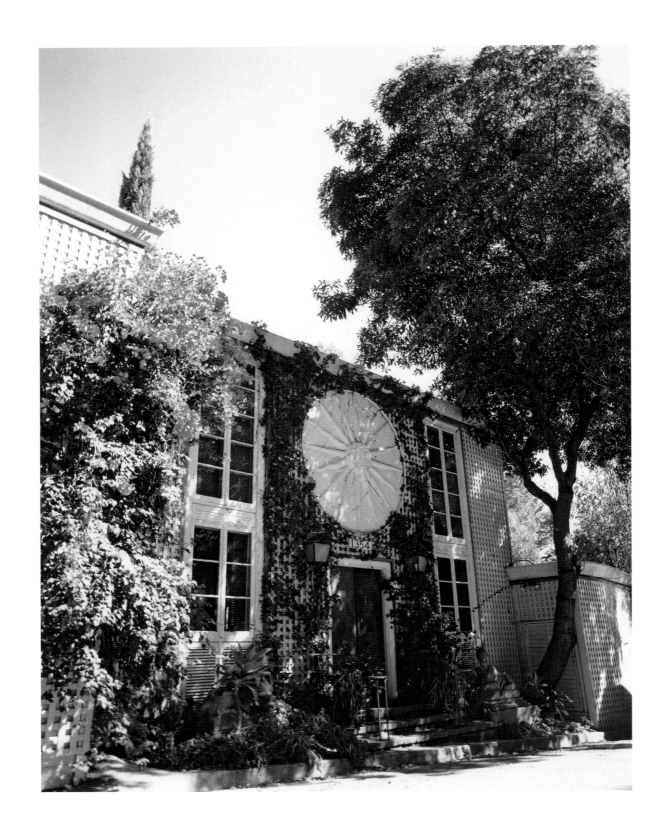

TONY DUQUETTE

Above: The ivy-covered exterior of Dawnridge, Tony Duquette's house in Beverly Hills, photographed by Fernando Bengoechea in the early 1990s. Tony and his wife, Beegle, purchased a wild landscape in a gully in 1949 and built a simple Hollywood Regency-style pavilion. *Opposite:* Tony and Beegle's bedroom at Sortilegium, their ranch in the Malibu mountains, in the 1950s, photographed by Danforth Tidmarsh.

TONY DUQUETTE WAS THE GREATEST FABULIST OF ALL. I am convinced that Tony was from another planet. My first meeting with Tony and his wife, Beegle (her real name was Elizabeth, but Tony dubbed her Beegle, for the industry of the bee and the soaring poetry of the eagle), in 1990 was at their ranch in Malibu, since burned to the ground. As our car wended its way down the road that went through the property, I saw buildings that were amalgams of machinery parts and other things I couldn't even identify, all patched together. After passing several of these, I seriously thought that this place had been visited by aliens.

Tony called himself an argus, "the bird with a thousand eyes, or in legend the Phoenix." Over the years, I was to learn that one of Tony's greatest strengths was his ability to rise up after the destruction of things he had made and loved, and start again. I kept going back to do story after story on Tony, always discovering new aspects of his legend, for there was no one on this earth like him. He was a natural born scavenger with a baroque sensibility, elevating recycling into an art form long before it was in vogue. No object was ever too humble or

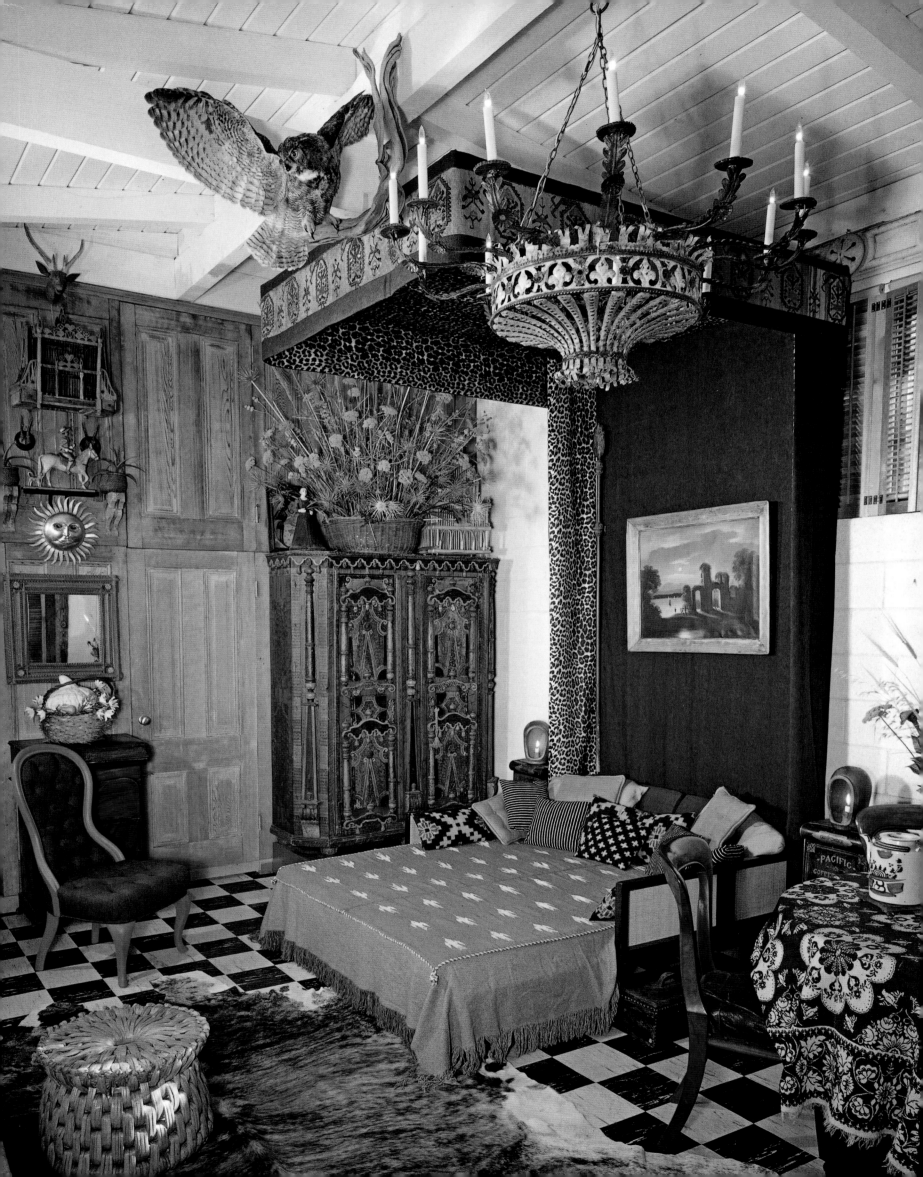

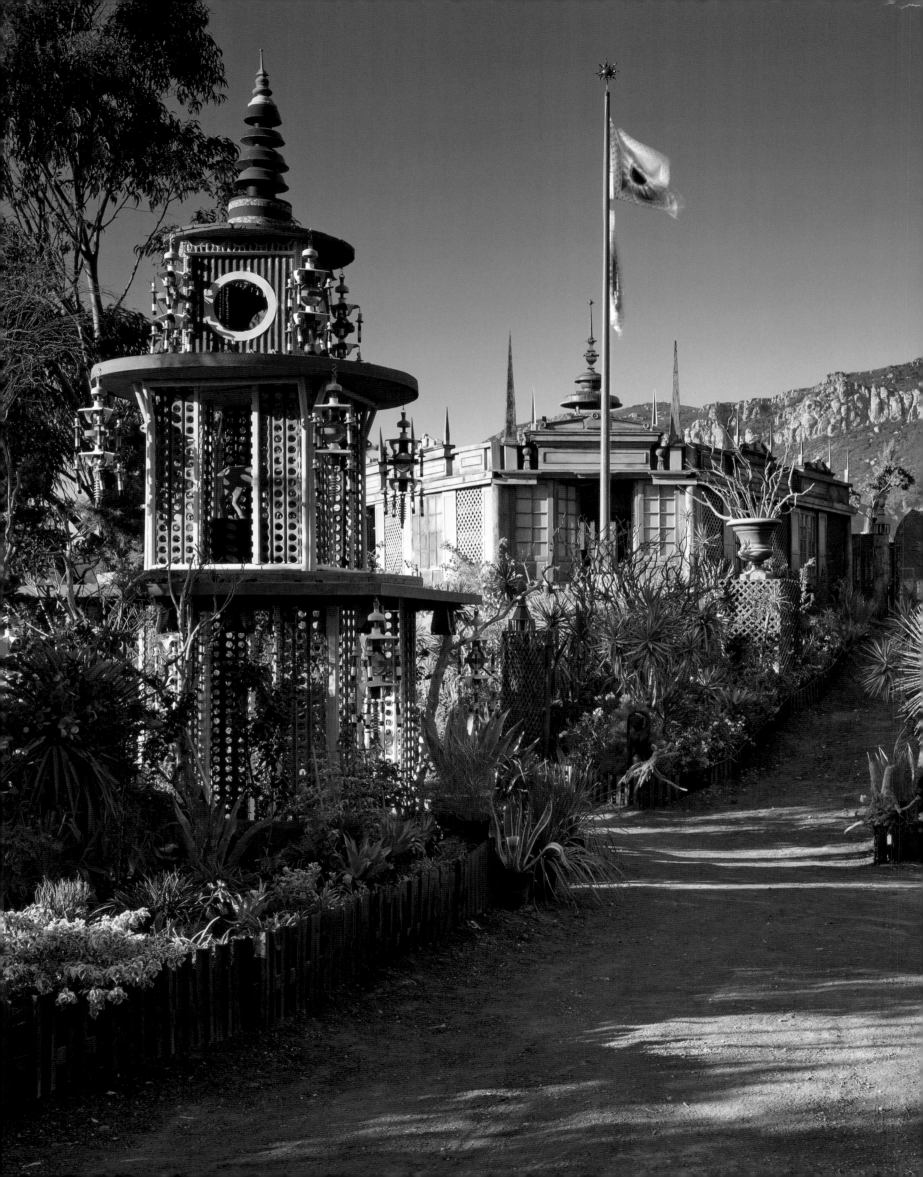

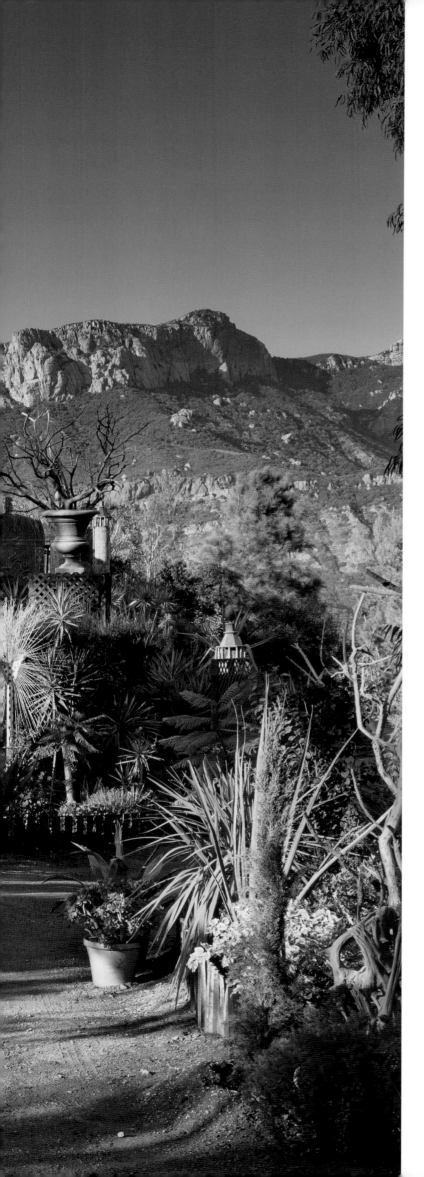

Opposite: Tony and Beegle's ranch in the Malibu mountains, photographed by Tim Street-Porter. It burned to the ground in the Green Meadow wildfire of 1993. Tim has taken iconic photographs of Tony's world over the decades. *Above:* Fernando Bengoechea photographed me with Tony during a walk on which I was no doubt trying to persuade Tony to let me do yet another story.

too mundane for his attention. The pearl and the bottle cap equally enthralled him. His refrain was always, "beauty, not luxury, is what I value."

Tony and Beegle had known each other since their student days at Chouinard School of Art in Los Angeles. They were married on Valentine's Day in 1949 and began to build their house, Dawnridge, in Beverly Hills, that same year. Dawnridge has become as mythic and fragile as an apparition in *Brigadoon*, and one wonders how long such a dream, set in a jungle, can exist in the super-manicured world of Beverly Hills. But magic lingers at Dawnridge, and I experienced it first-hand living there by myself while I was researching and writing *Tony Duquette* with Hutton Wilkinson. Beegle died in 1995 and Tony in 1999. I was visited by Tony in so many ways long after he was gone.

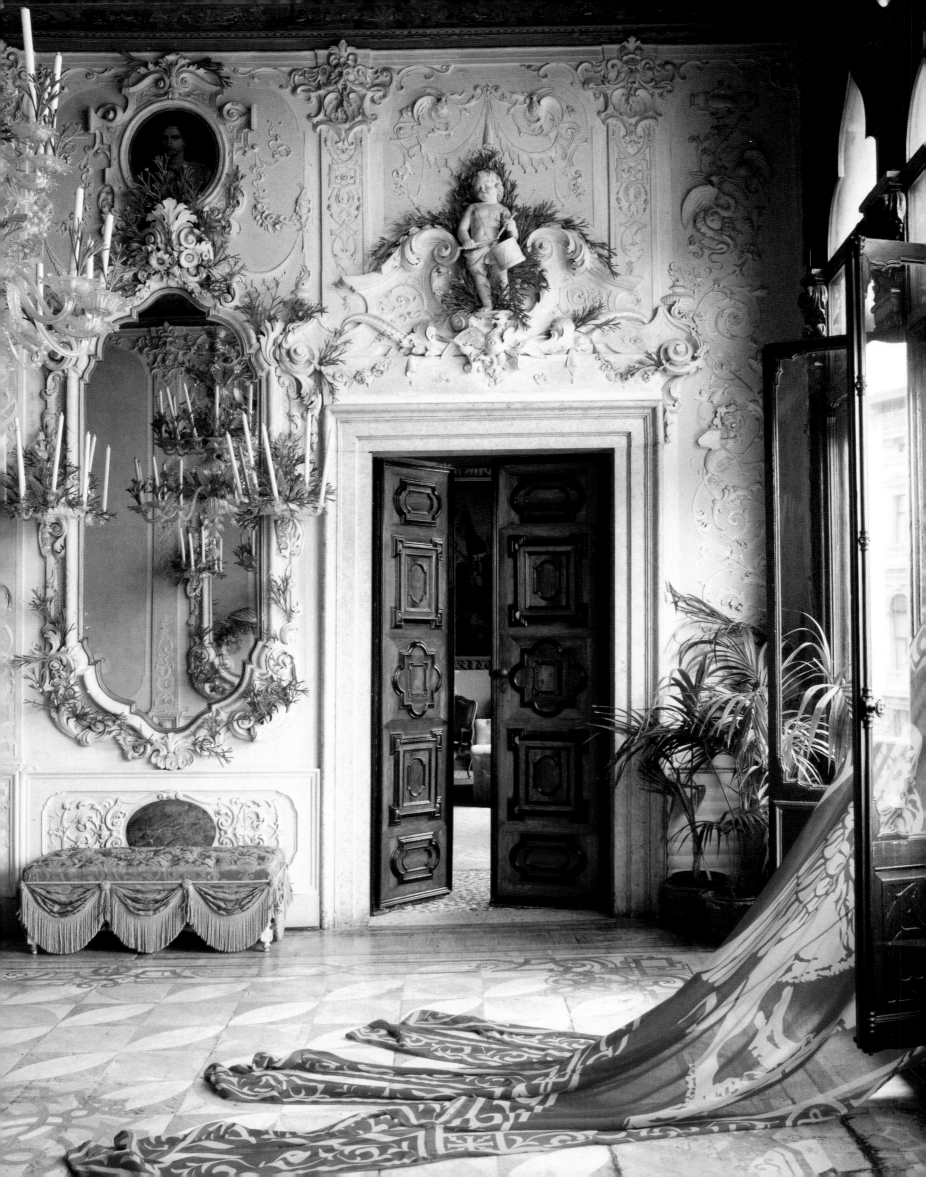

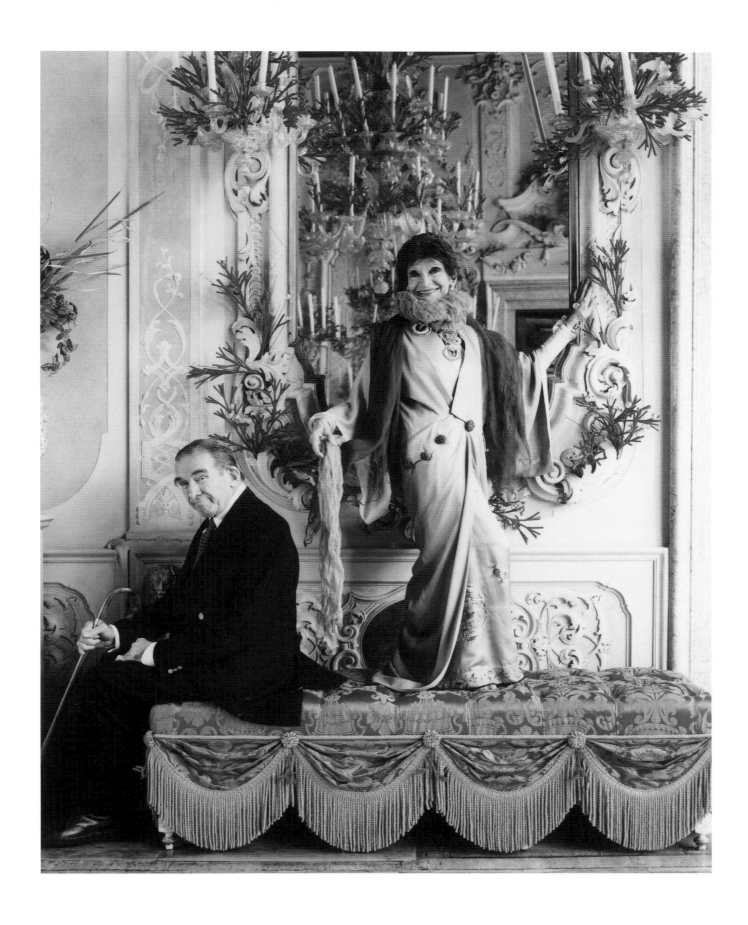

John and Dodie Rosekrans, San Francisco art collectors and philanthropists, enlisted Tony Duquette and Hutton Wilkinson to create a Venetian fantasy in the piano nobile of the Palazzo Brandolini, where they had a long-term lease in the late 1990s. *Opposite:* Tony and Hutton added coral-colored raffia branches to the elaborate nineteenth-century stuccowork in the ballroom. It was photographer Fernando Bengoechea's idea to take the flag hanging off the balcony over the Grand Canal and drape it on the floor. Above, John with Dodie, dressed in John Galliano.

2

Chapter Two

FAR & AWAY

Some people have the gift
of being at home in the
world no matter where they
are; for everyone else the
world can feel far and away.

Michael James O'Brien photographed Li Galli on a magical three-day trip for *Departures* magazine in 2015.

GIOVANNI RUSSO

THE FIRST TIME I saw the three small islands off the Amalfi coast, near Positano, known as Li Galli, I was in a little motorboat. Their steep rise out of the sea made them feel forbidding and mysterious. During the boat ride I learned that the islands then belonged to Rudolf Nureyev, and before him to the great dancer and choreographer Léonide Massine, who had been a protégé of Sergey Diaghilev, the founder of the Ballets Russes. More than twenty-five centuries ago Homer related how Circe warned Odysseus not to listen to the song of the sirens who lived on the islands' rocks. Circe instructed Odysseus to put beeswax in his sailors' ears and have the men tie him to his ship's mast so he wouldn't succumb to the half-bird, half-human seductresses' beguiling calls. Later the islands cast their spell on the ancient Romans, who took advantage of the natural harbor on Gallo Lungo, the largest island; on the king of Naples, who built a fortress there; and on seventeenth-century pirates, who stashed their loot and built a prison there.

Today the islands are the private sanctuary of hotelier Giovanni Russo, who bought them from the Rudolf Nureyev Foundation after the dancer's death in 1993. On Gallo Lungo is a restored fourteenth-century tower where both Massine and Nureyev had their dance studios. The Siberian-wood floor installed by Massine in what is now the tower's living room is still there. The restoration of the tower was only one of Massine's triumphs on an island that the mainland locals had thought was habitable enough just for rabbits. He proved them wrong, building a radio station, clearing four

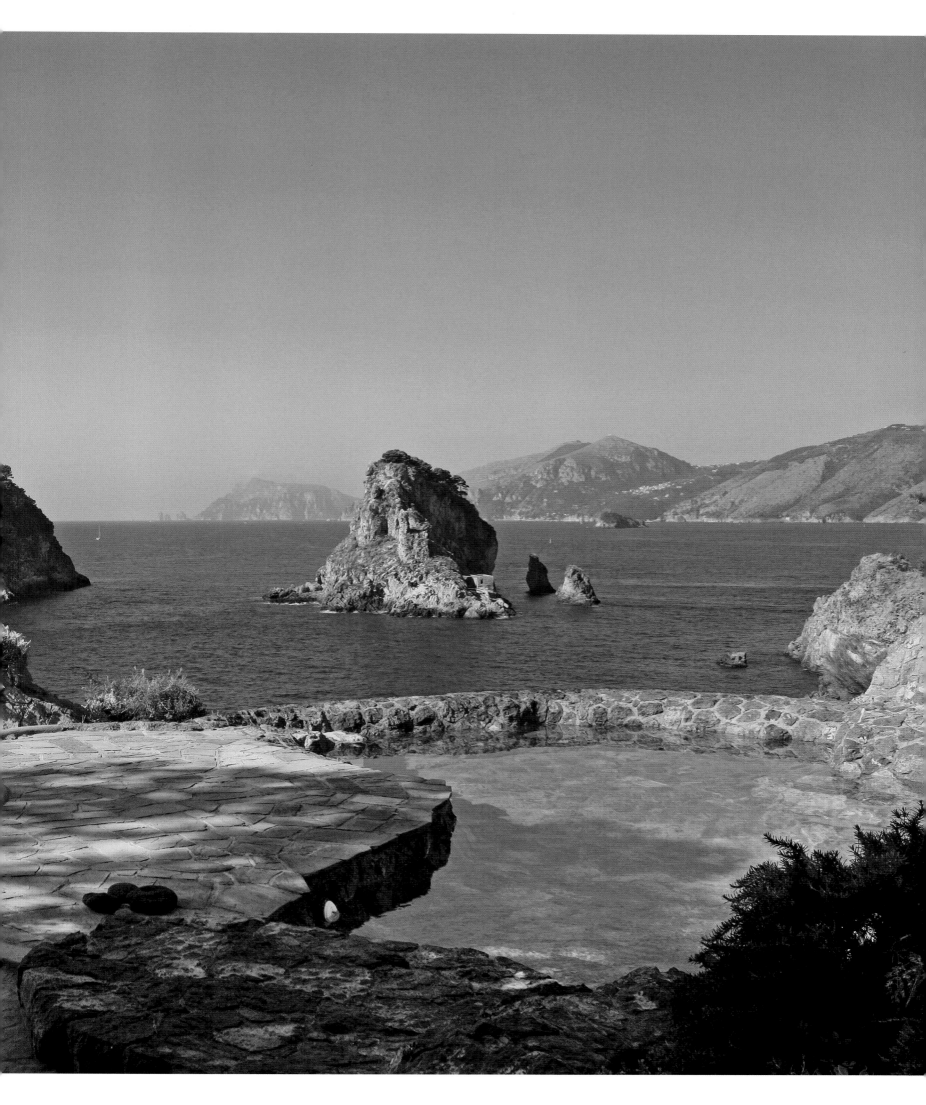

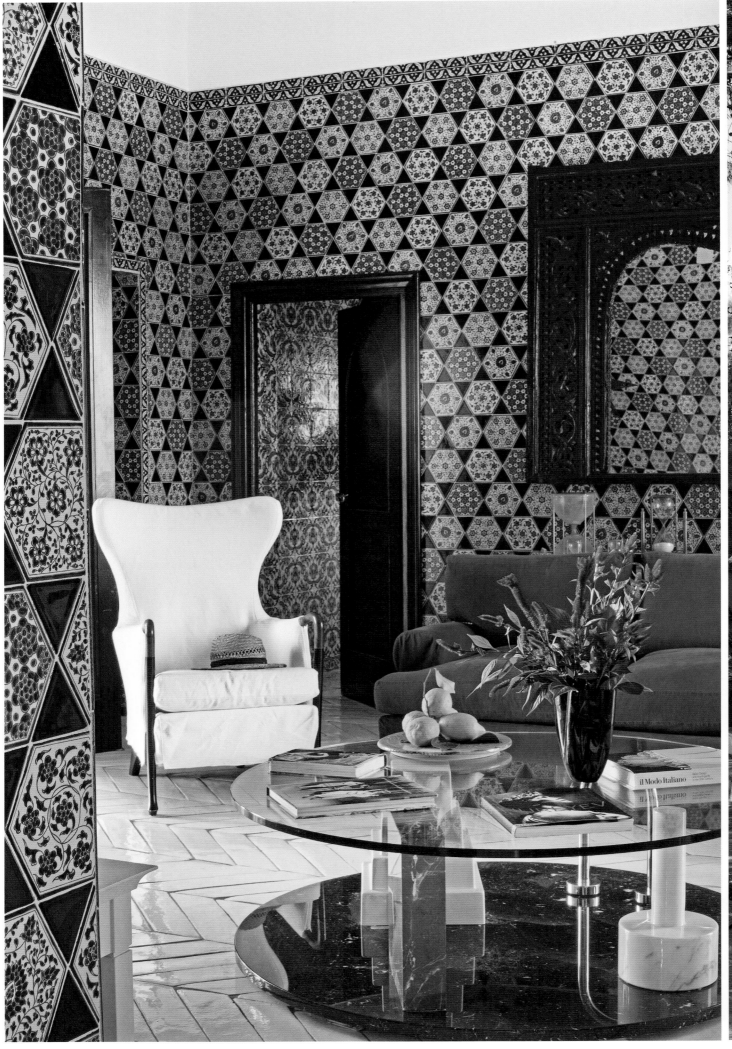

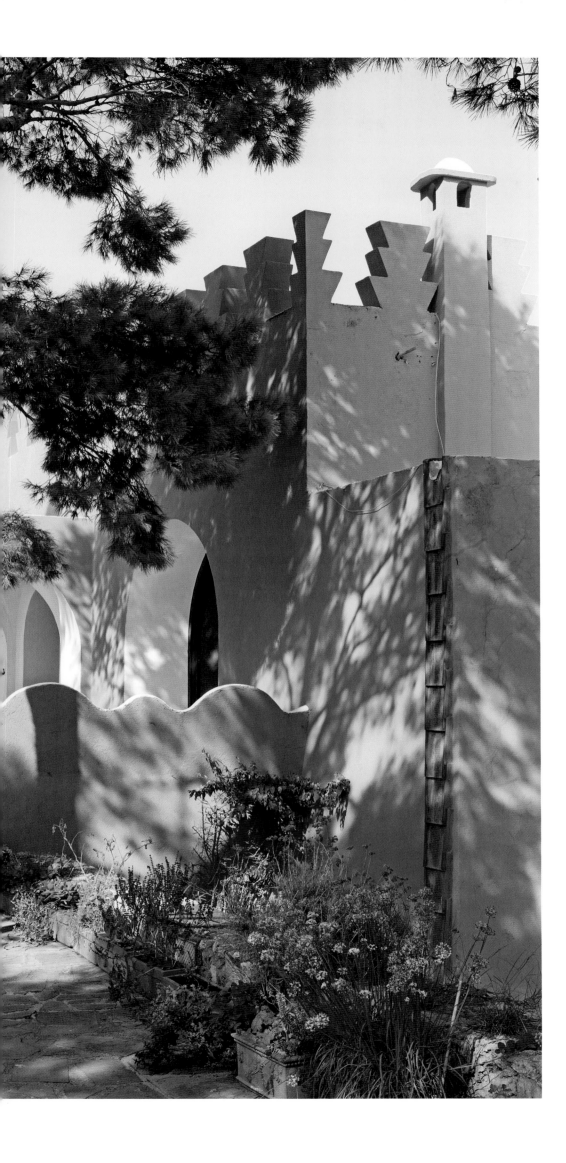

Far left: The tiled sitting room in the villa on Li Galli was created by Rudolf Nureyev, who owned the islands from 1988 until his death in 1993. *Left:* The villa was built by Léonide Massine, who owned the islands from 1922 until his death in 1979, after which his family sold them to Nureyev. Massine enlisted the help of his friend Le Corbusier to enlarge the house.

beaches, constructing a boathouse in the port, and turning an old terraced vineyard into a vegetable garden whose bounty is harvested to this day. The villa that Massine started building after his purchase of the islands in 1922 evolved slowly, and in the 1930s Massine's friend Le Corbusier weighed in on the design. Nureyev's work on the villa included covering the walls and floors of certain rooms with Turkish tiles that he found in Seville.

In 2016, years after that first boat ride, I returned with my friend photographer Michael James O'Brien and his husband, Zoltan Gerliczki. We stayed for three days producing a story for *Departures* magazine. We had the islands all to ourselves, save the staff of husband and wife who cooked and kept things spic and span, and the foreman who went fishing daily for our meals. One day, after lunch, we were chatting, and I asked him if there were any ghosts on Li Galli. He told me that after Nureyev's death, local fishermen were told never to go up to the tower. One disobeyed and ran back, too scared to report what he saw. The sirens are still in residence, of that I am sure.

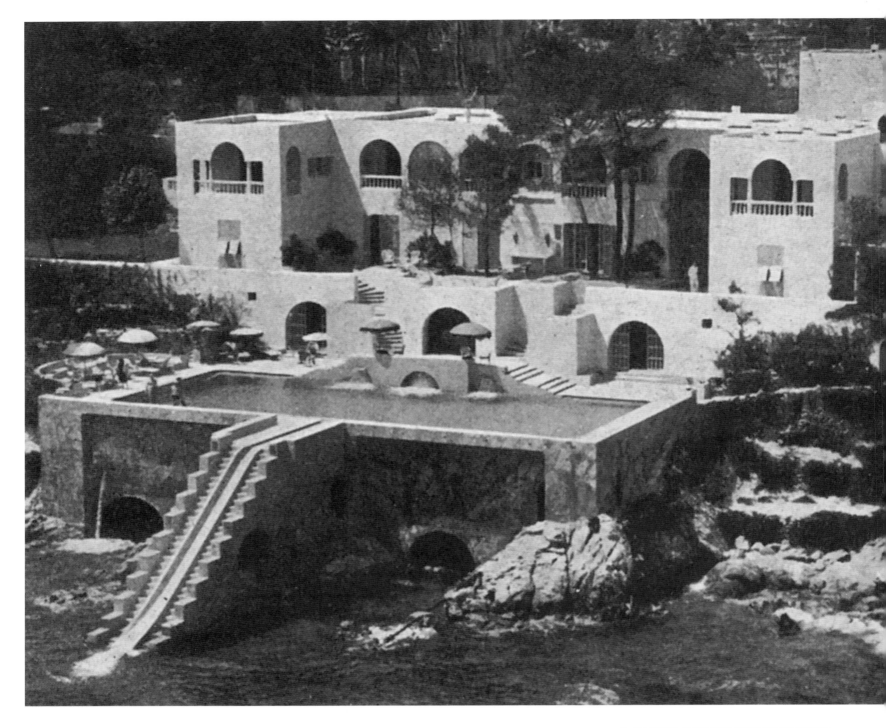

Above: I became obsessed by the Château de l'Horizon, outside Cannes, designed by Barry Dierks for the actress Maxine Elliott in 1932, with its chute from the pool to the sea, after I discovered this photograph from the Archive des Cannes, which fell into my lap during my research for Tony Duquette's book. *Below:* Dierks designed Villa Le Trident for himself and his partner, Eric Sawyer, outside Nice, also on the rocky coastline. Photograph by Martin Scott.

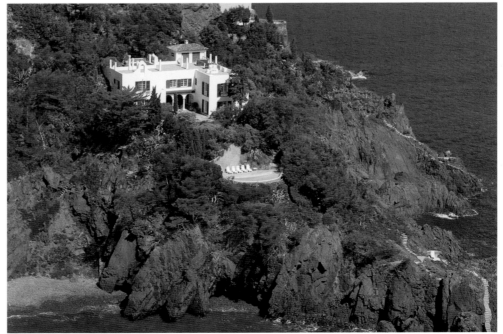

THE MYSTERIOUS CHÂTEAU DE L'HORIZON

During my years researching a book on Tony Duquette, with Hutton Wilkinson, I spent a lot of time living at Dawnridge, Tony's house in Beverly Hills. One day, while I was looking through a folder of Tony's papers (I never knew what I was going to find), a black-and-white photograph escaped and landed in my lap. The photo was an aerial view of a château built into the rocks of the Mediterranean coast. The swimming pool featured a slide down into the sea, bordered by two sets of stairs; once you'd finished your swim, you could climb back up to the pool. Who ever would have thought of such a fantastic thing, I wondered? The château was spectacularly beautiful, its Moorish-modernist architecture featuring a flat roof and arched windows. After careful scrutiny, I noticed figures on the terrace above the pool, giving a sense of scale to the enormous house, and then I noticed that there were two old-fashioned villas, partially hidden by palm trees, above the château. I was mesmerized. I had to find out who the architect was and who had lived there.

It wasn't that easy. I took the photograph to any number of historians and antiques dealers. No one knew anything. Finally, after months of trawling the Internet and many books on the Riviera, I discovered that my mystery house was the Château de l'Horizon and the architect was American-born Pittsburgh native Barry Dierks. Dierks had moved to Paris in 1921, where he met his partner, Englishman Eric Sawyer, and together they settled on the French Riviera in 1925. There they built their own Villa Le Trident in the rocky terrain above the coastline near Cannes. Somerset Maugham, for whom Dierks refreshed the Villa Mauresque on Saint-Jean-Cap-Ferrat, was his first client in the area. When American actress Maxine Elliott retired from the stage and moved to the South of France, she commissioned Dierks to make her a fantastic château that would befit the doyenne, who had had her own theater built for her by her husband. Dierks delivered the spectacular Château de l'Horizon in 1932. Elliott's guests were pampered and waited on but had to put up with her pet lemur, Kiki (after Kiki bit Elsie de Wolfe, the decorator refused all invitations to return). After Elliott's death in 1940, the château was sold to Aly Khan, who married actress Rita Hayworth there in 1949.

The Château de l'Horizon, now in the hands of the Saudi royal family, was off-limits, but my passion to discover all I could about Barry Dierks led me to Andrew and Laura Merton, who were in possession of the Villa Le Trident when I reached them in the summer of 2007. Andrew was a grandnephew of Eric Sawyer, and Eric and Barry had been Andrew's godparents. Laura and Andrew generously invited me to come and stay at Villa Le Trident, and they gave me Dierks's own bedroom for my night there.

During our shoot, Valentino invited photographer Oberto Gili and me to join the luncheon party in his beautiful dining room with its frescoed walls that gave you the feeling of being inside a leafy garden.

VALENTiNO

CAPRI IS ALWAYS ON HOLIDAY. The minute the boat pulls out of the harbor in Naples and the mainland recedes in its wake, you begin to breathe differently. You can feel the giddiness of the other passengers; some come with piles of luggage and some are just day-trippers, but everyone is anticipating the seductive splendors of the island. When we pulled into the harbor in Capri one day in 1991 on assignment for *HG*, there was one yacht that stood out from all the others. On the gleaming, white-and-navy-blue-painted vessel, members of the very handsome crew were attending to a pair of pugs. This was the polished floating palace of one of couture's last great kings; this was fashion designer Valentino Garavani's 152-foot *T.M. Blue One*, the yacht he named after his parents, Teresa and Mauro.

What a perfect introduction to Valentino's life in his Villa Cercola on Capri. As members of his staff arrived with what seemed to be a mile-long procession of luggage, I sensed the great ceremony involved in moving not only Valentino but also his entire entourage throughout the world, which most definitely was his oyster to enjoy. When he finally walked into the kilim-carpeted salon, he was charming and relaxed and spoke in a soothingly melodious voice. Valentino told me that he bought the villa in 1967, and when he was younger and his life as a designer was less frenetic he was able to spend every weekend between March and October on Capri. He said that he loved to entertain here, "in a cozy way. I think one's vacation home must be very relaxed." He sold it in 2002.

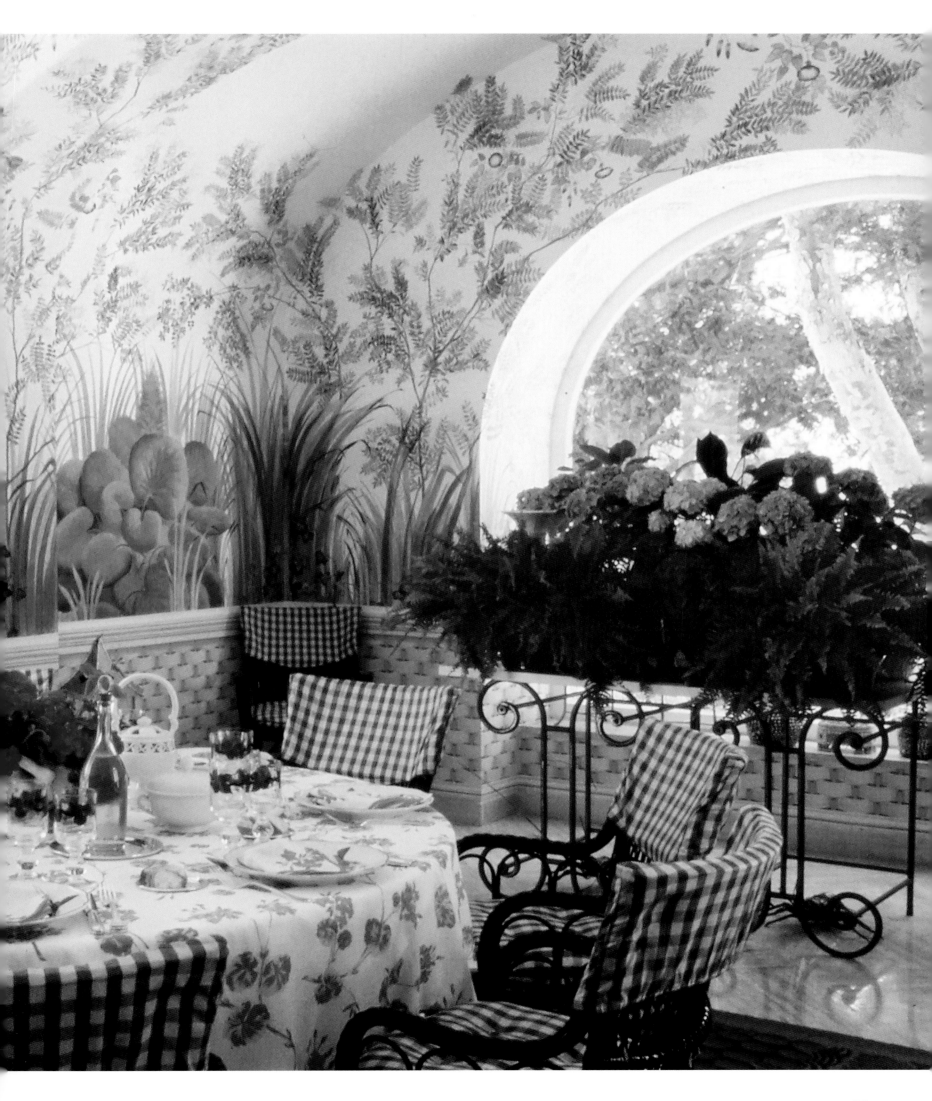

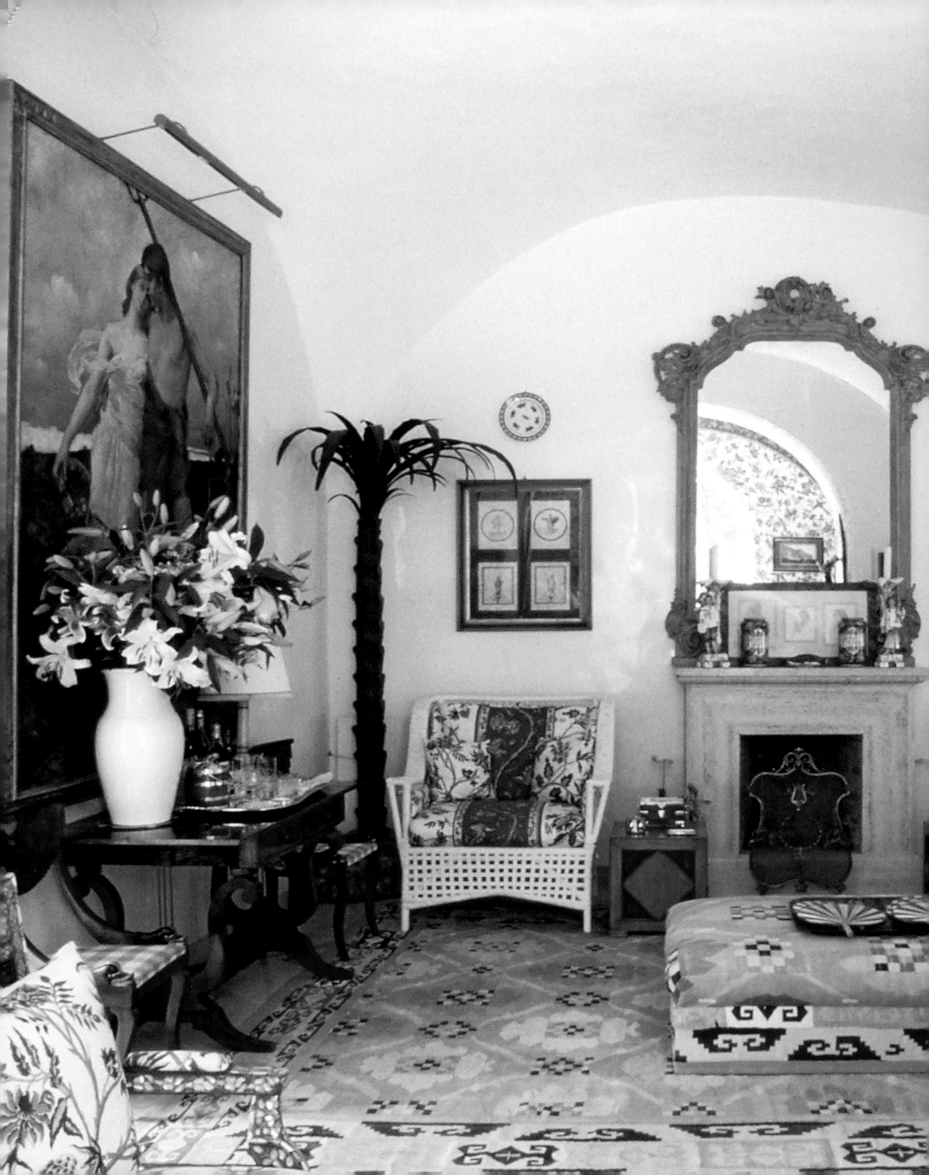

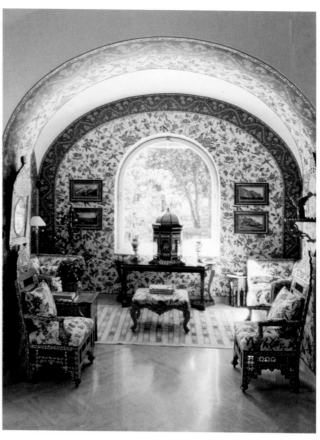

Opposite: The kilim-carpeted salon featured metal palm trees, wicker furniture, and a nineteenth-century Italian mantel. *Above left:* Valentino relaxed with his godson, Sean, son of his indispensable friend and right hand, Carlos Souza. *Above right:* An alcove with walls upholstered in floral fabric from Brunschwig & Fils.

"Relaxed" for Valentino still entailed being served by white-gloved butlers at lunch, for which we sat in the vaulted dining room that was frescoed with foliage to the point where you almost wondered where the painting ended and real vines began. The table was set with a geranium-patterned Porthault tablecloth with matching napkins and a centerpiece of bright red geraniums. The simple lunch seemed to have been plucked from the garden of paradise; you had never tasted anything so delicious. We all bowed and *mmm*'d in unison as we indulged in each new course, which led to the subject of the chef, who, we learned, had come from England, and we wondered if he might have come from one of the royal households, as that conversation was quickly shut down. After lunch we got to work while Valentino and his family went out to the pool and bathed in the sun. Before he left the dining room, Valentino told me that the activity here was "dolce far niente," which means "sweet to do nothing." Then he added with a little smile, "If you want to do something you move from one sofa to the other."

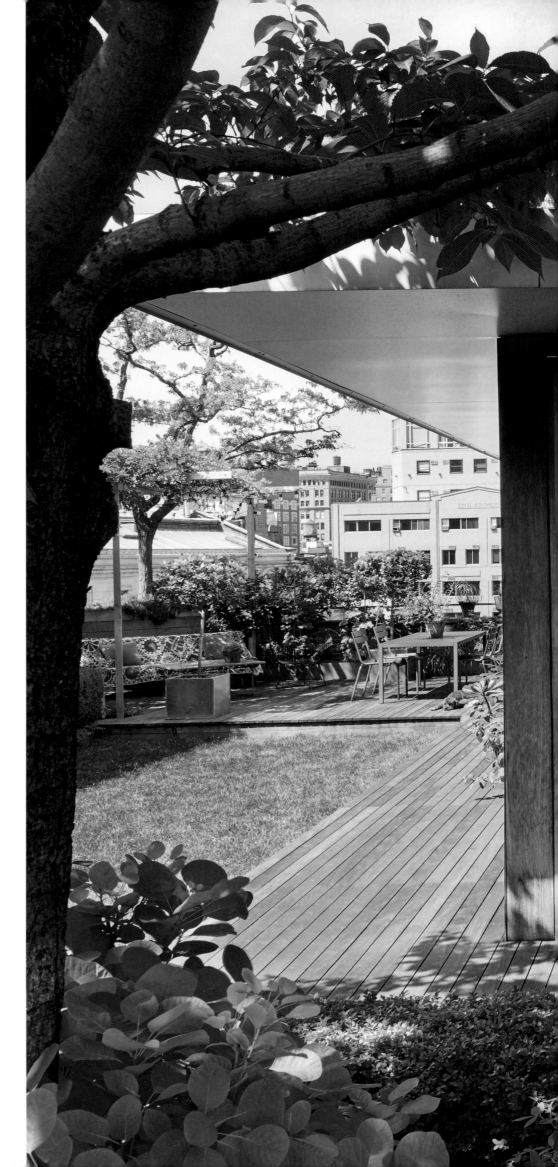

I returned with Annie Schlechter in 2017 to photograph Chris and Lisa Goode's rooftop pavilion in New York's Little Italy for this book, as the plantings had grown since 2008, when it was photographed for *New York* magazine by Gregory Goode.

CHRIS & LISA GOODE

I N 2007 I WAS ALL SET to do a story on Chris and Lisa Goode's duplex penthouse in Little Italy for *House & Garden*, when the magazine closed, again. It was impossible déjà vu; I had been there the first time that the magazine closed. I miraculously found myself back at *New York* magazine and knocked on the Goode's door again asking if I could do their story for *New York*. When the story was published in 2008, I wrote, "There are rooftop gardens, and then there's Chris and Lisa's rooftop garden, which is essentially an urban farm on top of a Little Italy building, complete with chickens and vegetables, fruit trees and migrating butterflies; all anchored by an elegant modernist penthouse pavilion designed by architect Andrew Berman." With a lawn, a rose garden, pots of lavender, a kitchen garden, and a black locust tree, there's not just one garden spread out around the house, but there is a second garden of wildflowers on the roof of the pavilion. It is a spectacular estate, to say the least. I went back to reshoot the gardens for this book with Annie Schlechter, as in the intervening years things had grown quite a bit, and Lisa and Chris had added a swing downstairs, outside Chris's office and the room of their daughter, Charlotte.

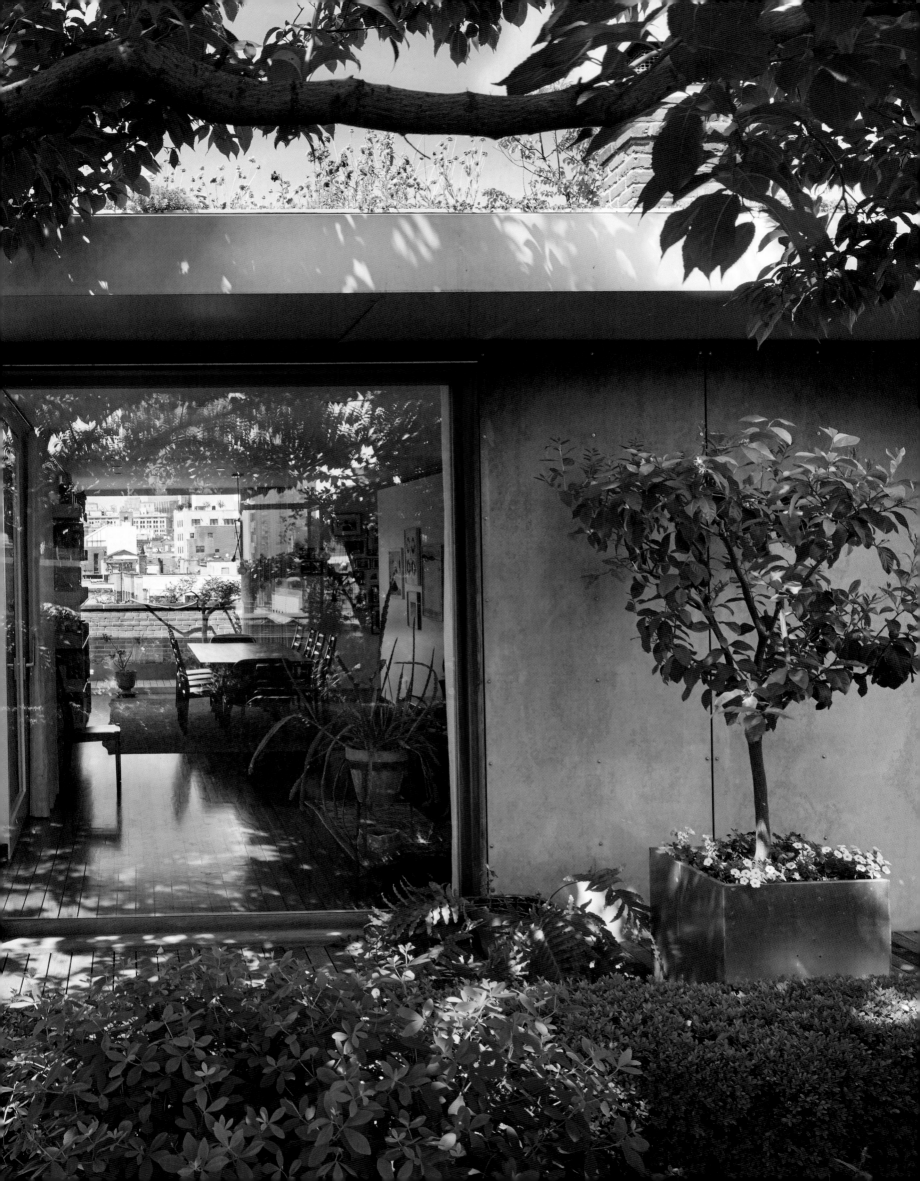

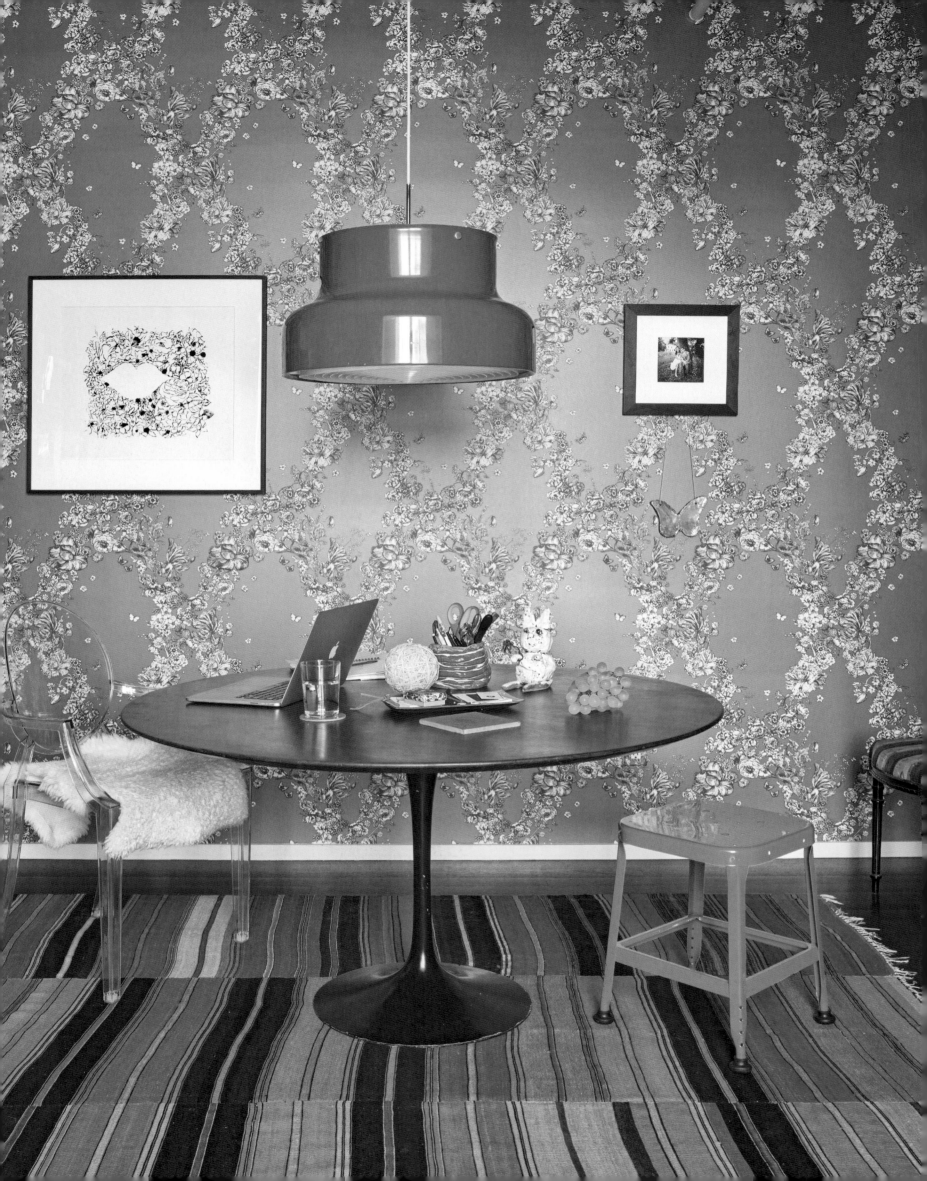

Opposite: Annie Schlechter also photographed Lisa's office, featuring Cole & Son's Fiori wallpaper, based on a design by Piero Fornasetti. *Top:* The upper level of the Goode's vast gardens. *Bottom:* Chris built a greenhouse downstairs that doubles as a natural light source. The stair leads to the rooftop pavilion.

97

Michael James O'Brien photographed landscape designer Ronald van der Hilst and Marcel Vissers's sixteenth-century home in Antwerp. They added their own bohemian glamour to the rooms.

RONALD VAN DER HILST

L ANDSCAPE DESIGNER RONALD VAN DER HILST became a tulip fiend when he discovered seventeenth-century Zomerschoon varietals. "Those tulips are like living antiques," he told me in 2014, when I interviewed him for *New York* magazine, for a story on his house in Antwerp. His obsession with tulips spawned a business of wallpaper, fabric, ceramic and glass vases and planters, and hand-painted tiles, all of his own design. But the real living antique is the house in Antwerp in which he resides with his husband, Marcel Vissers. When they met in 1994, Ronald was living in a neoclassical house that had formerly been renovated for use as student housing. The couple bought the house next door in 1997—both houses date from the 1500s—and when they combined the two the fun began. "There were many nice surprises," Ronald said. But the greatest find, besides original wood floors, exquisite paint colors hidden beneath layers of wallpaper, and resurrected stained-glass details, was the discovery that the ground floor of the second building had housed one of the city's oldest cafés. And guess what used to transpire in these cafés, besides the drinking of steaming cups of coffee? Tulip trading. And the bulbs were as highly valued as gold. Sometimes you find the house and sometimes the house finds you.

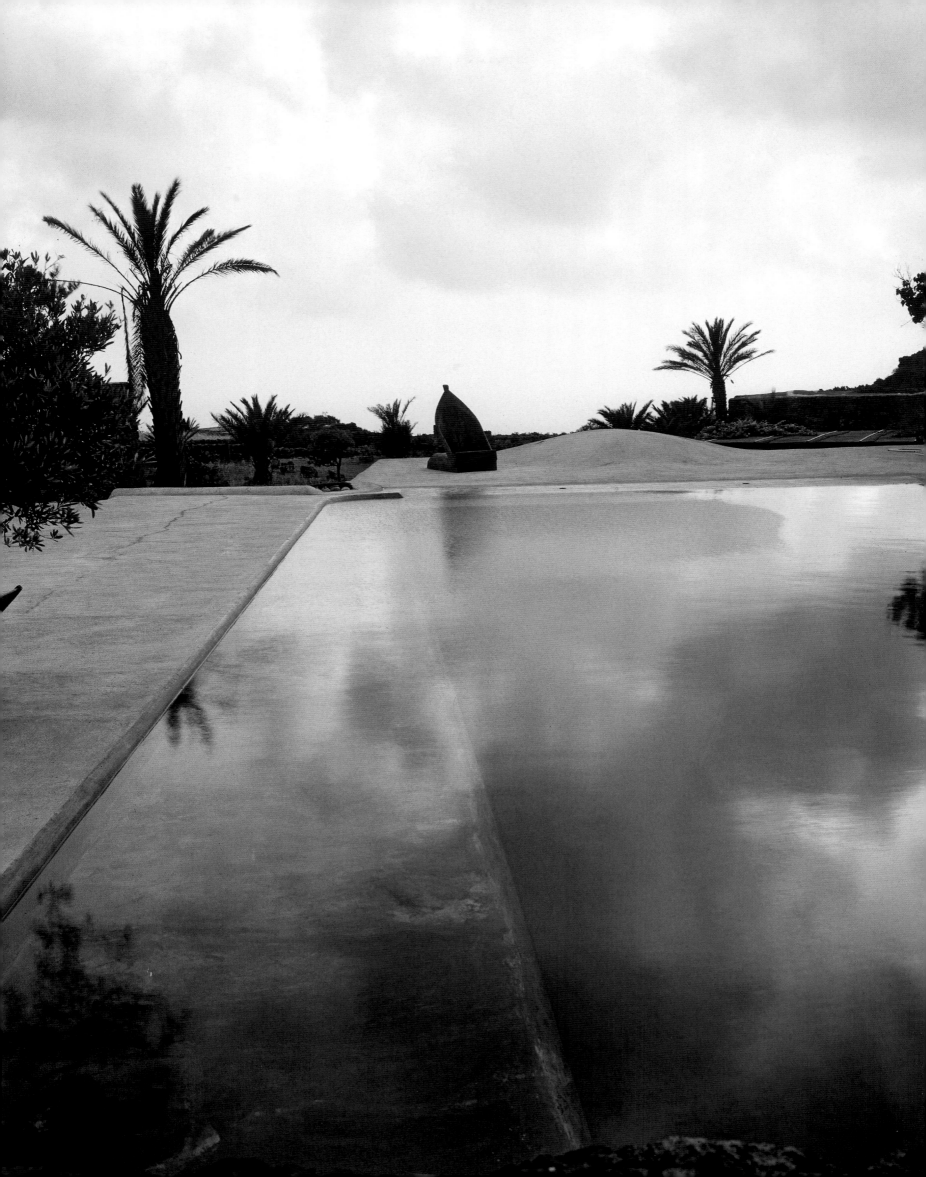

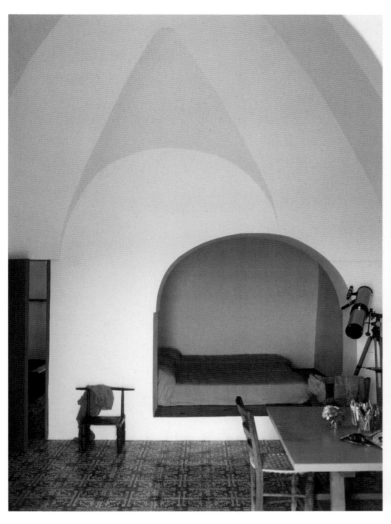

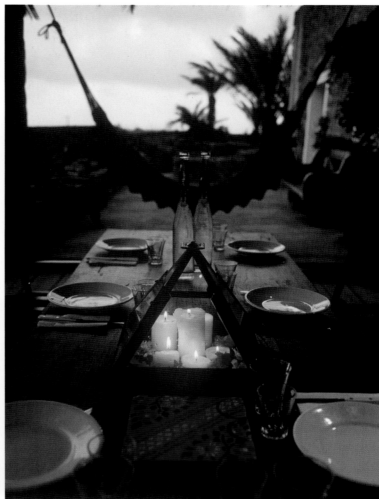

FABRIZIO FERRI

Fabrizio Ferri photographed his property on Pantelleria
for *HG* in 1993. His story ran in the last issue of
the magazine before it closed that year. *Above left:*
The interiors of Fabrizio's houses, with vaulted ceilings,
reflected the local *dammuso* architectural style.
Above right: Alfresco dining by candlelight. *Opposite:*
Fabrizio's sublime swimming pool.

OUR LANDING WAS HAIR-RAISING, but at least we were allowed to make the flight from Palermo to the tiny volcanic island of Pantelleria in the Mediterranean Sea off the coast of Tunisia. More often than not, wind conditions prohibited flying into this remote spot. The landscape we traversed from the airport to photographer Fabrizio Ferri's compound, Monastero, was biblical in its rugged beauty. Stone walls partitioned the hilly terrain, and we saw only the tops of trees, as, to protect them from the wind, they had been planted deep in the earth in holes reinforced by stone linings. The harsh weather conditions accounted for the design of the local houses, called *dammusi*, one-room domed structures with thick stone walls outfitted with small windows—this style of architecture has been in use in the island's Arab culture since the tenth century.

Fabrizio first visited the island in 1985 and fell in love with its remote beauty. He purchased a deserted village in 1988. Giorgio Armani was also captivated by the island and had purchased property in 1981. Photographer Oberto Gili and I came in the summer of 1993, when Fabrizio and a local architect, Gabriella Giuntoli, had finished the restoration of some of the *dammusi* on Fabrizio's property, to do a story for *HG*. They had also designed a pool that seemed always to have been there in the landscape, dotted with palm trees under the open sky.

Fabrizio had shown me a Polaroid of the pool about a year before I visited. His compound was Eden, undisturbed by the modern world and still virgin territory, hidden away even from the ever-growing population of savvy tourists. Fabrizio's sensibility and sensitivity to balancing the past and the comforts of the present were pitch perfect. Simplicity reigned. Today Monastero is the most coveted spot to rent for a trip to paradise, if you like to take yours on the rocks.

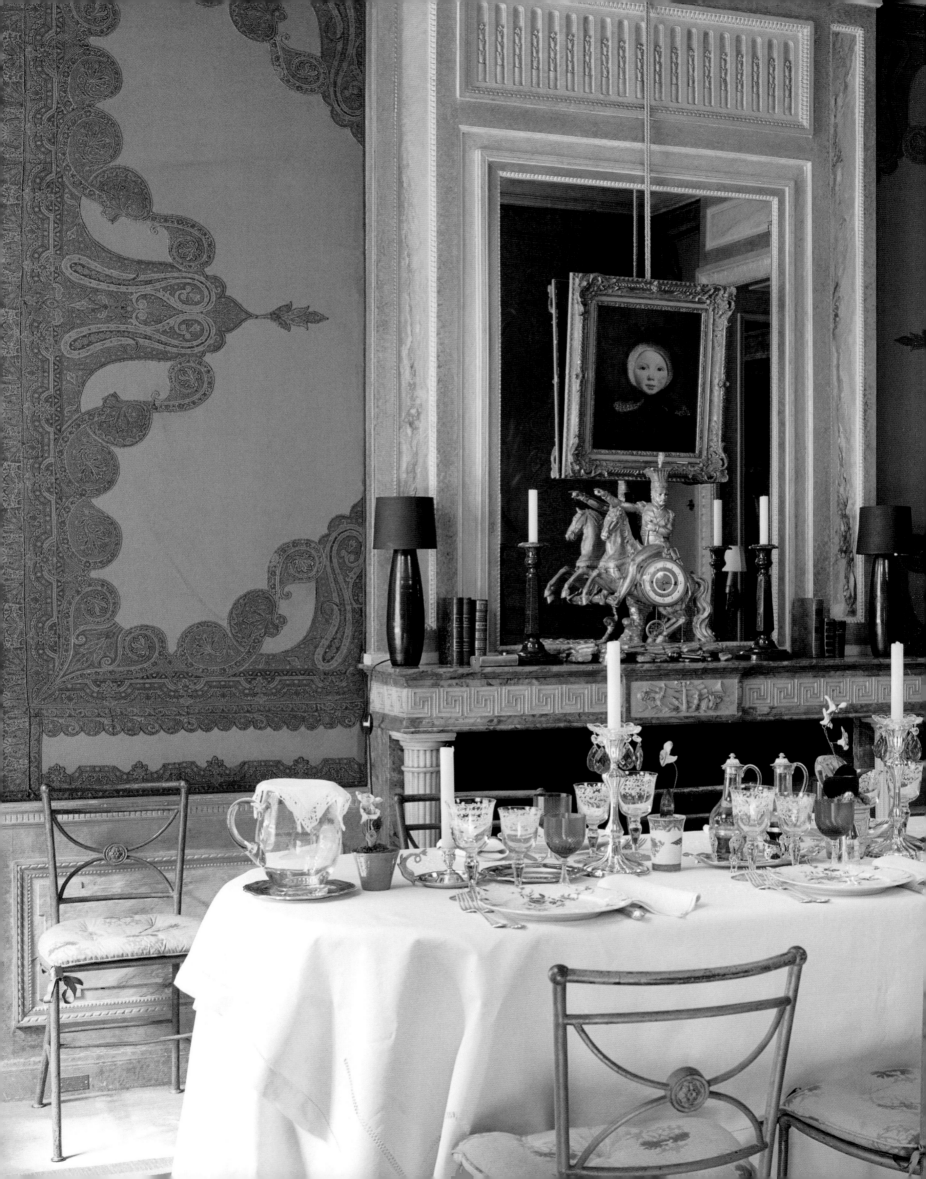

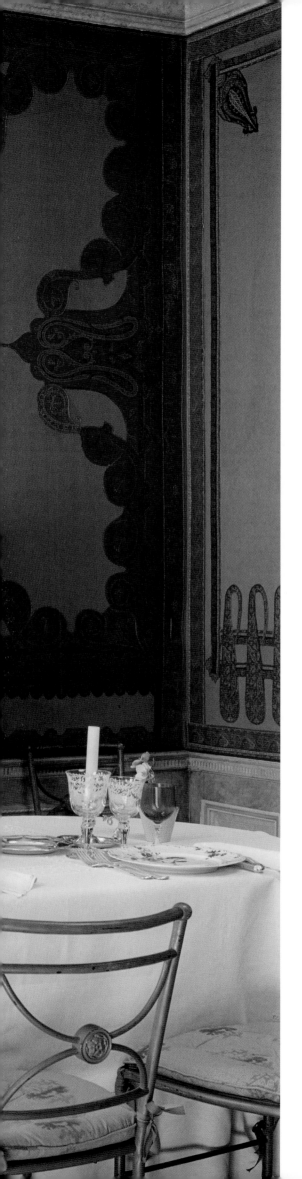

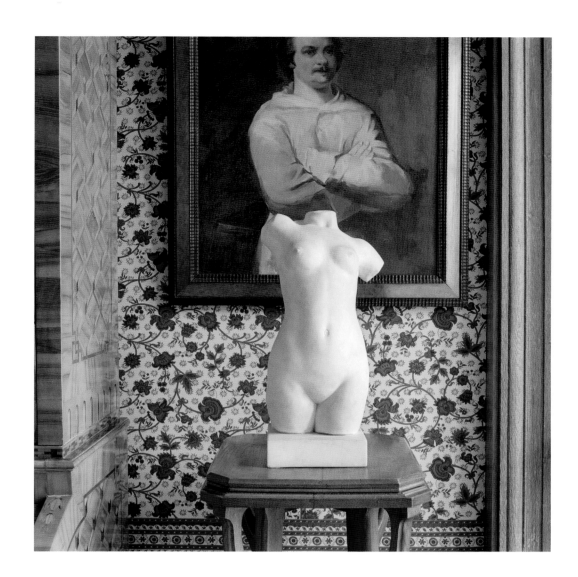

Opposite: Renzo Mongiardino decorated three floors for the countess, upholstering the walls of her dining room with embroidered cashmere shawls that took a year and a half to sew together for the panels. *Above:* A marble torso in the third-floor sitting room. I worked with photographer Simon Upton for two days on the shoot.

A COUNTESS
IN PARIS

THE LIVES HIDDEN BEHIND the walls of Paris's *hôtels particuliers* are so enticing. Lots of cities have imposing old mansions with forbidding facades, but the ones in Paris seem especially steeped in intrigue and romance. So it's understandable that negotiating one's way in would take time, as it did for a story in *W* magazine in 2002, especially if the residence in question belonged to a countess who had the great fortune to enlist Italian decorator Renzo Mongiardino to spin his lavish design feats in the already sumptuous rooms. Think walls upholstered in great swaths of hand-embroidered cashmere and curtain tiebacks that the countess described thus: "This type of thing that looks like nothing costs more than a picture!" (And among the pictures is a portrait by Élisabeth Vigée-Lebrun of one of the countess's ancestors). Rock-crystal chandeliers and a Louis XIV armoire by André-Charles Boulle are all part of the decor that spreads out like a giant field of wildflowers, blending together the rich colors and textures that form the total picture of what the French call *luxe, calme et volupté*—"luxury, peace, and pleasure" to us.

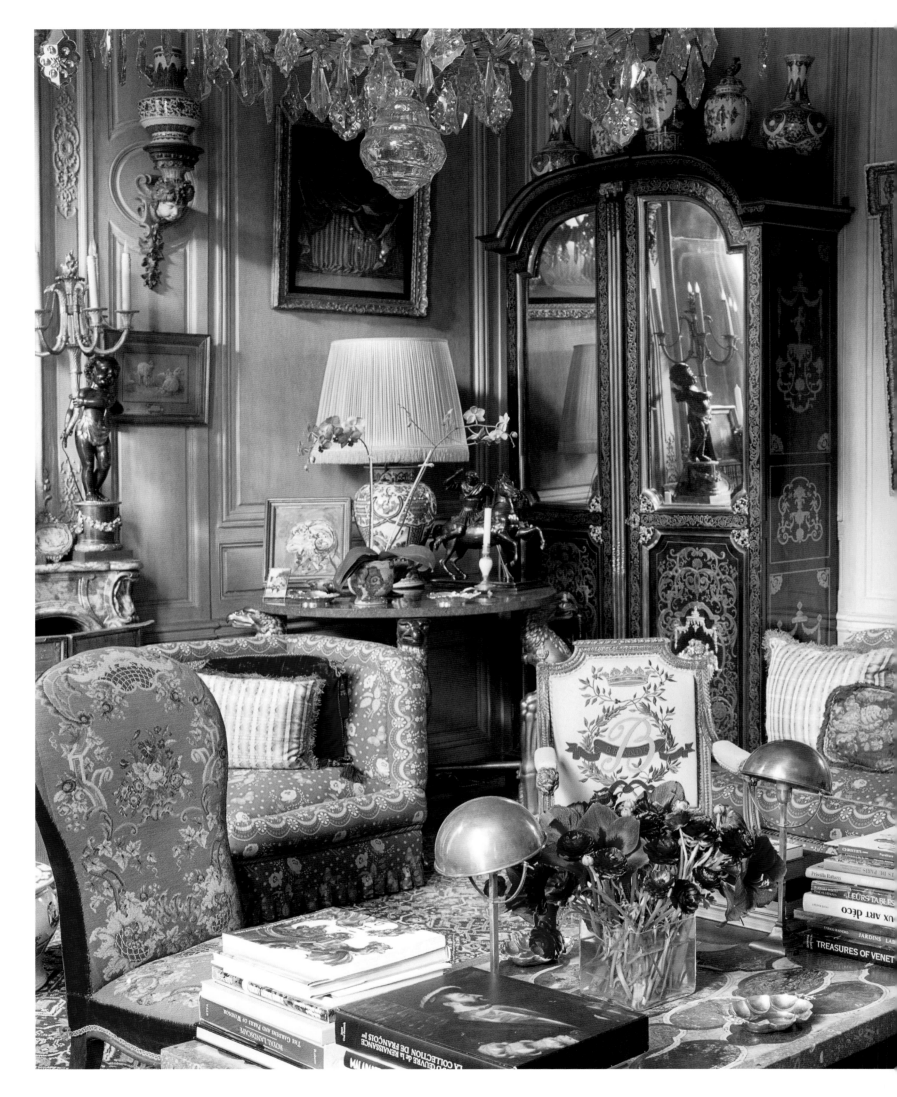

Opposite: A sitting room filled with a cozy array of books, paintings, a Boulle armoire, crystal chandelier, and needlepoint upholstered chairs. *Above:* The entrance to the dining room. *Below:* The third floor sitting room with sofa and walls upholstered in the same fabric.

3

NEO
TRADITIONALISTS

They have the most fun
scrambling history
and provenance and what
you thought you
knew about rules; but they
really bring home
that there are no rules.

MICHAEL HENRY ADAMS

"I DON'T LIKE TO THINK OF MYSELF AS A SCAVENGER," gay rights and preservation activist Michael Henry Adams told me during our shoot for *New York* magazine in 2002, "but I like to take a souvenir of something that's about to be lost." His floor-through garden apartment on 122nd Street was filled with such souvenirs, including a plaster cast of fruits and flowers salvaged from the Audubon Ballroom, the site of Malcolm X's assassination in 1965. Michael's apartment was a walk-in cabinet of curiosities—at one turn it looked like a nineteenth-century salon, and at another, a pop art gallery. This author and lecturer is a public advocate for historical preservation in Harlem and beyond. To this day he is fierce and fearless, often standing alone, as he did during his protest in 2003 of Davis Brody Bond's modernist glass-and-steel addition to the neo-Georgian brick-and-limestone McKim, Mead & White Harvard Club building on West Forty-Fourth Street. He has been arrested for disturbing the peace numerous times, always wearing his trademark bowler or boater hat (depending on the season), notably in 2014, when he protested the demolition of Harlem's Renaissance Ballroom and Casino, a magnificent hot spot between 1920 and 1979 that had been left to languish and deteriorate. Michael wrote, in a story for the *New York Daily News* on December 8, 2014: "But for blacks encumbered by a bitter past, landmarks reflecting African American perseverance matter even more."

Above and opposite:
Ethan Hill
photographed
Michael Henry Adams
and his former
Harlem apartment.

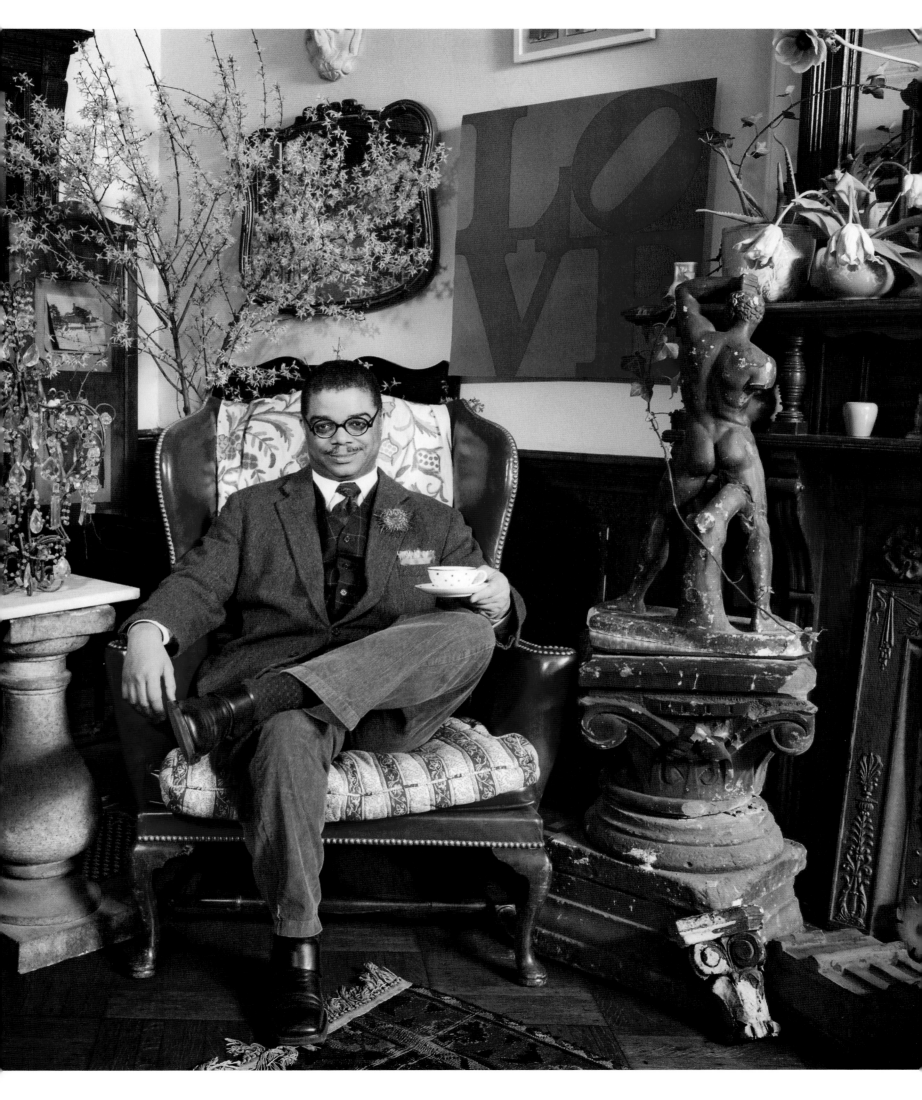

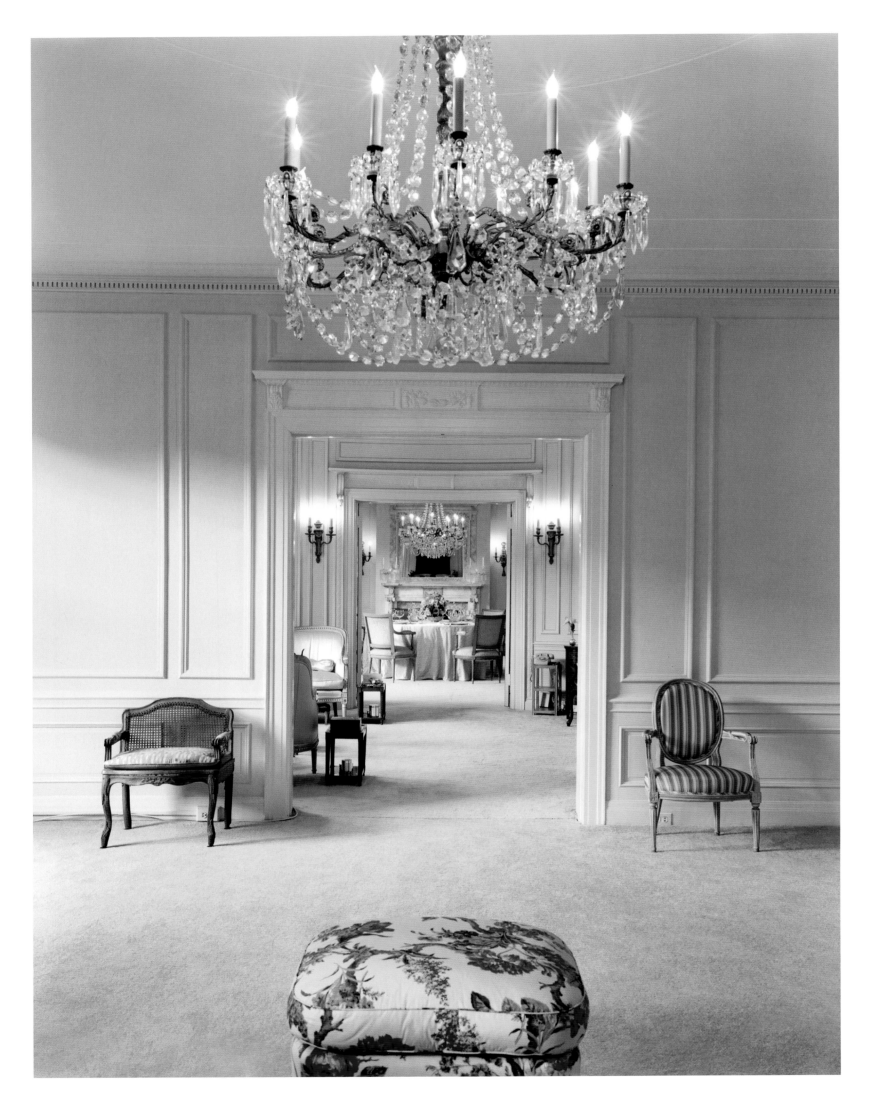

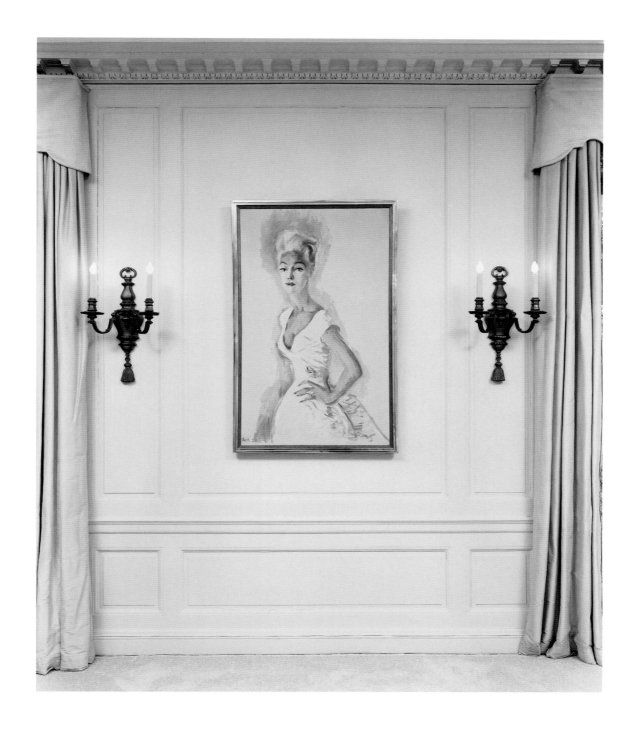

ANNE SLATER

Opposite: Anne Slater's prewar apartment—
that's pre–World War I—featured a graceful
enfilade of living, sitting, and dining rooms.
Above: Anne's portrait by Peter Sheil in her
dining room. The story, photographed by
Mark Heitoff, was an adventure with Anne and
John Cahill's delightful participation.

I N APRIL, 2006, Kathy Sloane, of Brown Harris Stevens, called to say that
she had a very important property that had just come on the market.
I met her at the entrance of 998 Fifth Avenue, the twelve-story, Italian
Renaissance–style building designed by McKim, Mead & White in 1910.
The apartments were created to entice rich clientele to forsake mansion
living for the comforts and convenience of European-style apartment dwell-
ing, complete with jewelry and silver vaults and servants' wings and six to nine
bedrooms, not to mention the wine cellar in the basement. We took the ele-
vator to the third floor. Kathy rang the bell of a very large wood-paneled front
door. When the door opened, we were greeted by a vision of porcelain-white
skin, perfectly coiffed platinum hair, a pair of sapphire-blue sunglasses, frame
and all, and a mile-wide smile. I realized that Anne Slater, New York City
socialite extraordinaire, had opened the door to *her* apartment. Not only was
I standing in the midst of a magnificent interior filled with history, and still in
the original McKim, Mead & White layout, but there was Anne Slater! It was
a once-in-a-lifetime, stellar double bill of a story for *New York* magazine.

But first I had to get the story. I didn't want to just photograph the apart-
ment; I wanted Anne in the story, and I wanted archival photographs of
Anne entertaining in the apartment, as I knew that her aversion to anything
ho-hum resulted in out-of-this-world party scenarios with the crème de la
crème of who was who at the time. As Anne and her partner John Cahill led
us through the massive apartment, you could just imagine the fun that must

have unfolded throughout the enfilade of rooms. Once you left the creamy satin decor of the library and the living and dining rooms, the working wing, that is, the kitchen and maids' rooms, felt like an altogether different world, with its own darker palette. Anne and John were game to participate as players in the story, and we started by perusing boxes of photographs that Anne had brought up from storage in the basement. There were literally hundreds of fantastic shots depicting a life of glamour long gone. We chose a picture of Anne in a satin jumpsuit trimmed with ostrich feathers from the knees down, a picture of the Duke of Windsor playing the drums at a party, and a picture of Rosie the bear—a real bear—with guests in the front hall, among many others. One of Anne's guest powder rooms was entirely mirrored, walls to ceiling, and featured a custom-made mirrored dressing table that had belonged to legendary 1938 debutante Brenda Frazier. Another guest bathroom still had the original wicker-encased toilet (exposed fixtures were once considered vulgar). One of the maids' rooms in the back had a tented ceiling and fabric-upholstered walls; it had been Bing Crosby's home away from home when he was in New York. He practiced his soft-shoe routines in the gallery. In her fifty-three years in the apartment, you can bet that Anne Slater never had a ho-hum day.

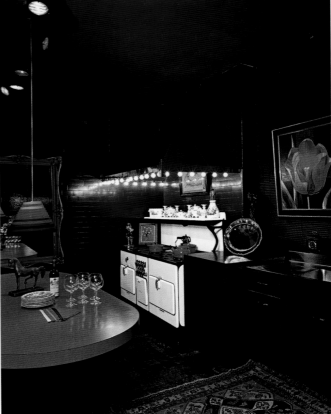

Opposite: The mirrored powder room. *Above:* Anne in the apartment's oval sitting room. *Right:* The tented guest-room that was Bing Crosby's home away from home. *Far right:* Anne's chocolate-brown kitchen with its original Imperial stove.

Fashion designer Hervé Pierre always wears an Hermès scarf, even in bed. Photographer Todd Selby (aka The Selby) asked him to change into his pajamas and get under the covers for this portrait.

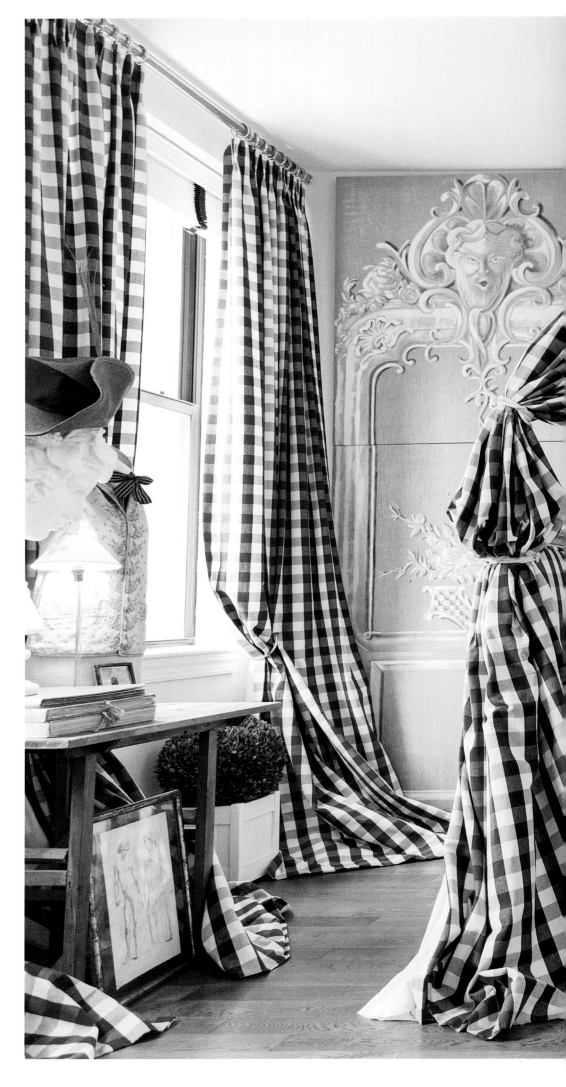

HERVÉ PIERRE

I MAGINE A CONTEMPORARY MAN with both a modern spirit and the skills to summon up any amount of the beauty normally associated with the eighteenth century. This unique and delightful chemistry belongs to fashion designer Hervé Pierre, who enchanted me from the moment I met him many years ago.

Hervé grew up in the Loire Valley and at the age of twenty-four went to Paris, where he became the head of haute couture for Pierre Balmain. At the time of our shoot in 2010, he had lived in New York City for fifteen years and was the creative director of Carolina Herrera. I think I begged him weekly to allow me to do a story on this new space, having been bereft after his former apartment had been featured in another magazine. So I totally wore him down.

The opening spread of the story that appeared in *New York* magazine shows Hervé in his sumptuous canopy bed wearing blue pajamas and his signature Hermès scarf. I would never have dreamed of asking Hervé to put on his pj's and get into bed, and that is why, as an editor, you can get very lucky working with a photographer like Todd Selby, aka The Selby, who thought nothing of it. I winced, fearing that Hervé might be offended, but he was perfectly game, and his being in bed makes the picture! Collaboration is a glorious thing.

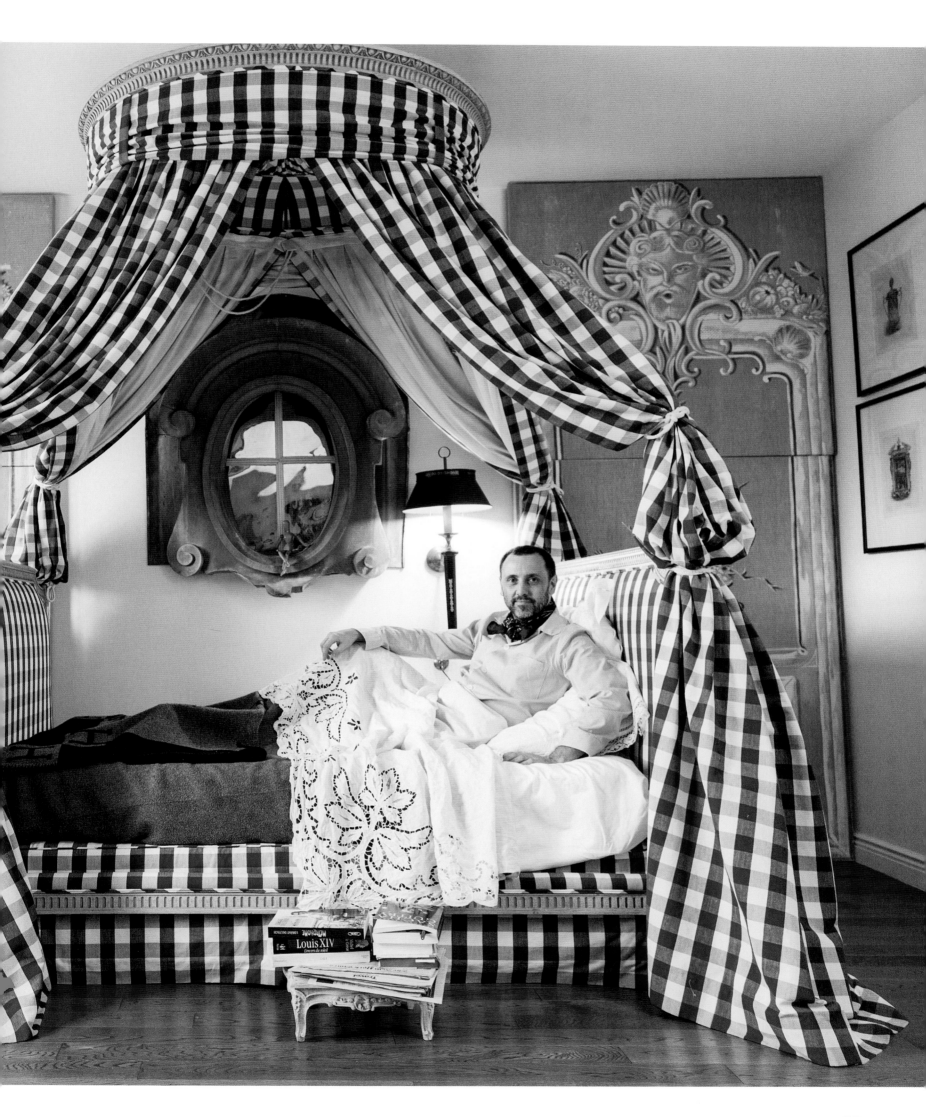

Opposite: The Louis XV couch is covered in silk velvet. *Above:* An eighteenth-century-style frame, made of cardboard, took Hervé two years to make.

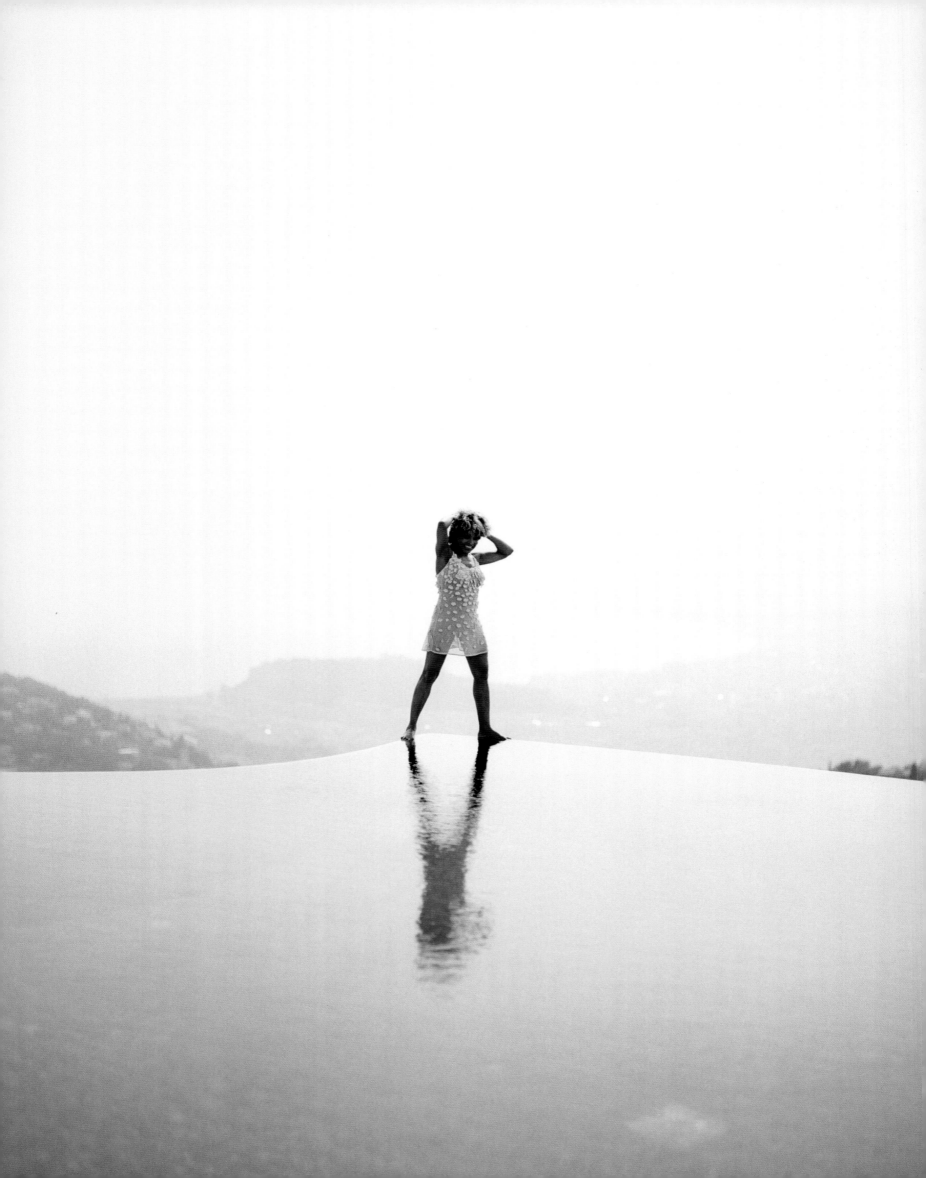

TINA TURNER

T HE EXCITEMENT OF PHOTOGRAPHING, let alone meeting, Tina Turner was beyond imagining, and yet there I was in Nice the day of the shoot in 1996, looking over the call sheet that detailed the rundown of activities for our *Harper's Bazaar* photo crew and the *60 Minutes* film crew who had come to do a part of their story. I had brought trunks of designer clothing for Tina to try on, before doing a final run-through for photographer Peter Lindbergh, makeup artist Kevyn Aucoin, and hairdresser Orlando Pita, all icons in the business. Tina, used to people being starstruck around her, was relaxed and delightful, putting everyone at ease.

Her villa high above the city of Nice felt like Mount Olympus, with its view of the Mediterranean and the surrounding hills. The famed decorating duo of Stephen Sills and James Huniford had worked with Tina on the decor, which incorporated a twenty-two-piece suite of gilt Louis-Philippe furniture designed for one of the king's palaces. The only thing that Tina hadn't nabbed was the bed, as that was already in the Louvre. For Tina, it was love at first sight, and she knew the ensemble would work in her living room in front of her massive stone fireplace. Stephen and Ford had taken Tina to one of their favorite historic houses, Villa Kérylos, in the nearby town of Beaulieu, to show her how spartan neoclassicism could live in the present. Tina had noted what she loved, namely, the frescoes and Greek and Roman pottery, but she wanted more comfy luxe, hence the royal furniture. At the end of the day, in that magic hour when the sun is setting but not yet gone, Peter took an extraordinary portrait of Tina standing at the edge of her infinity pool, looking like the modern earth goddess that she is.

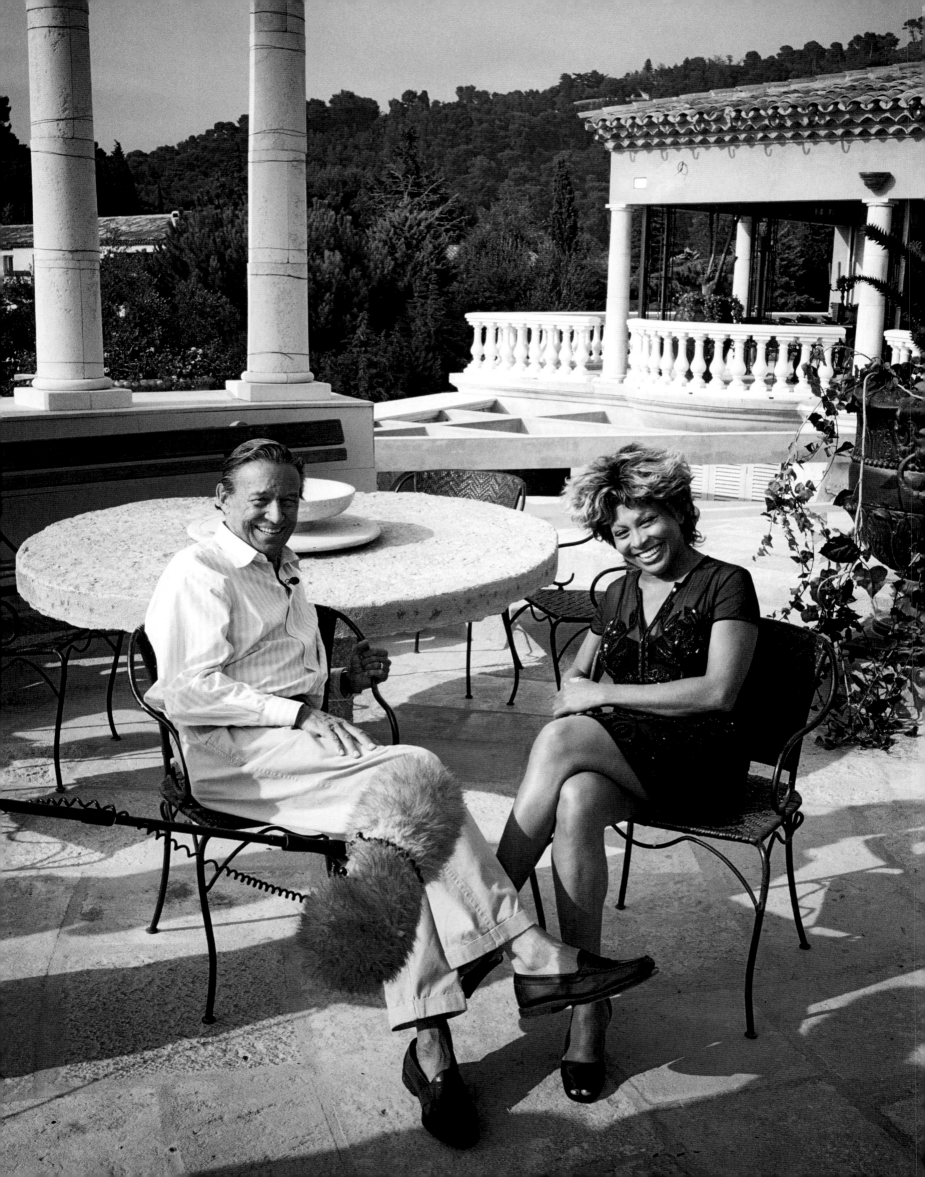

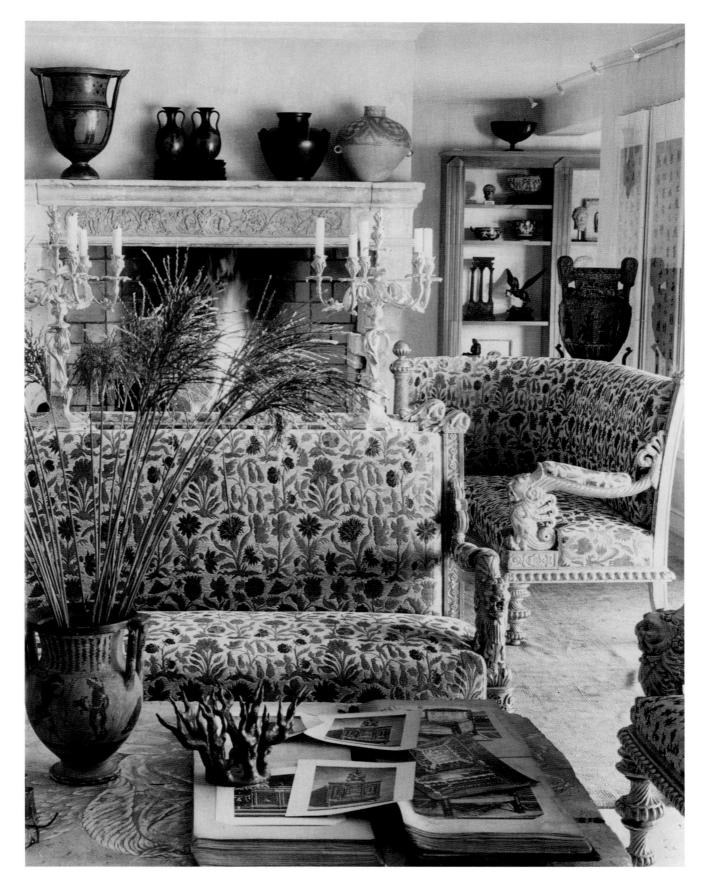

Opposite: Mike Wallace
and Tina during a break in
filming *60 Minutes* during
our shoot. *Above:* Stephen
Sills and James Huniford
decorated Tina's villa, and
in the drawing room
Tina's Louis-Philippe gilt
furniture was the center
of attention in front of her
Renaissance-style stone
fireplace. We did the shoot
in two parts: all portraits
were done by Peter; later
Oberto Gili and I returned
to do the interiors.

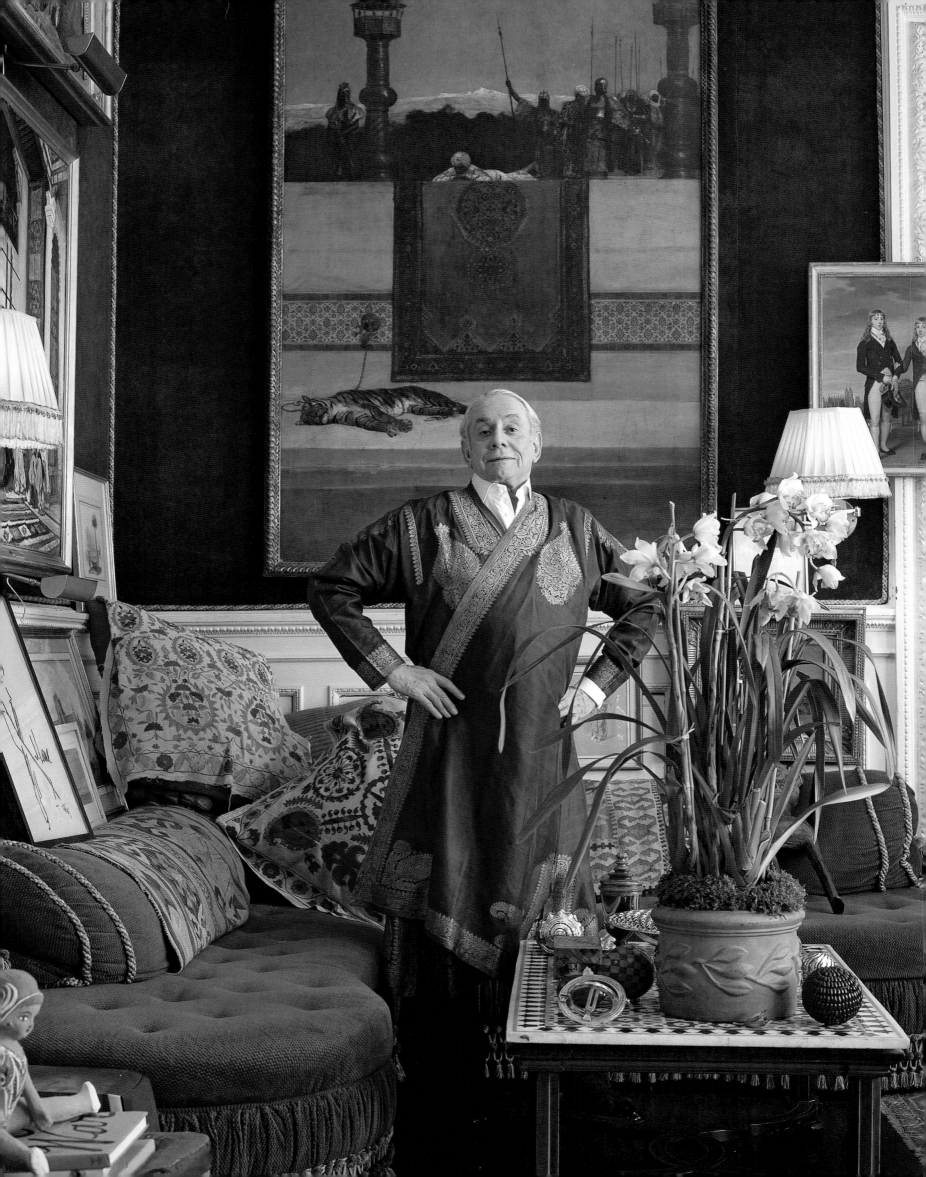

KENNETH JAY LANE

I
F THE LATE COSTUME JEWELER KENNETH JAY LANE hadn't found his grand duplex in one of the few remaining Stanford White–designed mansions left in New York City, he would have built it himself. Or so his lifestyle would have had you believe. His square living room, with its double-sided banquette, designed by Lane himself—one side used for pre-dinner cocktails, the other for post-dinner coffee—was the scene of endless entertaining. Just imagine the waste of this magnificent room if anyone but Lane had lived here! It would have been too sad if a clumsy modernist had dumped all the Gilded Age embellishments of this historic masterpiece. The living-room walls were upholstered in brown brushed cotton, and there was lots of tiger- and leopard-printed fabric spread throughout the room. Two large double-billiard lamps designed by decorator Robert Denning hung over the banquette, shedding soft pink light from beneath their pleated silk shades. The room was enthralling, designed for fun and conversation. It was here that Lane presided for decades as the society king of New York, entertaining everyone from the empress of fashion Diana Vreeland to the Duchess of Windsor; guests flocked to drink in the sumptuous atmosphere and the delicious, mischievous gossip.

When Lane retired for the night, after having been out on the town at one glamorous dinner after another, he would retreat to a bedroom, upstairs off the mezzanine, that rivaled the living room in the depths of its elegance and comfort. Its walls were sheathed in deep forest-green fabric. A silver bowl on the mantelpiece overflowed with the handwritten invitations seeking the honor of his company. But the most extraordinary thing was not just the beauty of the bed, set like a barge within a double swag of curtains lined in green and white stripes in front of a mirrored wall; no, the most extraordinary thing was the way the bed had been made, or unmade, by Lane's maid, Isabel, who clearly knew his tastes down to the tiniest minutia. The bed was dressed in snow-white linens with a milk-white cashmere fringed throw folded at the foot. Two European square pillows rested upright against the headboard, and one standard pillow lay flat, positioned exactly over the turned-down part of the top sheet. The bed exhibited something that was so particular, so finessed, about this lifestyle of his, cultivated during a lifetime of visiting the grandest houses and sailing on the grandest yachts and flying through the skies on the grandest private jets.

Down below, the sleek, ever-debonair bon vivant entertained no more than eight around the circular William IV table in his red-painted entry hall. Like the nimble-minded courtiers of Versailles, you were expected to lob conversation back and forth, dodging the host's occasional jabs, delivered with wit and humor over the specialty of the house, crab Isabel, and stuffed tomatoes. Did he really just say that? Once in a while Lane would get busted, as when, in 2002, while I was preparing my story for *New York* magazine, a journalist who had been at a particular lunch repeated, in print, one of his mean-spirited quips, delivered with a smile, about a friend of his, one of the city's grandes dames. Lane was not happy about that, but, as he would have told anyone who suffered the same fate, he should have known better.

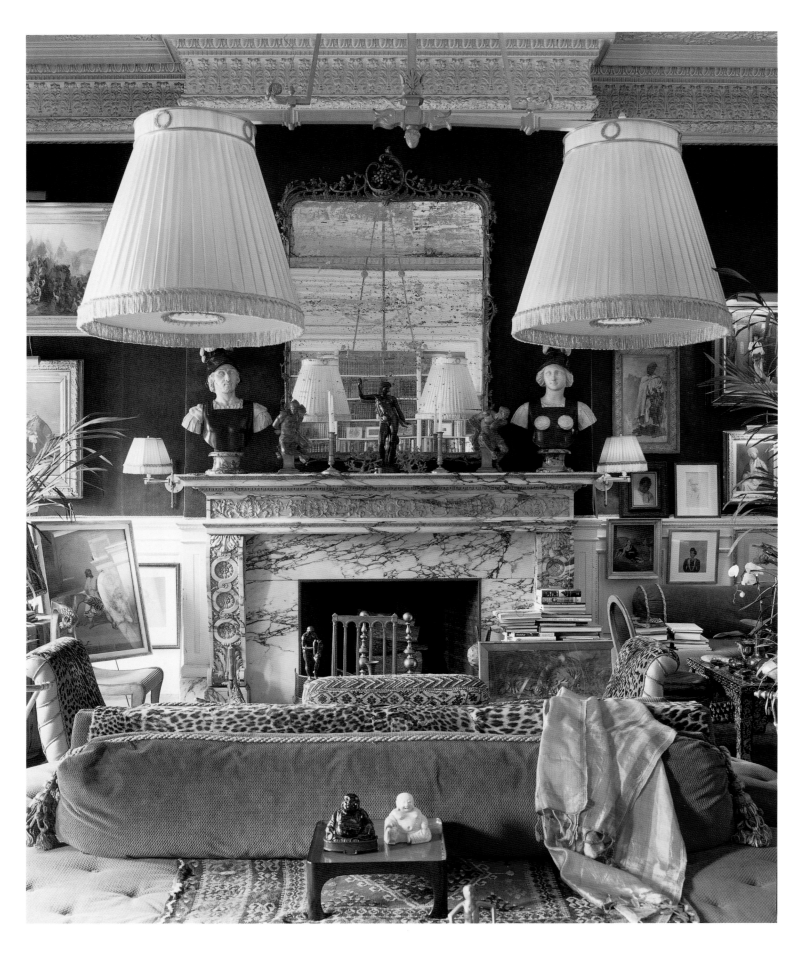

Above: The double-sided banquette in Lane's living room. *Opposite:* His bedroom was fit for Proust, with a pristine bed turned down just so every night by his maid, Isabel. Andrew Bordwin and I spent two wonderful days here with Lane doing the shoot.

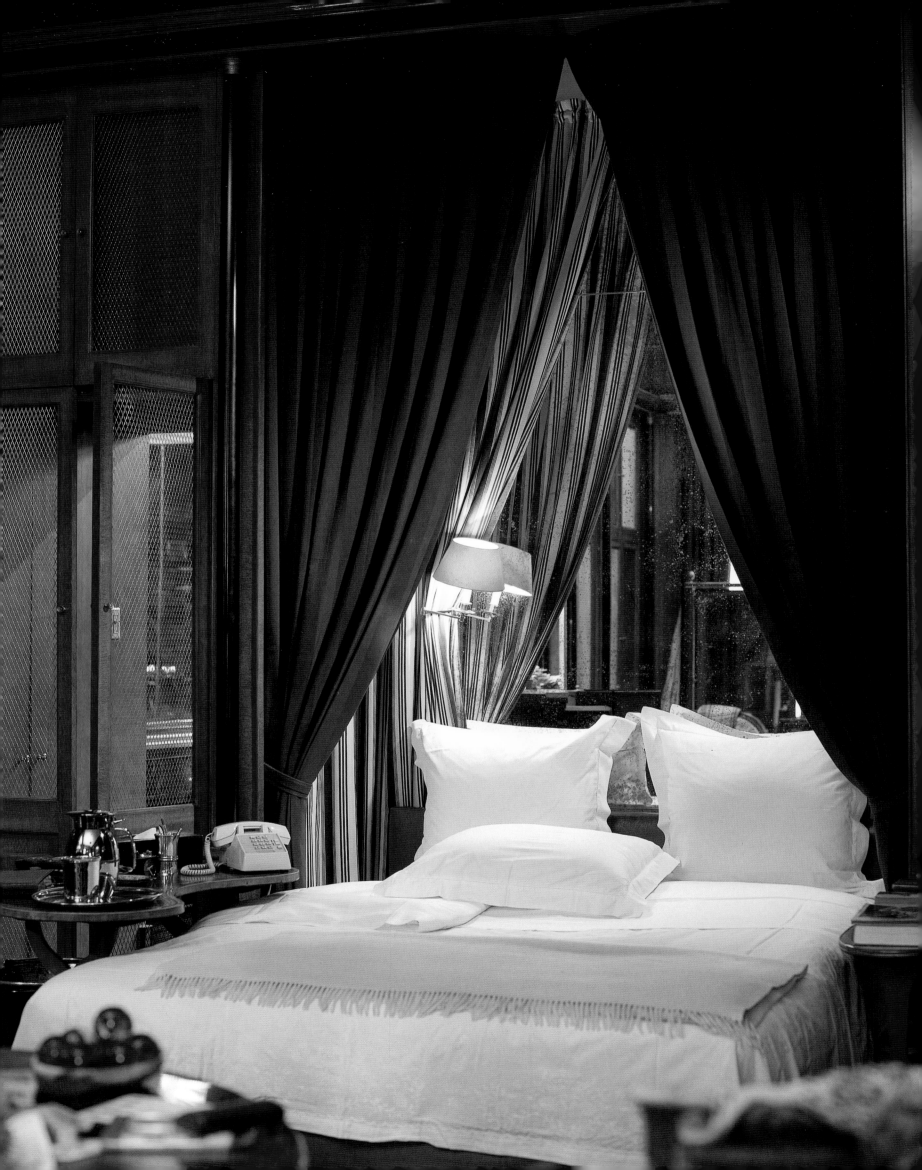

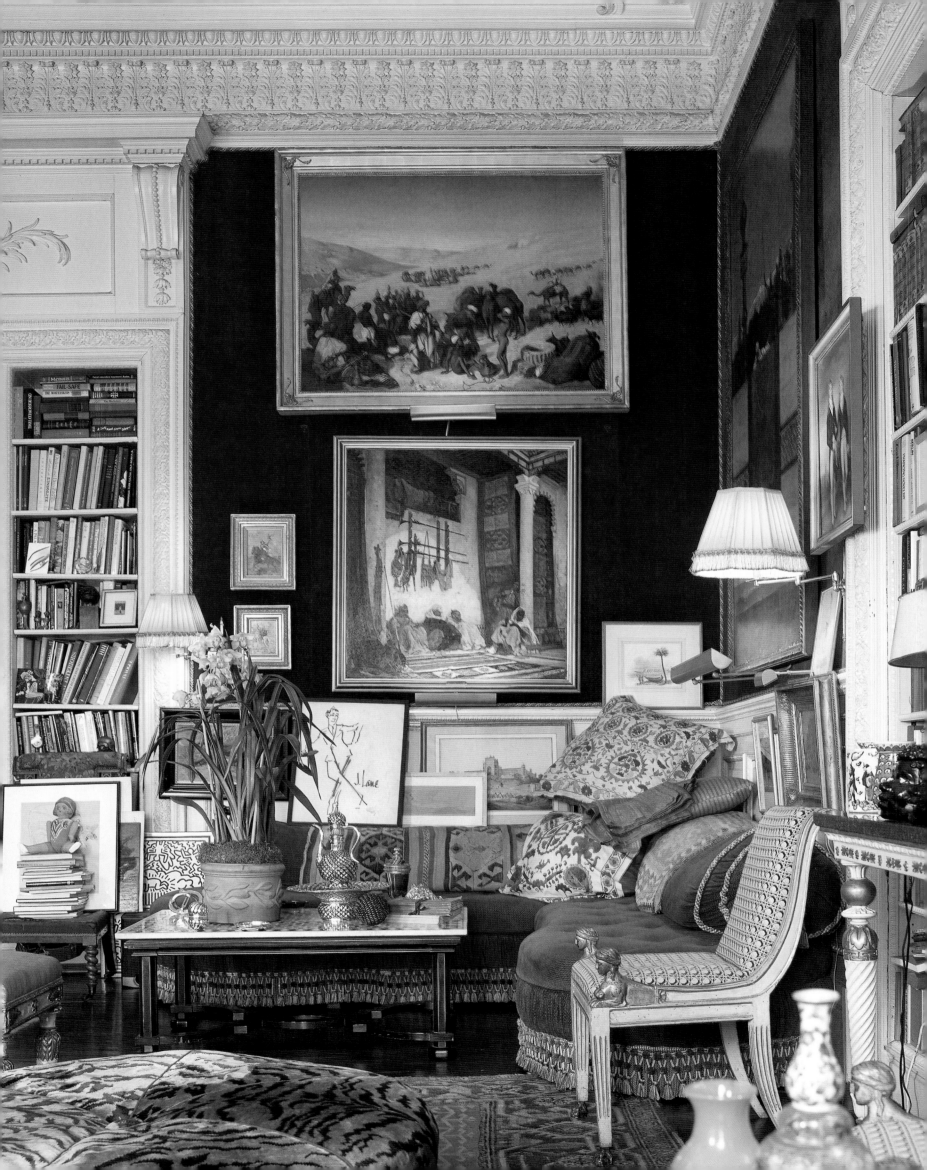

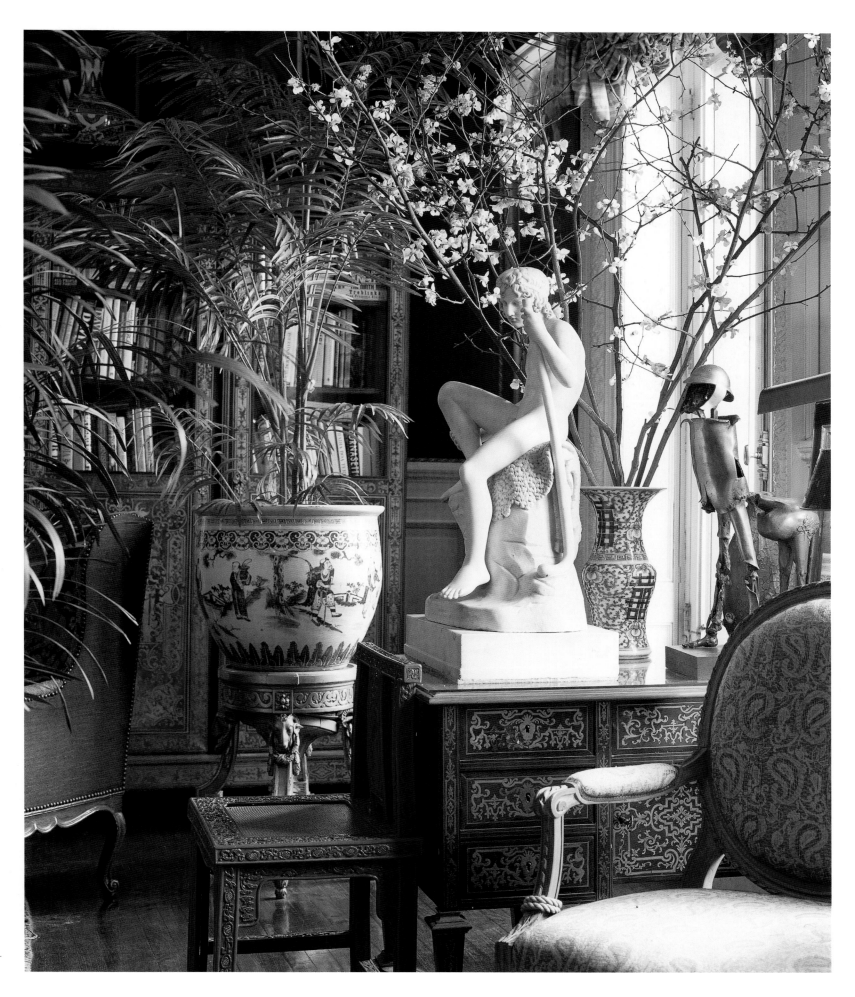

Opposite: Lane would nestle in the corner of the banquette in the book- and art-filled living room. *Above:* Decorator Robert Denning had a hand in aspects of the decor.

PETER MARINO

I HAD BEEN WONDERING where in Peter Marino's duplex apartment on East Fifty-Seventh Street we would be taking his portrait. I had hoped that it would be in the double-height living-room salon with a proscenium stage at one end; it was here that he and his wife, Jane Trapnell, the costume designer, frequently hosted concerts featuring distinguished artists from all over the world. I had been thrilled when his assistant led us into the extraordinary room. The old world intarsia floor had been made to measure in Europe, and one would be tempted to say that it was the room's main attraction, were it not for the twenty-two-foot-high coffered ceiling and the green scagliola columns, looking precisely like marble, with their white carved-plaster Corinthian tops. There was a Wedgwood fireplace mantel and rare signed furnishings, no doubt from courts throughout Europe.

I'd first met Peter when we were both starting our careers, and on occasion we'd assemble with mutual friends; Peter wearing a pert bow tie with a button-down shirt and a tweed sport jacket. He had a white Scottish terrier by his side pretty much everywhere he went. Peter was adorable and funny and knew more than anyone about art and architecture and was always fascinating. In subsequent years, as he ascended from one height to the next, he was developing a personal style that was 180 degrees away from the preppy guy I had known, masterminding the alter ego whom he now calls Pedro. I finally caught up with him for a story for *New York* magazine in 1999. When Peter entered his living room wearing black leather pants and a ribbed cashmere sweater, it was a splendid departure. His white Scottish terrier was with him.

Today Peter is one of the most famous architects in the world, known not only for his extraordinary work but also for his commitment to Pedro, whose leather pants are the least of his evolving style.

Above: Peter Marino in his living room, 1999. His leather pants signaled a style change that would evolve to become his trademark. *Right:* The double-height living room included a proscenium stage for performances and recitals. William Waldron photographed the story.

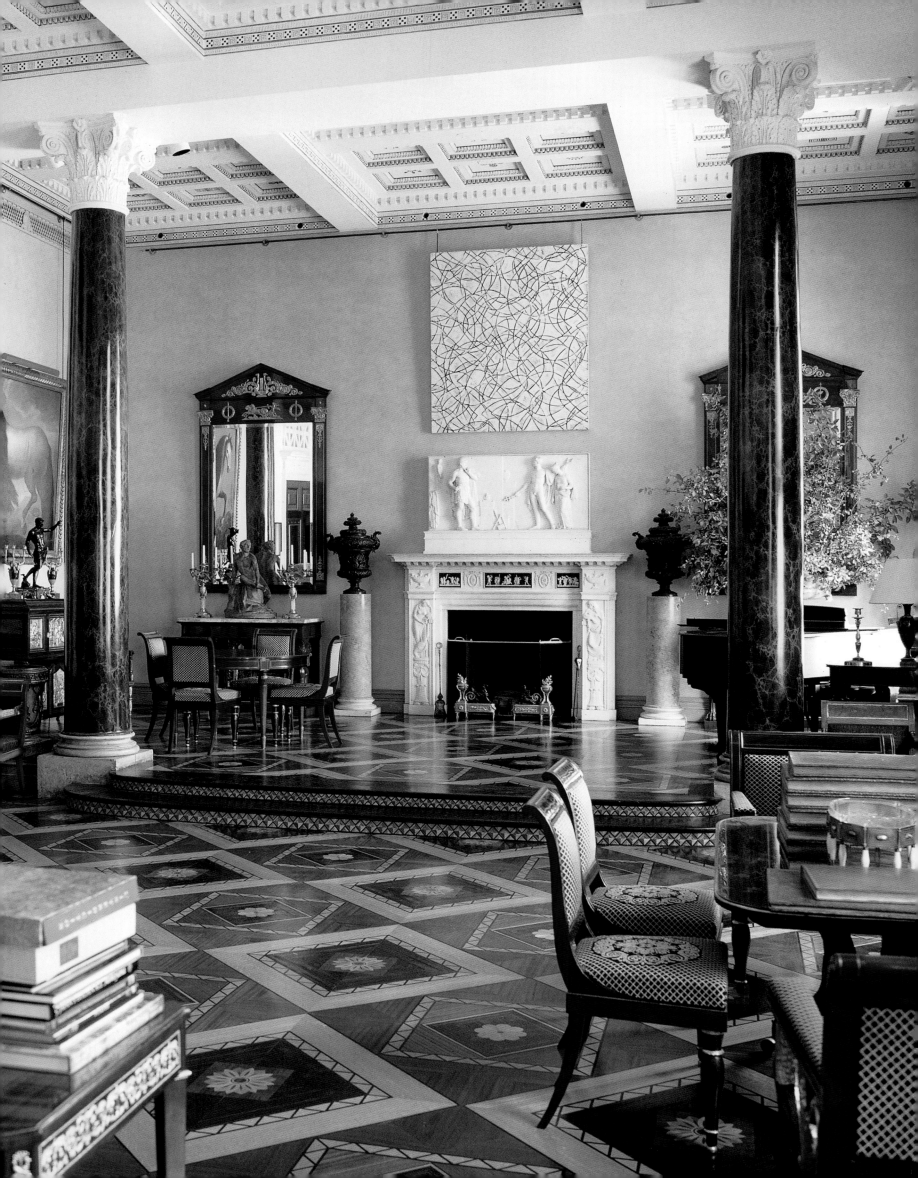

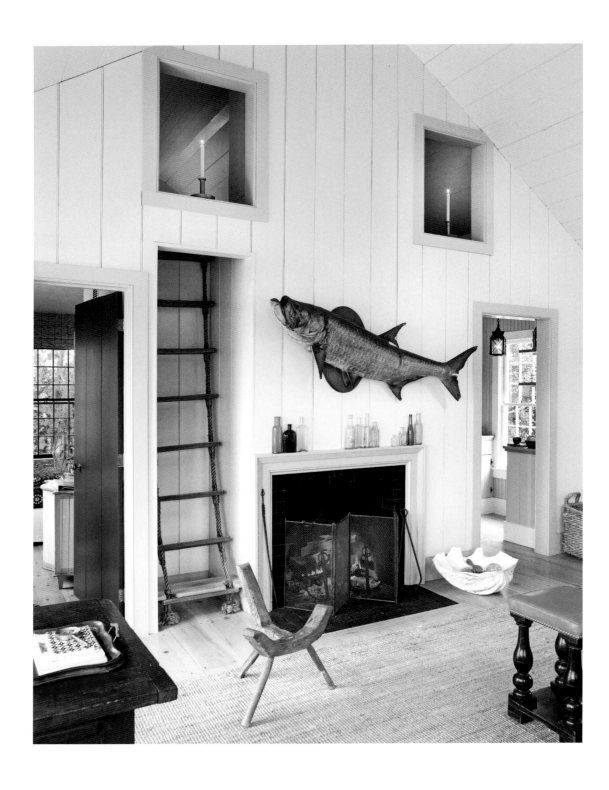

STEVEN GAMBREL

Above and opposite: I took a drive out to Sag Harbor, New York, to do a story on Steven Gambrel's renovated guest cottage, with photographer Thomas Loof in 2005 for *New York* magazine.

STEVEN GAMBREL BOUGHT THE HAUNTED HOUSE. It was the house at the intersection of two very quiet streets in Sag Harbor, a two-story colonial, larger than most of the other cottages in the neighborhood and barely visible through the impenetrable forest that had grown up to engulf it after decades of neglect. But it was a treasure, and its mystery made it all the more enticing. I had bicycled past it a hundred times, wondering why it had sat there for so long. Steven, whose career was still young, already showed his skill at recognizing a Cinderella property; he made his first of many brilliant real estate moves by buying the house and renovating it into a proud beauty.

Then, in 2002, Steven and his then partner, Chris Connor, bought the property right across the street, and this one was much more ambitious, as it had a main house and a small cottage in the back, where the land went down to the water. Again, the structures were forlorn and falling apart, "a crashing-down wreck," as Steven put it, plus the land was in bad shape, but it was another diamond in the rough, just waiting to be polished. When I visited the little fisherman's cottage that Steven renovated first and lived in on weekends and during the summer, while he was renovating the big house, I fell in love. My *coup de foudre* had everything to do with the way Steven enhanced

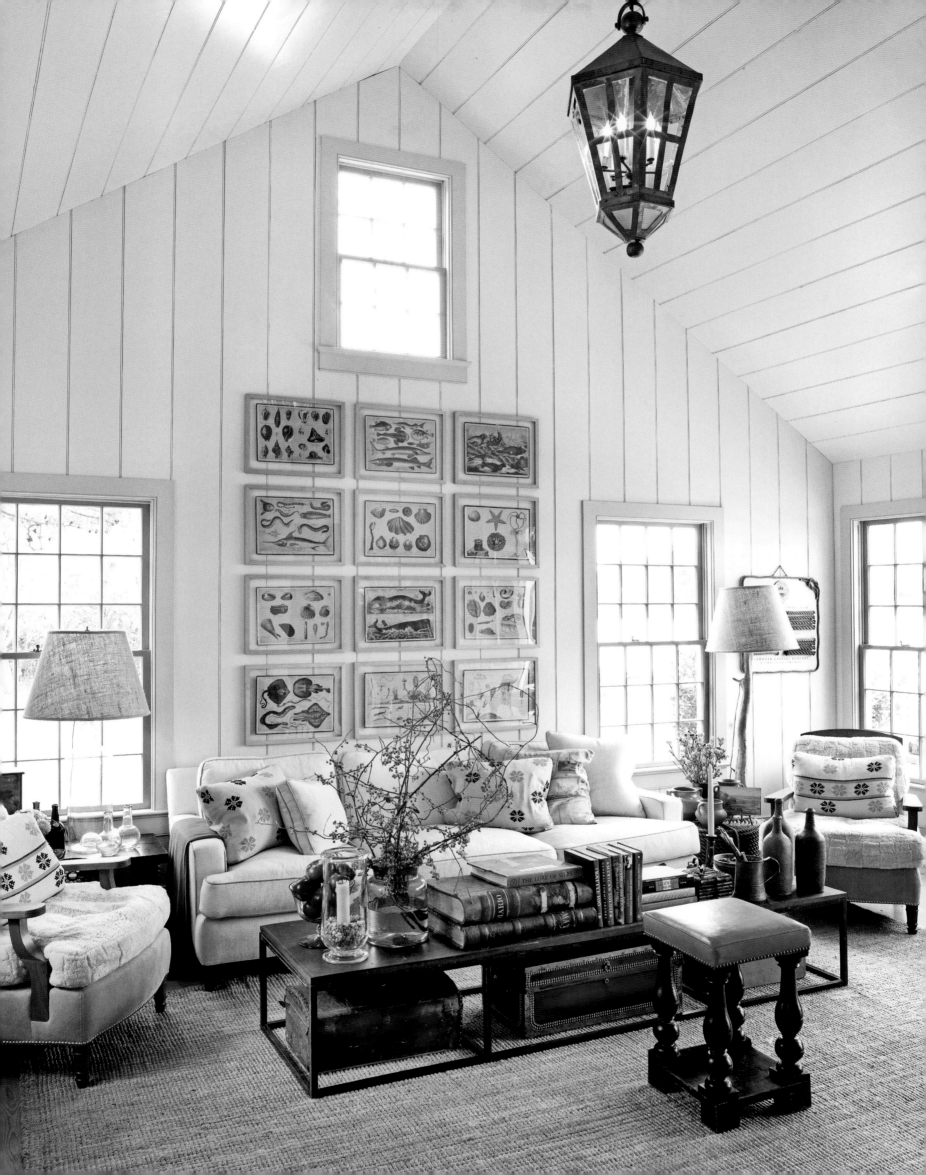

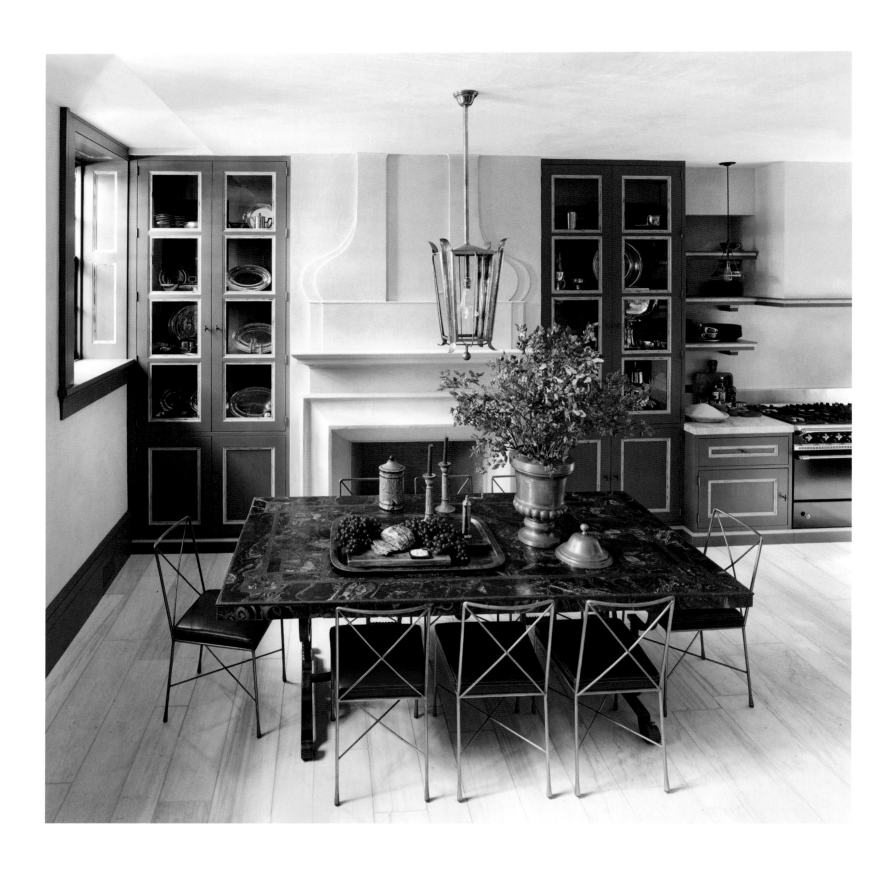

Above and opposite: In 2015, I went with photographer Annie Schlechter to Steven's New York City kitchen, which he described as "a mix of refined apothecary and updated London townhouse," for another story in *New York* magazine.

the modest character of this little cottage. It was a microcosm of what has become Steven's signature move: his ability to create a narrative that drives the design. In this case, Steven told me, "I dreamed of a fisherman's cottage modeled on a rum house in Nantucket." He also had in the back of his mind Sag Harbor's history as a whaling town, where sea captains had the big properties on Main Street, and fishermen had the less desirable land on the water, as it was colder and windier there. He implemented his love of big furniture in a small space. He tweaked and added architectural details that look like they have always been there; he put in a Dutch door, enlarged the original windows, and hung a vertical grid of pictures that he feels adds height to a small space. Steven also told me that what sealed the deal for him when he bought the property was that his labradoodle, Dash, was insanely happy racing down to the water during his first visit. "This was the first time for me that nature won over architecture."

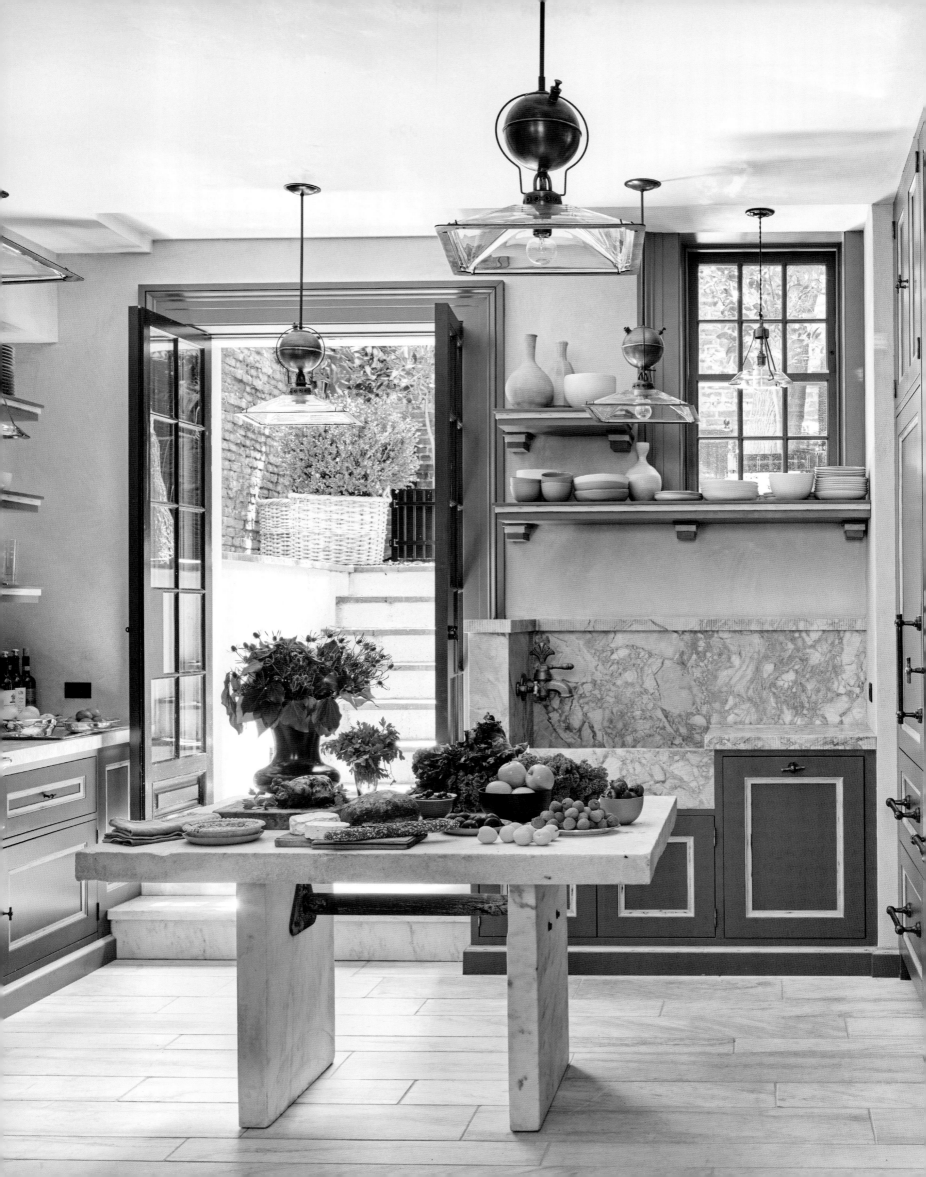

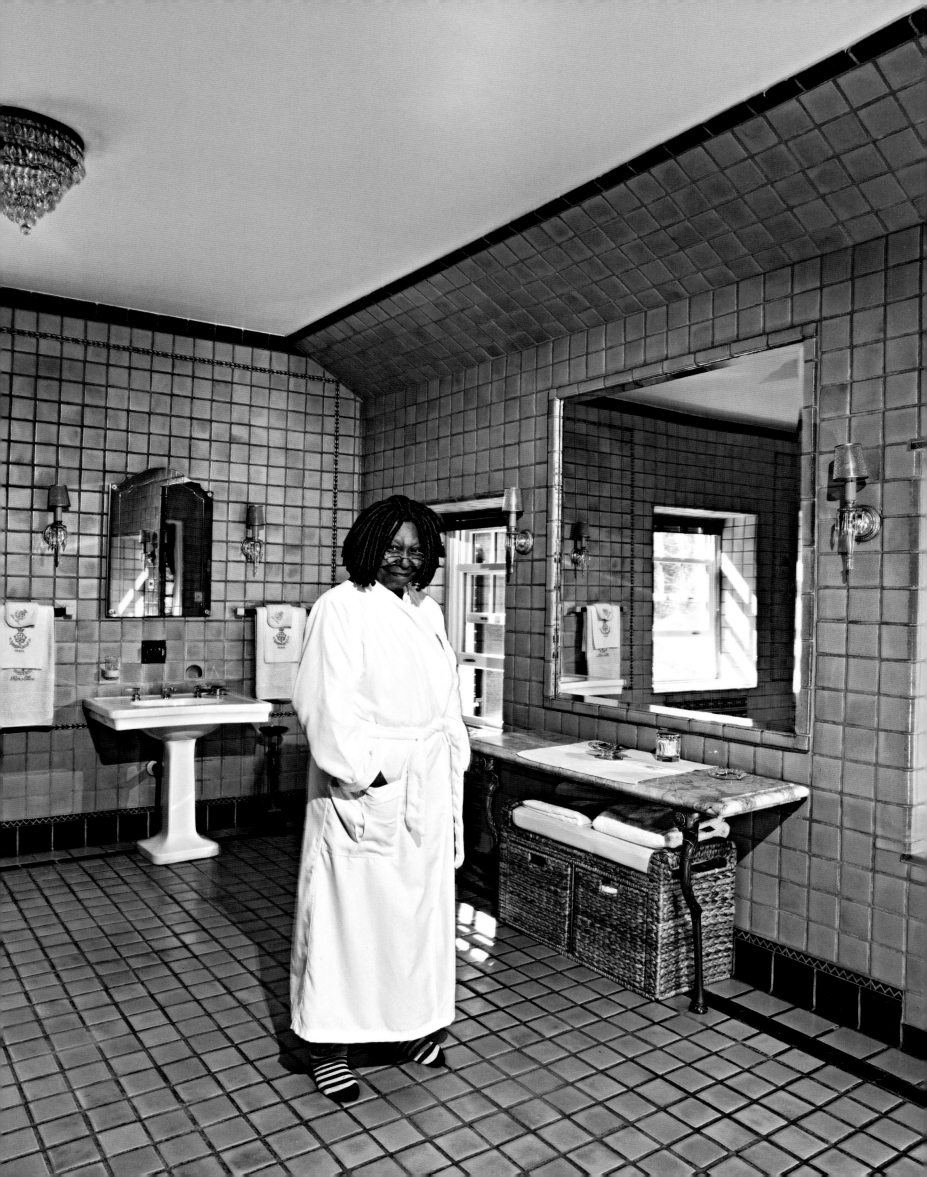

WHOOPI GOLDBERG

WHOOPI GOLDBERG HAS NEVER REALLY *NOT* BEEN FAMOUS, and she is one of the very few to have claimed all the prizes there are to win in her profession: Emmy, Oscar, Tony, and Golden Globe. But it was in 2007, after joining the hit TV show *The View*, that her life as a normal New Yorker living in a loft on Wooster Street became impossible. She recounted one tale that illustrated the point in her book *Is It Just Me? Or Is It Nuts Out There?* She was in a public restroom, inside a stall, and a woman stuck her hand under the divider, with a pen and paper, asking for an autograph.

"Suddenly, I was a bit besieged," Whoopi said gracefully about the incident, as she sat in the bohemian grandeur of her mansion's living room in 2012 for a *New York* magazine story. She was still wearing the bathrobe she had been photographed in inside her massive tiled bathroom. The fantastic portrait shows the humor and devil-may-care strength of this iconic artist. Whoopi explained that she felt the house belonged to her the minute she set foot in the eight-bedroom, 9,486-square-foot Georgian colonial, built in 1927 by a mogul she dubbed "the chicken king." We were in one of the first gated private communities in New Jersey, dotted with one glorious estate after another. The house was filled with a collector's finds: lots of paintings, porcelain, silver, loads of rare books, and a diverse array of furniture. It's glamorous all right, but, like its owner, it's down to earth and welcoming. "I am sort of eclectic," Whoopi said. "The periods kind of clash all over the house, which is great for me—it feels like you can hang out. It's formal, and yet it doesn't give a shit."

Whoopi's bedroom is anchored by a gigantic art nouveau mahogany bed, with art, from left, by Cristina Vergano, Andy Warhol, and Robert De Niro Sr.

DANIEL ROMUALDEZ

ARCHITECT AND INTERIOR DESIGNER Daniel Romualdez grew up
in a prominent family in the Philippines (Imelda Marcos is his
aunt). His father's wish was for him to become a banker. Happily,
that didn't happen. Daniel met his muse, Deeda Blair, the distin-
guished philanthropist and legendary style maker, in the mid-
1960s, when her husband, William McCormick Blair Jr., was the American
ambassador to the Philippines. Seeds of his future vocation were planted
when, as a student at Georgetown Prep in Maryland, Daniel spent time with
the Blairs in nearby Washington, DC, in their Billy Baldwin–decorated town
house. "What really impressed me," Daniel said, "was that there was something
sumptuous and grand about the things she had, but there was also something
so comfortable, so welcoming, so offhand. It wasn't like it was saying, 'Look
what a fancy chair I am,' it was more like, 'Come in and sit on me. I just happen
to be a Louis XVI.'" After graduating from Yale, where Vincent Scully's courses
on art and architecture permanently derailed his father's banking hopes,
Daniel received a master's degree in architecture from Columbia University
and worked brief stints for Thierry Despont and Robert A.M. Stern. He went
out on his own in 1993.

Today Daniel and his husband, investment banker Michael Meagher, live
in a magnificent New York apartment, in a 1906 building designed by architect
Charles Platt (they also have a cliff-side compound in Montauk; a modernist
house in Los Angeles; a house in Connecticut, which formerly belonged to Bill
Blass; and a retreat in Ibiza). When I did a story on the apartment for *Departures*
magazine in 2010, Daniel had just finished the renovation. The architectural
tweaking, which had called for melding two apartments, was so seamless that
the two Doric columns flanking the entrance to the living room looked as if Platt
himself had put them there. A coffered ceiling, moldings, and a wide frieze, all
new, went perfectly with Platt's original double-height leaded-glass windows.
In the midst of these grand architectural gestures stood objects that were the
very definition of eclecticism, namely, two Ikea sofas placed back to back, with
their legs cut down so that they almost sat on the floor, and a piece of furniture
I really coveted: a large pine table topped off with a giant slab of weathered
marble that came from the garage at Clarendon Court in Newport. It had sup-
posedly been the drafting table of Horace Trumbauer, the mansion's architect.
It's elements of surprise like these that lead to the most invigorating interiors.
Daniel, who knows a thing or two about diplomacy and entertaining, has
served up plenty of beauty, yet, in the manner of his mentor, never in a way that
would keep you at arm's length. Just the opposite: Everything welcomes you to
come in and enjoy the generosity of his friendship.

The living room in James Aguiar and Mark Haldeman's downsized apartment in Park Slope, Brooklyn, had shocking lime-green and lettuce walls accented with persimmon, photographed by Thomas Loof for *New York* magazine in 2013.

JAMES AGUIAR & MARK HALDEMAN

K ISMET? It kind of has to be, as how does it happen that a couple, perfectly happy in their Park Slope duplex, find a doppelganger apartment, only smaller, two buildings away, when they need to downsize? We photographed James Aguiar and Mark Haldeman's new living room in 2013 for *New York* magazine; it illustrated their exuberant aesthetic in all its eye-popping color. The defining qualities of these two self-proclaimed dandies begin with scholarship. Their vast knowledge of historical periods and of aesthetes like Cecil Beaton and Tony Duquette inform their design passions. But then there has to be an outlier sensibility that feasts on the unexpected, as persimmon and acid-green hues aren't the first colors that come to mind for an architecturally traditional living room festooned with moldings. Creative talents that they are, why not? If you believe, as I do, that one's style is a declaration of independence, then all bets are off when it comes to predicting what you will discover.

Eventually, kismet struck again, and James and Mark were able to move back to the duplex down the street, where they decided to go with a slightly more sophisticated color palette.

143

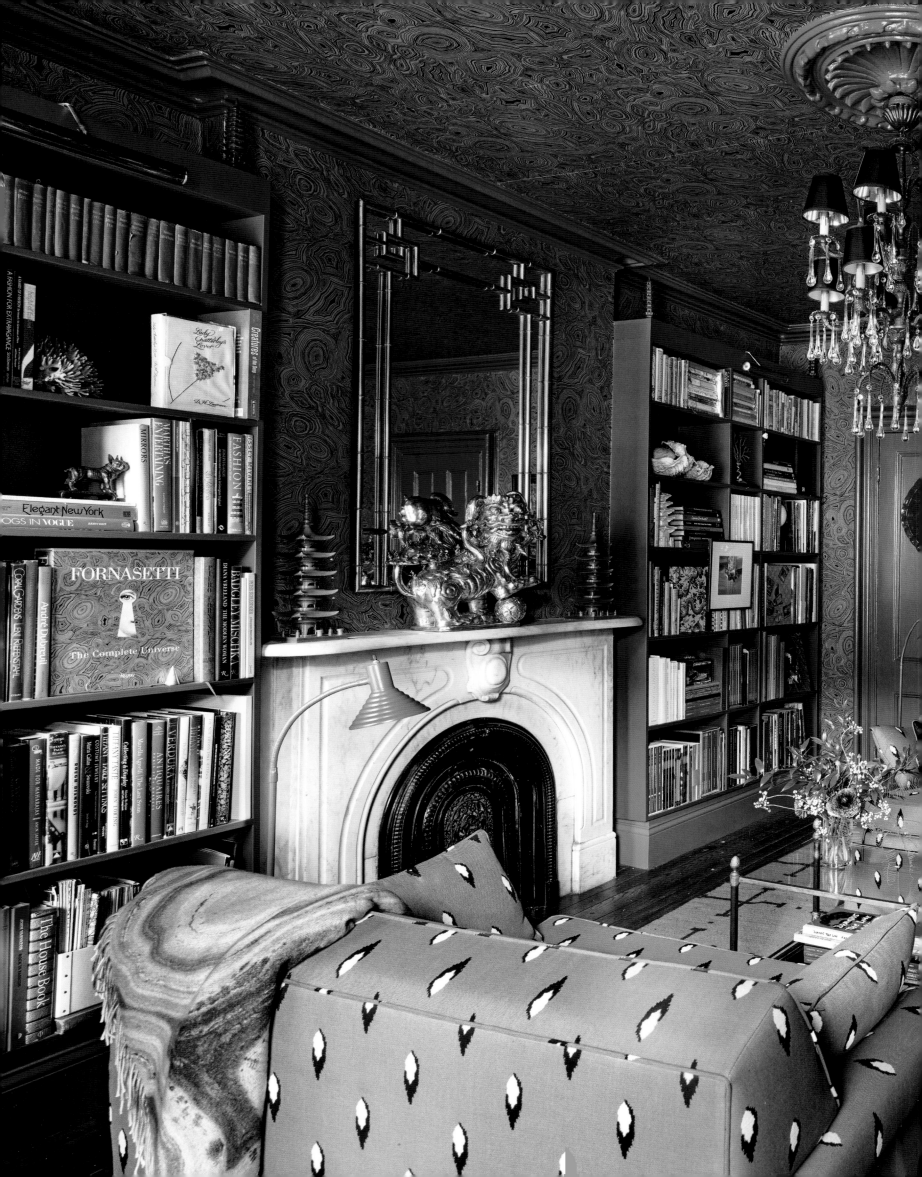

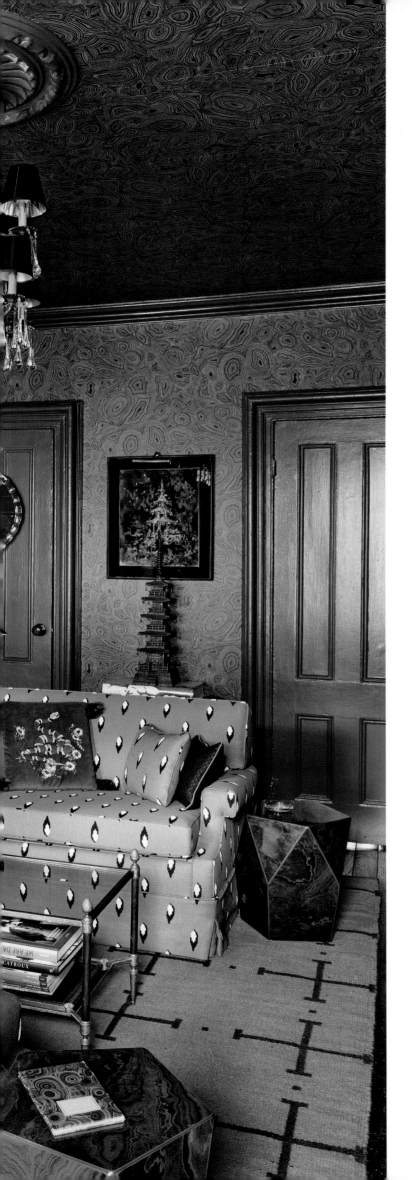

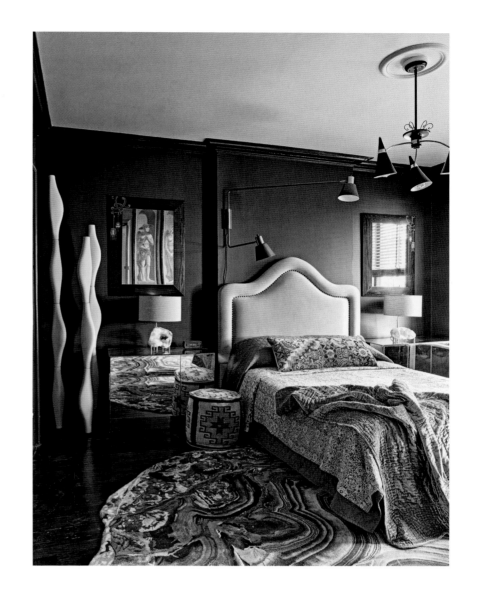

In 2017, James and Mark moved back into their original duplex apartment down the street, and photographer Annie Schlechter and I visited for *New York* magazine. There was a keyed-up sophistication in their decor. *Opposite:* The library, with malachite-patterned wallpaper and ermine tail–patterned upholstery. *Above:* The bedroom is painted in soothing dark tones.

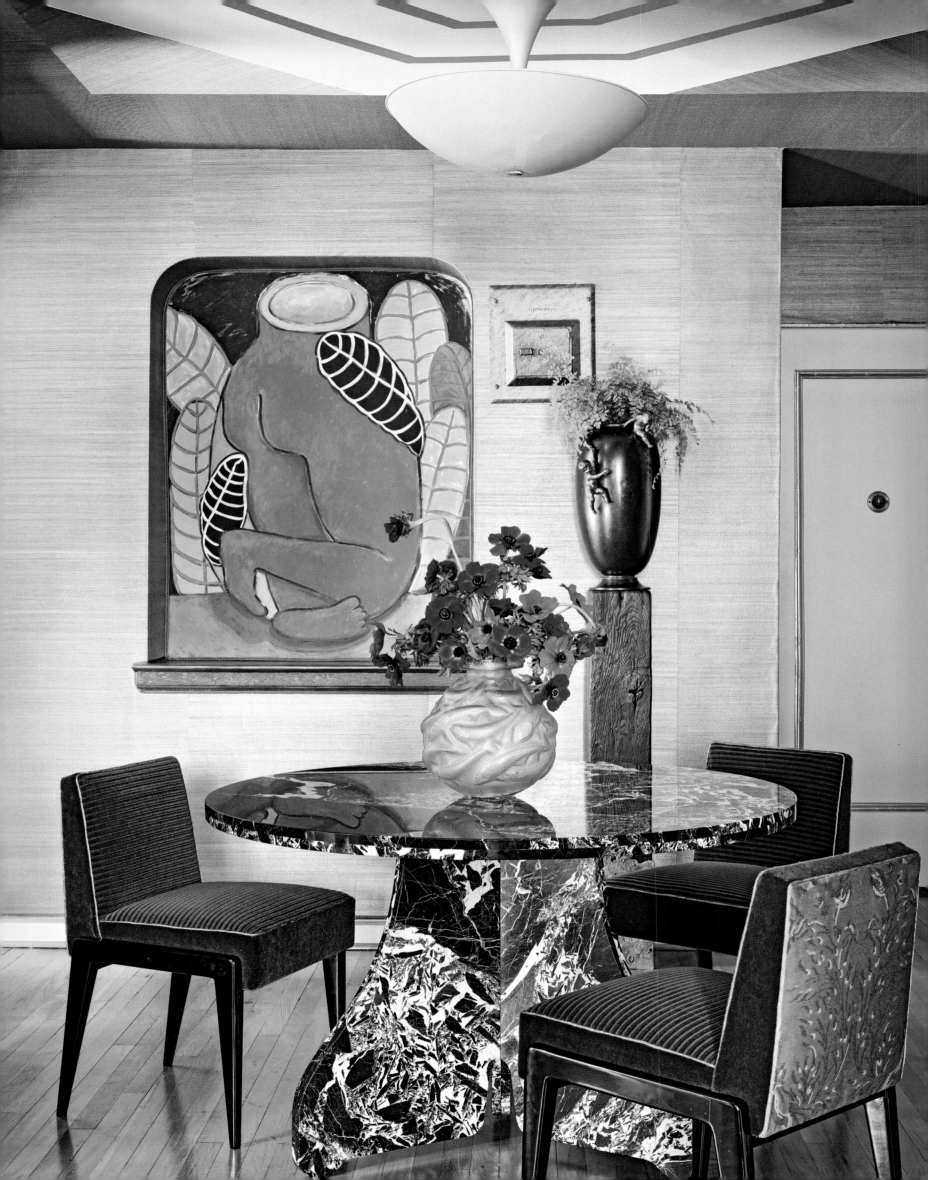

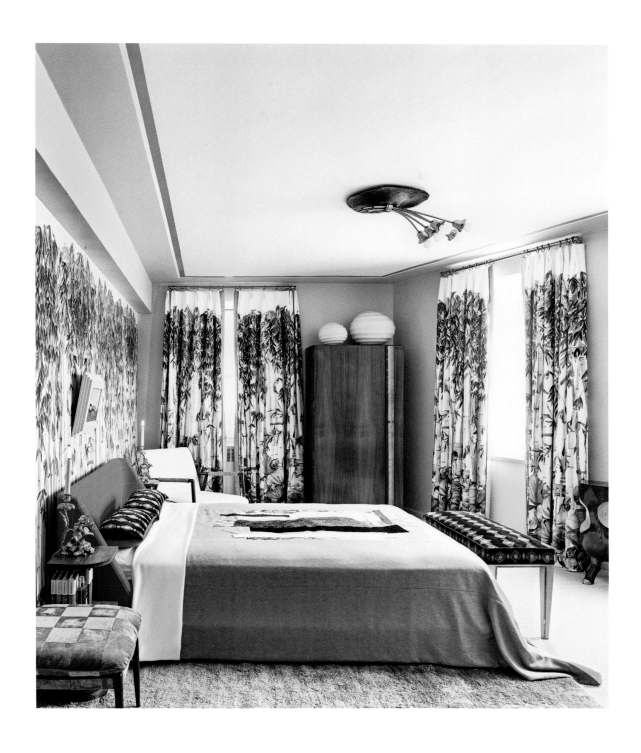

BRŒK FORSBLŒM

Opposite: Interior designer Brock Forsblom elevated
an ordinary 1950s rental apartment with design
coups. What do you do with a low ceiling? Paint
illusionistic moldings. *Above:* A bedroom wall is
upholstered in the same Voutsa fabric used for
the curtains, and a clunky armoire in the corner of the
room looks like a mahogany refrigerator. It all
works. Annie Schlechter photographed the apartment.

NTERIOR DESIGNER BROCK FORSBLOM is one of a new generation of profes-
sionals whose training—in Brock's case, working with high-end decorator
Tony Ingrao—has given them the resources and know-how to invent
their own visual vocabularies. When Brock and his boyfriend, Jeremy
Heimans, moved into a one-bedroom rental in a 1950s West Village
building in 2017, Brock embraced the opportunity to roll out his own divinely
skewed concoction of millennial-meets-uptown-lady decorating chic, and
I covered it for *New York* magazine. All of Brock's ideas were executed with the
utmost professionalism, down to the giant fringe he installed over a kitchen
shelf to mask stored pots and pans. He featured a clunky, brown oak cabinet
in the living room, which was totally foreign to what you might think he'd
have gravitated to, but he felt that "rooms need a little meat to keep them from
floating away." He disdained the idea of a more modern, spindly console in
its place. The dining room was a dramatic affair with a gold-painted ceiling
and a dominating black-and-white marble table of Brock's design. He paired
the table with fifties French chairs, flawlessly upholstered with gold brocade
on the backs and contrasting fabric on the seats. In the bedroom the walls,
like the curtains, were upholstered in hand-painted Voutsa fabric by Brock's
friend George Venson, and, again, there was a large piece of heavy furniture:
a wardrobe that looked like a massive mahogany refrigerator. Brock's confi-
dence in spinning formidable decorating adventures is a treat to behold.

Chapter Four

PILGRIMAGE

The pilgrimage is about obsession, tracing history, and paying tribute to people who are conduits to a lost time, or visionaries of the future.

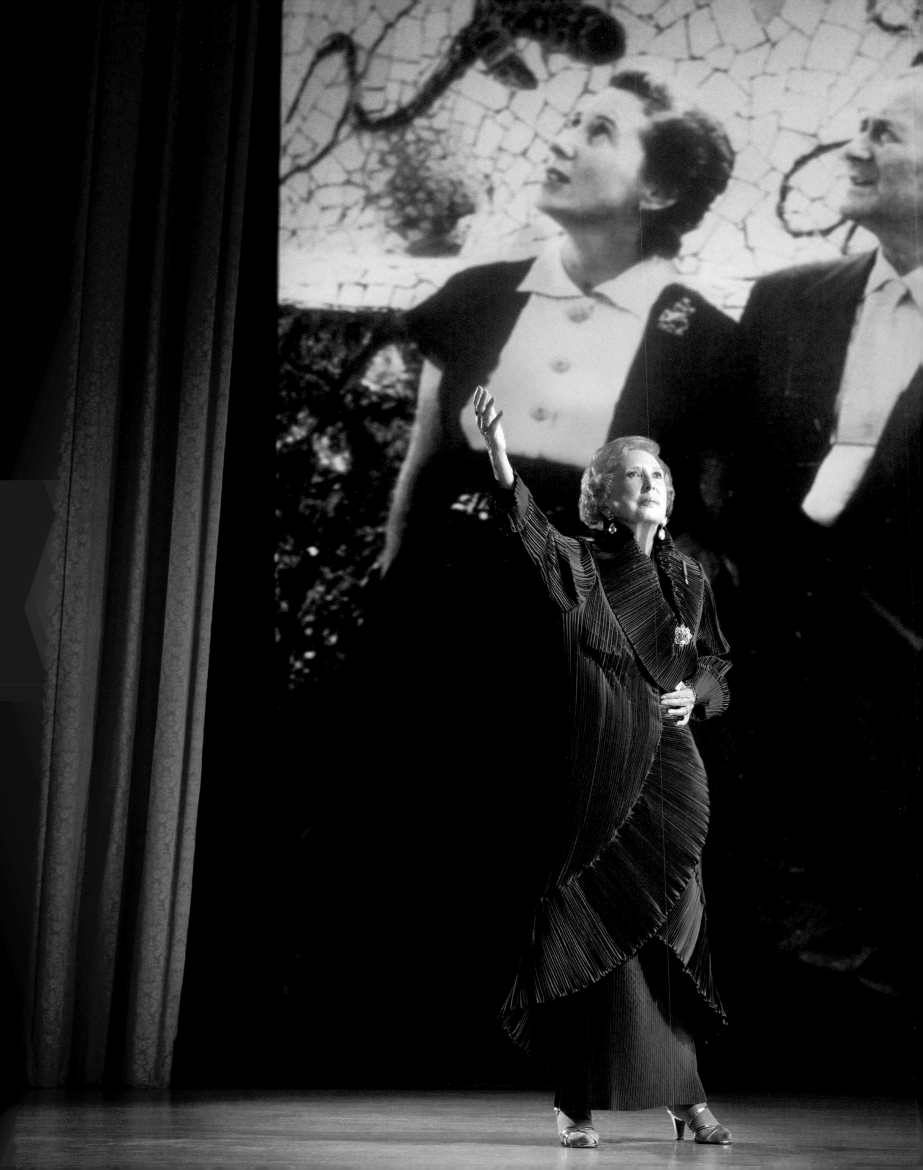

Rosamond Bernier took to the stage of the auditorium at the Metropolitan Museum of Art for this portrait by Eric Ogden for *House & Garden* in 2006. It was the eve of her retirement from her lecture series there, and she chose a photograph of herself with Joan Miró in Parc Güell taken by Brassaï in 1954 as the backdrop.

ROSAMOND BERNIER

A<small>RT AND CULTURAL HISTORIAN</small> Rosamond Bernier would float onto the stage of the Metropolitan Museum of Art's main auditorium wearing a long dress and sparkling earrings that illuminated her pale-rose skin. She was dressed to dazzle, and dazzle she did. From 1971 to 2007 she educated and enchanted us. I thought of Rosamond as "the Met's living treasure," who drew more than two hundred thousand people to her eight hundred lectures, which were always sold out. Her retirement was a sad day indeed. Rosamond did so many incredible things in her life; she founded the brilliant magazine *L'Oeil*, and her book *Matisse, Picasso, Miro—As I Knew Them* celebrated friends from her time in Paris. After years of going to her lectures, and as a fellow editor at *HG*, I got in touch with Rosamond in 2006 to see if I could visit her at the apartment she shared with her husband, John Russell, chief art critic at the *New York Times*. Rosamond was gracious and generous as ever and told me all about the art and her decision to paint the living-room walls black; all the better to see the resplendent painting by Howard Hodgkin and the Louise Bourgeois plaster cast of Rosamond's and John's hands and feet. A table by Maison Jansen bearing a slide projector and hundreds of slides stood in the middle of the black dining room. There were treasures everywhere you looked, but nothing could match the most elegant treasure sitting right there in the midst of it all.

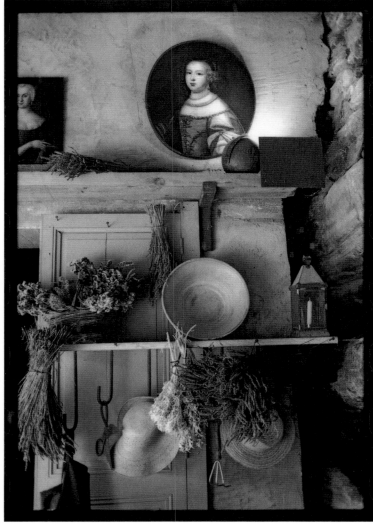

NICOLE DE VÉSIAN

Photographer Oberto Gili and I went to Nicole de
Vésian's house in Bonnieux, in the Luberon region of
France, while doing a story on Eli and Devon Zabar's
nearby house for *House & Garden* in 1995. *Above right
and opposite:* Her own house and garden, seen here,
were a revelation to me. *Above left:* Nicole is sitting
in her garden.

Eli and Devon Zabar had asked Nicole de Vésian to help them trans-
form a wonderful village property that they had purchased in the
Luberon, in the South of France, in 1995. It consisted of two derelict
buildings in a beautiful, neglected landscape. The great, diminutive
wonder woman Vésian lived nearby, in a medieval farmhouse that
she had restored. It offered proof that she would do a flawless renovation of
Eli and Devon's domain; in other words, it would look as if it had always been
like that. A former textile designer for Hermès (credit for the iconic knife-pleat
scarf goes to her), Nicole had a vision for the property that included lowering
grown trees into place by crane and, if she was not happy, having the crane
move them. For the Zabars, she insisted on using "wild stones," which she
foraged herself, for the fireplace in the library; she presented the mason with
three large slabs for the mantel after rejecting his elaborate plaster proposal.
During our interview for a story in *Harper's Bazaar* in 1995, she told me,
laughing, that the mason proclaimed her a "barbarian." We took a trip over
to Nicole's house, where one level of the garden terrace beneath her house
consisted of hundreds of lavender plants clipped into perfect spheres. There
were no flowers, only green plants of different textures. Her stone house had
indoor gravel paths, and the air was heavily scented. The romantic austerity
was enchanting and unique.

SARA & GERALD MURPHY

Opposite: One of the few champagne glasses left after F. Scott Fitzgerald broke the rest during a dinner at Villa America. The necklace belonged to Sara Murphy and was rumored to have been a gift from Pablo Picasso. Photograph by Laurie Lambrecht. *Above:* Honoria Murphy at the villa in the 1920s in a portrait by Man Ray and Gerald's painted sign for Villa America.

A T AN EVENT FOR THE RELAUNCH of the leather-goods store Mark Cross, I discovered that the original owner's son, Gerald Murphy, had lived with his wife, Sara, in a series of houses in East Hampton. That aroused my interest, as the Murphys were the models for F. Scott Fitzgerald's protagonists Dick and Nicole Diver in *Tender Is the Night*. I then found out that their daughter, Honoria, still lived in what was known as the Pink House, the only remaining building—the former garage and chauffeur's quarters—left of the Dunes, a property that had belonged to Sara's family. More questions elicited the information that Honoria had a garage full of furniture and bric-a-brac belonging to her parents from the family's time on the Riviera and before. I beelined out to East Hampton in 1992 to do a story for *HG* magazine. I was entranced by Honoria and her daughter, Laura Donnelly, and by their stories about Sara and Gerald, and the garage didn't disappoint.

An aesthete and brilliant artist, Gerald hadn't relished the idea of returning to the States to run the family business. He had taken his family to Paris in the 1920s when it was a hotbed of creative bohemianism, and he basked in the freedom of the artists' circle, which included Pablo Picasso and Jean Cocteau, that he found there. The Murphys bought an old villa in the South of France that they renovated. Villa America, as they called it, had a flat roof for sunbathing, and Sara entertained with inimitable style, setting the table with black lace tablecloths and pots of parsley in lieu of floral centerpieces. Gerald cleared the seaweed off the beach near the villa, and the Riviera as we know it was born. There were picnics with Picasso and his then wife, Olga, and dinner parties where F. Scott Fitzgerald flew into a drunken rage, throwing all

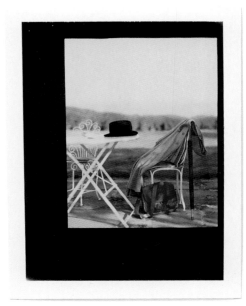

but a few of Sara's crystal champagne glasses off the terrace. The Depression changed everything, and in 1934 the Murphys returned to New York, and Gerald made the best of directing operations at Mark Cross. With his typical panache, he went on scouting trips around the world to find artisanal work. One of his finds was a battered donkey's feed bag. Honoria had saved it along with much of Sara and Gerald's bounty of furniture and decor. She explained that Gerald had spied it in use on a donkey during a trip to Greece, and he bought it on the spot from the perplexed farmer. That feed bag became the inspiration for Mark Cross's famous bucket bag, designed by Gerald.

Through Honoria I met her best friend, artist Fanny Brennan, and Fanny's husband, Francis, and even managed to collect some of Fanny's brilliant tiny paintings that were so coveted, they were spoken for before going up on the walls for a gallery show. Critic Calvin Tomkins described them in his foreword to Fanny's book, *Skyshades*: "The paintings of Fanny Brennan carry this kind of enchantment. They measure six square inches at their largest (some barely bigger than postage stamps), and the perfection of their making is such that each one is a miniature world, convincing in all its details. Convincing but unsettling." One day, after Francis had died, Fanny and I ate lunch at the small round table set for two in Fanny's new apartment. She had prepared cold artichokes for the first course. As we were chatting and consuming our artichokes, I noticed the way Fanny had neatly placed her discarded leaves, arranging them on her plate in a perfect circle around the heart. Fanny was a lady, and an artist in everything she did. Through Fanny I met her son, Dickie, and his family, and the circle was complete.

Above: Polaroids by Michael James O'Brien of Honoria (bottom right) and various items that belonged to Gerald, as well as a *verre églomisé* painting in the house. *Opposite:* The original feed bag that Gerald brought back from Greece, next to the bucket bag it inspired.

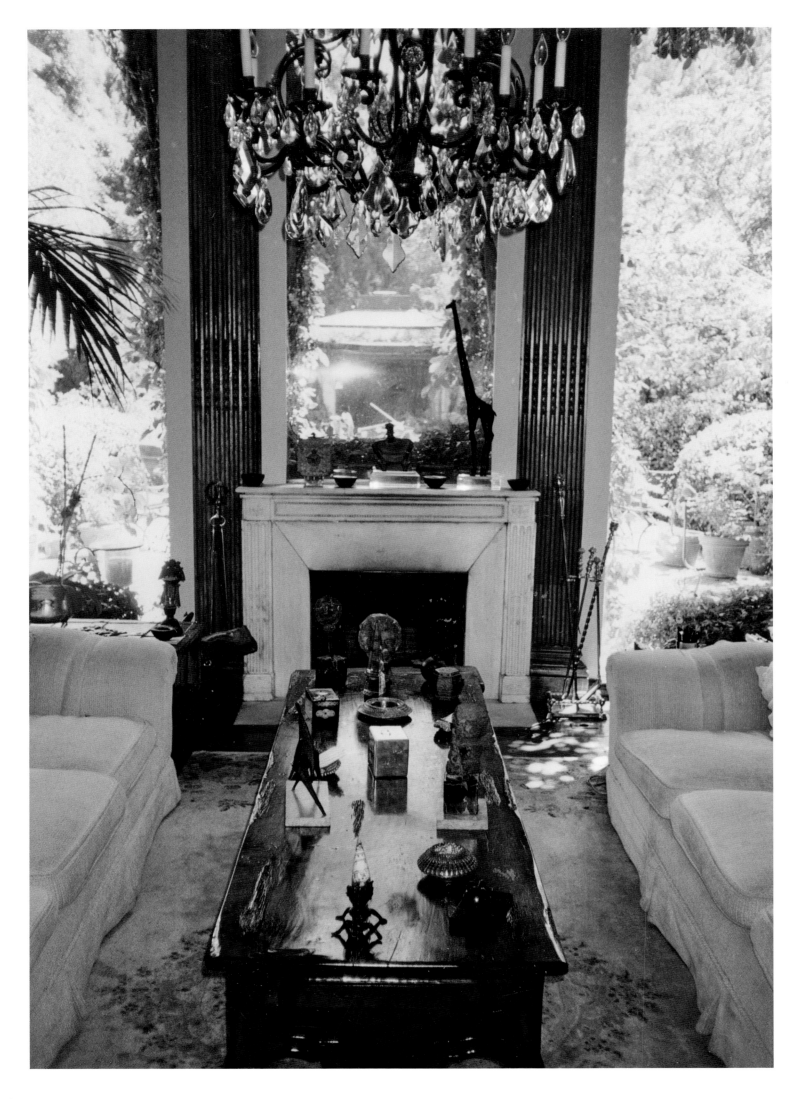

MAY I COME IN? —— PILGRIMAGE

ROBERT EVANS

A T THE CORE OF PRODUCER Robert Evans's 1994 autobiography, *The Kid Stays in the Picture,* is the story of Evans's love affair with Woodland, a house originally designed in 1942 by John Elgin Woolf for interior designer John Pendleton. The house defines Hollywood Regency style at its ripest, starting with its regal entrance featuring a rounded portico containing tall, black-lacquered double doors framed by slender columns. A spectacular fireplace flanked by glass walls is the first sight as you enter the living room; the views beyond are filled with the greenery of the garden. Slim Aarons's iconic 1960 photograph of the elliptical pool and the elegant pool house, where John Pendleton and his wife and their formally attired guests are being served by a white-jacketed butler, is the epitome of Hollywood glamour. When Evans first spied the house on a visit with actress Norma Shearer in 1957, it was not for sale, but he was determined to have it, and a decade later he rang the doorbell and made Pendleton, now a widower, an offer he didn't refuse. As the head of Paramount Pictures, Evans masterminded the renovation of the pool house by a team of studio craftsmen and builders, who turned it into a state-of-the-art screening room. Evans concluded some of his biggest deals in the house, where the rich and famous were entertained and where they paid court to the man who produced *Chinatown, The Godfather,* and *Love Story* and who married *Love Story*'s luminous star Ali McGraw.

In 2003 a horrendous fire turned the screening room into a charred ruin. Evans wanted to rebuild it, and, as fate would have it, Tatijana Shoan, his girlfriend at the time, suggested he meet me to advise him on architects. This was the house that I had wanted to experience more than anything. How was it possible that I was invited to go by Evans himself? My stay there was surreal. Evans was lovely if a bit eccentric. His bedroom served as his office, and his huge bed as his desk, and he would summon me and whoever else might be visiting to bedside conferences at all hours of the night. I went out to the Paramount lot where Evans still had an office and met production designers Robin Standefer and Stephen Alesch, who had been recommended to me by Elizabeth Kling and Skip Lievsay, two friends of my sister Stacy, who were A-list industry talents in editing and sound. Robin and Stephen had started a design firm in New York City the year before the fire, and were commuting back and forth. They took me around their set studio, and I thought, who better to rebuild Evans's screening room than these energetic, talented, lovely artisans! In the end they didn't do the job, but today their company, Roman and Williams, is one of the top firms in the country.

BABS SIMPSON

Above: Richard Rutledge photographed Babs in the
1950s with her pet bird Tikko.

BABS SIMPSON, NÉE DE MENOCAL, is magazine royalty, in a league of her own. She was the confidante of photographers, the editor who dressed Marilyn Monroe in the black Dior dress for one of her last sittings, with Bert Stern, for *Vogue*. I think of her as one of the grandes dames in my life, though she would scream if she knew I described her like that; she is much too down to earth and no-nonsense to put up with anything that might be taken as pretentious, which is the last thing in the world she is. Babs is a modern woman who has been granted a life of the best of everything: talent, love, career, and majestic environments, both inherited and by her own design. On Babs's ninetieth birthday, there were ninety long-stemmed white roses in an enormous vase on her coffee table. "Kenneth sent them to me," Babs said matter-of-factly, referring to the famous hairdresser who coiffed all the grandes dames in the city. She then added, "Isn't that lovely!" Babs had a pet bird that liked to perch on top of her head, above her trim chignon. Pity the man who tried to get close to Babs when that bird was around. Babs built a house in a field out in Amagansett and left the field wild, so her house felt like a glass boat in a tall grassy sea. Babs wore a string of fantastic pearls the first day I met her at *HG*, where she was a senior editor. I admit I was at first hooked on her pearls, but soon I was hooked on Babs.

Above: Architect Paul Lester Wiener designed a house for Babs in Amagansett where I used to visit her often. John Stewart photographed it for *Vogue* in 1963, where it was described as "a yacht in a meadow." *Below left:* A floor spot bounced light off a hanging reflector in the living room. *Right:* The fireplace took up an entire wall, and by the time I visited Babs had replaced the fish weather vane with a full-length Louise Nevelson sculpture.

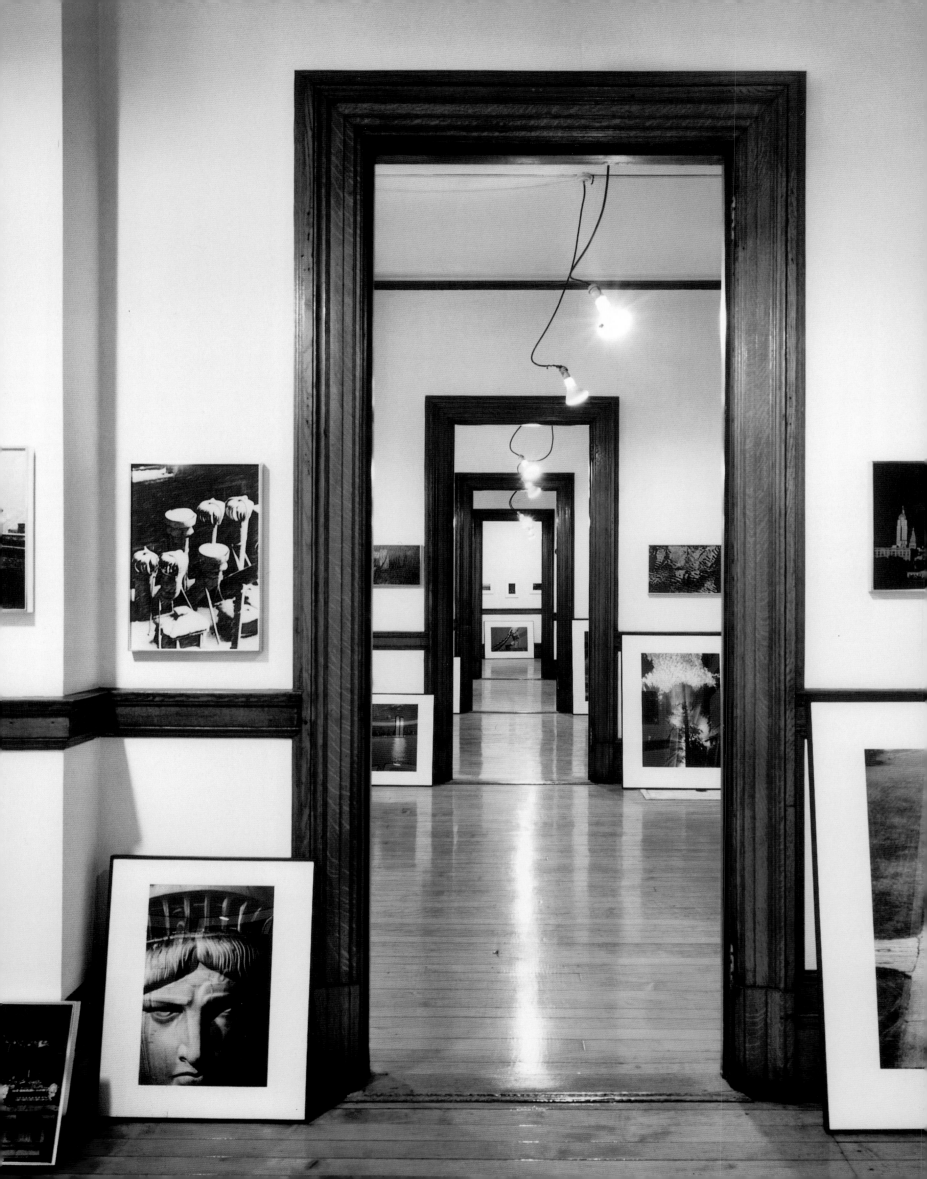

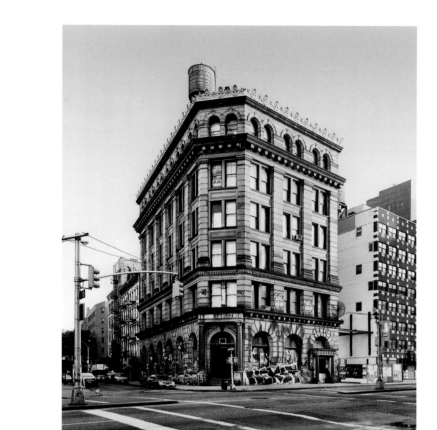

JAY MAISEL

I F YOU EVER PASSED THE TURN-OF-THE-CENTURY BEHEMOTH of a building scrawled with graffiti over every square inch of its lower half on the corner of the Bowery and Spring Street in New York City, you might have wondered what was going on inside. The structure appeared to be deserted, but there was one possibly decorative detail that spoke to someone doing something inside: The windows were covered in silver Mylar. It turned out that the photographer Jay Maisel lived there with his wife, Linda, and their daughter, Amanda. Maisel had purchased the thirty-five-thousand-square-foot building, which had seventy-two rooms, for $102,000 in 1966, when it was knee-deep in garbage; its glory days were then long gone. It had been built for the Germania Bank in 1898, at the height of the Gilded Age. Architect Robert Maynicke had left no design stone unturned. Opposite the walk-in vault in the basement he had provided a large changing room with a full-length mirror, so that when ladies came to retrieve their jewels for an evening out, they could see how they looked.

When I visited in 2008 for a story for *New York* magazine, the building's only elevator, a beauty of a copper cage that Maisel polished up religiously, was still in use. The top floor was where Maisel and his family lived. They kept the original kitchen, which had what appeared to be little updates from the time when chefs would provide meals for the bank's executives in their own dining room beyond, now the Maisel's living room. Maisel used the voluminous floors downstairs as galleries for his work, as teaching areas when he gave classes, and for a very particular kind of hoarding that went on in the long corridors off the former clerks' offices. He had lined the walls of the corridors with file cabinets, and on the surface of each one he had arranged a medley of objects in very specific configurations. The coins all lived in piles together, then there were machine parts and other objects, all arranged just so.

Maisel is a New York character, an urban pioneer who forged a path on the Bowery when it was so down and out that his parents cried when they saw the building after he bought it. "Every single thing that can come out of the human body has been left on my doorstep," he said. "But it was more disgusting than dangerous."

163

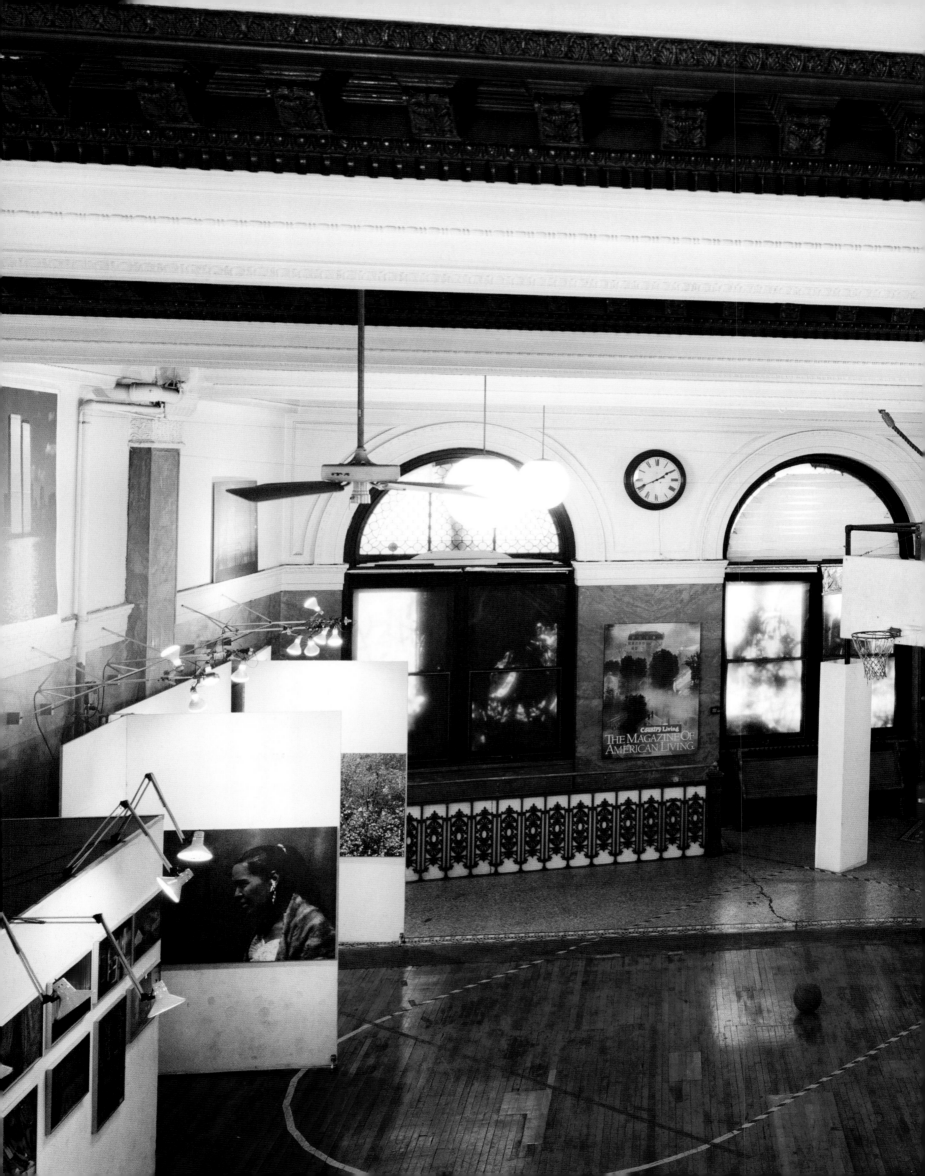

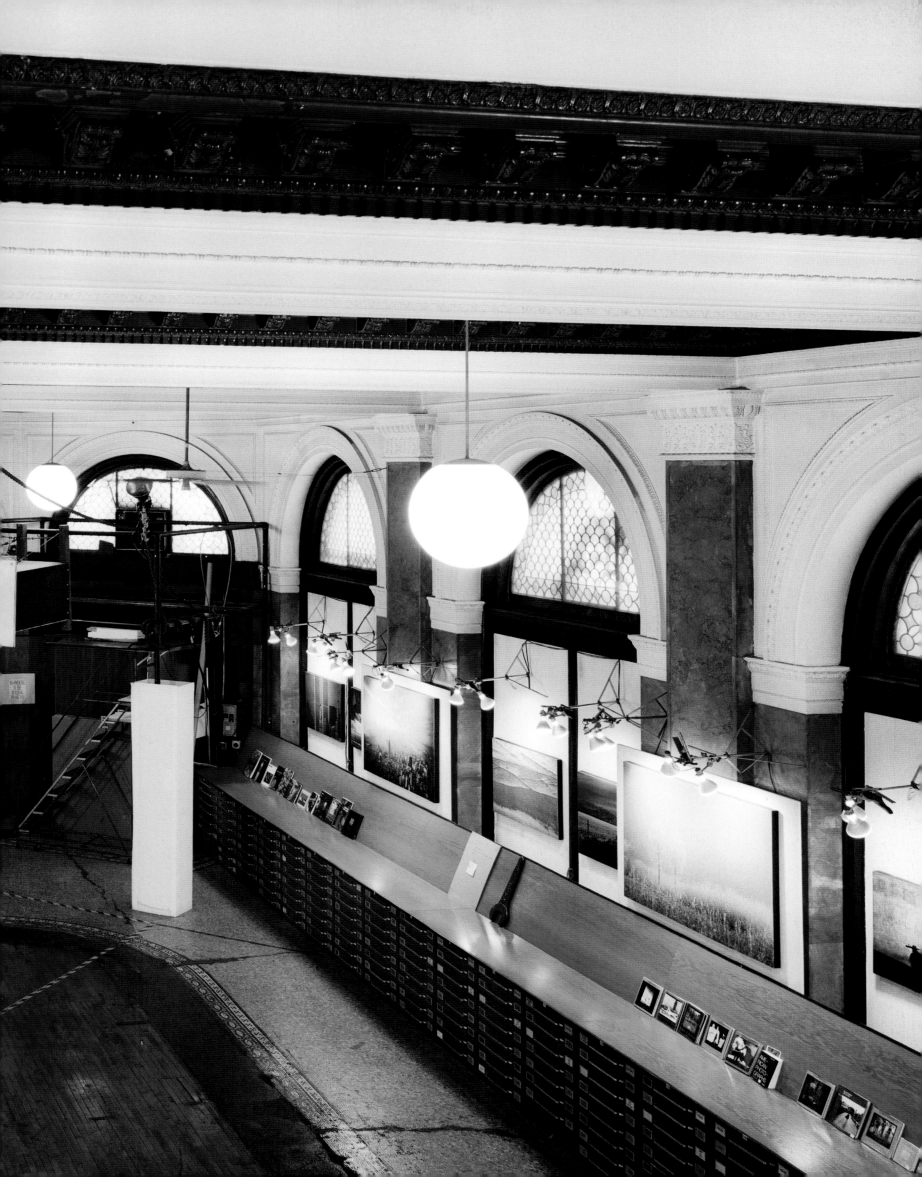

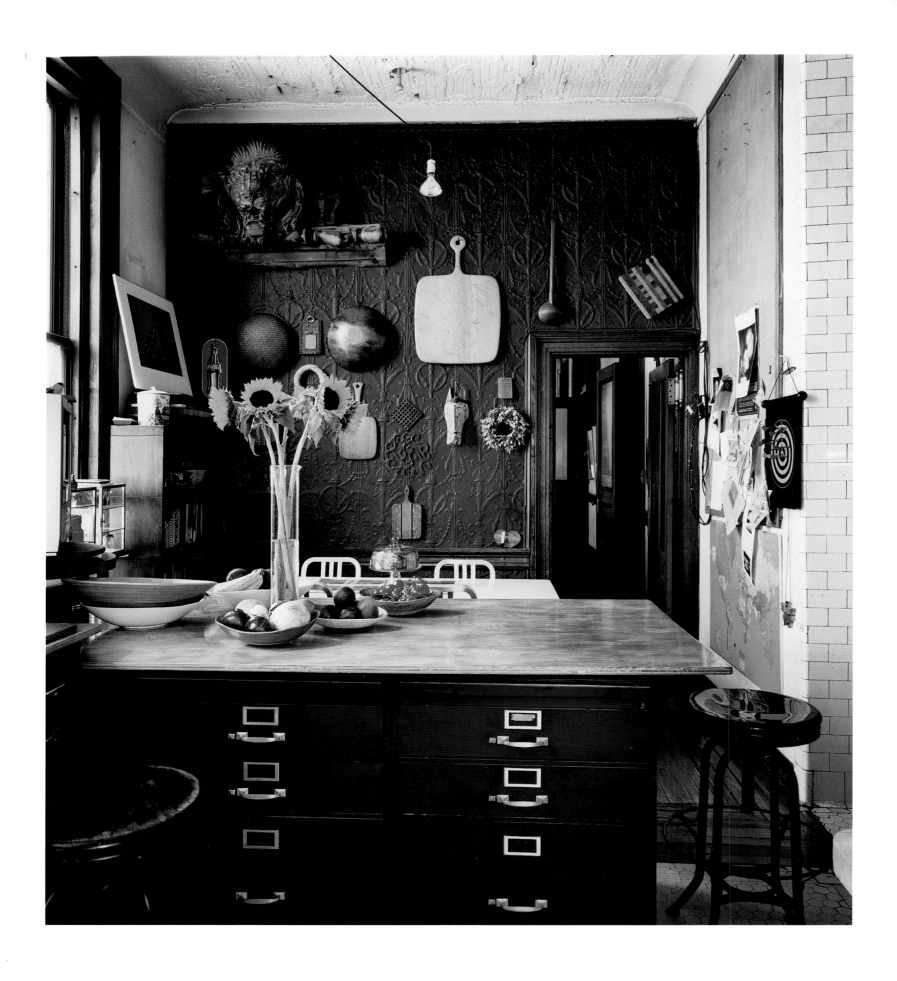

Above: The top-floor
kitchen at 190 Bowery.
Opposite: Jay had an
endless number of objects
squirreled away in the
building's empty offices.

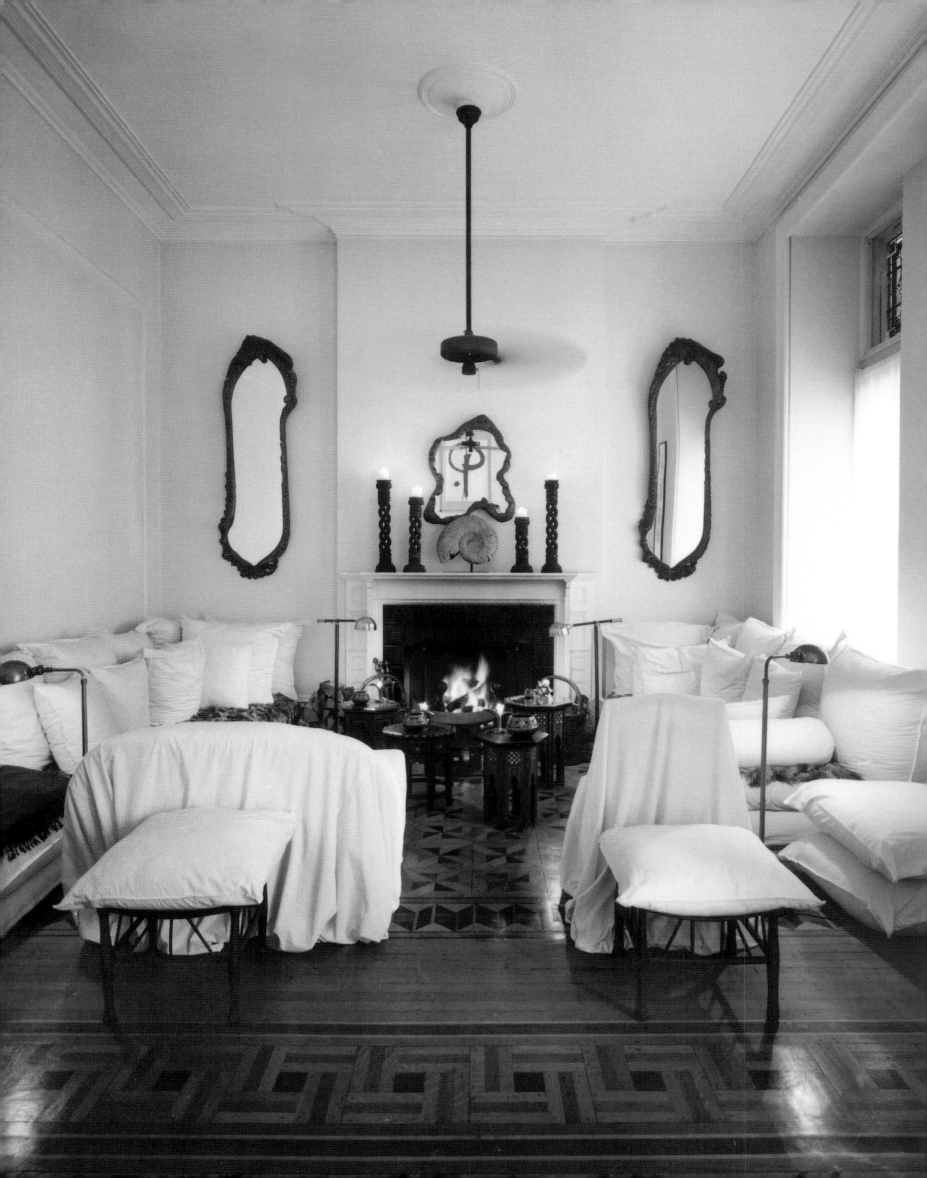

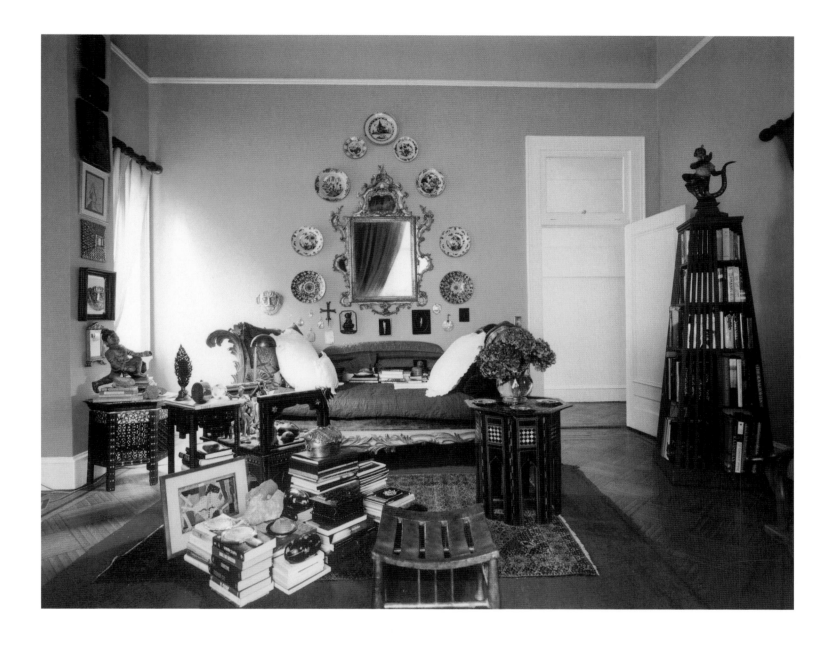

FERNANDO SANCHEZ

Opposite: Fernando Sanchez's living room had a grand effect with
simple gestures, including Gaudí mirrors flanking the fireplace and two
armchairs, found for twenty-six dollars by Maxime de la Falaise, that
Fernando covered in plain white sheets. *Above:* The bedroom was painted
in Mediterranean colors. The sleigh bed, from Jacques Grange, was
a copy of a bed designed for Florence Gould by Jean-Michel Frank.
Alexis de la Falaise, brother of Loulou and son of Maxime, designed the
pyramid bookcase. Dean Kaufman photographed the story.

FASHION DESIGNER FERNANDO SANCHEZ owned the last remaining
original apartment, one that had not been chopped up into mul-
tiple dwellings, in the historic Osborne building at 205 West Fifty-
Seventh Street in New York City. I visited him there in 2004, two
years before his death, for a story in *New York* magazine. It was a
divine relic in the building completed in 1885 by architect James Edward
Ware, designed to entice the moguls of the Gilded Age to consider forsak-
ing their mansions for the comforts and conveniences of apartment living.
The building's design proved that there had been no need to sacrifice the
luxuries of mansion living. Fernando's entrance hall had originally been
the apartment's ballroom, and Fernando paid tribute, furnishing it with a
huge, gilded rococo mirror over the fireplace. That room was always in use
as a modern version of its past incarnation, as Fernando entertained lavishly
and expansively. His parties were filled with friends from every part of the
globe and from all artistic professions: Peter Beard, Pierre Bergé, Kenneth Jay
Lane, Elsa Peretti, Yves Saint Laurent, Diana Vreeland, Andy Warhol, and so
many beautiful, exotic Europeans were draped over the living room's white
cushions that it was all you could do not to stare.

169

Opposite: Alexandre Noll's daughter Odile showed me his house and studio outside Paris in 2007. It was as he had left it, with all his tools, his works in progress, stacks of raw wood, and portfolios of drawings. It had been a dream of mine to visit and I took lots of photographs that day. *Right:* My own Noll box found at Pierre Passbon's Paris gallery many years ago.

ALEXANDRE NOLL

GALLERIST CRISTINA GRAJALES is something of a sorceress who has activated my design-hunting-obsession gene more than once. I was really struck by a lightning bolt when she introduced me to the work of French furniture artist and sculptor Alexandre Noll. Noll made wood look as sensuous and smooth as modeled clay. He had to be channeling some sort of mystical understanding of the life within trees and the nature of wood to be able to conjure such a unique choreography between maker and materials. Noll died in 1970, but his studio outside Paris, the source of his alchemy, was intact, and I had to visit. Cristina made that happen in 2007. She introduced me to Noll's daughter, Odile, who was still living at the family house, with its two outbuildings containing his studio and woodshop and a small shed where he had stored finished pieces and flat art. I stood in Noll's cobweb-filled studio, with all his tools and huge pieces of wood lying in wait for a transformation that would never come. It was so still. I found a trove of finished, polished pieces, as smooth as satin, in rows on the shelves of his little studio. It was a secret Aladdin's cave filled with the immeasurable bounty of a genius who long before his death had retired from the world to be with his wood and his family.

ADELAIDE DE MENIL

Above and opposite: A forest of trees fills the living room of Adelaide de Menil's New York apartment. The coffee table is an African wooden bed, and a Calder mobile hangs above. *Overleaf:* The dining room: The "big item here," according to Adelaide, is imported French stone, grounding the apartment in Spartan luxuriousness. Dean Kaufman photographed her elegant aerie.

A SPECTACULAR DOUBLE-HEIGHT DUPLEX APARTMENT in a historic studio building on Central Park South was the setting for a memorable dinner party, where we entered through what could have been mistaken for an outdoor garden, a forest of illuminated trees that created a mysterious ambience. The floors were big, worn slabs of old French stone, and there was a blue-and-white Hawaiian tapa cloth on the wall of the dining room. The furnishings had been cleared out to make room for dining tables.

Years later, in 2016, on a visit to the apartment and its owner, collector, photographer, and philanthropist Adelaide de Menil, for a story in *New York* magazine, I relished the perfection of the spare furnishings. The dining room contained one Shaker rocking chair balanced on its two back legs, a Diego Giacometti standing lamp, and a Shaker dining table surrounded by directors' chairs. The living room, still filled with its forest of potted trees, had three pristine Windsor chairs, a John Chamberlain sculpture, and a low African wooden bed used as a coffee table; a red Calder mobile turned slowly above it all.

The walls of the small entrance foyer were covered in brown felt the color of a fawn's coat; even the light switch was covered in felt. Beyond, a soft François-Xavier Lalanne serpent sculpture lay coiled in the corner, and there were two glass cases protecting a flock of exotic stuffed birds that had originally been ornaments on a fireplace screen. The serene atmosphere was defined by the authority of knowing when to stop and declare visual détente.

173

The Hercules Gallery
in the Hôtel Lambert,
Paris, photographed by
Christina Vervitsioti.

BARON ALEXIS DE REDÉ

SATURDAY, JULY 3, 2004. That was the day Baron Alexis de Redé had given me for an interview in his private apartment at the Hôtel Lambert in Paris. I had been obsessed with the legendary seventeenth-century house, built for the Lambert family by Louis XIV's architect Louis Le Vau and his designer Charles Le Brun, ever since spying it on a school trip to Paris when I was sixteen. It was one of my last interviews for *Tony Duquette*, the book I had been working on for the past decade with Hutton Wilkinson. Hutton had given me a number to call for the baron, but I couldn't have imagined that Redé would pick up the phone himself. I couldn't be one second late, but I couldn't be early, either. I had to arrive at six o'clock on the dot. I felt as if I were going to have an audience with the king, as Redé, whom Nancy Mitford proclaimed "the best host in all Europe," was going to host me! It was like a dream. I had rehearsed the walk from where I was staying, in the Marais, to the Hôtel Lambert twice. When the day came, I walked slowly over the Pont de Sully, breathing deeply, my heart thundering in my chest, thinking about the questions I was going to ask. I was a good forty-five minutes early, so, to kill time, I went into the nearby church of Saint-Louis-en-l'Île. The first thing I saw in the dark interior was a thick altar candle illuminated by a shaft of sunlight. I walked over, mesmerized by the slow dance of free-floating particles in the air. The flame seemed to hold a silent message. Then it was time to go.

I rang the bell at the gate. The baron's butler buzzed me in and watched me walk across the courtyard where so many horses and carriages had smoothed the stones over the centuries. He ushered me into a side door, not the grand entrance, and led me to a tiny elevator. He then escorted me through a long, narrow hallway, where the walls were hung with rows and rows of photographs I was dying to inspect. The butler led me to a small room where I found the baron sitting in a large armchair with a crisp white linen cloth smoothed over the top, should he wish to rest his head. He was immaculately attired in a three-piece suit. I was shocked to see how unwell he was and understood that getting dressed for this interview must have been very difficult and taken a very long time. He didn't move at all as I introduced myself, but his eyes followed me as I took the seat the butler offered opposite him. I was sitting near a window, where I felt like a specimen under glass. I started to ask my questions but quickly realized that his impeccable courtly manners could not mask how ill he was. I concluded our talk after about ten minutes.

It was then that the baron asked if I would like to see the house. I answered that it would be my honor to do so, thanked him, and bade him goodbye. The butler took me down to the legendary rooms and stood at the door of each one while I walked across the ancient polished parquet, making the same creaking sound that thousands of feet, including Voltaire's and Chopin's, had made before me. I could feel my camera in my pocket, and I wanted more than anything to take it out and photograph every single thing I saw, but I couldn't bring myself to ask the butler for permission. It would be so grossly American of me. I would have to remember the crystal drops of the huge candelabra in the Hercules Gallery. I would have to rely on memory to stop time in my head. After I had seen every room, the butler led me down the famous grand staircase and then out through the main entrance. I crossed the courtyard, wanting so much to look back, but I kept on going. Ten days later, in the very same church where I had watched the sun pouring over the candle's flame, a private mass was held for Baron de Redé, who had died the previous Thursday.

CORNELIA GUEST

Above: I made a pilgrimage with Thomas Loof to do a story on Cornelia Guest and her family home, Templeton. Photographs and mementos were in evidence everywhere you looked. This photograph shows a baby Cornelia in the arms of her mother, C.Z. Guest. *Opposite:* The walls and banquette in the cozy library at Templeton were upholstered in Brunschwig & Fils paisley fabric that spoke to years of family life and entertaining.

IT'S NO WONDER THAT CORNELIA GUEST vacillated for years between selling and keeping Templeton, the estate she inherited from her mother, C. Z. Guest, who died in 2003. Templeton, the storied twelve-thousand-square foot, twenty-eight-room Georgian-style red-brick mansion, sat on fifteen and a half verdant acres in Old Westbury, on the fabled gold coast of Long Island. Her father, Winston, an heir to the Phipps steel fortune and second cousin of Winston Churchill, was an ace polo player. C.Z. (born Lucy Douglas Cochrane) was a society beauty and counted Cecil Beaton, Truman Capote, and the Duke and Duchess of Windsor (Cornelia's godparents) as her close friends. She was also an accomplished horsewoman and gardener. The couple had two children, Alexander and Cornelia; Cornelia was something of a wild child in her youth, earning the title "Debutante of the Year" in 1982 as she was squired around town by Andy Warhol before waiting press photographers. Had there been social media back in the days when she was splashed across every gossip and society page, she would no doubt have rivaled the Kardashians in followers. But Cornelia never let the glamour sidetrack her, and she has made serious businesses of the things she holds dear: animals, animal rights, and healthy eating. She had a cruelty-free handbag and accessories line and a vegan catering company; now, in her new life in upstate New York, she runs an animal-rescue organization. When she did finally sell Templeton in 2014, a year after I visited for a story for *New York* magazine, she took her menagerie of eight dogs, four cats, a tortoise, and a donkey with her, but carried no regrets for the place that had so many memories locked within its walls.

179

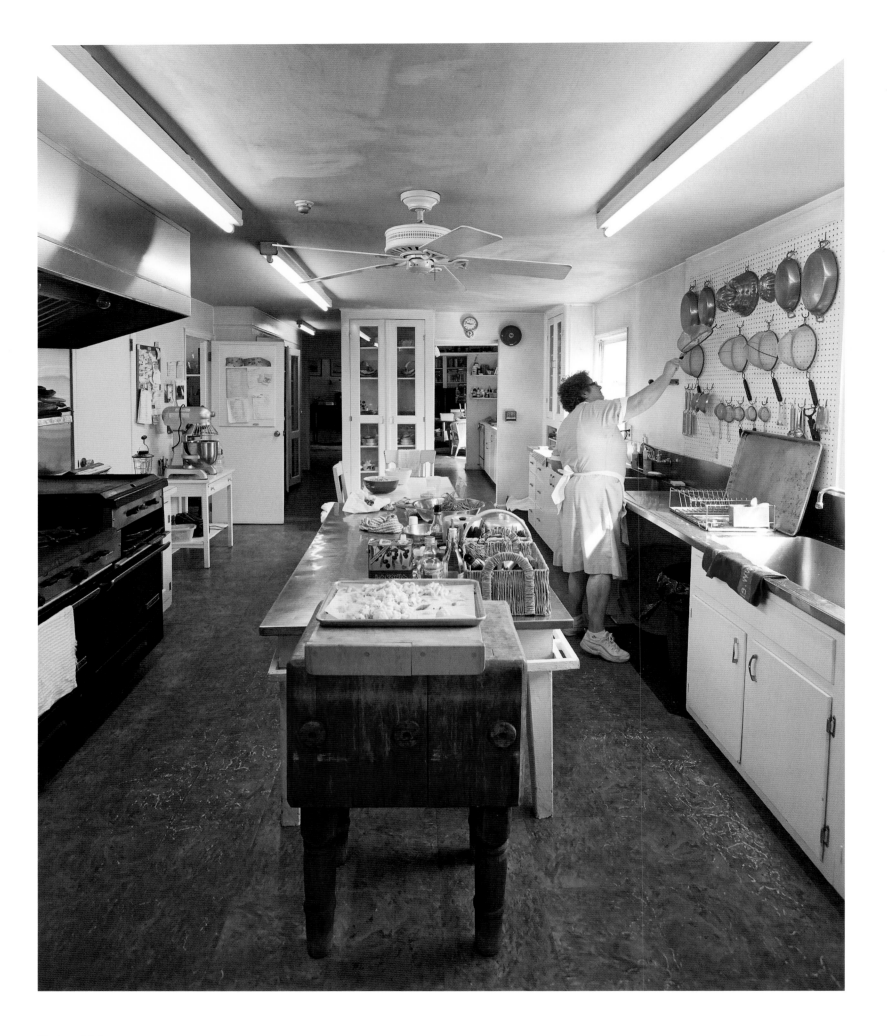

The large kitchen was
always buzzing with staff
preparing an endless
procession of delicious meals.

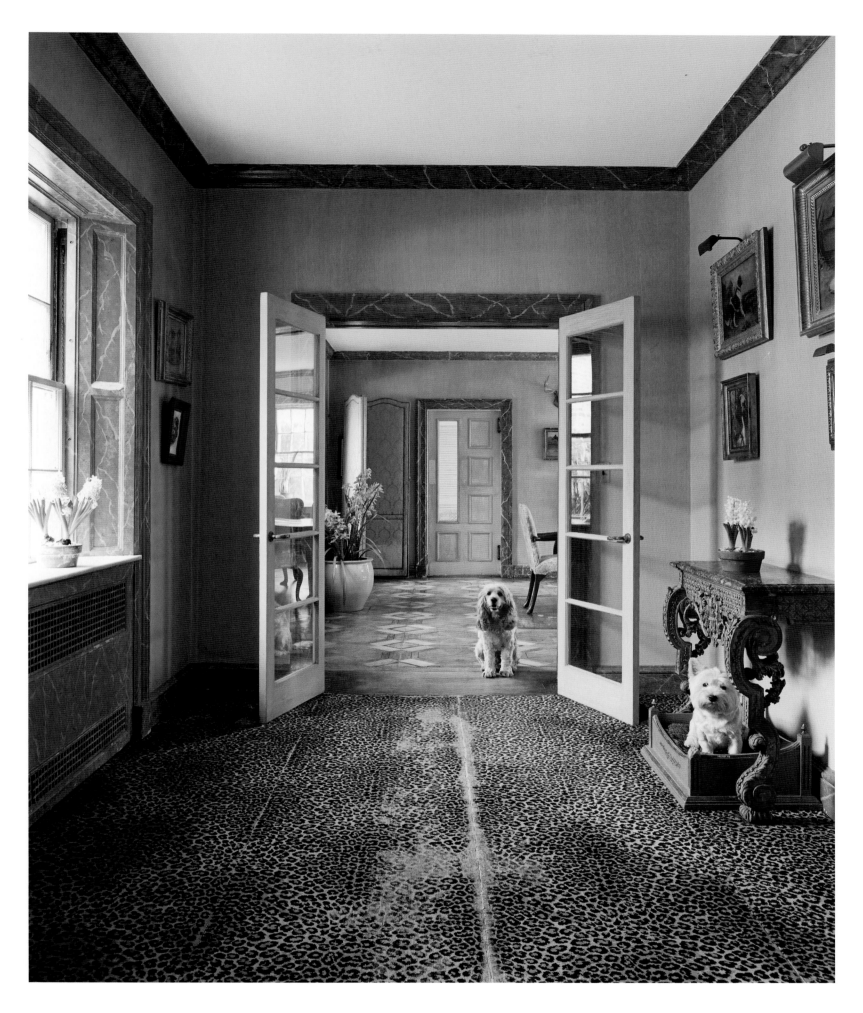

A worn leopard-print carpet
led to the dining room. Olive
loved her dog bed under one of
a pair of regence consoles.
The wood trim was faux marble.

181

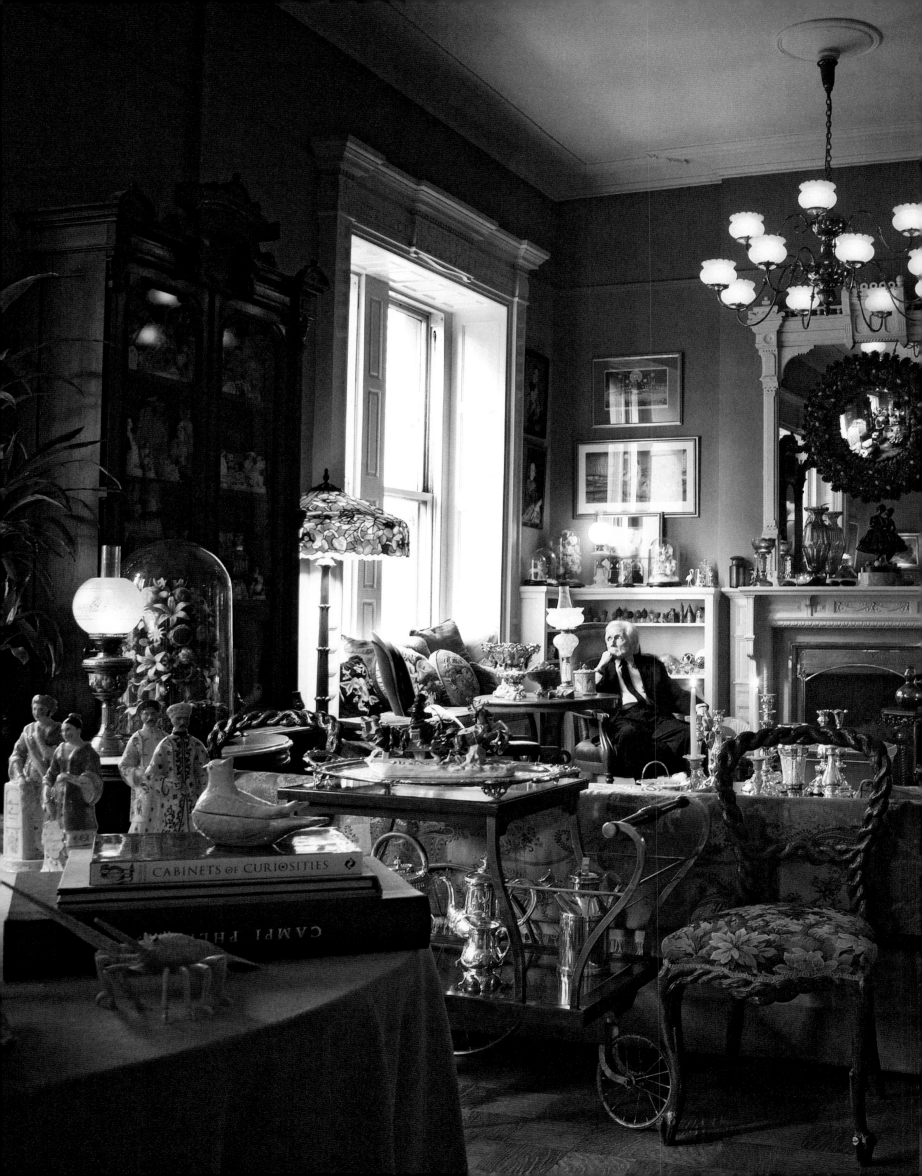

Gray Foy, pictured here in 2007 in his living room at the Osborne, is engulfed by the antiques and other treasures that he collected over a lifetime with his partner, Leo Lerman. He was photographed by Erwin Olaf. *Overleaf:* That same room, photographed by Howie Guja in 2016, with completely different decor to suit the tastes of a family with young children.

GRAY FOY

"DO YOU REMEMBER ME?" I asked Gray Foy on the telephone, hoping to reconnect with the man I first met in childhood and had always adored. He had been as handsome as a lion, with his mane of silver-white hair, and he wore a cape that spoke to his swashbuckling elegance, though he would have raised an eyebrow at you if you told him that. Leo and Gray, they were never without each other when I was growing up. Leo Lerman was a collector of artists and of anyone who had talent and was in the arts, and a legend and mainstay at Condé Nast, where he served as editor in chief of *Vanity Fair*, as features editor at *Vogue*, and, toward the end of his life, as editor at large for everything. Gray was an extraordinary artist who worked in pencil.

That phone call was followed by subsequent visits. Joel Kaye, Gray's close friend, had moved in to live with him at the Osborne apartment building on West Fifty-Seventh Street following Leo's death in 1994. Joel went on to make Gray's life possible. He kept the home fires burning with home-cooked meals served beautifully in the formal dining room, where dinners were anything but formal. Joel set a magnificent table, and the apartment was always ablaze with the glow of candles illuminating the paintings and silver and objects everywhere you looked.

Gray died in 2014, and the apartment was sold. Eventually I was contacted by Fogarty Finger Architects, who had renovated it for the young family who now lived there. At first I was a bit reluctant to go back, but when I did, I realized that the dramatic change in the decor that was so beautifully done for the new owners was exactly what should have happened, and I did a story on it for *New York* magazine in 2016. The apartment that had held so much happiness and love with Leo and Gray and Joel and all their friends now served to contain another chapter of love, family, and friendship. Nothing can ever stay the same.

183

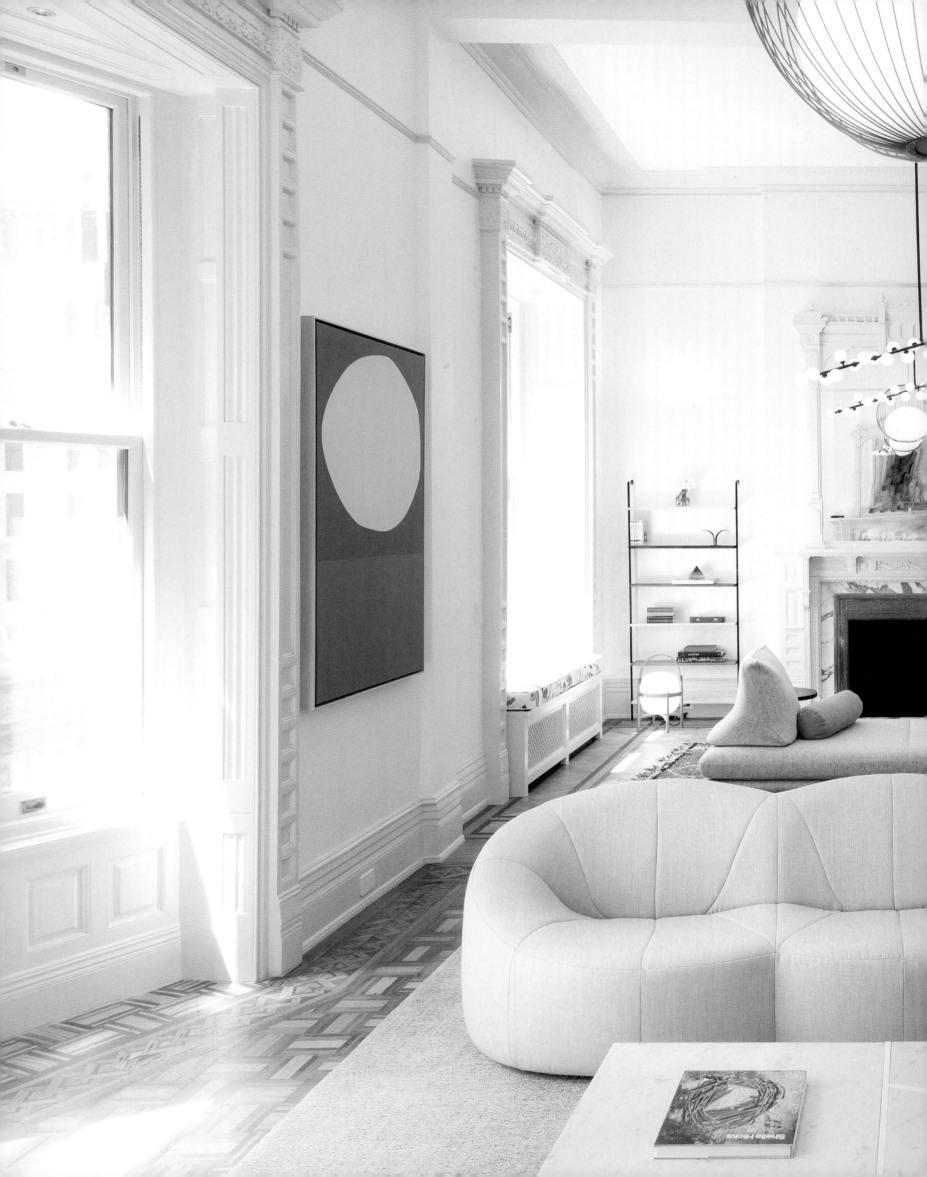

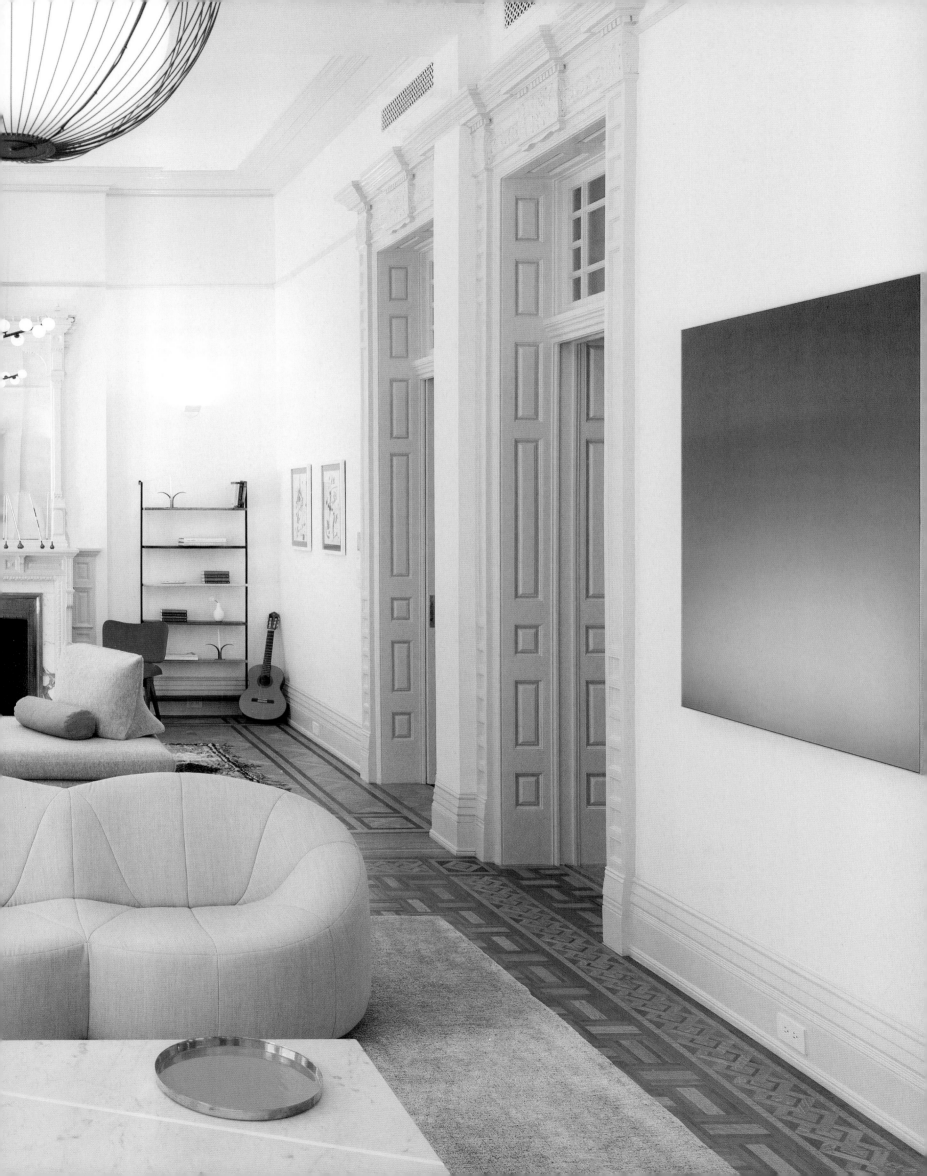

HOME MADE

How lucky, and rare,
to be able to dream up
an idea and make it
happen with your own
hands—and maybe a little
help from your friends.

PAGES 186–211

The fun begins the second you enter Amy Sedaris's apartment. Hugh Hamrick, the boyfriend of Amy's brother David, painted the bulldog and frame on the wall. Amy huddles in the corner beside a painting by David. Dean Kaufman photographed the story.

AMY SEDARIS

I COULD ONLY DREAM to do a story on Amy Sedaris, much less actually meet her, and had it not been for designer extraordinaire Todd Oldham, her close friend, I would not have been able to do either. In 2011 I mentioned to Todd that I was doing a design issue for *New York* magazine on how family influenced decorating decisions. Todd told me that Amy had created a craft room, really a child's playroom, only she didn't have any kids, plus she had a pet rabbit that had free reign of the house. What would you give (a) to meet Amy Sedaris, and (b) to do a story on her home, especially knowing that? Thanks to Todd I rang her doorbell, along with photographer Dean Kaufman, and we spent the day in Amy Land, where the more time we spent with Amy, the more her rare humor played out.

189

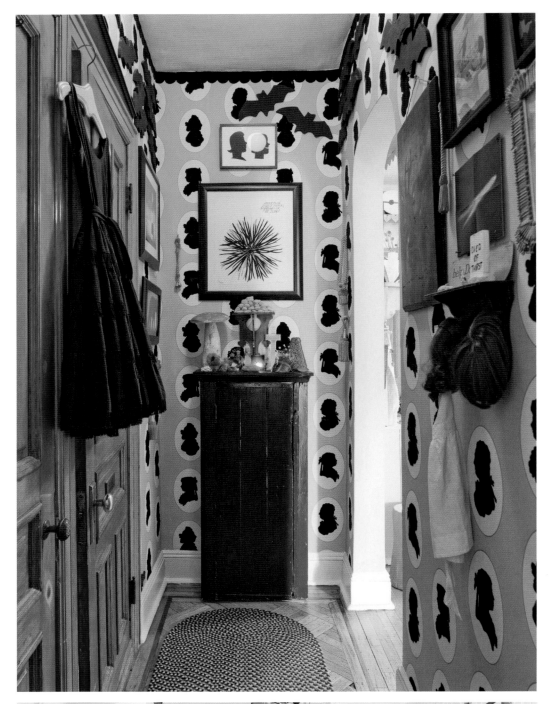

This is the story that Amy wrote for the issue:

OBSESSION: Imaginary Friends

I wouldn't call myself a shut-in. I have the ability to leave my home; I just choose not to. But because I'm such a homebody, it's important to be surrounded by things I love. I prefer items that convey a sense of mystery, playfulness, or theatricality. My favorite things often have a story behind them and are usually handmade or discovered at a flea market. My furniture is small and low. It's not unlike living in a dollhouse.

Sometimes, to keep things exciting, I decorate my house as if I owned a child. I'll toss a tiny pair of shoes in the hallway or lean small wooden crutches in what I refer to as "the baby's room," which is actually a tiny space where I make things. I continue to call it the baby's room because it confuses people and it's creepy.

I love theatrical props: a cup filled with solid fake tea, say, or a collection of fake food, including a rubber turkey, which, during the holidays, I wrap in tinfoil so it appears to have just come out of the oven. I also have a fondness for prosthetic skin disorders, artificial nails, and stage weapons. My favorite lampshade is adorned with hair-sample swatches dangling from the rim. I have sixty wooden flying bats—sixty!

So what is my decorating philosophy? Mostly, I choose things on a whim and worry later about how they fit my décor. For many people, this wouldn't be a big problem. But without any preplanning, why don't you try and figure out where the antique wax medical model of syphilis goes—above the table with the taxidermy duck or next to the papier-mâché Cyclops? Hmmm.... And now you begin to understand my world.

— Amy Sedaris

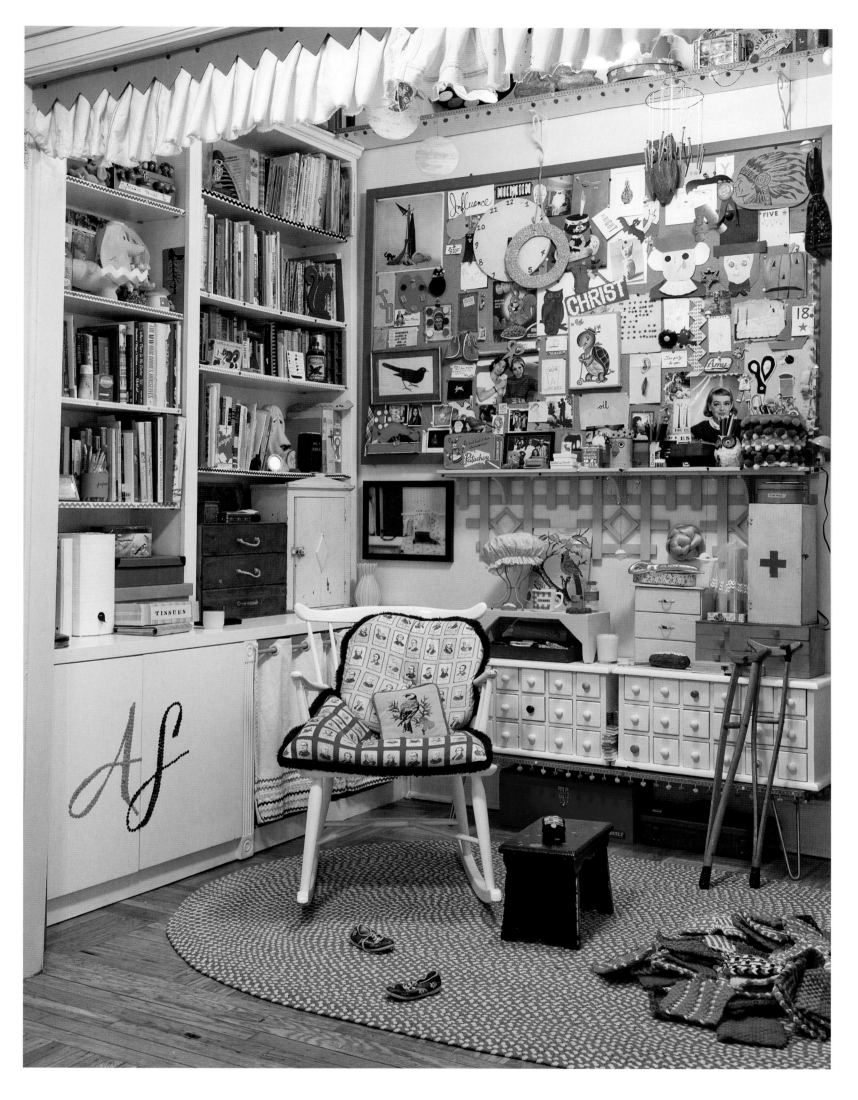

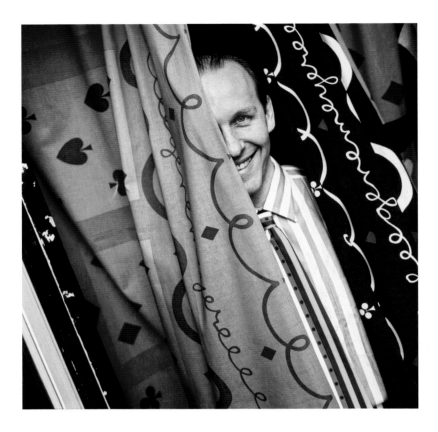

GENE MEYER

THE FIRST TIME I MET GENE MEYER, in the mid-1980s, he was working for fashion designer Geoffrey Beene. His courtly manners were always tinged with a hint of humor, and I sensed that a really good time was lurking just below the surface. Meetings at Mr. Beene's showroom—you only ever called the designer Mr. Beene—were formal, as Mr. Beene believed in propriety and repeated that word often; I was always especially conscious of being uber-polite and respectful, and that of course spilled over to everyone associated with Mr. Beene. I followed Gene's career after he left Geoffrey Beene to start his own women's fashion line, making exquisite clothes that a generation of New Age Babe Paleys snapped up. When that folded, Gene started a collection of scarves and fashion accessories, including men's ties, and anyone wearing one of his ties or scarves today has to guard it with his life, as they are treasured collectibles. Author and fashion journalist Amy Fine Collins, Gene's great friend, had the brilliant idea of using his scarves as seat upholstery for her dining-room chairs. That in turn inspired Gene to decorate his entire apartment with his scarves in all their various patterns and materials. Naturally, when I heard that he had done this in 1992, I appeared on the scene with a photographer in tow for *HG* magazine. The photographer, Ruven Afanador, had already worked with me on Ruben and Isabel Toledo's story, and I knew that together we could come up with a beautiful brew of Gene's fashion designs featured in the context of his unique apartment. To this day the story is one of my favorites, as Gene's unique sensibility was so perfectly captured by Ruven.

Color has always been the lifeblood of Gene's work, even when beige interiors were in vogue. He said in one of our interviews, "It hurts me when I see the modern world dressed in black. The right colors can transform anything into something arresting that transcends style."

Above: Ruven Afanador photographed Gene Meyer in the doorway to his terrace. *Right:* Gene used scarves he designed for curtains and furniture slipcovers.

Above: A still life in the living room with objects that Gene collected over the years. *Opposite:* The living room walls were painted ballet-slipper pink.

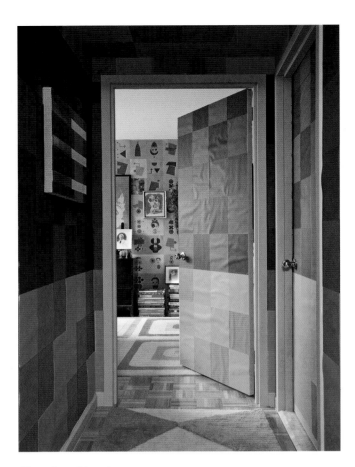

Above: Doug Meyer's one-bedroom near the Highline was covered with 2,398 sheets of letter-size colored paper that he and his brother Gene painstakingly applied. The runner in the hallway was one of their designs. *Opposite:* The Warhol print of Marilyn Monroe in the bedroom echoed the palette used on the wall, photographed by Floto + Warner.

DOUG MEYER

WHEN DOUG MEYER TOLD ME that he and Gene had wallpapered every square inch of their West Village office, aka Doug's one-bedroom apartment, I was intrigued. But when he explained that they had applied every single piece of paper individually by hand, all 2,398 sheets of the 8½ by 11-inch paper, and that each one was digitally printed with one of 223 of their designs, I was flabbergasted. On top of that they had bought paper in sixty-one different colors and ended up narrowing down to twenty-one on which to print the different patterns. Since doing a story on that apartment in 2011 for *New York* magazine and getting to know Doug, I have learned that his creativity manifests itself in surges of energy that fuel the herculean tasks he sets for himself, both at home and in his art. Doug's Hero Portraits, first created for New York City's annual DIFFA (Design Industries Foundation Fighting Aids) fund-raiser dinner in 2015, featured nineteen mixed-media images of artists, designers, and writers who were cut down in the prime of

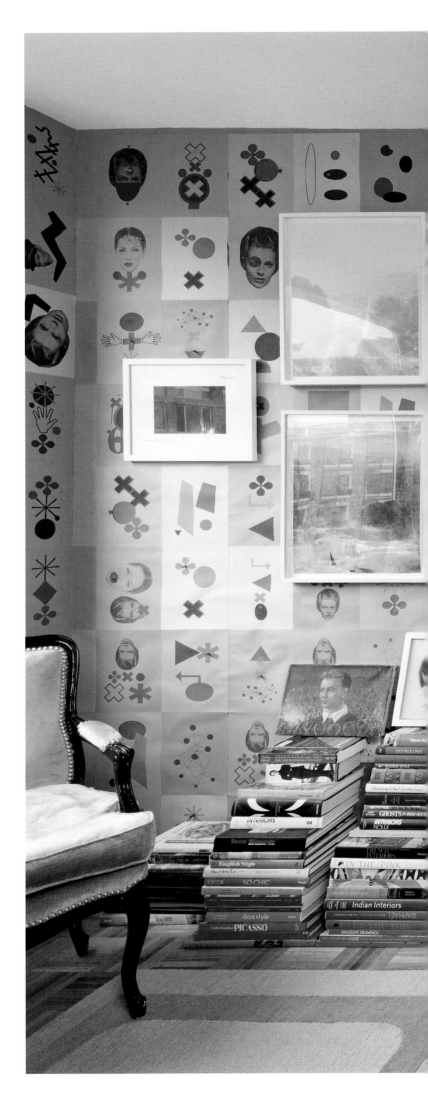

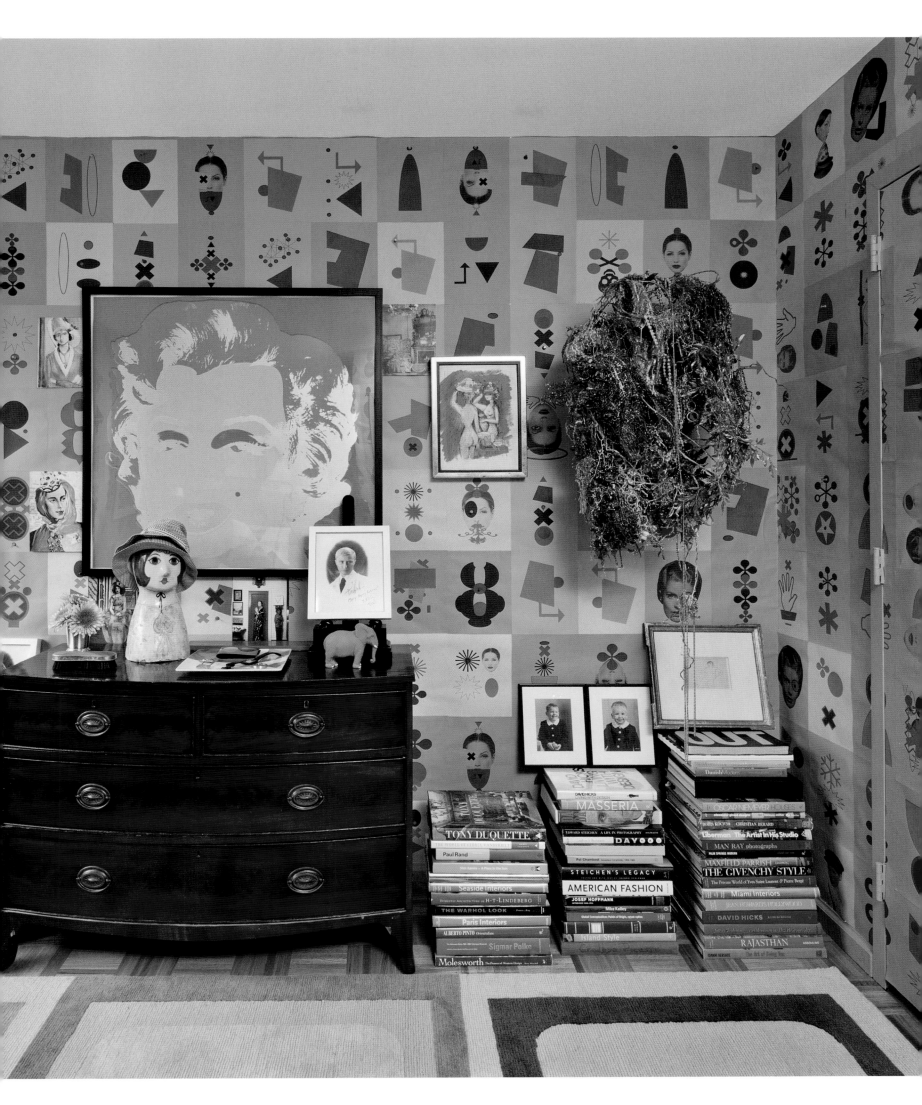

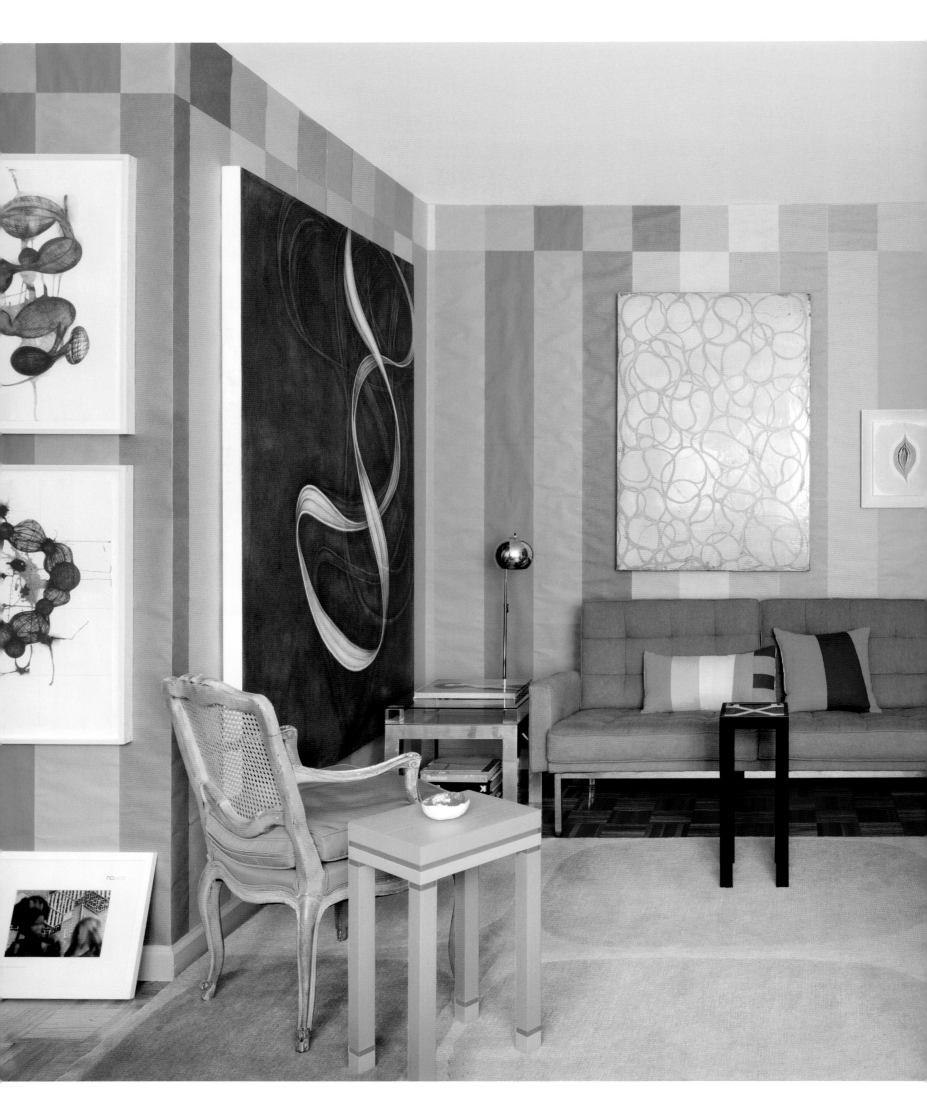

Opposite: The living room featured a Florence Knoll sofa, with a painting by Antonio Murado and a small painting by Philip Taaffe above. On the left wall is a painting by Mark Sheinkman. *Above:* Tableware designed by Doug and Gene in the kitchen.

their lives by AIDS. The Hero Portraits were also shown at Liz O'Brien's gallery in New York and went on tour in 2016, with fifty portraits in all. This design maverick, who grew up with his brother Gene in Louisville, Kentucky, acquired his appreciation of wildly saturated color early, as their mother favored bright orange rather than the muted eggshell and avocado palettes of their neighbors. He studied fine art at the Parsons School of Design and worked with legendary art dealer Holly Solomon, whose own apartment blew out any concepts of conventional living.

Doug has also finessed a method of creating life-size cameos, done in deep jewel colors, that are coveted by one and all. Doug's work is virtually unlike anyone else's. Color is not an accessory; it is the centrifugal force of his aesthetic. Doug wields color to conquer a space in ways that no one else would dare.

MATT AUSTIN

Opposite: Annie Schlecter photographed
Matt Austin's Bushwick rental; he painted the
bedroom in shades of gold and gray. He
made the pair of double-dolphin girandole mirrors.
Above: Matt, seen here, covered the kitchen
cabinetry, and the refrigerator, in plywood
paneling. He mixed the paint for the colored panels
on the front door from pigment powder.

"I MEAN, I'VE HAD SOME PRETTY GROSS APARTMENTS on the Lower East Side, but this took the cake," Matt Austin said in the kitchen of his third-floor walk-up in Bushwick, Brooklyn, when I visited in 2016 for *New York* magazine. It was hard to imagine that he was referring to this enfilade of rooms, each one ingeniously reflecting different aspects of this artist's talents as a decorative painter and product designer. Five years before, John Gilliland, a friend who owned the building, rented Matt this wreck, knowing full well he couldn't have lucked out more. Matt not only renovated the place but also made an art installation out of each room. Everything in the kitchen was clad in plywood, even the refrigerator, and there was a small table that Matt designed, with mahogany legs and a zebra-limestone top, placed in front of a tiny banquette.

It became clear that Matt could do anything and everything as far as renovation and decor were concerned, with a little help from furniture designer Marcus Santora and his brother, Clayton, a top ornamental plasterer. Marcus fashioned a plywood cubby beside the front door into which to drop keys and other items. The front door's four panels were painted different colors, but not with paint out of a can; Matt had hand-ground the pigments, which were a gift from Kremer Pigments, which, he said, "have all the old formulas, that place is my paradise." Matt's painting in the kitchen is his own version of a Botticelli landscape, and an enigmatic wooden bust was carved from a tree

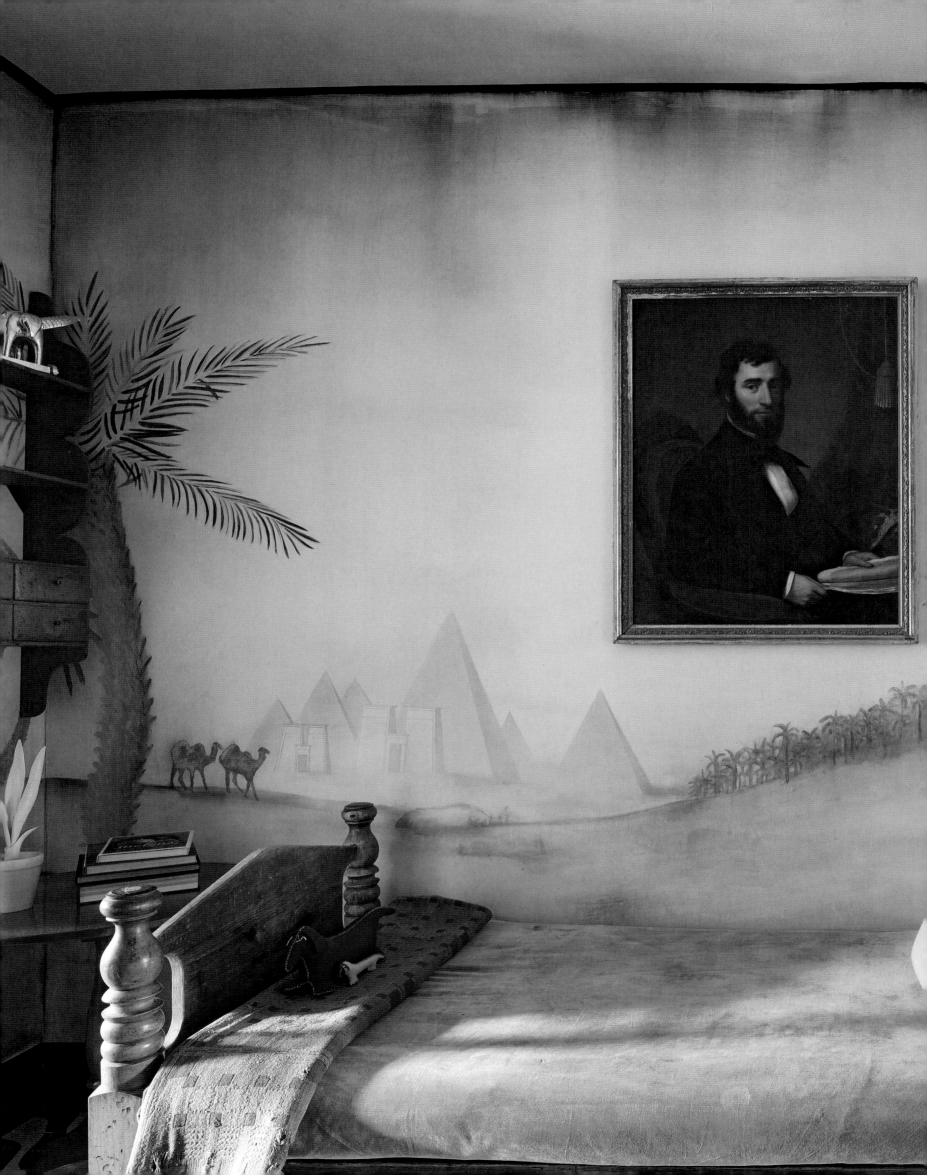

that had fallen in a friend's yard. Are you getting the picture? Matt doesn't take the easy way out, and he sees challenge as opportunity. The office/guest room off the kitchen had a painted mural of the Egyptian pyramids that Matt would have done in fresco had he owned the apartment. There was a portrait of Senator Willis R. Austin of Connecticut, Matt's great-great-uncle, on the wall over the four-poster bed, also a family heirloom. The romantic air of this room was offset by the room beyond, where the floor was painted with the squiggly lines of a classic serpentine pattern. It took eight hours to get it done for a birthday party Matt threw for himself and sixty-five of his closest friends. Matt's bedroom was where his skills and imagination converged to conjure his nineteenth-century sensibility. Matt carved the giant fish hanging above the bed, inspired, he said, by a Cape Cod weather vane. He bisected the room with color: The headboard of his bed was surrounded by yellow-gold walls, floor, and ceiling, and the foot by soft gray. He said that the paint was the defining detail: "I thought, well, my head rests on a pillow at night there, so I want my dreams to be golden dreams—sort of my halo."

203

Joe Serrins beefed up the proportions of the living room in his art deco apartment by ignoring the period moldings when he painted the walls and ceiling four different colors. The decor is late-mid-century modern: a sofa by Adrian Pearsall, a pair of Milo Baughman armchairs, a standing lamp inspired by Wendell Castle, a vintage rug on the wall, and a flokati on the floor. Annie Schlechter photographed the story.

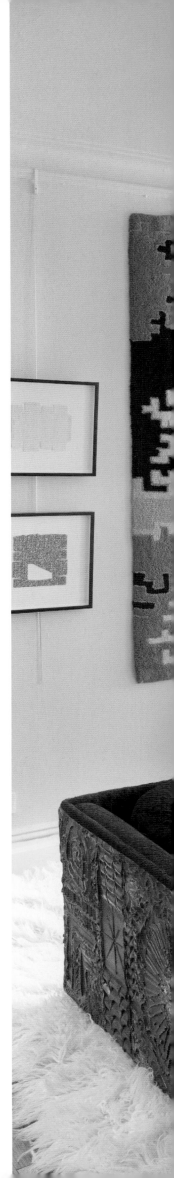

JOE SERRINS

I CAN'T HELP THAT EVERY TIME I think of the wonderful designer Joe Serrins, I remember the first time I went to visit him in his studio and his new puppy, Bushwick, a pitbull–border collie mix, chewed a hole in one of my gloves. I loved that I (well, my glove) had made such an immediate connection with his puppy, but Joe was horrified, and his sweetness, not to mention his generous gift of a much better pair of gloves than what had been chewed on, was typical of his delightful character. Joe is brilliant and he is also modest, two things that don't usually go together. I had bugged Joe for years to let me do a story on his apartment. The answer was always that it wasn't ready, until, in 2016, it finally was. When I went to see it for a story in *New York* magazine, I was transfixed: He had totally transformed a rather ordinary if charming apartment in a modest art deco building into a triumphant blaze of design, yet it didn't look overdesigned. Joe had painted the ceiling of the living room in four quadrants, continuing the different colors down the walls. He explained his thinking to writer Kat Ward: "The paint was really following the logic of the sunlight. This corner is the darkest, so it's bright yellow. The paint runs over the molding and ignores the logic of the moldings, breaking that traditional way of painting." His next move was to hang on the wall a vintage rug that incorporated some of the wall color, and then he added a rather massive 1960s brutalist sofa to the mix, anchoring it all with a very fluffy flokati rug. Joe also said, "None of the furniture really matches, or goes together, but the pieces talk to each other in a nice way."

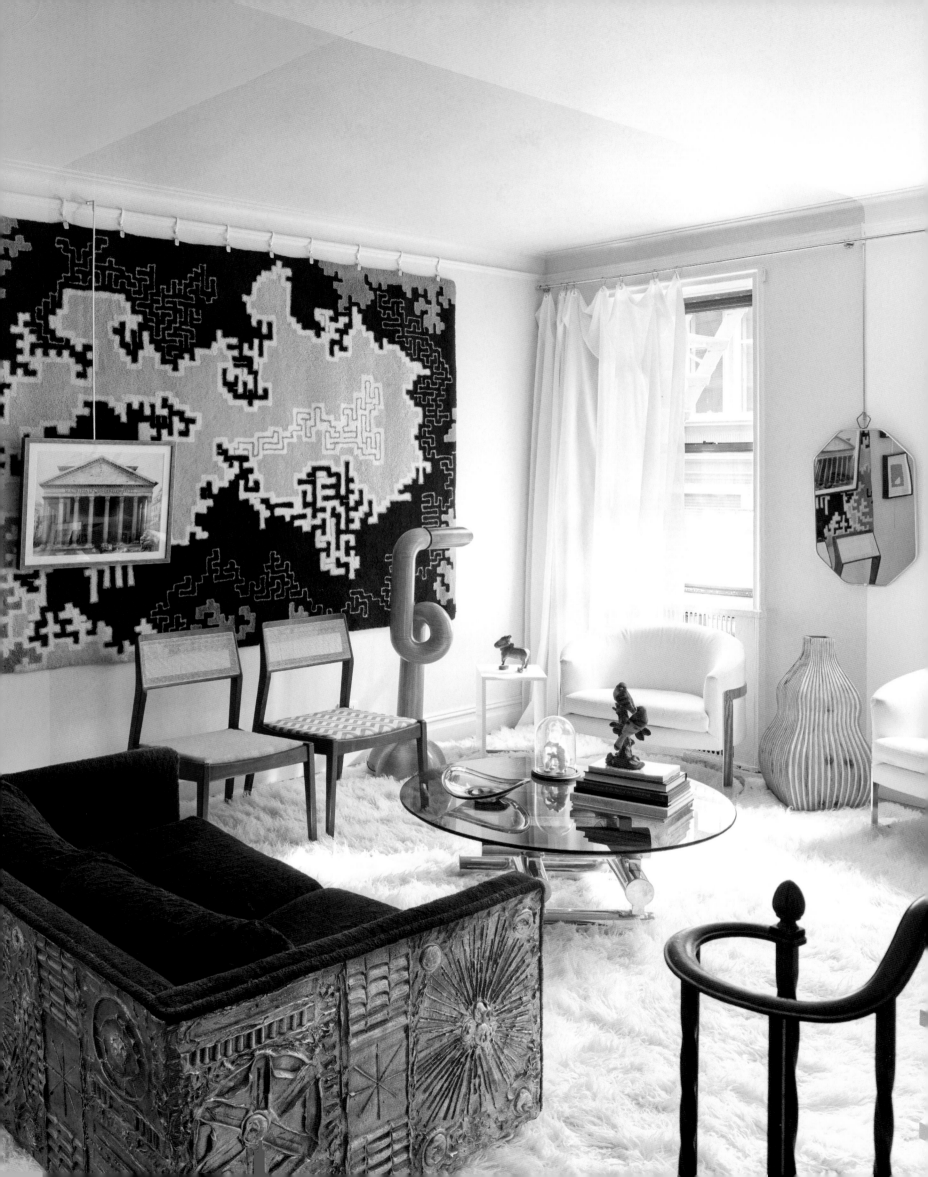

J. Morgan Puett converted a Pennsylvania chicken coop into her home, photographed by Paul Warchol. She covered the walls in blue milk paint.

J. MORGAN PUETT

J. MORGAN PUETT WAS A PIONEER WOMAN, a heroine straight out of a Willa Cather novel. She created a store on Wooster Street in New York's SoHo neighborhood like no other, with an industrial look and featuring clothing that could have been worn on the prairie or to a square dance. The first time I came into the shop I asked Morgan where and how she lived. She described a chicken coop that she had converted, on her brother's land in Pennsylvania, where she lived with her dog, Sister, and her cat, Roadkill. I made a beeline with photographer Paul Warchol to do the first of many stories for *Harper's Bazaar* in 1994.

Morgan has been formed by the splendors of an eccentric, enchanted childhood in Hahira, Georgia. Her father was a third-generation bee-keeper who shipped queen bees worldwide. Morgan studied painting, sculpture, and film at the School of the Art Institute of Chicago. In the mid-1980s she began selling her handmade, hand-dyed, washed linen clothing; in 1989, she launched her own mail-order business. Morgan told me, "When I first started out eight years ago, buyers laughed at me—everyone was buying Alaïa. I was totally out of it!" But she stuck to her beliefs and customers responded. "Clothes should be friendly, honest, and comfortable. Clothes are a person's history." Morgan's chicken coop, with its blue milk–painted plaster walls and plank floors, filled with her artwork and simple furniture, honored her family roots and love of nature. She told me, "I love to find objects; even a little piece of fabric holds a secret language all its own."

207

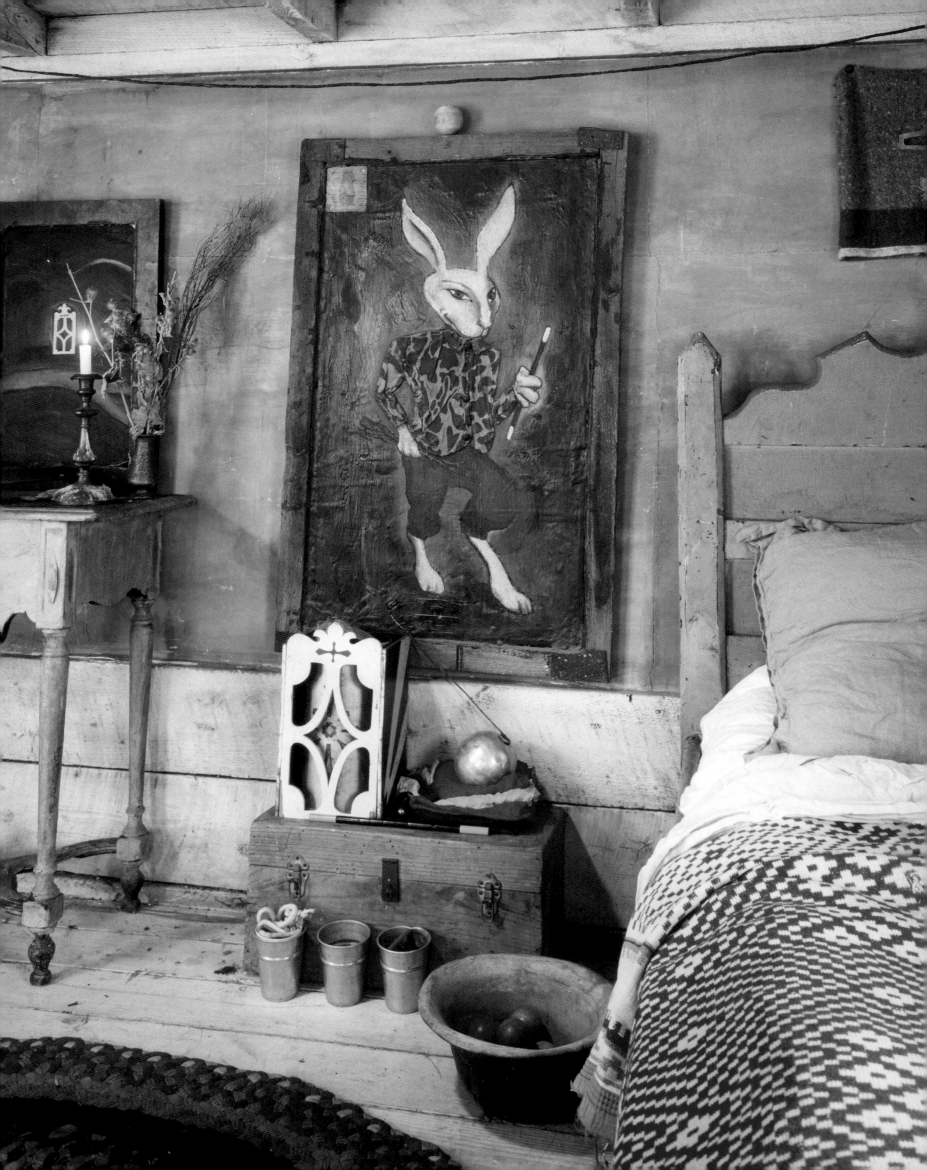

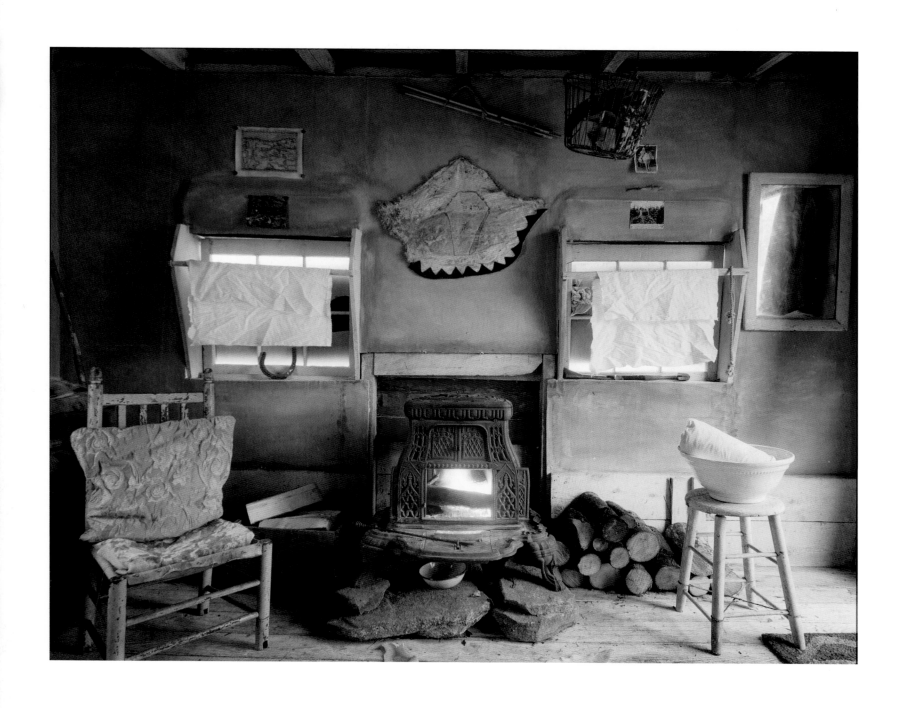

Left and above: Country
life: a woodstove and
folk art—in this case,
a painting of a rabbit by
Morgan herself.

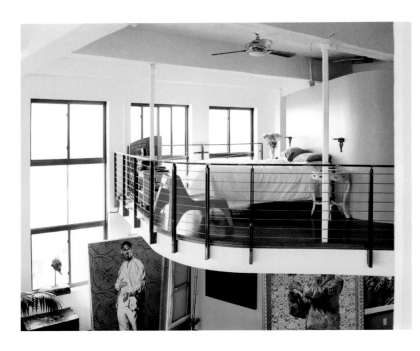

KEHINDE WILEY

As we stood in his studio in 2006, Kehinde Wiley told me, "Normally I wouldn't go for a space this ambitious," but his experience as artist in residence at the Studio Museum in Harlem had made it clear to him that a live-work environment was imperative. "I had my work there, a futon and a television. It was just the most insane, overcrowded, intense moment, but it allowed me to engage my work in a way I never had." At thirty-two hundred square feet, this Williamsburg loft could not only accommodate Kehinde's giant canvases, on average nine by twelve feet, but also provide space to throw parties, serious parties where as many as a thousand people might pass through on an evening. His studio area was filled with his World Stage paintings, many completed, some not; once you wandered farther into the room, the designated living area was painted a deep tomato red. There was a catwalk that accessed the bedroom, which was suspended like a bird's nest over the living room. A grand piano looked dwarfed in the cavernous space; it was there because Kehinde said he dreamed that one day he would learn how to play. This place was a temporary perch for Kehinde. On my walk back to the subway from our shoot for *New York* magazine, I turned around and looked at the lights of his loft way up high in his industrial building, rising like Oz on the yellow-brick road that once was Williamsburg.

As I write this, Kehinde's official portrait of President Barack Obama has just been unveiled. Could there be a higher or more deserved honor for this world-class, brilliant American artist?

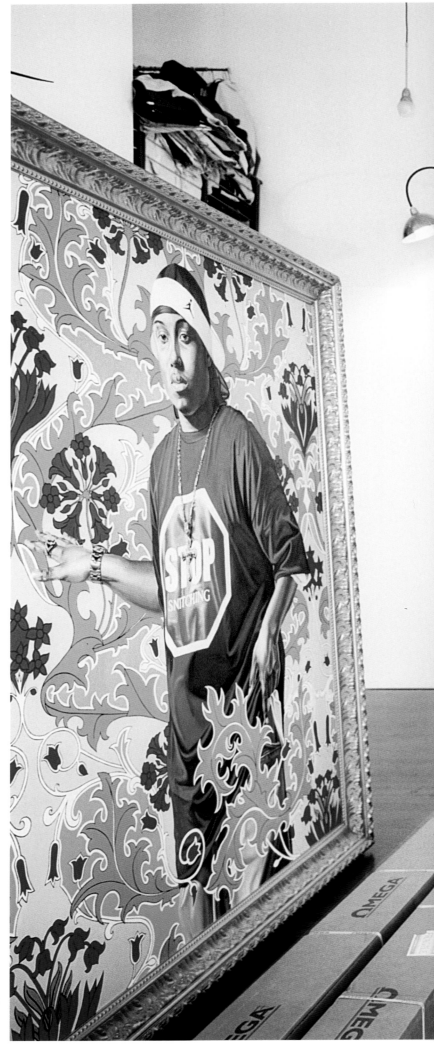

Opposite: Kehinde Wiley in his former Brooklyn studio, amid his early portraits of street heroes, young men he discovered in Harlem. Dean Kaufman photographed Kehinde and his live-work loft. *Above:* Kehinde's bed.

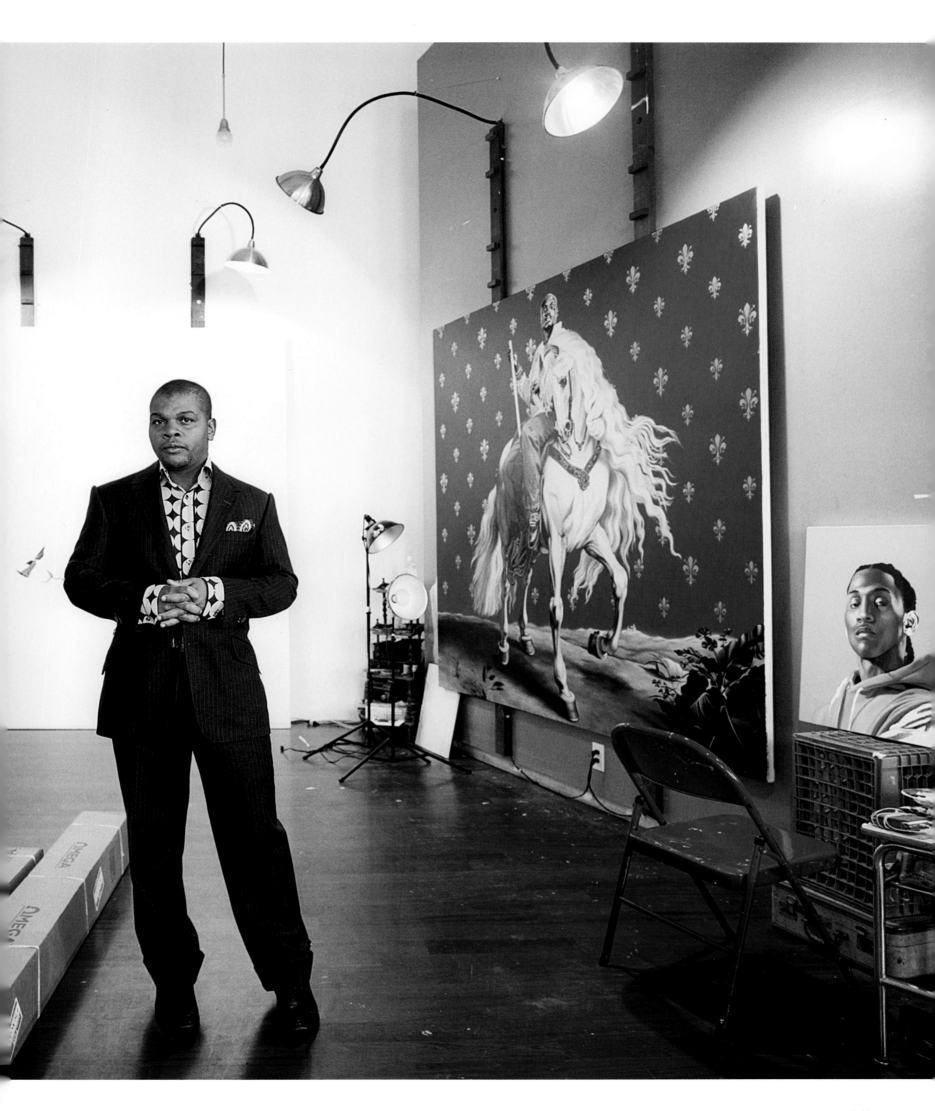

6

SPARTAN SPLENDOR

When confidence informs
highly edited choices, Spartan
splendor reigns. It is letting
things speak for themselves,
and that includes the
absence of things creating
a magnificent void.

BILL KATZ

BILL KATZ TOWERS OVER A CROWD, moving
through it with the detachment of a mod-
ern-day mystic; you are not quite sure
where he is looking. He has the hands of
a figure sculpted by Michelangelo, and
there is a deep sense of mystery about him. The time
I spent with him in his house in New Mexico was
a treasured experience. And, again, I owed the expe-
rience to my career and to photographer Timothy
Greenfield-Sanders, who photographed a story
on Bill and the house Bill designed for himself in
Abiquiú, New Mexico, in 1996 for *Harper's Bazaar*.
Bill knows everybody in the art world, and many
artists, including Jasper Johns, Agnes Martin, and
Louise Nevelson, have relied on him for advice about
everything from hanging their shows to designing
their houses. Alba and Francesco Clemente have
a house and studio nearby, designed by Bill.

"I wanted to build a twentieth-century version
of an eighteenth-century fortified hacienda," Bill
told writer Brad Gooch. The one-story adobe house
outside Taos, overlooking the Sangre de Cristo
mountain range, is deceptively simple. The magic
begins as you approach from the long, winding
road that leads off the main road to the house. You
see the house, and then, as you keep going, it disap-
pears, and then, in the blink of an eye, it pops back
up and seems to be floating in the ocean of sage
brush that goes on for as far as the eye can see.

215

Bill's living room had
three main elements:
a polished wood
floor, a pair of couches
covered in loose
fabric, and a fireplace.

Bill's home was made in the traditional adobe
way, using a mixture of mud, sand, and straw and
fashioned by hand. The main entrance opens onto
a courtyard with an apple tree sheltering a small
herb garden. The house is elevated off the ground,
surrounded by a large deck that allows you access
to the landscape from a heightened perspective,
which feels much like standing on the deck of an
ocean liner with the sea as your universe. The liv-
ing room features two deep couches facing each
other, both draped in dirt-gold-colored cloth that
pools on the floor, where the reflection of the
roaring fire makes a path of light on the polished
wooden planks. At night you feel like you're inside
a piece of amber.

The first morning I woke up there, I sat in bed,
watching the sun sweep over the sage, turning it
the color of bitter orange. And then I noticed the
dancing tails of a coyote family weaving through
the brush, on the hunt for breakfast.

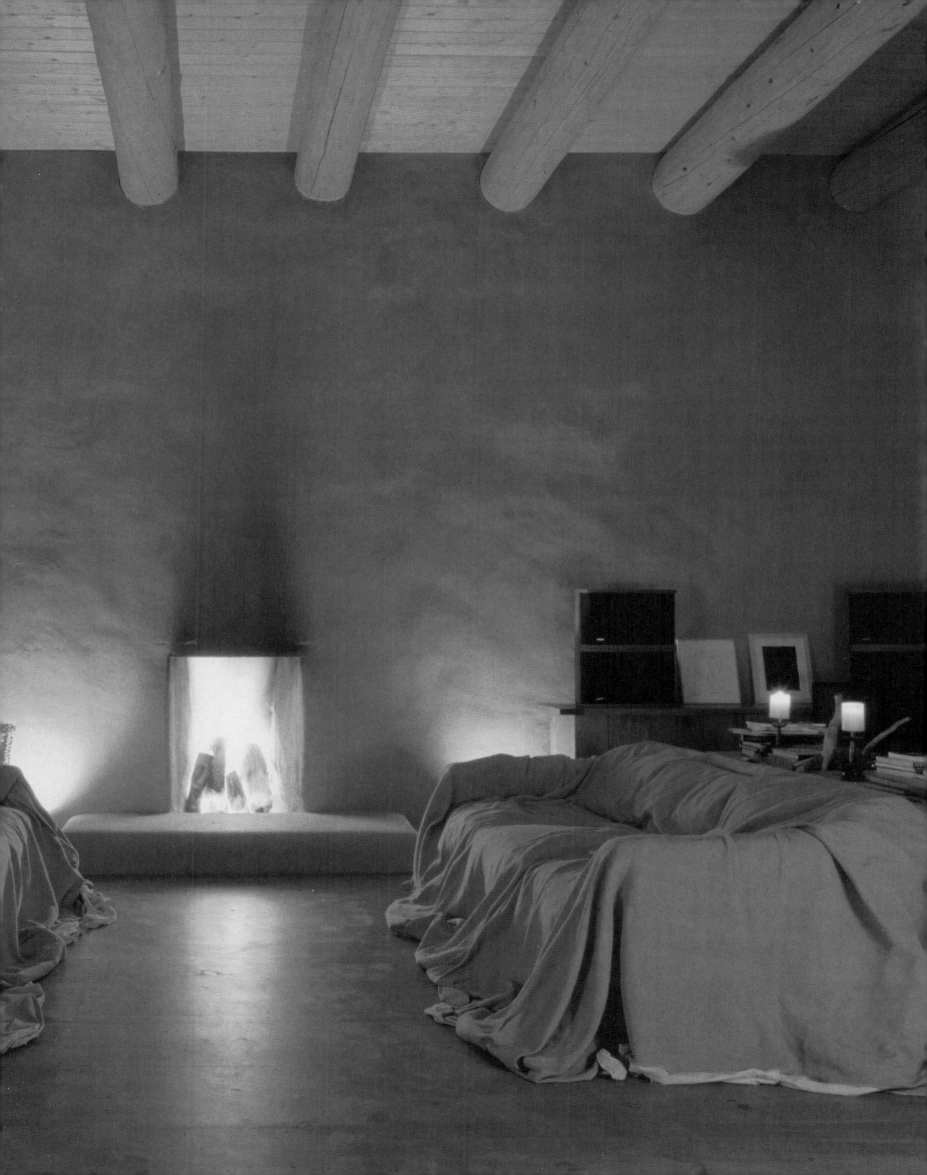

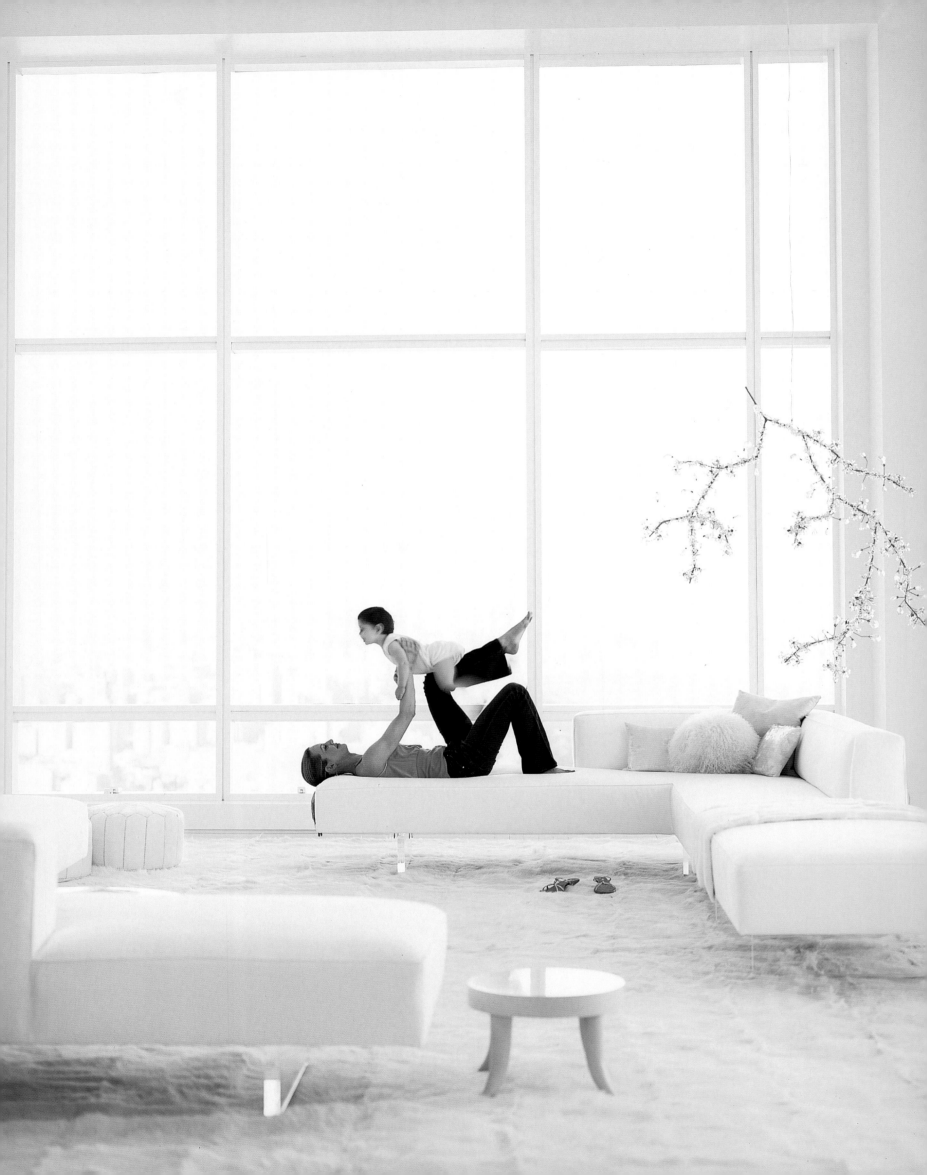

KELLY BEHUN

I FIRST SPIED THE WORK OF KELLY BEHUN and her then design partner, Natasha Ziff, in a *House & Garden* story featuring Ian Schrager's Soho rental. He had given them the keys and told them to get it done, on budget, no questions asked. It was fresh, unfussy, and effortlessly elegant, Ikea chaise included; I had to find them. It turned out that Kelly started her design firm, Behun Ziff, in 2001, after she and Natasha had cut their teeth working together for Schrager. They had no design training, but, as Schrager told writer Amy Larocca, "I knew they had the eye."

I arrived at the penthouse of the building at Columbus Circle that Kelly and Natasha had recently renovated for Kelly and her husband, Jay Sugarman, and two boys, Miles and Arno, under the age of five, plus their dachshund, GI Judy, in 2004. When Kelly opened the door, all I saw behind her was a luminous landscape floating out over the city, with views that stretched from river to river. The decor of this winter-wonderland palette was exquisitely spare. A Tord Boontje crystal chandelier sparkled like a giant jewel over a custom-designed white leather Vladimir Kagan sectional sofa that sat on top of a 17-by-25-foot white goatskin rug, begging for bare feet, in one corner of the living room.

It was all so dazzling and otherworldly; was I really making the first tracks in the snow? It was too good to be true, and I didn't even want to ask whether I could do a story, so I didn't until the very end of our visit, after I had seen the playroom with Elvis towering on the wall in a photograph that had been digitally transformed for wall covering; and after I had seen the views of New Jersey from one son's room with a wall-to-wall Paul Smith carpet; and after I had seen the master bedroom envelop all who entered like a giant fluffy cloud that you never wanted to leave. Finally, I asked the question, and the answer was yes. I had found the biggest, fattest, most delicious mouse to triumphantly deposit at the feet of the new editor in chief of *New York* magazine, Adam Moss. I had surpassed myself in sleuthing out such a prize. I left Kelly and Natasha's home walking on air, but what no one knew when I got back to the magazine was that I had promised Kelly a cover story, because I knew it had to be, it deserved to be. I also knew what a dangerous thing that was to do, as it wasn't my decision, but I also knew that I always keep my promises, no matter what, so I kept that promise to myself.

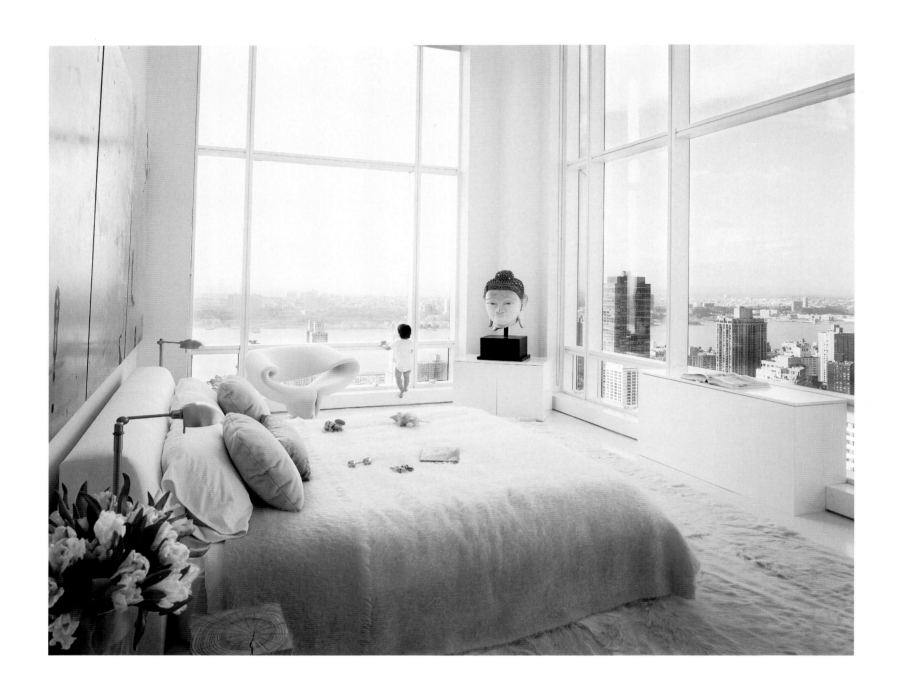

Above: The master bedroom with views of the Hudson River and beyond. *Opposite:* Kelly Behun's ingenious decor, including a blow-up of a photograph of Elvis Presley papering a wall in her sons' playroom.

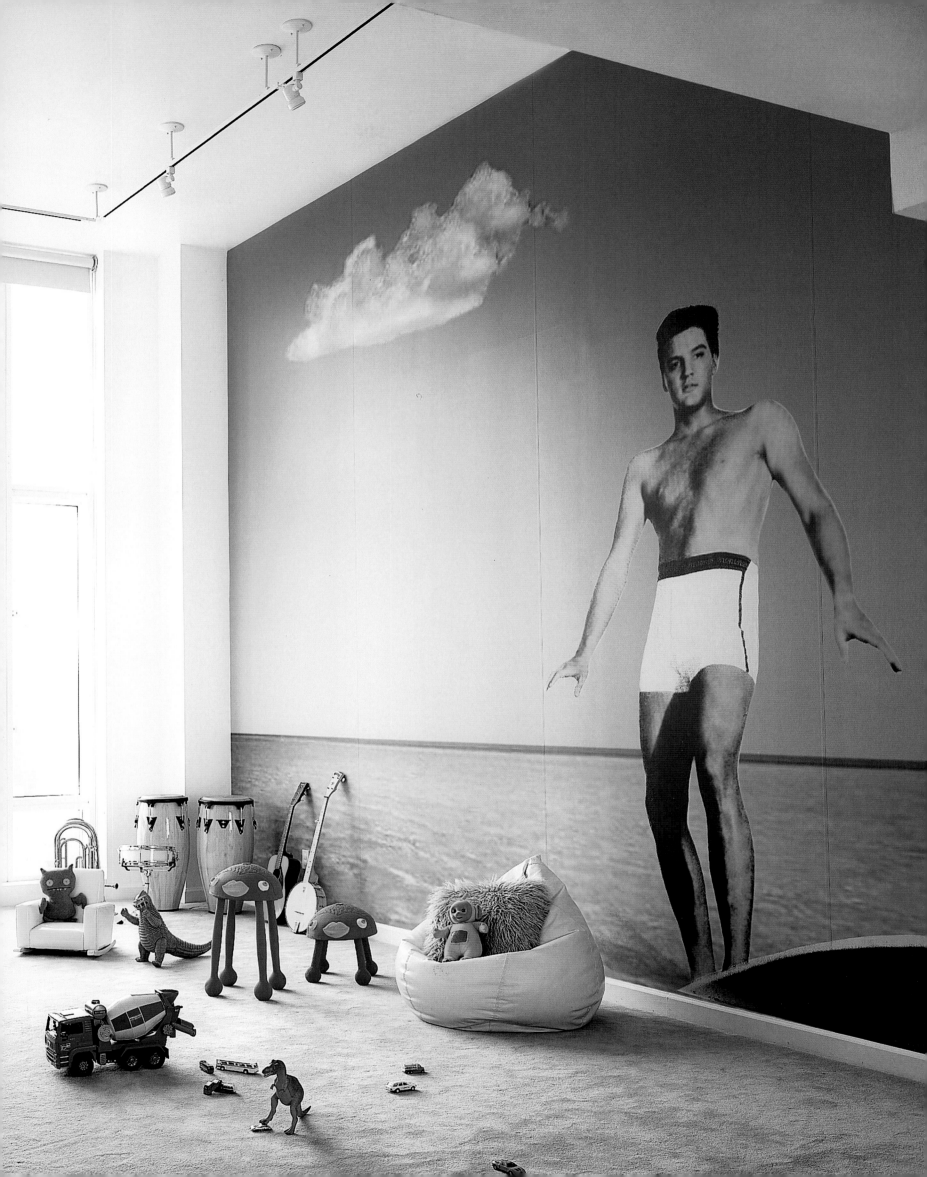

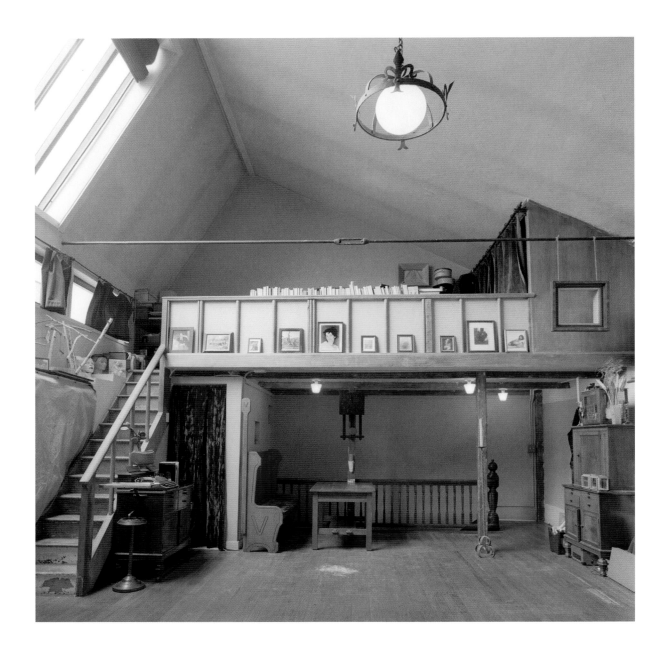

JOSEF ASTOR

Josef Astor photographed his work-and-live space in the Carnegie Hall Studios, capturing the beauty and serenity that the founders of Carnegie Hall had wanted to create for artists. When I went to visit Josef, the destruction was all around, and as we talked we could hear the jackhammers and workmen destroying this irreplaceable corner of the city's history.

I DARE YOU TO WATCH photographer Josef Astor's brilliant 2011 documentary, *Lost Bohemia*, about the life and demise of the Carnegie Hall Towers studios above Carnegie Hall, and not feel your heart break. By the time I had made my pilgrimage to visit Josef in his extraordinary studio in 2007 for a story for *New York* magazine, the clock was ticking toward the studios' destruction. I remembered how much time I had spent, and taken for granted, in Editta Sherman's photography studio when I did fashion styling for Estée Lauder and Editta had rented out her space to the Lauder team. I recalled hearing the sound of a piano and the dance teacher across the hall counting out the steps for the baby ballerinas taking their lessons. Actors, dancers, and writers had lived and worked here since the day the addition was completed in 1895, four years after architect William Burnet Tuthill's concert hall had opened. It was inconceivable that the value of this hallowed haven, specifically designated for artists, was now denied by the board of the institution. Those studios had harbored the dreams and daily lives of Leonard Bernstein, Marlon Brando, Enrico Caruso, Isadora Duncan, Marilyn Monroe, and so many others. New York City's own living treasure Bill Cunningham had a tiny studio there, where he lived and stored his treasury of photographs. The northern light in Josef's studio was ethereal and never needed any artificial supplement until night fell. It was where he worked and lived from 1985 until 2007. The only remnant of the life in the studios is in photographs and Josef's film. It is too sad, but at least we have that.

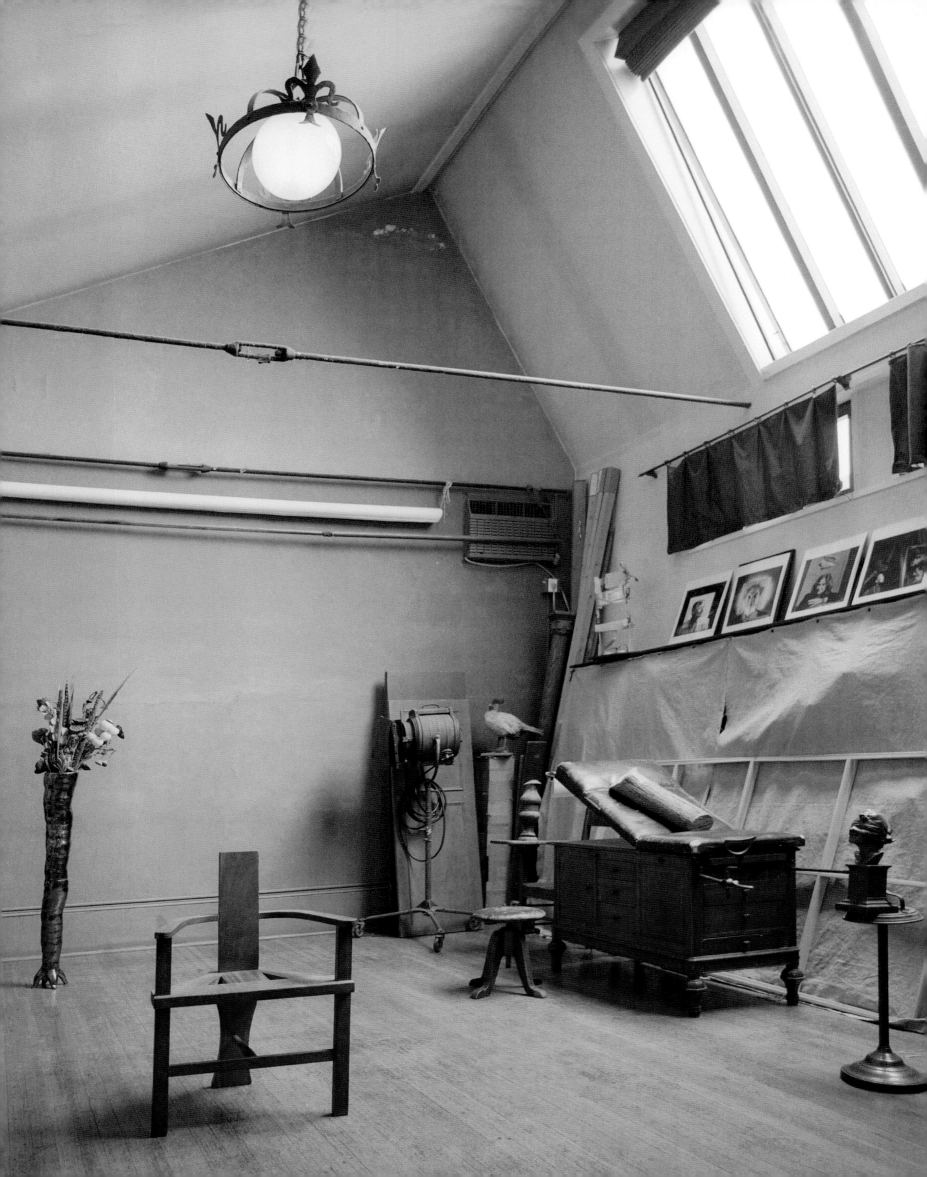

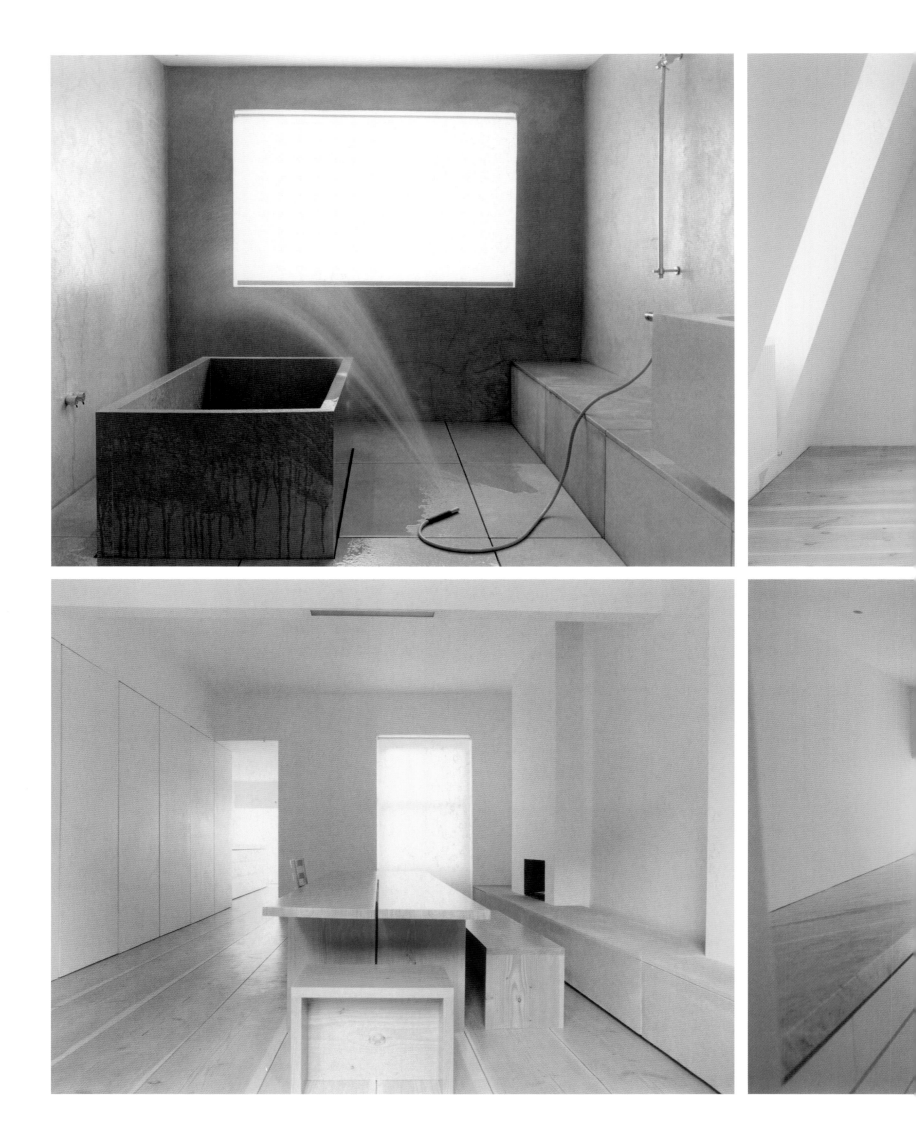

John Pawson's immaculate modernist town house in London, photographed by Oberto Gili, gave away its strict secrets only once you got past the front door, as from the facade you might have thought it harbored cozy little rooms with floral wallpaper.

JOHN PAWSON

J OHN PAWSON'S VICTORIAN TERRACE house in Notting Hill looked exactly like his neighbor's, save the all-white painted door, but when you entered, all familiarity stopped. A small child's head peered around the corner at the top of the narrow staircase that greeted you from the barely there entrance hall. Off to the side there was a door into an open space, where there had once been two small parlors and where now living and dining areas converged into one. The Douglas fir planks featured in the floor had also been used for the dining table and bench. In the bathroom the brimming concrete Japanese tub was as deep as a well and was designed to overflow, as there was a drain beneath the stone flag floor and not much else. There was nothing, not a book or a vase or a plant, that would disturb the minimalist purity of the interior architecture. But in 1995 there were John's two young sons, Caius, eight, and Benedict, four, and his wife, Catherine, who had worked for the English decorating firm Colefax and Fowler, which was about as far from the minimalist aesthetic as you can get. So I wondered how it all worked. Where was the detritus of daily life? Was it possible that John had conditioned his family to purge on an hourly basis? I was stumped, if not a tad envious, at the rigorous discipline enacted to produce such a pure palette of order.

John was about to go to New York City for the opening of the first freestanding Calvin Klein store, on Madison Avenue, which he had designed, and his minimalist star was on the rise. I felt relieved when I read Martin Filler's story for *Harper's Bazaar* that accompanied the photographs. In it he quoted Catherine as saying, "You can't come home and leave your handbag and coat, because they completely destroy the space. It's a whole new discipline." Even John himself admitted back then, "It is very demanding." I will confess that before we left, I took a peek behind one of the wall panels concealing a closet and I did spy a few things.

TOD WILLIAMS
& BILLIE TSIEN

I T WAS NOVEMBER 9, 2007. My cell phone kept vibrating in my pocket as I was picking out branches in the flower market for a shoot in East Hampton. A message said simply, "Get back to the office, right away." I could not ever have imagined that the urgent news awaiting me was that Condé Nast was closing *House & Garden* again, a second time; I had gone through the first closing in 1993. When I arrived, the office seemed deserted, as everyone was squeezed into a conference room listening to the officers of S.I. Newhouse Jr. tell us that the magazine was closing that day and we had to clear out our stuff ASAP. The January issue was already done; in fact, it had gone to press; I had minis—layouts—of the entire issue. It was an exciting issue, as Dominique Browning, then editor in chief, had invited brilliant design guru Murray Moss to be the guest editor. Every story was Murray's idea, including the feature on the penthouse aerie designed by architects Tod Williams and Billie Tsien as their getaway retreat a few blocks from their offices in Midtown.

No one except Murray could have persuaded Williams and Tsien to do a photo shoot. His eye was the industry gold standard. Chee Pearlman wrote the story, and I produced it with photographer Jason Schmidt. Jason scouted the location before the shoot and figured out how to access the perfect spot in a neighboring building to show off the apartment's unique terrace and give the viewer the perspective that a bird might have flying over Central Park. He had also figured out, down to the minute, the exact time when the terrace would be the only point of light in the photograph.

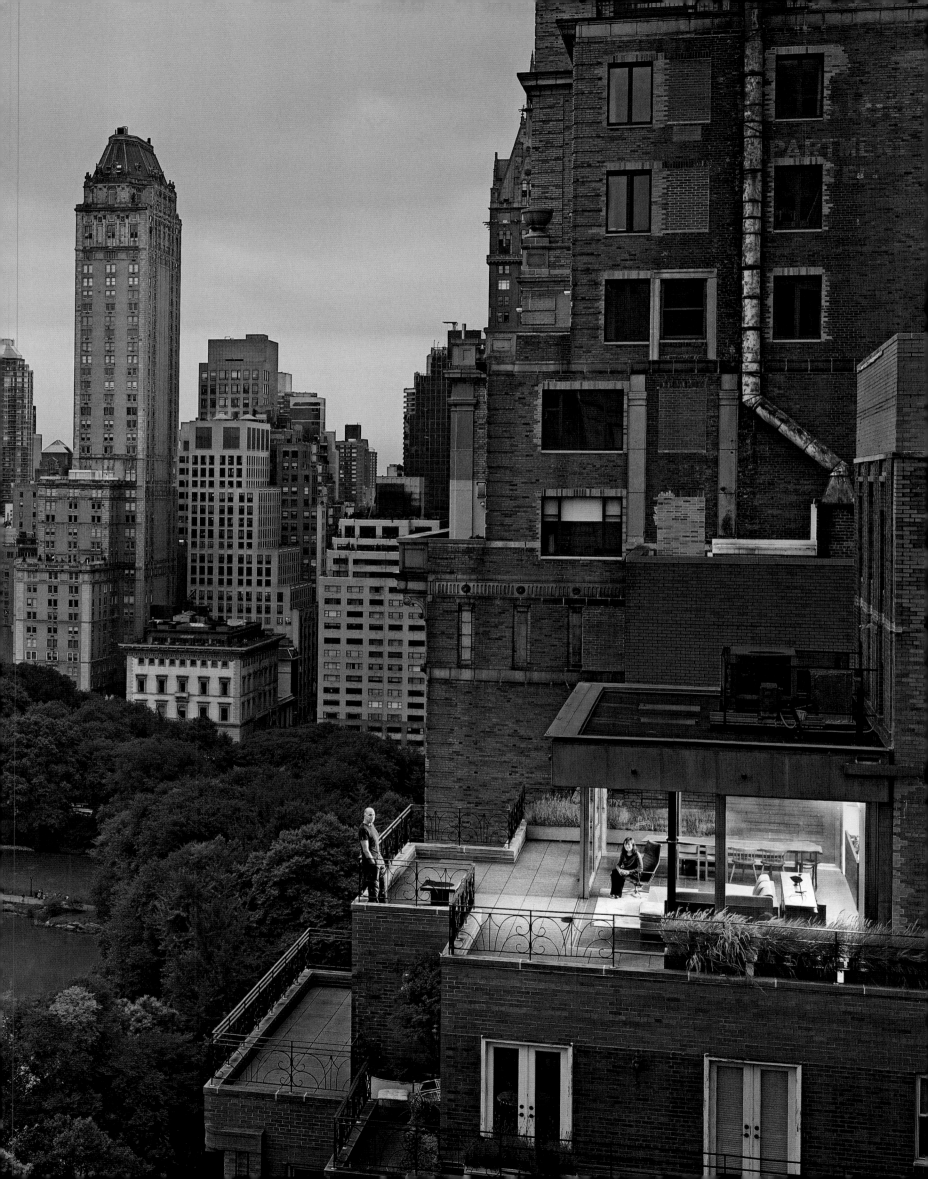

MARIKO MORI

Opposite: Mariko Mori photographed by Rowland
Kirishima, performing a tea ceremony in the
tea room in her all-white apartment in Tokyo. *Above:*
Her sculpture by the entrance to the tea room.

I HAD NO SCOUTING PICTURES. I had nothing but my enthusiasm for what I had heard about artist Mariko Mori's all-white apartment in Tokyo from her art dealer, Jeffrey Deitch. Jeffrey described a surreal environment where the walls and ceiling disappeared into a cloud-like space; it sounded to me as if the whole experience was like being inside one of Mori's art installations. In 2001 I pitched the story to Dennis Freedman and Patrick McCarthy at *W* magazine, and, to my delight, they gave it a green light and I was off to Tokyo. I stayed at the legendary Hotel Okura, and it was the first time I experienced the sublime aesthetic of Japanese simplicity in all its wabi-sabi finesse. The night I arrived, I had dinner by myself in the hotel restaurant, where the sight of one triangular wedge of watermelon served upright on a turquoise plate rocked my world.

Here I was in Tokyo, halfway around the world, and two days into my stay I had yet to meet the artist. I was told that she was working on many projects, and I needed to be patient. Finally, on the third day, the time came to meet Mariko and see her apartment. I was dazzled. It was everything Jeffrey Deitch had said it was, but even better. In place of the traditional wooden *tokonoma* (alcove), Mariko had installed an acrylic shelf; a circular glass window, which could be by turns opaque or transparent, stood in for the traditional hanging scroll. As in her art pieces, Mori used state-of-the-art

The living room, with its curved walls and palette of varying whites, had a mysterious, unearthly quality, much like Mariko herself.

materials to rework historical ideas and spiritual traditions. In our interview Mariko told me, "I had the idea of creating a space that transcended time and place, so you don't know where it is—it's just another dimension." Her apartment, she explained, was inspired by her project *Dream Temple* (1999), commissioned by the Fondazione Prada. That exhibit, shown in Milan, took three years to complete and included a full-size octagonal structure patterned after the eighth-century Yumedono Hall at the Horyuji Temple in Japan. In place of wood for the building, Mariko used glass that changed color as you walked around it.

The apartment was devoid of any personal objects. When Mariko performed the tea ceremony in her New Age teahouse, she did it in the traditional way that she had been studying since the age of three, when she started her practice with her grandmother, a tea master. The tea ceremony is the most profound metaphor in Japanese life for one's regard for relationships. "Serving and sharing tea," Mariko said, "signifies for me that beings in this world are connected. In the teahouse you leave behind your class, you leave behind your race, you leave behind all those social structures—you leave behind everything, and then you just do a very simple thing: You drink tea. The whole experience is art, including the guests."

230

DAVID &
INDIA HICKS

Above: François Halard photographed India Hicks
at the door of Savannah, the house that her
father David Hicks designed on Eleuthera Island,
the Bahamas, for *Harper's Bazaar* in 1994. *Opposite:*
The dramatic design of the house's boardwalk
entrance path flanked by "pylons" was inspired
by the ancient Egyptian temple of Djoser at Saqqara.

AVID HICKS APPEARED OUTSIDE ALBANY, the venerable London apartment house where he had had a "set of chambers" since 1978. He greeted us as we were unloading the photo equipment and then stood back to observe how we handled the cumbersome camera cases and lights, sizing up, I felt sure, whether to allow us into his rarified world upstairs. I knew that, with a temper as famous as his iconic decorating style, he didn't suffer fools. It was Hicks who had infused the staid formality of English and continental decor with high-octane color, graphic printed textiles, and idiosyncratic mixes of period furniture since his first commission in 1955. He embraced modernism as a palate cleanser after the rooms of his parents' generation and took vivid color to new heights at home. He thought nothing of putting grand tester beds and bathtubs smack in the middle of rooms, and he loved gardens and lavished the same discipline and rigor on his landscape designs as he did on his interiors.

It was 1996, and we had come to do a story for *House & Garden* celebrating both his urban and his rural style at home, documenting his rooms at Albany and at the eighteenth-century farmhouse, the Grove, in South Oxfordshire, that he shared with his wife, Lady Pamela Hicks, daughter of the last viceroy of India, Earl Mountbatten, and his wife, Edwina. Hicks had moved his family to this smaller idyllic place in 1979, when they sold their eighteenth-century Georgian brick house, Britwell Salome.

Opposite: Oberto Gili photographed David Hicks's rigorously geometric garden at his country estate, the Grove, for *House & Garden* in 1996. *Right:* Hicks's bedroom in his London residence, Albany, for the same story, featuring both residences. The three-sided bed he designed is flanked by Directoire swan chairs, all under a plaster copy of a frieze from the Parthenon. His son, Ashley, and Ashley's wife, Kata, and their son, Caspian, now live in the apartment, which, as you might guess, looks very different than it did when Oberto photographed it.

Hicks had also built a vacation house on Eleuthera Island in the Bahamas that was quite unlike the colonial-style bungalows there. His house, modeled on an Egyptian temple, was constructed with cement and had an entrance walk flanked by large stone slabs. Inside he created a series of airy rooms drenched in the soft tropical light and decorated in pastels. A fashion story on his daughter India took me there, to complete a Hicks trilogy of sorts. Lady Pamela's sister, Lady Braybourne (aka Countess Mountbatten of Burma), also had a house nearby. Her husband, Lord Braybourne, saved the day, as the hairdresser Maury Hopson lost all his luggage en route to the island. A crisis was averted when Lord Braybourne procured a tube of Afro Sheen in town, and Lady Braybourne found some rusty bobby pins that she recalled had probably been used to secure the queen's scarf when they went horseback riding together.

Above: The hall at Albany, with lacquered walls and plaster casts of sculpture from the British Museum, photographed by Oberto. *Opposite:* François photographed India in the Savannah living room, in front of a painting by Bruce Tippett.

Right: Oberto Gili photographed Robert Isabell relaxing next to the fireplace in the bedroom of his Greenwich Village town house. *Opposite:* The vast bedroom had a glass roof and a sunken staircase.

ROBERT ISABELL

OBERT ISABELL WAS MOVIE-STAR HANDSOME and had the grin of a Cheshire cat who knew things he would never tell. His talent and magnetism made him catnip for the powers that were in New York City in the high-flying 1980s. Like the Gilded Age, the eighties were about showing your wealth through spectacle, and Robert knew how to create luminous, reality-defying spectacles; they became his *spécialité*.

Robert hailed from Duluth, Minnesota, and worked in a greenhouse growing up, so he knew flowers, and he had an innate sense of elegance burnished by his appreciation of industrial design. He entered the New York scene in the perfect storm of the late seventies at the height of Studio 54, that brilliant mosh pit where socialites, artists, designers, superstars, and pretty people danced the night away. Robert was then working for the florist Renny Reynolds, who counted the club as one of his clients, but soon Robert's élan and flair for drama caught the eye of 54's cofounder Ian Schrager, who enlisted Robert to do the decor for his lavish happenings. Isabell went on to become *the* event planner du jour for everyone from Madonna to Jackie O, not to mention Anne Bass, Tina Brown, and Anna Wintour.

As much as he could produce the most magical setting for one evening, it was in his own house that he really gave form to his dreams of otherworldly beauty; I did a story on it for *Harper's Bazaar* in 1996. Robert spent his time transforming his three-story town house on Minetta Lane, with a carriage house in the back, into a wonderland mix of modernity and Moroccan-inspired mystery. He laid down epoxy floors that glistened like wet paint, built free-floating cement staircases, and collected furniture by Charles Eames, Paul Evans, Vladimir Kagan, and George Nelson. From the narrow entry passage hung with lanterns and plants to the third-floor bedroom under a triple-height glass ceiling imported from a greenhouse in Holland, filling a space where there had previously been four apartments, we were bewitched.

Clarina Bezzola's moon wall in her Brooklyn house was inspired by an illustrated book that she loved as a child. It conceals a tunnel to the second floor. Annie Schlechter photographed Clarina's world.

CLARINA BEZZOLA

SOMETIMES IT'S BETTER NOT TO GET YOUR wish. I learned this from listening to Swiss-born artist Clarina Bezzola tell me about her life and her house in Brooklyn in 2016 when I interviewed her for *New York* magazine. Clarina explained to me that the house, which she had purchased in 2011, had been superhideous. It was hard to imagine anything less than amazing, now that it had a moonscape wall that you could not only climb into, but also light a fire in, and slither through like a snake, up a tunnel that would get you to the second floor, should you be inclined not to use the stairs. All that fantastic design came about because she didn't find what she was looking for, which was a house with charm. She told me, "I mean, this place not only had zero charm; it had *minus* charm." Her minus-charm house led Clarina on a design odyssey that ended with her hiring architect James Ramsey, founder of Raad Studio, and the force behind New York City's Lowline park. The astounding moon wall was her idea, inspired, she says, by a children's book, *Barbapapa*, about sweet creatures that changed shape depending on what they wanted to express. "They lived in this house that was like a bubble house." She said it had been her favorite book since she was six years old. Clarina also mentioned her discovery of Swiss architect Peter Vetsch's work. His organic earth houses have a definite Clarina vibe. "Swiss people," Clarina told me during our interview, "I don't know how many you have met, but they are so repressed. The society is so tight and structured that everyone kind of swallows everything until, by the time something actually comes out, it's really weird. The weirdest people I have met in my life are from Switzerland."

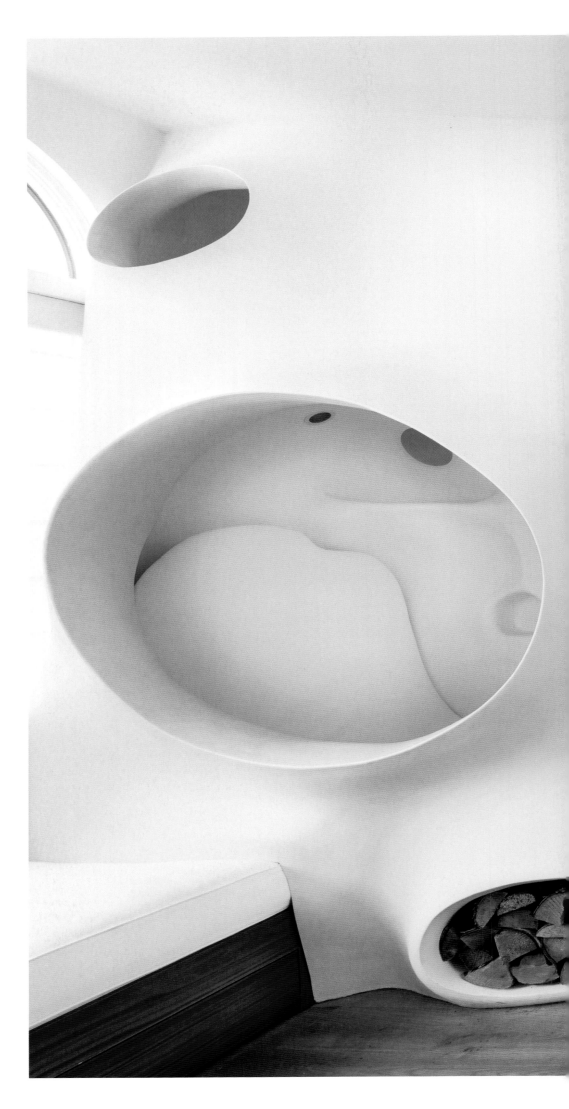

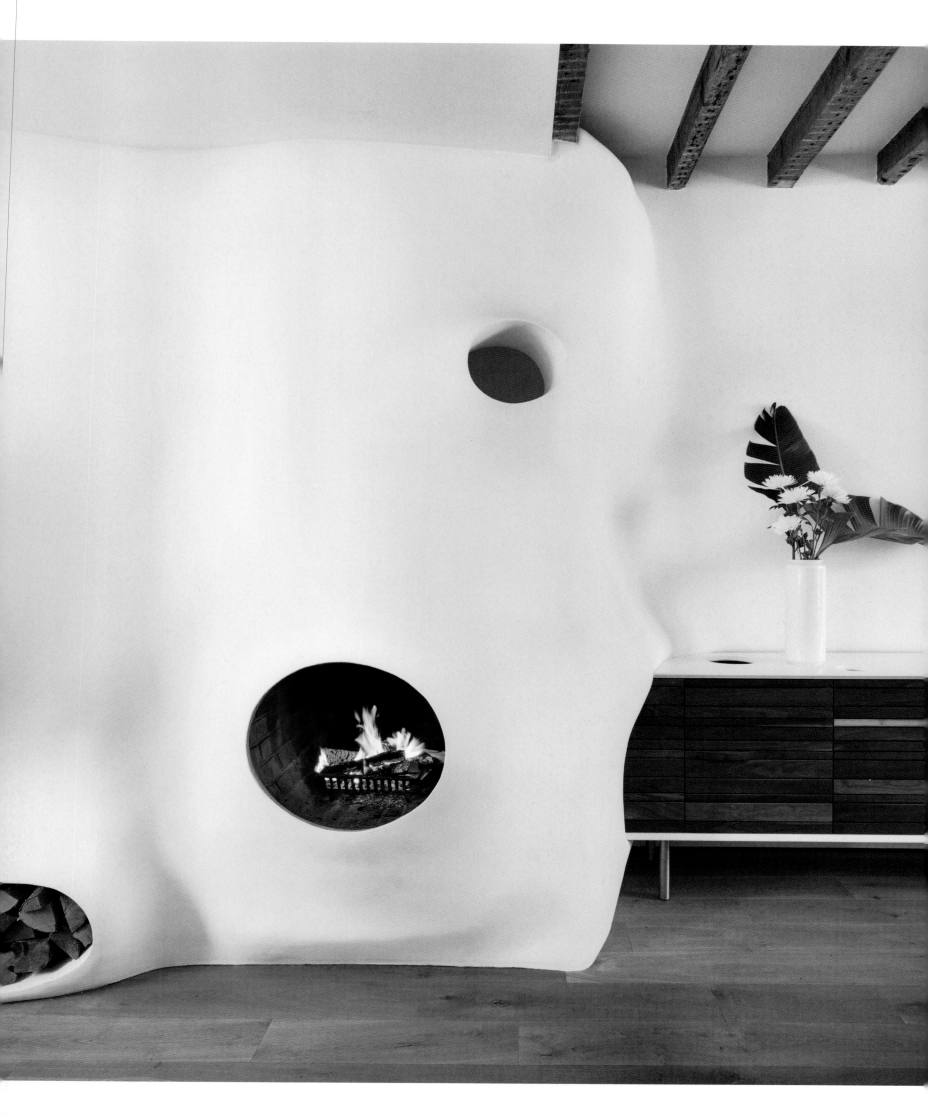

EXTREME
INTERIORS

It's never more true
that one person's heaven
is another person's
hell than when you see
the extremes of what
some people call home.

PAGES 242–281

SUSANNE BARTSCH

Opposite: Susanne Bartsch, photographed in
her apartment in the Chelsea Hotel by Michael James
O'Brien, definitely ushered in a new zeitgeist for
HG stories in 1989. *Above:* Her blood-red apartment
was small but impressive, with a Chinese bed in the
living room/bedroom.

SUSANNE BARTSCH, THE EVER-FABULOUS EVENT PROMOTER, nightclub diva extraordinaire, lived in a red, and I mean chili pepper–*red*, apartment in the Chelsea Hotel, with her then husband, Ty Bassett, in the late 1980s. Photographer Michael James O'Brien suggested that their place could be a great, unexpected feature for *HG* in 1989. It was a design-hunting score: so completely original and idiosyncratic that it could belong only to the person who lived there. Susanne was as lovely and down to earth as she was exotically gorgeous. Swiss-born, she spoke with a thick, musical accent. Her pinup girl's figure included perfect, mile-long legs, and when we arrived for the shoot, Susanne was showing them off to best advantage in one of her nightclub outfits. It couldn't have been more perfect for her portrait if we had planned it for a month. She had lived here since 1982, inheriting the apartment from a former boyfriend. Susanne and artist Joey Horatio did the decor and lavish wall painting. The pièce de résistance was a Chinese bed that Susanne found at auction. The rest of the furniture was flea market finds. Susanne was one of the first fund-raisers to help people living with AIDS, and at the time of our shoot she had just raised one million dollars with her Love Ball 2. One of New York's great originals, she's still living in the Chelsea Hotel and still going strong as an event and nightclub promoter. Long live Susanne!

BENJAMIN NORIEGA–ORTIZ

BENJAMIN NORIEGA-ORTIZ is one of those creators who consistently design joyful and edgy interiors. His former high-rise apartment on the West Side, all silver gray, made the cover of *New York* magazine's millennium design issue in 1999 with its future-forward sensibility. Benjamin and his partner, Steven Wine, founder of ABYU Lighting, then moved south to Chelsea, where they created another single-palette refuge, this time an all-white decor that looked straight out of a New Age Hollywood manse. Then they were on to decorating a two-bedroom getaway on the beach. How far away was this retreat? An hour, door-to-door, courtesy of the A train, from West Fourteenth Street right on out to the Rockaways. And this time the decorating scheme featured a double bill of romantic color: hot pink and Tiffany blue, inspired by a portrait of teenage Marie-Antoinette. Ever the pragmatic fantasist, Benjamin started to imagine what her world would have been like in 2011 out there in the Rockaways, with a bird's-eye view over the Atlantic.

"She wouldn't have plastic furniture," he mused. "She should have velvet and furs and crystals." The color of the queen's dress in the portrait, which commands a wall in the living room, decided the Tiffany-blue palette. Benjamin also embedded small crystals in the wall, so that light reflected off the water caused a dazzling rainbow to mysteriously appear. He used furniture that hadn't worked for clients, including a large, white couch that Lenny Kravitz thought was too small and a table that wasn't large enough for Sean Combs; both were perfect for this room. The luxurious wall-to-wall carpet was matched to a sample of sand from the beach outside.

The bedroom was another story, based on—what else? The hot-pink color of Marie-Antoinette's flushed cheeks. It is a boudoir of *calme et volupté*, as the French say, interpreted as: "There is nothing to do here but relax and enjoy." The pink La Murrina chandelier was imported from Venice, and the pink ostrich-feather duvet was accessorized with pillows made from satin and Tom of Finland toile. There were stuffed birds and a feathered lampshade. "We realized that Marie-Antoinette turned Hameau de la Reine into a working farm," Benjamin explained. "So these are the chickens and turkeys from her farm. The queen commands the apartment. Even when we're not here, the place is not empty."

JOSEPH HOLTZMAN

I MET JOE HOLTZMAN for the first time on Wednesday, June 16, 1999. I was excited and nervous. *Nest*, the ridiculously brilliant game changer of a shelter magazine, if you could even call it that, was Joe's creation. I remember sitting in the living room of his Upper East Side apartment, trying not to stare too much at his amazing art collection. I wrote in my journal that he had a poodle groomed to resemble a chenille pillow, and I have no idea what I meant by that. Joe mesmerized me. He asked: Did I have anything I wanted to do for the magazine? *Are you kidding? Of course I did!* But what could I bring him that was fantastic enough? I had to walk all the way home to calm myself.

Years later, in 2013, my friend and hero Todd Oldham, who photographed many stories for *Nest*, told me that he had taken photographs of Joe's place in Palm Beach. Did I want to see them? Joe had inherited a ground-floor apartment in an oceanfront mid-rise from his parents in 2011. His partner, Carl Skoggard, told me that it had originally been "white on white on white" when I interviewed him for a story in *New York* magazine. Todd's photographs recorded the Holtzman decor takeover. It was an ode, he said, to "the giddiness of Palm Beach style," although not as the society matrons of the neighborhood would have had it. Joe installed Styrofoam waves, painted sea blue, on the ceiling, saying, "It gives me that ocean roll in there." The furnishings were a salad of things collected along the Dixie Highway, mixed with treasures gleaned from estate sales at Addison Mizner–designed mansions. There were fish-adorned Minton plates, displayed in a niche created by Joe's mother, Mitzie, above a big, boxy sofa covered in vintage bark cloth. A bathroom sported a mélange of different wallpapers, including one designed by Alexander Calder, and a bedroom featured a pair of lampshades protruding over the bed as decorative objects.

The neighbors weren't exactly thrilled when Joe started to landscape his patch of lawn, and he and Carl kept the curtains drawn most of the time, to block the offending glare of the color scheme within. But the couple liked their part-time hermit existence in Palm Beach, where their vicarious socializing was done by keeping tabs on the goings-on recorded in Palm Beach's society paper, nicknamed the *Shiny Sheet*, Joe no doubt with a paintbrush in hand adorning pieces of exotica destined to join the phantasmagorical interiors sprung from his imagination.

Joe Holtzman shows that more (and even more) is more in his Miami apartment. *Above:* Lampshades as decor above the bed in the bedroom. *Opposite:* A bathroom multiplies itself. The madness was captured in photographs by Joe's good friend Todd Oldham.

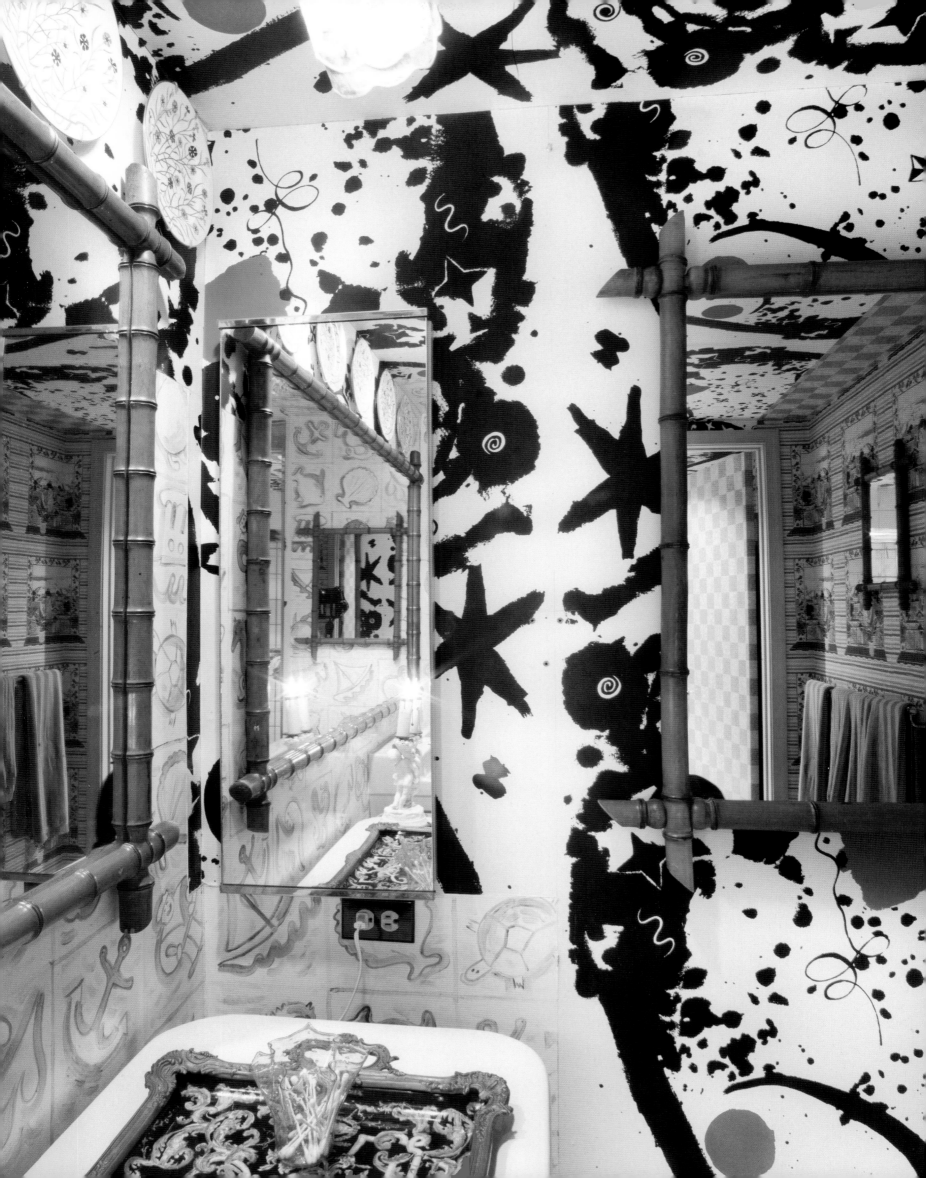

SYLVIA HEISEL
& SCOTT TAYLOR WITH
DOUG MEYER

I'D RECEIVED A TIP THAT I SHOULD CHECK OUT the apartment of fashion designer Sylvia Heisel and her husband, Scott Taylor. Word had gotten out that I was doing a 2011 design issue for *New York* magazine featuring extreme interiors, but my scouting mostly turned up projects that just weren't extreme enough. I wanted to get inside an obsessive's head. I wanted to find places that would define one person's heaven and another person's hell.

As I approached Sylvia and Scott's nondescript building in Midtown, I thought how great it would be to see Sylvia again after so many years. I rang the doorbell, and Sylvia greeted me from inside what can be described only as an abstract 3-D art piece. I stepped into a visual maze, created by a network of black lines crisscrossing every square inch of the floor, walls, and ceiling. The large, black-polished surface of the kitchen island was reflective, so the drama played out there too. What had prompted this most extreme of extreme interiors?

It turned out that this duplex rental (yes, rental) had undergone a decor game change after a contractor's crew dinged the big plate-glass window in the kitchen, creating a large crack. Enter friend and designer Doug Meyer, who experimented with Sylvia and Scott on ways to mask the crack with tape, and then went a step further, making the corrective tape into an installation in the room, which took three weeks to complete. The upstairs level of kitchen and dining room became a virtual spiderweb. But things didn't stop there. Downstairs at basement level, each room took on a life of its own. The bedroom, with its skylight, was in a way even more extreme than the kitchen. Sylvia and Scott covered the room in fabric, because, remember, with a rental you have to deliver the place back to the owner in the same state that you found it, and in this case it had been all white-washed walls and lacquered wood floors. So the fabric was used as one giant canvas, enabling everyone to go to town, drizzling black paint over the entire surface, including the bedcover. The study was decorated in a much more conventional mode, as the wall covering was who-could-guess-how-many fashion-magazine tear sheets that Sylvia has collected over decades. (Today it would be no surprise to see such a pattern in a wallpaper collection.) The room also had a Knoll sideboard, Artemide chairs, and a mannequin from Sotheby's that had once belonged to Charles James. He would have approved, I think, of the decor; it lived up to his own life of outlier originality.

251

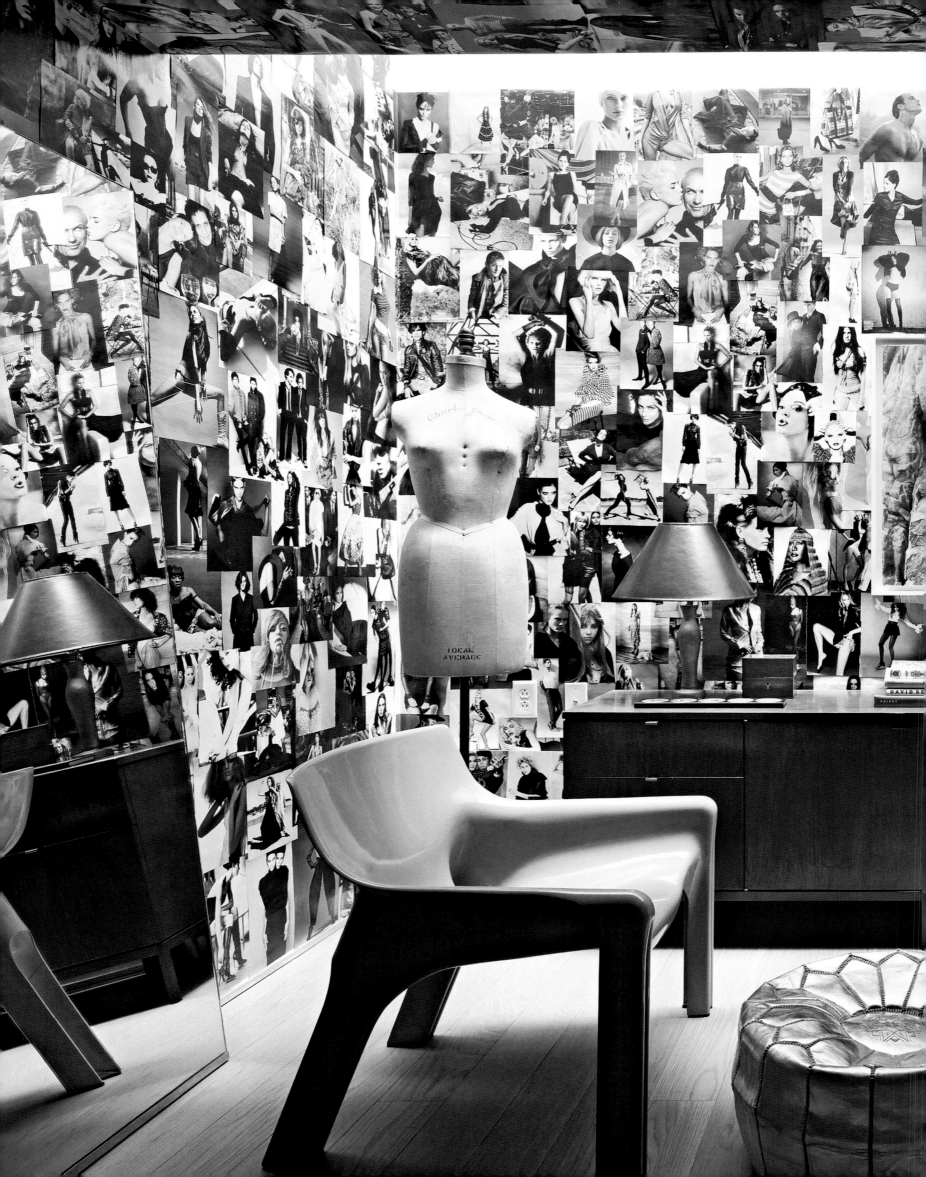

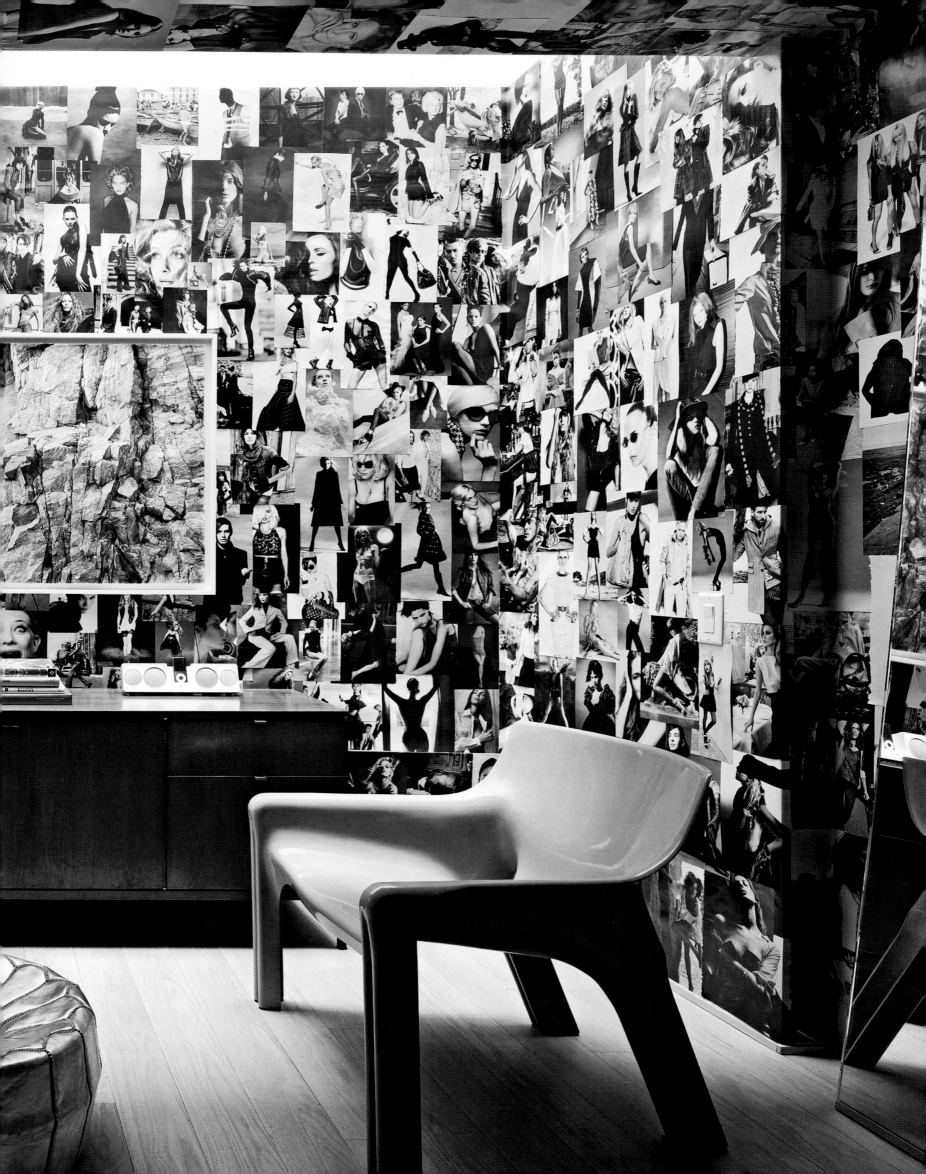

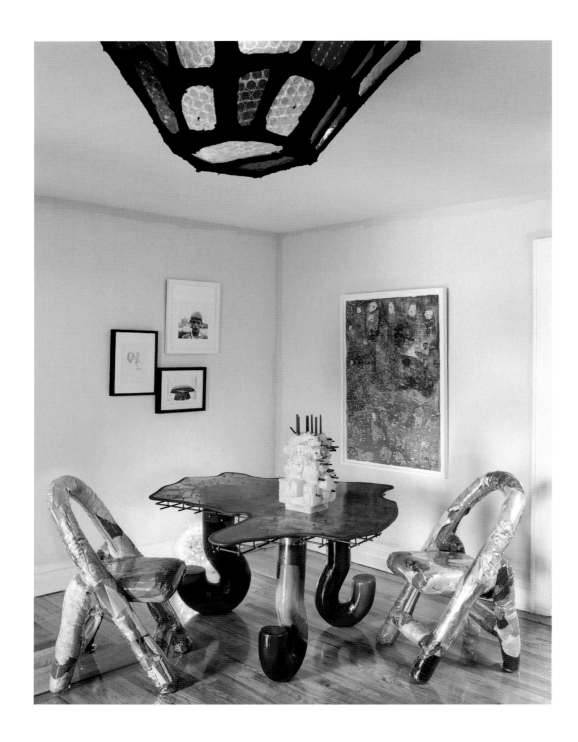

MISHA KAHN &
NICK HARAMIS

Above: Misha Kahn's and Nick Haramis's friends and family all contributed to the madcap decor in their Brooklyn rental, which included Gaetano Pesce's wobbly rubber dining table and chairs by Katie Stout. *Opposite:* The kitchen was its own feast of color and pattern, no food needed. Annie Schlechter photographed the design caper.

I STALKED ARTIST MISHA KAHN FOR YEARS, waiting to pounce when the time was right, and it arrived on the eve of his one-man show at Friedman Benda in 2017. Misha is part of a brilliant rat pack of young artists, friends from the Rhode Island School of Design who are supportive of one another and share work back and forth. Adam and Alexander Charlap Hyman, Katie Stout, and George Venson are members of this tribe. Misha and his boyfriend, Nick Haramis, editor in chief of *Interview* magazine, moved into a perfectly normal fifth-floor walk-up in Greenpoint, Brooklyn. As two creative individuals with vastly different aesthetics regarding home decor, they had issues to sort out.

"This is our first apartment together," Nick told me for a story in *New York* magazine, sitting in the lap of a furry couch near a cabinet covered in the skin of the pirarucu fish and studded with tufts of raffia, both by the Campana Brothers. "So we wanted to get it right." Nick explained that he had been a no-nonsense modernist, describing his last apartment as "very Patrick Bateman on a budget: sparse with a lot of glass and metal and black leather." Misha, on the other hand, is pretty much allergic to anything that is not highly original, exquisitely unique, and pulsing with color, just like the furniture he creates: "I'm just a bit of a hoarder," he said. Determined to find a "long-lost gem," he dug deep on Craigslist in search of the right place. "Misha spent a lot of time online, finding places that he loved," said Nick, "and that I didn't have

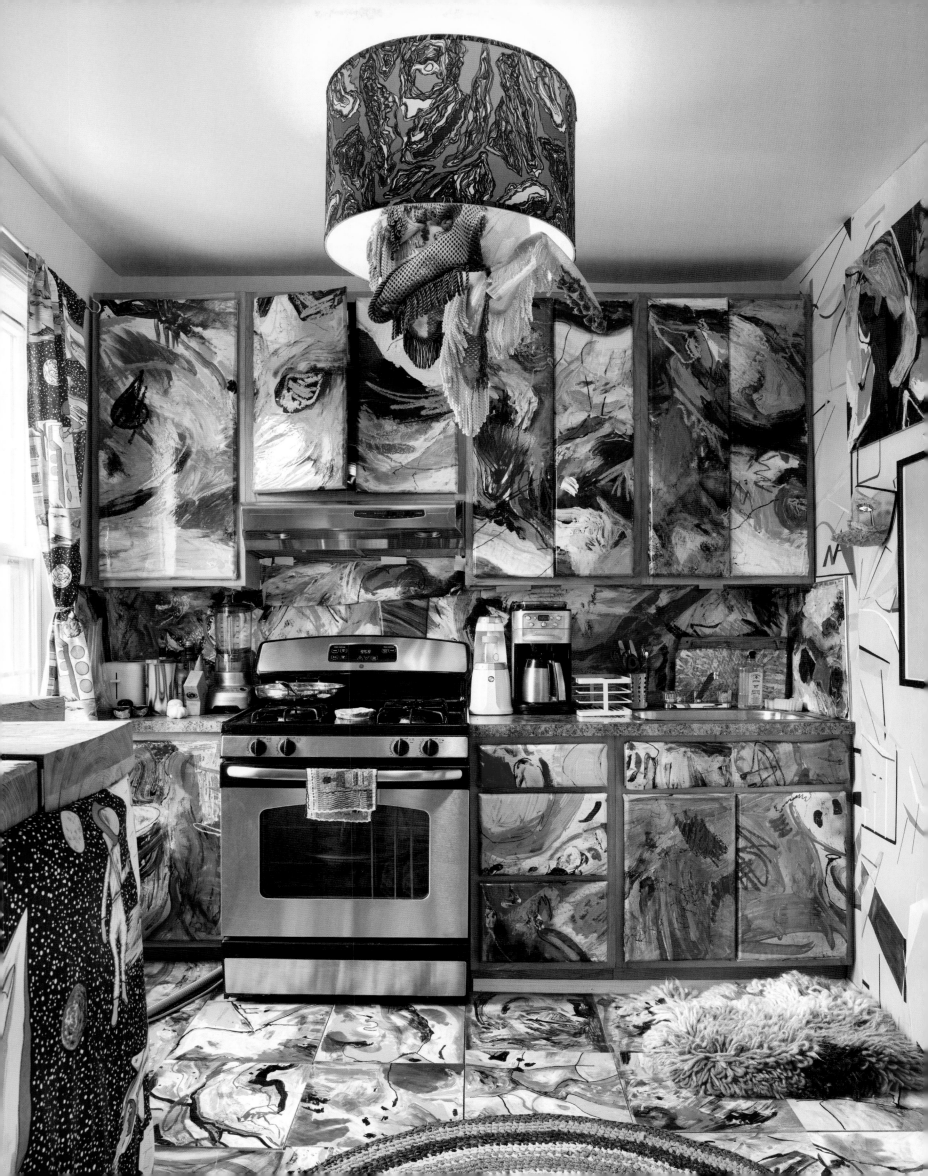

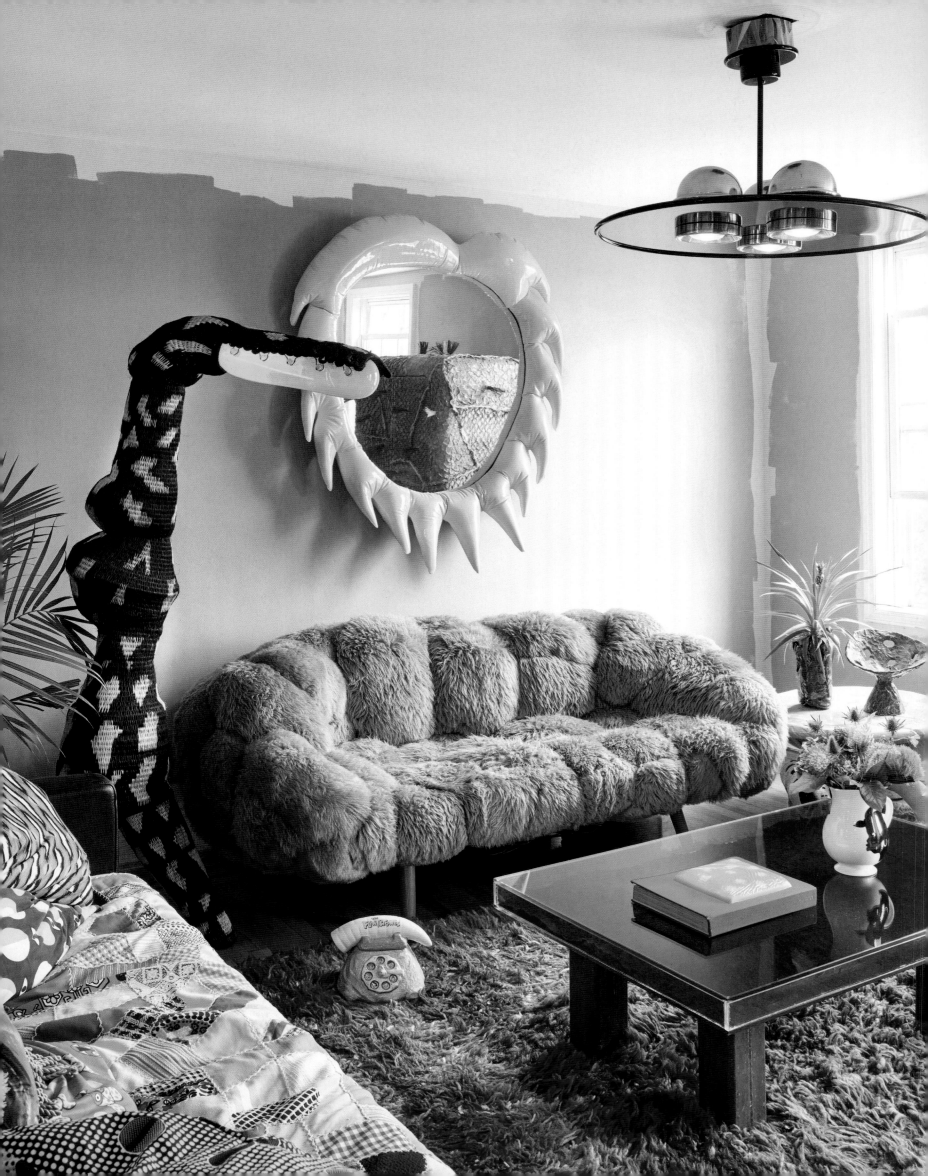

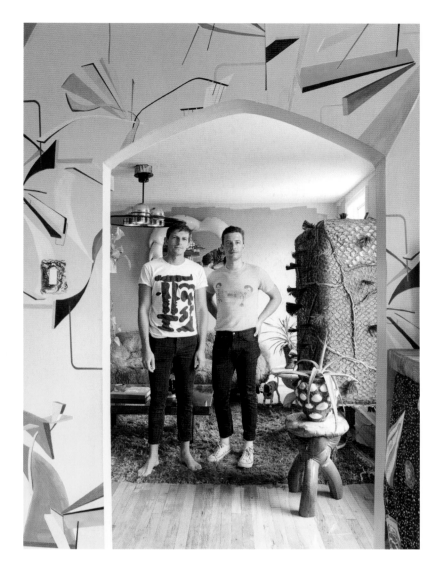

the heart to immediately dismiss because they didn't have windows or running water." The compromise: "We would move into a totally nice, normal apartment on the condition that Misha could do whatever he wanted to it. So now we live in a Pee-wee's Playhouse with a cabinet made out of fish and a soft, rubber dining table in the shape of Norway." And that is not all. Their apartment is a rental, and while that usually puts constraints on how ambitious tenants get with decorating, limits were not part of Misha's vision. All kitchen surfaces save the oven are covered in what looks like a deconstructed Chagall painting, with one wall done in Voutsa wallpaper.

The wall treatments in the other rooms evolved from a technique that Misha and Nick have dubbed "lazy painting." This entails rolling the paint up the wall as far as your arm reaches, full stop. The gap left between the painted part of the wall and the unpainted part looks like an intentional, wabi-sabi border.

Misha's 2017 show, called *Midden Heap,* was based on the way octopuses accumulate and arrange found objects in their ocean environment. It's Misha's ability to create a new visual vocabulary with found objects and precious materials that gets the heart racing, very much the way that your heart races the minute you step inside the bold new world of Misha and Nick at home.

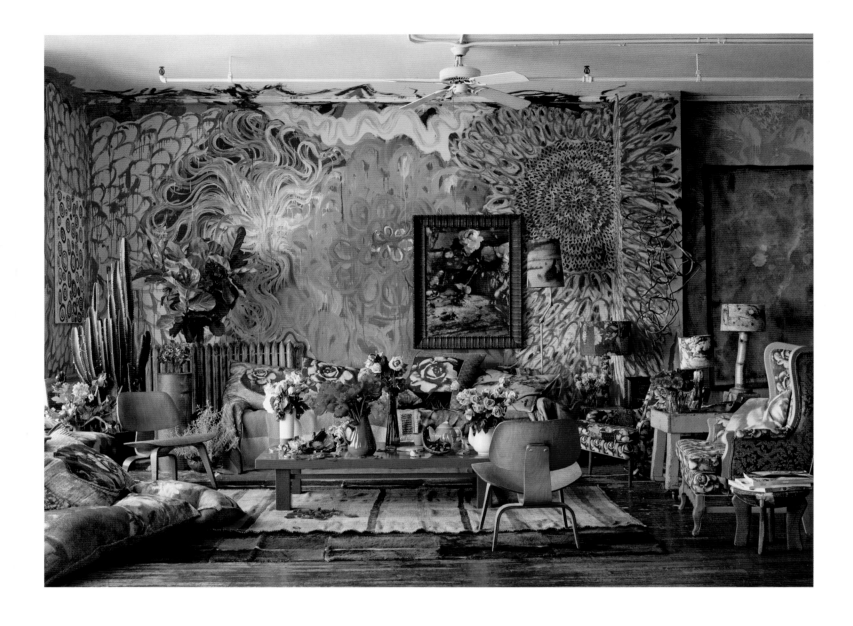

MARTYN THOMPSON

Opposite: The pillows and the wall behind the bed
in Martyn Thompson's New York loft are covered
with fabrics and wallpaper by Martyn Thompson Studio.
Above: The living room, with more designs by
Martyn Thompson Studio and a mural by Dove Drury
Hornbuckle. Photographs by Martyn Thompson.

PHOTOGRAPHER MARTYN THOMPSON has been generous with his talents when he could have settled into being just a brilliant interiors photographer and left it at that. But Martyn could not, once he first experienced the adrenalin rush of New York City in 1982. "Everybody was going to be something," he said. "Ambition was born in me at that moment. And I got back to Sydney with this idea that whatever I want to do, I can do." And he has done. Martyn has been a painter, he is still a photographer, and he designed fashion collections while living in London and Paris for more than a decade before settling in New York in 1999. He also won the real estate lottery when he was searching for an apartment, at the moment when his broker told him that he had the perfect place though it was out of Martyn's price range. The loft he had in mind was in the Little Singer Building in Soho, built in 1903 and converted into residences in 1979. It was that rare find: a space that had not been messed around with; it was pristine, and it was meant to be his.

In the 2015 incarnation of the loft's decor, which I published in *New York* magazine, Martyn's then partner, ceramist Dove Drury Hornbuckle, took his brush to the walls, painting a fantastical mural of exploding floral imagery. There was a Charlotte Perriand chair here and an Eames chair there and a set of Gio Ponti chairs from another lifetime in Europe, and I know that if I were to walk into that space today, it would be totally different, lying in wait for another story.

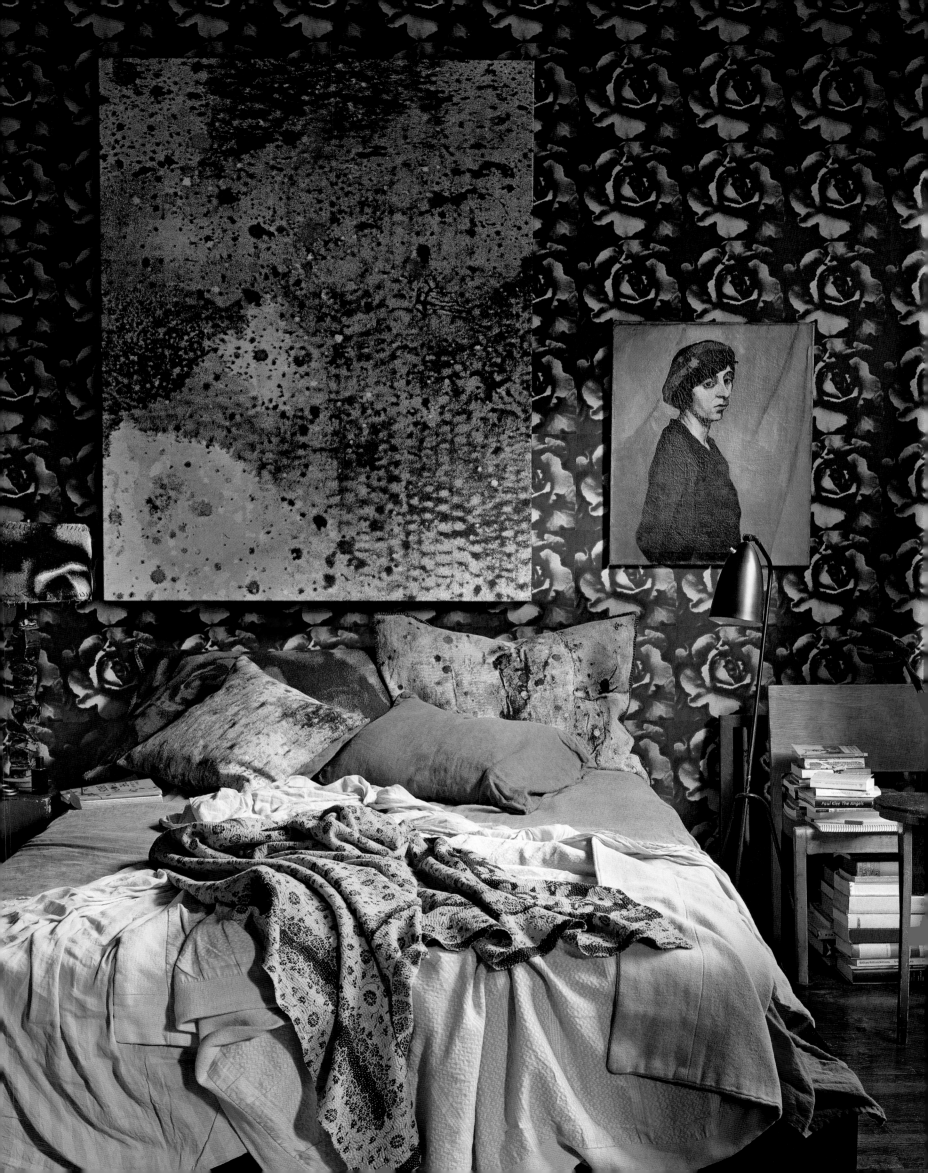

Ruth Shuman went where few people dare to go, giving carte blanche to artist and designer Gaetano Pesce, who transformed her formerly staid, oatmeal-hued Park Avenue penthouse into a supercharged, color-saturated environment where everything was custom-designed. Floto + Warner photographed the adventure.

RUTH LANDE SHUMAN

I HAD SEEN RUTH LANDE SHUMAN'S penthouse apartment on Park Avenue during dinner parties at night, so it was impossible to know that the decor, all of which was made and installed by Italian architect and industrial designer Gaetano Pesce, was the brightest Crayola-colored marvel this side of a rainbow. Those parties were always so packed with people that you could barely discern what the odd shapes and textures were all about, but one thing was crystal clear: This was the most unusual and original take on decorating that I had ever seen. Not one thing—well, that is incorrect, there were two things that had a traditional heritage; the pair of gilt-wood Chippendale mirrors that hung over the couch had belonged to Ruth's mother. Designed by Pesce, the couch looked like a pile of oddly shaped floppy cushions with fabric balls hanging from each corner, but, if you made just one move adjusting those pillows, the bells inside the fabric balls would rock and roll, making a tinkling cowbell sound. And those floppy, devil-may-care-where-they-landed-looking cushions were not random at all, as I was to discover when I moved the unruly hunks into an arrangement that I thought would read better in a photograph (it was 2016 and we were shooting for *New York* magazine). Ruth was aghast and asked me if the rearranged pillows were like that in the shot. I froze. I knew I'd done a terrible thing by touching the pillows and realized that my rule of always asking before moving anything during

The bell-trimmed
cushions on Pesce's
Giullare sofa in the living
room guarantee
that no movement will
go undetected.

a shoot should definitely have been applied to those idiosyncratic pillows! A pillow crisis was averted, however, as I hadn't messed with them too much. In fact I finally recalled that, feeling I'd made a heretical move, I had tried to get them back to their original shapes before the final shot.

Suffice it to say that styling a room, or *not* styling it, as the case may be, is critical to the success of an interiors photo shoot. Houses, like people, have characters, and there is a fine line between tweaking a detail and trying to make a banana look like a pearl. Every detail of Ruth's apartment knew its place and had been painstakingly art-directed by Pesce. Even the floors of poured resin in swirling colors incorporated drawings of objects used in the various rooms; in the dining room the floor design included a knife, a spoon, and a fork.

Ruth's life had not always been so vibrant. When she met Pesce in the 1980s, her apartment was done in a palette as beige as cream of wheat. Pesce asked a simple question, "Why doesn't your apartment look like you?" Ruth, who has been passionately devoted to empowering and changing students' lives through the use of color in public schools, founding the nonprofit Publicolor in 1996, took that to heart. It wasn't long before the beige came tumbling down, and to this day her kingdom of color lives happily ever after.

In 2001, Joshua McHugh
photographed Julian LaVerdiere's
loft in Hell's Kitchen. It felt
like a military site where secret
formulas were being cooked
up. *Above:* He spray-painted
a Saarinen tulip chair gray.
Opposite: He had a dust-resistant
office where he could draw
up plans on a glass partition.

JULIAN
LAVERDIERE

"I WANTED TO BUILD A CROSS between a bun-
ker and a lab," artist Julian LaVerdiere told
me inside his very bunker-like loft in Hell's
Kitchen back in 2001, a few months before
the September 11 attacks, during a shoot
for *New York* magazine. LaVerdiere's thirteen-
hundred-square-foot space was like something out
of a Jules Verne novel. He had a stalactite-growing
machine and a track ball powered by a slime mold.
"My work is all oriented toward science and exper-
imentation," he said. But the most prophetic aspect
of his living environment was that it was outfitted
against biological warfare and the city's patho-
gens. He had covered his floors with hospital-grade
Kentile vinyl squares, and, to get to his sleeping
chamber, roughly the dimensions of a super-
size coffin (inspired, he said, by Japanese capsule
hotels), he had installed a submarine ladder. He
had a year's worth of bottled water, one thousand
gallons, stored in case of the calamity predicted
for Y2K. But the best was that his workroom was

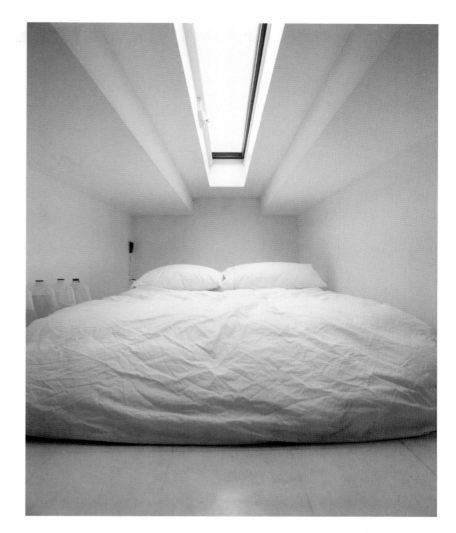

Opposite: The recycled plastic bench from Lab Safety was heat- and fire-resistant. *Above:* The bedchamber, reached by ladder, had room for a mattress and water bottles.

a dust-free safe room that housed his A/V system. He had installed a 3M liquid-crystal panel, which could be used as a dry-erase board for notes and formulas. The eeriest thing I remember was that Julian had an inflatable raft squirreled away, and when I asked why, he answered, "In case of an attack." He planned to run over to the Hudson River, only a few blocks away, and make an escape.

A few months after our shoot, Julian invited me to come visit a group of artists' studios on the ninety-first floor of the North Tower of the World Trade Center. There I was particularly fascinated by the bioluminescent-light installation that Julian and artist Paul Myoda had been working on for the radio tower of the WTC. Julian and Paul's *Phantom Towers* was the first rendering of what later evolved into the *Tribute in Light,* which went up on March 11, 2002, consisting of eighty-eight searchlights shooting light skyward in two four-mile-high beams and which has become the iconic tribute to the people who lost their lives on that unthinkable day.

GEORGE VENSON

Above: Floto + Warner took the photographs and
portrait of George Venson in a shirt he designed
in the same pattern as the wall covering in the
bedroom of his tiny Chinatown apartment.
Opposite: George's kitchen was awash with snakes.

MY FRIENDS THE DECORATORS Matthew Patrick Smyth and
Matthew White both recommended that I meet George
Venson, an artist who was hand-painting wallpaper and
experimenting with fabric design. That was back in 2013,
when I made the first of many visits to George's sublet stu-
dio on Union Square. He had covered the walls of the massive space with his
paintings of birds and beasts; he had one armchair and a desk improvised out
of packing boxes.

George came to New York City from San Antonio, Texas, in 2008, and had
slowly but steadily been laying the foundation for his business, Voutsa. His liv-
ing situation was in flux when we first met, but over the years I kept asking if he
had located a permanent place to live. In 2015 George let me know that he had
found a hole-in-the-wall in Chinatown, near his new studio. It was 275 square
feet and with three people inside felt like a subway car at rush hour. But, as he
told me then, "I knew I could just transform it into a little tree house." And trans-
form it he did. Every square inch of space was covered in Voutsa wallpaper and
fabric. A Murphy bed was always in sleep mode, as guests loved to lounge there
over cocktails. For certain people, the smaller the space, the more entertaining
seems to occur, and George was one of those people. A little console by the front
door morphed into a dining table for four, and, if you were one to be wary of
snakes on a plane, George's kitchen might just have freaked you out, as beautiful
as it was, because you would be dining with serpents.

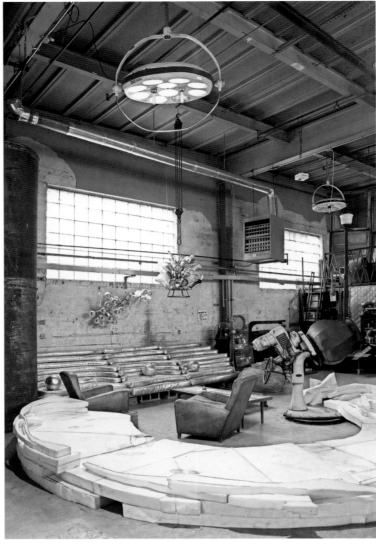

RANDY POLUMBO

Randy Polumbo's studio in Gowanus had to be seen
to be believed. Costas Picadas photographed the
site. *Above:* the rooftop had a chicken coop fashioned
from an old cupola, and down below he worked
under operating-room light fixtures. *Opposite:* The
extraordinary design concoctions included
a motor home Randy rigged up near the ceiling.

A RTIST RANDY POLUMBO LEADS A DOUBLE LIFE. There's his profes-
sional work as a builder whose clients include Santiago Calatrava,
Maya Lin, and Rafael Viñoly. And then there's his personal work:
If you want to get a feeling for what kind of sorcerer this man
is, just take a peek into any one of his own worlds, whether his
home in an eighteenth-century building near South Street Seaport; his house
in Joshua Tree, California; or his four-thousand-foot warehouse-studio in the
Gowanus section of Brooklyn. Each expresses his vision: part *Mad Max,* part
Tony Duquette. His mantra is "nothing is impossible."

The first thing that you see when entering his studio is a ten-thousand-
pound Dodge Travco motor home perched on a salvaged truck lift. Randy uses
it as an air-conditioned office when it gets really hot. The 1930s-era building
was in rough shape when he found it: no heating or cooling system, no bath-
room, and "there was a humongous cylindrical lift for picking up boats—this
thing was left there, seething ancient grease." There are bathrooms now,
labeled "Human" and rigged within a shipping container; the mezzanine has
a wall made of discarded windows salvaged from a dump. The rooftop is cov-
ered in grass. An old cupola is now a chicken coop, and Randy is growing veg-
etables in raised beds. There are a grill and tables, and you can just imagine
soft summer nights under the stars, with the city far beyond. But wait, how
did that cupola get up here?

When I interviewed him for a story in *New York* magazine in 2016, Randy
just looked at me like that was the silliest question and shrugged. "For my cli-
ents, we've hoisted way worse stuff—like a two-story-tall curved glass terrace
addition on Fifth Avenue. And we always make it happen."

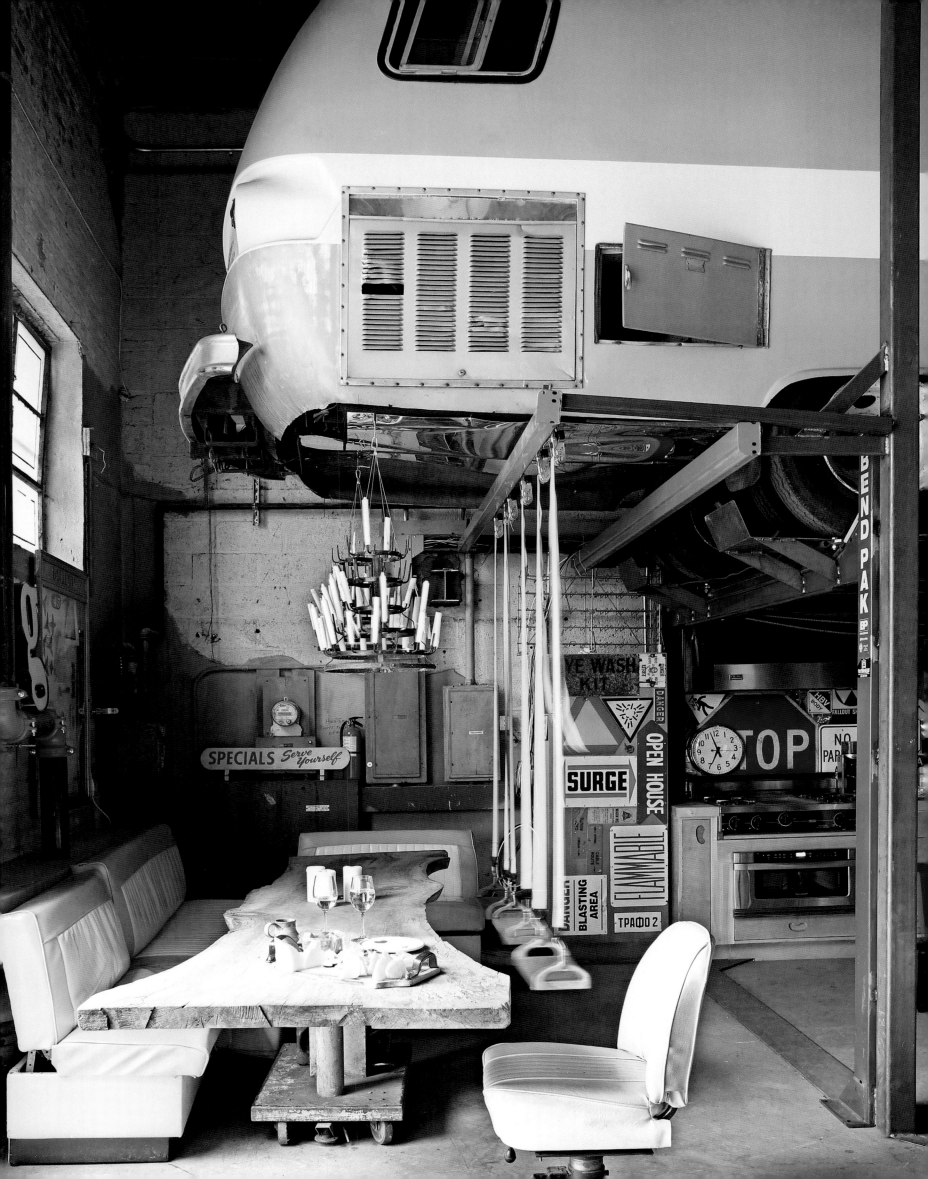

MAY I COME IN? ——— EXTREME INTERIORS

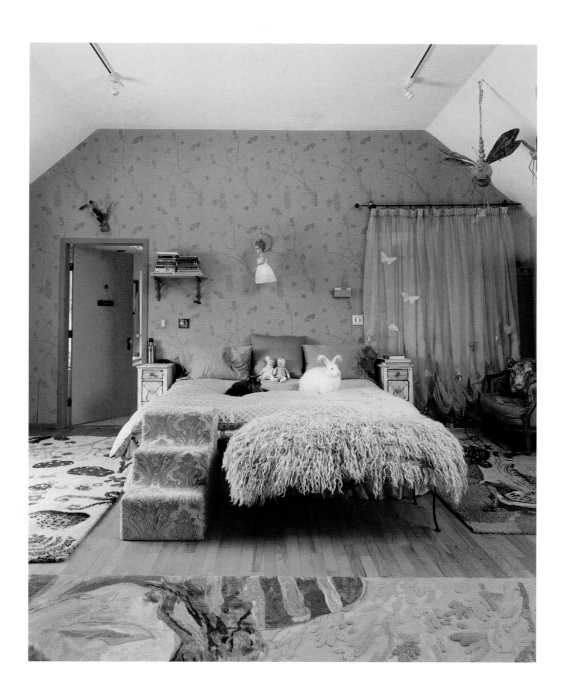

JANET & KATHY RUTTENBERG

Opposite: Kathy Ruttenberg's pigs sleep in special beds in her upstate New York house and have large, pristine pens in her studio building. *Above:* Her bedroom, with its wallpaper by artist Kiki Smith and rug and sconce by Kathy, is open to all four-legged creatures, including rabbits. Thomas Loof did a glorious portrait of one of Kathy's pet pigs and all the interiors of her animal kingdom.

WHO WOULD PLACE A LIFE-SIZE EIGHTEENTH-CENTURY PORTRAIT of a knight in the bathtub? The same person who would set an elegant table for one in the kitchen, where the Louis XV floral-upholstered dining chair is covered in a second layer of bubble wrap. "I'd like to use clear plastic as a tablecloth, actually. I think a lot of it is quite beautiful," Janet Ruttenberg told me for a story in *New York* magazine in 2013. The artist is petite, beautiful, and immaculately dressed, with an I-own-it kind of chic, that is, when she is not out in Central Park painting, where her outfits are geared to the weather. Her daughter Kathy is also an artist whose life is rooted in her art and her animals.

Kathy has moved to upstate New York, where she has created a kingdom for her animals, including birds, rabbits, dogs, cats, pigs, horses, ponies, and who knows what else. Her animals live better than most humans. The pigs sleep in immaculate pens in the house at night, very much in the style of *The Princess and the Pea*; they have so many blankets that they must feel they are sleeping in the clouds. During the day they root in hay-filled rooms out in the barn, where Kathy has an enormous studio and a kiln for firing her sculptures. In the house Kathy also has a room for birds, and rabbits roam her bedroom whenever the spirit moves them and their mistress. Kathy's sculptures evoke fantastic figures that are half animal, half human, and her ladies have delicate tapered feet that look exactly like their creator's. The decor of her guesthouse is made from different pieces of her art that have been translated into curtains, rugs, lamps, and bedcovers. Kathy imagines her own fairy tale and then lives in it.

Above: Thomas Loof also photographed Janet Ruttenberg's Beekman Place apartment, where she upholstered her dining chairs with alligator skins she found at a flea market. Artist Jeroen Vinken made silk curtains for the room. *Opposite:* Janet covered her Louis XV kitchen chair with bubble wrap because she liked the effect.

Kathy's living room
has a carpet by Nathalie
Lété; *Black Pearls*, a
sculpture by Alison Saar,
stretches over the couch.

Janet framed her own
painting, *Gannochy*,
adding gold sun rays.
The couch is upholstered
with a nineteenth-
century linen floral print,
with the back of
the fabric facing out.

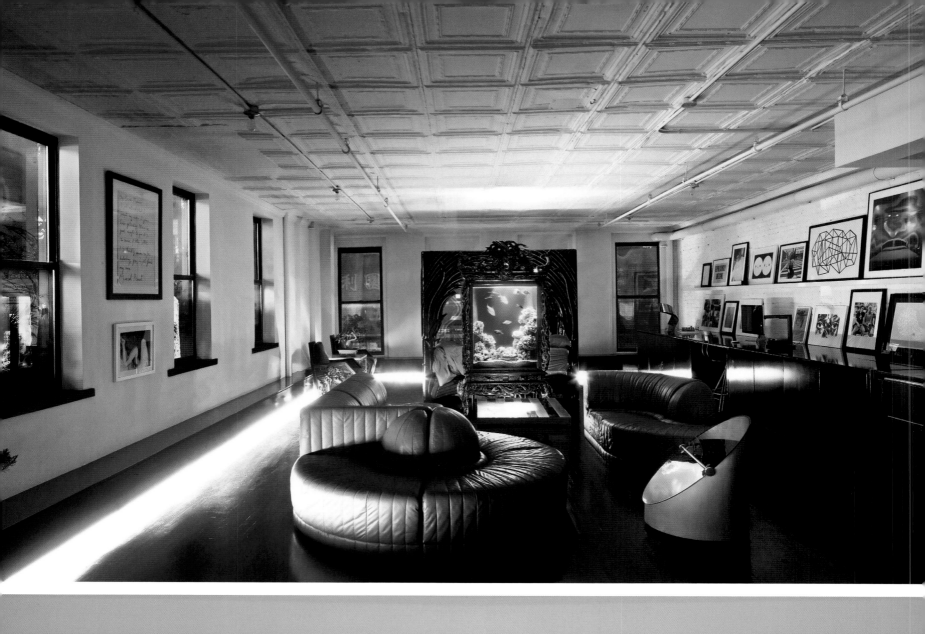

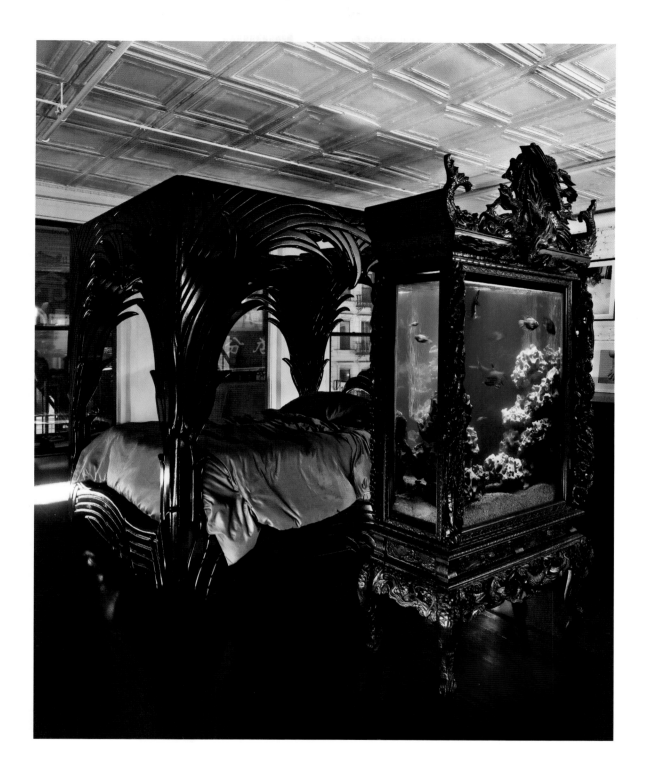

RICHARD CHRISTIANSEN

Jeremy Liebman photographed Richard's Chinatown loft decked out for entertaining in a dark, sexy vibe. Every detail was utilized to create a glamorous undertone, including the kitschy, black-lacquered eighties canopy bed, which had been a glossy banana color when Richard found it. His kitchen was also dark, accented with red objects and books.

ADMAN RICHARD CHRISTIANSEN FOUNDED HIS AGENCY, Chandelier Creative, in 2009, occupying a vast open office space in New York City where a lamp by Moooi in the form of a life-size horse was the first thing to greet you. He is a charming, rakish chameleon intent on living life as a party, and his living spaces have been fashioned to reflect that. His first home in New York was a loft in the Bowery Hotel. We photographed him in his bathtub, with a glass of wine and all the reading material for that day scattered on the floor, for a story in *New York* magazine. The tub was his home office, his thinking space, so it made sense to do his portrait there.

In 2012 he moved to a one-thousand-square-foot loft in Chinatown and it was time for another story. "I wanted it to look," he said, "like Donatella Versace had designed an opium den." The lair of dark drama, with a palette of black, silver, and red, came to life at night when invitees and drop-ins were equally welcomed. Richard found a lima bean–green banana-leaf bed from the 1980s and transformed its cheery, flower-power aesthetic into something more suited to Morticia Addams, giving it a dose of raven-black lacquer. The one-thousand-pound fish tank nearby added a touch of the unexpected, although if you know Richard at all, the unexpected is the norm.

Yes, even the sink and the toilet were yarn-bombed by the crochet artist Olek, who dragged her own bed from her apartment to her 2010–11 show at the Christopher Henry Gallery in Nolita. Dean Kaufman photographed the artist at the gallery.

OLEK

AGATA OLEKSIAK, AKA OLEK, entranced everyone she met with her statuesque beauty and devil-may-care lone-wolf attitude. She had grown up in the cold, gray climate of Ruda Śląska, Poland, entertaining herself by making colorful clothes for her Barbie dolls, along with the occasional crocheted hat. She got herself to Greenpoint, Brooklyn, in 2000, and taught herself English by watching subtitled movies. One day she found a crochet book at a dollar store, and her sometime hobby became an obsession that played itself out on street corners, where she turned lampposts, chained bicycles, and various discarded objects into a strange, fairy-tale menagerie of knit creatures. If you've ever seen a person in a crocheted bodysuit in the subway, then you've seen an Olek original.

When we met in 2011 for a *New York* magazine story, then thirty-three-year-old Olek had gained such a reputation that she was preparing an exhibit for the Smithsonian American Art Museum for the following year. She had shown the work first at the Christopher Henry Gallery in Nolita, and it had been no small feat. The installation of a fifteen-by-fourteen-foot studio apartment was conceived by Olek in her own Park Slope apartment. She had crocheted a yarn cover for everything: the bathtub, the sink, the toilet, the ironing board and iron, the TV set, the floor and walls, even the leftovers in the refrigerator. When I asked Olek where she slept during the show, she said she slept in the gallery, as she wanted to be in her own bed, which was crocheted in toto, naturally. Therefore we photographed her in bed, reading a book whose cover was, you guessed it, yarn-bombed in loopy pink-and-purple crocheted stitches.

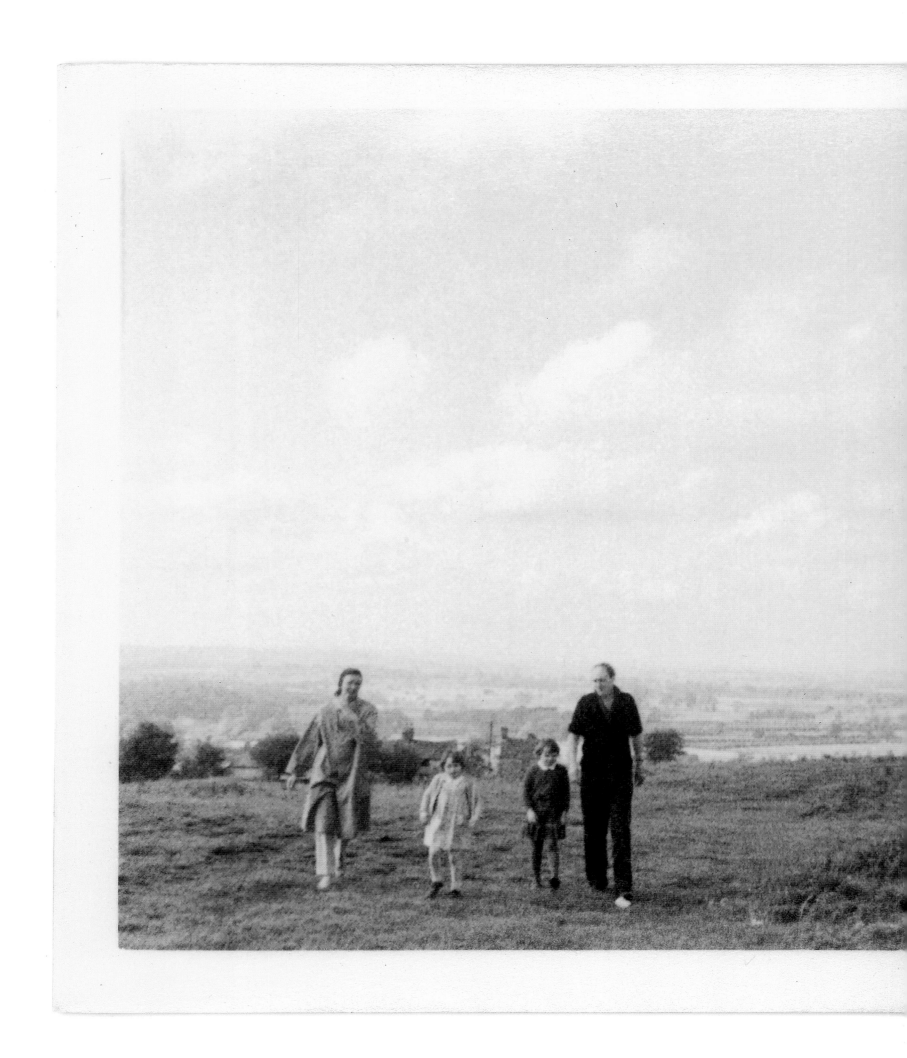

MAY I COME IN?

AFTERWORD

PATRICIA NEAL AND ROALD DAHL were good friends of my parents, and during the time they lived in New York—this was before they moved to Gipsy House in Great Missenden in the early 1960s—our families spent lots of time together. I have a faint memory of playing with Olivia, their eldest daughter. Olivia died tragically at the age of seven of complications from the measles in 1962, and that was only two years after her brother, Theo, then four months old, was hit by a cab in his pram, resulting in a brain injury. The Job-like tragedies continued with Pat's stroke in 1965. My parents rushed out to Los Angeles to be with Pat and Roald at the hospital.

Growing up I visited Gipsy House both with and without my parents. One time Roald took me to see his writing hut across the lawn from the house. It was small and snug, with just enough room for the big, ratty, comfy armchair where he would sit with a board across his lap and write in long hand. I was too young to realize that I was in the shrine of a legend. I knew Roald as my parent's friend, but as I got older, he became a friend in his own right. Roald took an interest in what I was doing, as he did with my sisters and brother. I was in awe of Roald and intimidated by his sharp wit and brilliance.

I went away to school in 1969, and one day I took a spectacular spill on a muddy hillside. The fall left me flat on my back, staring straight up at the sky; it was so sudden and so ridiculous that all I could do was laugh. I thought of Roald and how he would have thought it was funny, so I wrote him a letter describing the event and what I was doing at school. To my surprise I received a letter in return; I have kept it all these years. It is one of my greatest treasures.

283

May 10, 1971

My dear Wendy,

Your letter was one of the nicest I have ever received. It told me some things about you that are exciting—that all of a sudden you are no longer a child but an adult, a rare adult with subtle shades of wisdom seeping in from all directions; that you have the gift of warmth; that you are not afraid of expressing your feelings openly; and that you write superbly! Think about that last one. One day you may well write something that other people may want to read, and if they want to read it so much that they are prepared to pay money for the privilege then you are a professional. But don't hurry it. Don't do what that other girl did and push out pages and pages of nonsense. One page of good stuff is worth a thousand pages of rubbish. And don't hunt for a style as she did. You have your own. Play it straight.

My affection and love for your entire family is enormous and grows more enormous every year. I hope it will go on forever through my children and yours across the sea.

Love, Roald

THIS BOOK, NOT TO MENTION MY CAREER, would never exist were it not for the incredible editors, mentors, photographers, designers, and everyone who has ever let me into their homes over the years. Thank you with love and gratitude: Michael Henry Adams, James Aguiar and Mark Haldeman, Josef Astor, Matt Austin, Richard Avedon, Susanne Bartsch, Kelly Behun and Jay Sugarman, Rosamond Bernier, Clarina Bezzola, the Countess, Richard Christiansen, Alba Clemente, Adelaide de Menil, Baron de Rede, Nicole de Vésian, Honoria and Laura Donnelly, Tony Duquette, Robert Evans, Fabrizio Ferri, Fogarty Finger Architects, Brock Forsblom, Gray Foy, Steven Gambrel, Valentino Garavani, Whoopi Goldberg, Lisa and Chris Goode, Jean-Paul Goude, Cornelia Guest, Kitty Hawks and Larry Lederman, Sylvia Heisel and Scott Taylor, David and Lady Pamela Hicks, India Hicks, Joe Holtzman, Robert Isabell, Misha Kahn and Nick Haramis, Bill Katz, Kenneth Jay Lane, Julian LaVerdiere, Jay and Linda Maisel, Peter Marino, Charles Masson, Andrew and Laura Merton, Doug Meyer, Gene Meyer, Mariko Mori, Odile Noll, Benjamin Noriega-Ortiz and Steven Wine, Todd Oldham and Tony Longoria, Olek, John Pawson, Hervé Pierre, Randy Polumbo, J. Morgan Puett, Daniel Romualdez, John and Dodie Rosekrans, Giovanni Russo, Janet Ruttenberg, Kathy Ruttenberg, Fernando Sanchez, Vito Schnabel, Amy Sedaris, Joe Serrins, Ruth Lande Shuman, Babs Simpson, Anne Slater and John Cahill, Howard Slatkin, Andrew Solomon and John Habich, Martyn Thompson, Isabel and Ruben Toledo, Tina Turner, Gloria Vanderbilt, Ronald van der Hilst, George Venson, Donatella Versace, Gianni Versace, Alexander Vreeland, Diana Vreeland, Kehinde Wiley, Hutton and Ruth Wilkinson, Tod Williams and Billie Tsien, Eli and Devon Zabar.

I am indebted to the magnificent photographers who brought their magic: Ruven Afanador, David Allee, Josef Astor, Lillian Bassman, Fernando Bengoechea, Andrew Bordwin, Corinne Botz, Leigh Davis, François Dischinger, Fabrizio Ferri, Floto + Warner, Gentl & Hyers, Tria Giovan, Timothy Greenfield-Sanders, Howie Guja, François Halard, Mark Heithoff, Ken Heyman, Ethan Hill, Horst P. Horst, Ditte Isager, Stephen Kent Johnson, Dean Kaufman, Rowland Kirishima, Laurie Lambrecht, Larry Lederman, Jeremy Liebman, Peter Lindbergh, Thomas Loof, Joshua McHugh, Andrew Moore, Inge Morath, Michael Mundy, Michael James O'Brien, Eric Ogden, Perry Ogden, Erwin Olaf, Todd Oldham, Marvin Orellana, Costas Picadas, Mike Russ, Richard Rutledge, Annie Schlechter, Jason Schmidt, Martin Scott, The Selby, John Stewart, Tim Street-Porter, Mario Testino, Danforth Tidmarsh, Martyn Thompson, Ruben Toledo, Caroline Tompkins, Simon Upton, Max Vadukul, Christina Vervitsioti-Missoffe, William Waldron, and Paul Warchol. A special thanks to artist Jeremiah Goodman and Dean Rhys Morgan, and supreme gratitude to Oberto Gili and to special mentors from the Estée Lauder team: June Lehman, Alvin Chereskin, and Victor Skrebneski, who taught me everything I needed to know.

Thank you to the editors in chief who gave me wings: Dominique Browning, Alexandra d'Arnoux, Carrie Donovan, Stephen Drucker, Pamela Fiori, Louis Oliver Gropp, Ed Kosner, Anthony Mazzola, Patrick McCarthy, Marian McEvoy, Caroline Miller, Darcy Miller, Nancy Novogrod, Franca Sozzani, Martha Stewart, Richard David Story, Liz Tilberis, and Anna Wintour, and a very special thanks to Adam Moss for giving me the great privilege and joy of working all these years with my second family at New York magazine. Thank you Binky Urban for setting me straight on the path of this book. Thank you Alida Morgan for that phone call, John and Laura Avedon for your support, Isaac Mizrahi for always guiding me through the weather, Todd Oldham and Tony Longoria for being the first to rally and visualize this book, Larry Lederman for being the wisest, kindest, and most generous of men, and thank you Roald Dahl for sending me a dream in the mail.

Thank you Eric Himmel and the great team at Abrams: John Gall, Anet Sirna-Bruder, Gabby Fisher, Darilyn Carnes, Annalea Manalili, and Alicia Tan, and never enough love and thanks to my dream team: book designer, Aaron Garza, and photo editor, Leonor Mamanna. And last, but never least, thanks for the love and support of my treasured family.

Wendy Goodman

Designer: Aaron Garza
Photography Editor: Leonor Mamanna
Production Manager: Anet Sirna-Bruder

LIBRARY OF CONGRESS CONTROL NUMBER: 2017956945

ISBN: 978-1-4197-3246-1
eISBN: 978-1-68335-329-4

PRINTED AND BOUND IN GERMANY
10 9 8 7 6 5 4 3 2

Abrams books are available at special discounts when purchased in
quantity for premiums and promotions as well as fundraising or
educational use. Special editions can also be created to specification.
For details, contact specialsales@abramsbooks.com or the address below.

Abrams® is a registered trademark of Harry N. Abrams, Inc.

ABRAMS The Art of Books
195 Broadway, New York, NY 10007
abramsbooks.com

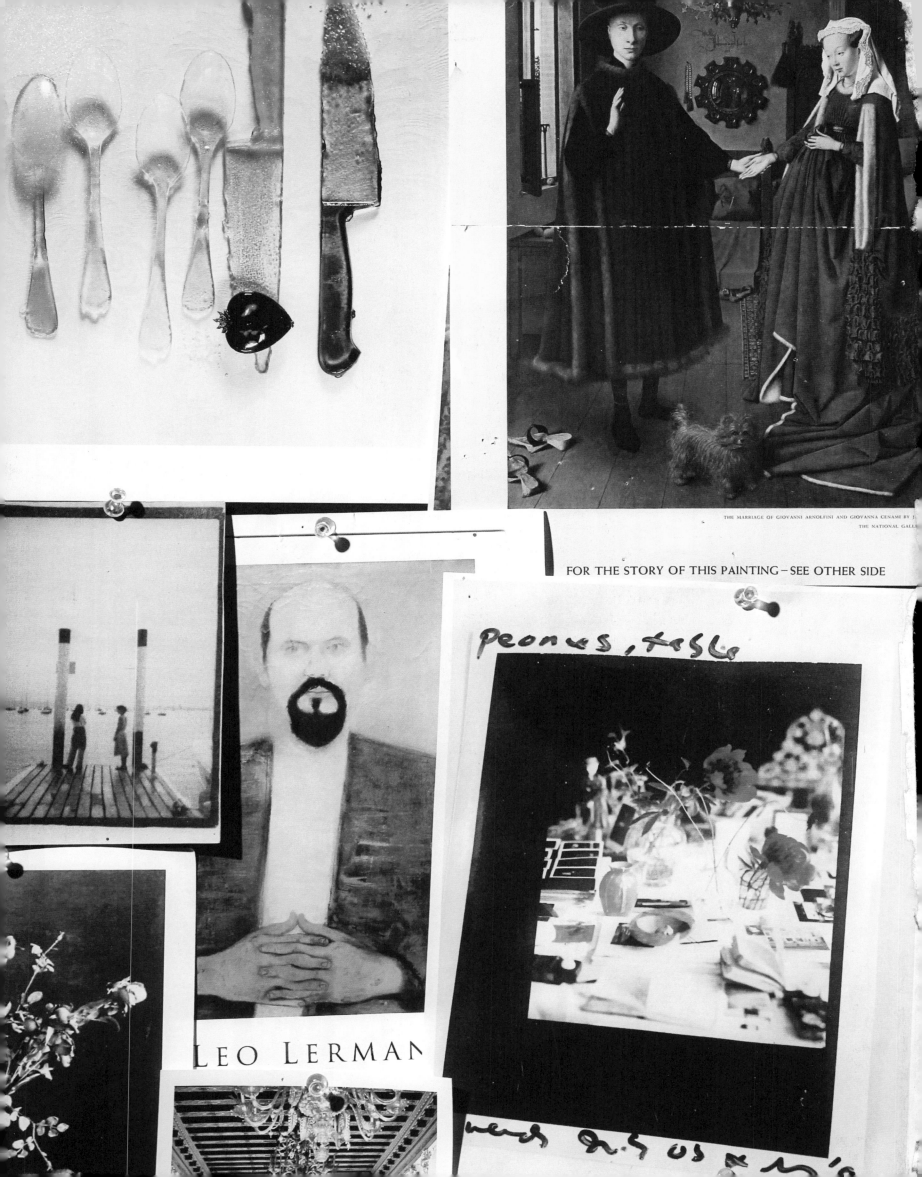

THE MARRIAGE OF GIOVANNI ARNOLFINI AND GIOVANNA CENAMI BY J...
THE NATIONAL GALLE...

FOR THE STORY OF THIS PAINTING—SEE OTHER SIDE

Peonies, 1956

LEO LERMAN